international 04

18 September – 28 November 2004

ional 04

Editor: Paul Domela
Production editor: Helen Tookey
Catalogue assistant: Raj Sandhu
Catalogue design: Alan Ward @ axisgraphicdesign.co.uk

Paper cover: Challenger Offset 250gsm
Paper inside: Skye Special Matt 130gsm
Typefaces: The Sans and The Mix, Lucas Fonts, Berlin
Printing: Andrew Kilburn Print Services

Published by Liverpool Biennial of Contemporary Art Ltd
ISBN: 0-9536761-5-3

Contents

VENUES
Bluecoat Arts Centre
FACT
Merseyside Maritime Museum
Museum of Liverpool Life
Open Eye Gallery
Tate Liverpool

PUBLIC REALM
Albert Dock
Biennial Centre
BBC Big Screen
Bispham House
Canning Place
Central Library
Church Alley
Church Street
Great George Square
Liverpool John Lennon Airport
Lime Street Station
Liverpool Town Hall
Lord Street
Pier Head
St George's Hall
St John's Gardens
The Palm House
The Port of Liverpool Building
Wavertree Common
Wood Street

Foreword

Lewis Biggs, Chief Executive, Liverpool Biennial
Declan McGonagle, Chair of the Trustees, Liverpool Biennial

International 04 is the centrepiece of the third Liverpool Biennial. The context of the Biennial and the city in which it takes place play a key role in forming the exhibition's intentions and values.

Liverpool Biennial was founded as an independent charitable trust in 1998 – thanks to the vision of James Moores, and the financial investment made by him and his fellow trustees of afoundation – in a city that was raw from years of neglect and still searching for a sense of direction. Anyone who visited the first Biennial in 1999 will be struck by the rapid changes that have taken place since then in terms of the urban fabric, and this is a fraction of the change that will follow in the next few years. The changes to the city's mood are equally clear, with a growing sense of confidence that the city can once again play a significant part on the global stage. This mood has been reflected in the accolade of being awarded the title of European Capital of Culture 2008.

We should like to acknowledge first the contribution played in realising the third Liverpool Biennial by Liverpool City Council, by Arts Council England, and by the Northwest Development Agency. This alliance of local, regional and national agencies has been hugely supportive in recognising and rewarding the unique contribution of the Biennial not only to Liverpool's regeneration but to the outlook of the visual arts in the UK. During the last eighteen months, these agencies have agreed to continue to fund the Biennial from year to year, and so secured its future.

Equally important has been the support of the European Union through the Objective One funding programme and the European Regional Development Fund, and the continued collaboration of the partner organisations that deliver the other three exhibition programmes of the Biennial: the Walker (National Museums Liverpool) and the John Moores Exhibition Trust; New Contemporaries; and afoundation, which has used its resources far-sightedly to secure space for present and future use by Liverpool-

based artists, as well as directly funding current exhibition activity. The collaboration of these partners is fundamental to the success of Liverpool Biennial as an event, and we are delighted to be able to acknowledge also a first, significant contribution from the Foyle Foundation.

The International itself would not be feasible without the expertise and active support of Tate Liverpool, the Bluecoat Arts Centre, the Foundation for Art & Creative Technology (FACT), and Open Eye Gallery. Their participation is a prerequisite for a central aim of the Biennial as a whole, which is to continuously develop the already rich arts infrastructure of Liverpool – making the city a better place in which to practise as an artist or to visit as an art lover. The exhibition has again received significant support from the Henry Moore Foundation, as it has from the Gulbenkian Foundation and Visiting Arts, to each of which we are grateful.

We owe much to the willing support of the researchers, Sabine Breitwieser, Yu Yeon Kim, Cuauhtémoc Medina and Apinan Poshyananda, in an unusual process.

Our final and greatest thanks are to the artists who accepted the invitation to participate in *International 04*, knowing that they were embarking on a demanding and risky process that would ask them to invest emotion and energy in the exhibition as well as time. We have been delighted that so many of the invited artists have been willing to accept this demanding situation, and we trust they are as delighted as we are with the results of their hard work. Without their imagination we should be so much the poorer.

The vision developed for the International, and shared by the staff and Board of the Biennial, is simple and powerful. It is a vision of artists who excel in their practice commissioned to make new art in response to their understanding of Liverpool as a cultural context – new art from around the world that is developed for a specific

location. Visitors from around the world therefore see art that, by definition, cannot be seen anywhere else, and which also helps them appreciate the place that they are visiting; and the same is true for visitors from the UK. The logic is simple but we believe unique in application.

The first International was commissioned from Tony Bond, Chief Curator at the Art Gallery of New South Wales, in the justified expectation that his grasp of global art practice was matched by his appreciation of the cultural context of Liverpool as a city (he is a native of Lancashire). The exhibition, *Trace*, fitted into the city, physically and contextually, in a remarkable way.

International 02 was researched and selected by a team of curators based in Liverpool – a view of art across the world from one city. *International 04* reversed this process, with curators from different parts of the world being invited to research Liverpool as the context for an exhibition, and then recommend the practice of artists that would have some resonance with this context. While the majority of the art in *International 02* was commissioned especially for the exhibition, this principle has been extended to 100 per cent new commissions for *International 04*.

At the centre of this process is the idea of negotiation. Addressing and empowering place as having value, not as an abstraction (which some current critical discussion about art and social engagement seems to represent), but as specific and particular, has been key to the negotiations carried out by the researchers and then by the artists in the development and realisation of new works. Central to the Biennial as a whole, in fact, is the idea that not only new work, but the new forms which art needs, will only germinate in projects that are positioned, with conviction and coherence, in specific places and in the art world simultaneously. Only those projects that can inhabit and negotiate the intersections between the global and the local, without disempowering the local or diminishing the art, will be able

to speak convincingly about the new possibilities for the transaction between art and society.

In addition to the principle of new commissions for a specific context, we have adopted a collaborative approach that fundamentally colours the art commissioned. We hope that despite the complexity and challenge of the process it also adds quality to the art. By dispersing the organisational functions among a number of collaborators, the process ensures that each proposal is refined through conversations with a great many people, and so also that it is understood by, and embedded in, the organisational context in which it is situated.

This process, which is one of facilitation rather than control, is described at greater length by Paul Domela in his essay. We thank him and the *International 04* exhibition team in the Biennial office (Mark Daniels, Sorcha Carey, and interns Raj Sandhu, Stella Fong and Renae Pickering) for their work in realising the exhibition through collaboration with our partner organisations, whose committed participation remains fundamental to the success of the International.

Liverpool Biennial 2004

'Founded by James Moores with the support of afoundation'

PRINCIPAL FUNDERS

The City of Liverpool

Northwest
REGIONAL DEVELOPMENT AGENCY

the**objective**one**programme**
eu&merseyside
European Funding is Creating New Opportunities

LIVERPOOL
the world in one city

englands**northwest**
BE INSPIRED

INTERNATIONAL 04 EXHIBITION PARTNERS

INTERNATIONAL 04 MAJOR FUNDERS

The Foyle Foundation The Henry Moore Foundation

INTERNATIONAL 04 SUPPORTERS

PROJECT FUNDERS

Australia Council for the Arts

austrian cultural forum lon

CANADIAN HIGH COMMISSION LONDON

Foreign Affairs Canada Affaires étrangères Canada

institut français

F R A M E
FINNISH FUND FOR ART EXCHANGE

fi
The Finnish Institute

The Embassy of Finland

GOETHE-INSTITUT MANCHESTER

i f a

Cultural Relations Committee
Department of Arts, Heritage,
Gaeltacht & the Islands
Ireland

EMBASSY OF ISRAEL

Italian Cultural Institute

JAPANFOUNDATION

Royal Netherlands Embassy

Mondriaan Stichting

SPANISH EMBASSY CULTURAL OFFICE

I ASPIS

EMBASSY OF SWEDEN

PRO HELVETIA
Arts Council of Switzerland

IN-KIND SUPPORT

LiverpoolJohn LennonAirport
above us only sky

Royal Liverpool Philharmonic

First
transforming travel

Radio City Tower
Toxteth TV
Liverpool Housing Action Trust

Windsave Ltd
Searchlight Electric Ltd
Virgin Trains

Liverpool 1 Partnership Group
Liverpool Post and Echo

LEARNING AND INCLUSION SUPPORTERS

Creative Partnerships

ARTS COUNCIL ENGLAND

five arts cities

community foundation for merseyside

Neighbourhood Renewal Unit

Education and Culture
Culture 2000

FirstLight
INSPIRING YOUNG FILM
'Supported by the Lottery through the UK Film Council's First Light initiative'

The Granada Foundation

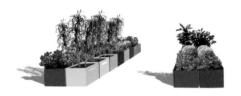

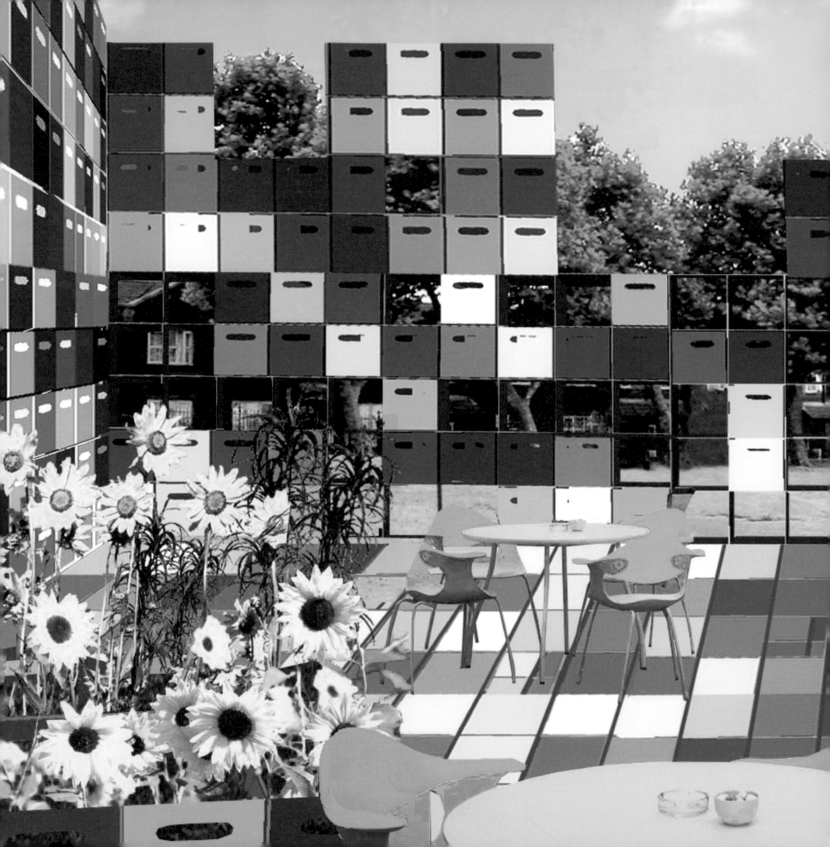

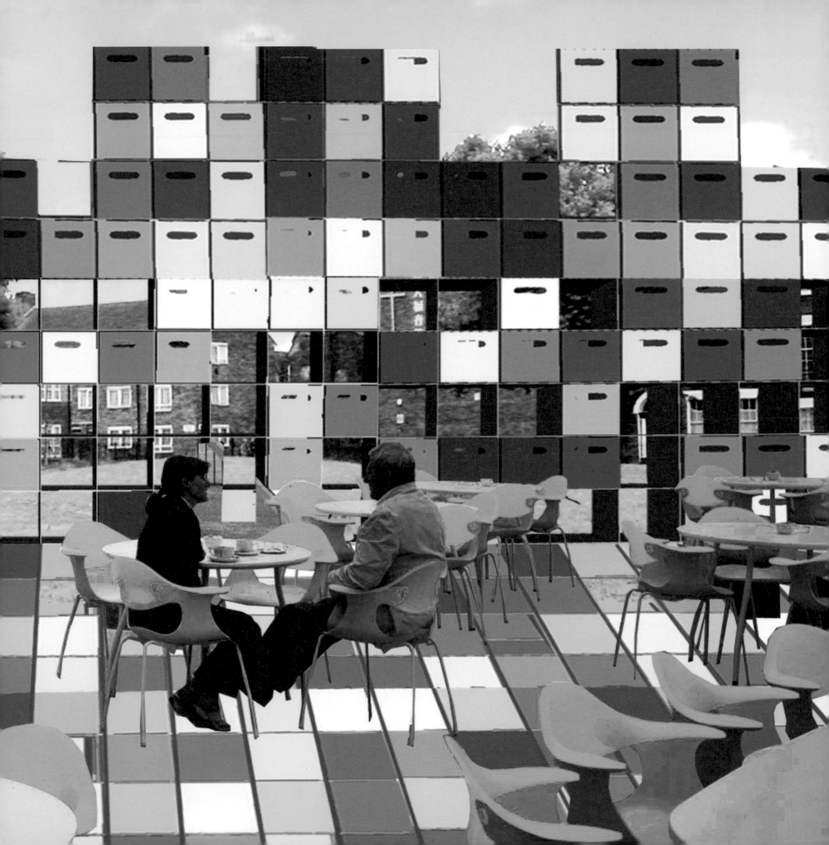

Azra Aksamija

Bread and Games, Plant and Play

In *Designs for the Real World* (Generali Foundation, 2002), Azra Aksamija presented her studies of Arizona Market. This market grew through a process of self-organisation in post-war Bosnia, when no regulated state existed and this was the only way people could get their essential supplies. It is now the largest black market in the Balkans and it employs over 30,000 people in over 2200 businesses. As the market grew to this size, problems regarding crime, disease and safety increased and needed to be addressed. The government responded by developing a masterplan to turn it into a shopping centre. The masterplan left no room for self-organisation.

In *Designs for the Real World* Azra exhibited video, photographic documentation, diagrams, maps and quotations to show the behaviour patterns that make up the market and to suggest interventions. Azra put forward a way of keeping the market that would allow for self-organisation. One intervention she suggested was a system of 'provocateur poles', which would offer an infrastructure for accessing water, electricity and so on while also encouraging the shops to cluster in these areas.

This would then free up other areas for leisure activities and parking. The exhibition included a prototype of one of the 'provocateur poles'.

Azra's project for *International 04* continues to look at ways in which formal and informal systems can work together in urban planning. Her project *Bread and Games, Plant and Play* proposes an infrastructural intervention for the St George's housing estate area in Liverpool 1. This is a residential area on the edge of the city centre. It borders on areas that have already seen big changes as part of the regeneration programme for the city. St George's housing estate mainly comprises local authority-owned social housing which is in a poor state of repair. Many of the houses are empty. A masterplan has been drawn up for the development of the area but, unlike the case of Arizona Market, here the local community have been involved in the making of the plans.

Bread and Games, Plant and Play will be realised as a series of 'navigator closets', units of stacked plastic storage boxes (in Biennial logo colours). These closets will be placed in various public spaces of the L1 area and are intended to provoke and initiate a process of self-organised and self-sustainable urban behaviour. The contents and uses of the boxes will be decided with local residents. The boxes are meant to be

taken, exchanged or stolen.

The project builds on Azra's idea of 'urban navigation', the guidance of self-organised urban behaviour, developed through her studies of Arizona Market into a practical application. What happens will be tracked and documented. Showing this in the context of an international exhibition will guarantee it attention.

An intervention such as *Bread and Games, Plant and Play* offers a refreshing way for community development teams and urban planners to work with an artist. Art has already become a very familiar feature within regeneration schemes but on the whole it comes along with a pressure to succeed. This project presents an opportunity for the local community which they can take or leave. It makes no promises and sets no expectations.

Sharon Paulger

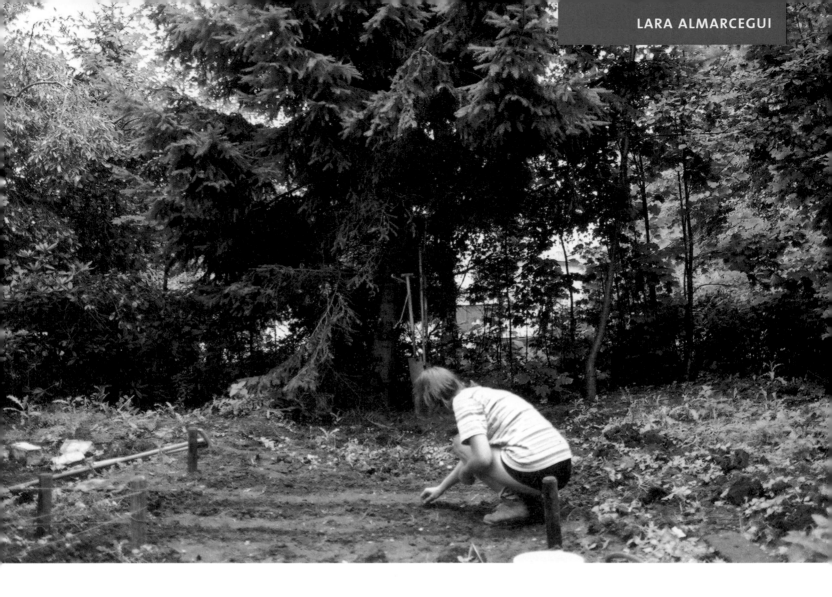

Becoming an Allotment Gardener
Rotterdam, 1999–2002

An allotment garden is a piece of ground, usually close to a road or railway, where citizens can plant and cultivate their vegetables and flowers. In a situation in which living, working and leisure spaces have been carefully planned, the allotment gardens appear to be in opposition to this state of affairs because they are among the very few places in the city that have been created by their users and not by urban planners or architects.

In order to deepen my studies of the allotment gardens and to reflect upon my position as an artist, I decided to become part of the allotment garden community. This project is an experiment carried out in real time and in a particular place (three years working in a garden belonging to an association of allotment gardens in Rotterdam). My goal is to make a garden, build a shed, and spend hours working there, with all the implications this might have.

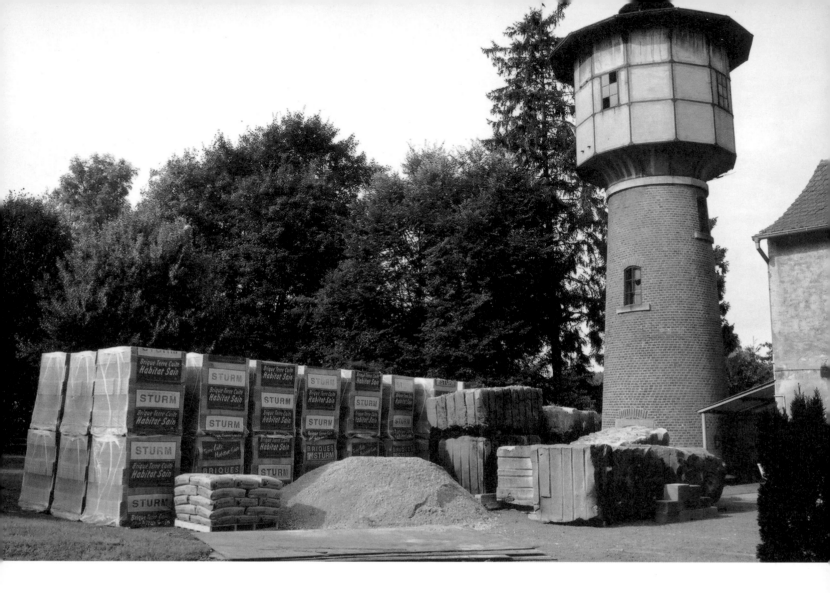

Water Tower: Construction Materials
Phalsburg, 2000

To speak about the situation of a water tower that was about to be demolished I measured and calculated the weight of its construction materials: 70 tons of bricks, 35 tons of stone, 10 tons of concrete, and 2.6 tons of steel. I put exactly the same quantity of construction materials next to the building, so that, much as in a cookbook where you can see the dish and its ingredients, here you would be able to see the building and its various component parts. I was fascinated by the idea that this pile of material was similar to the building before it was constructed, or similar to the pile of material it would become once demolished.

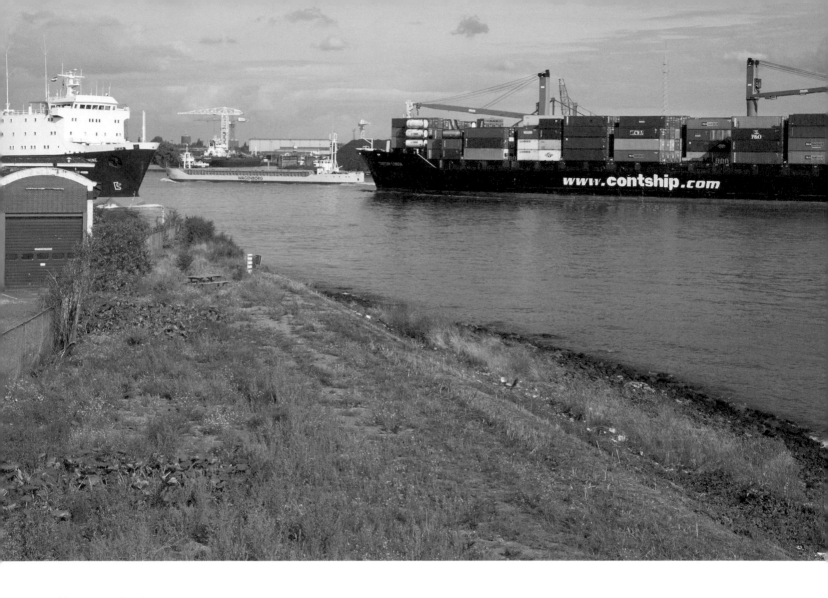

Making a Wasteland
Rotterdam Harbour, Rotterdam, 2003

I was offered the opportunity to make a permanent piece of work in a piece of ground at Rotterdam Harbour. The views over the water were so spectacular that it was evident that intervention had to be minimal in order to keep the focus on the landscape. What made the terrain so interesting was its openness to any possibility. I decided that my project would consist of leaving the piece of ground without design, to keep this open space available.

It is an experiment that consists of leaving a place without definition so that everything happens by chance and not according to a pre-determined plan. Therefore, nature develops in its own way and interrelates with the spontaneous use made of the land and with other external factors such as wind, rain, sun and flora.

Wastelands are important for me because I think one can only feel free in this type of land, forgotten by town planners. I imagine that, in a few years' time, this will be the only empty land once the surrounding lands are built on.

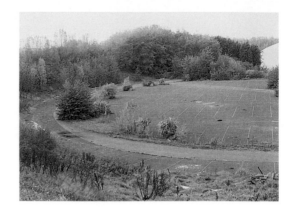

International Garden
Festival Site, Liverpool,
2004

Lara Almarcegui

Enclosed Gardens

Lara Almarcegui's work unearths histories and exposes the potentials of forgotten or neglected public and private space. Over the last decade, Almarcegui has made work that maps out, measures, reconstructs and deconstructs the urban landscape in an attempt to make visible that which is hidden. Her choice to explore the site of the International Garden Festival in Liverpool is a natural development of her work examining wastelands, condemned buildings, allotments, disused inner-city plots and sites lying on the margins of urban centres.

Fascinated by transformation and temporality, Almarcegui's work investigates sites of change. Enacting physical assaults upon her subject, in *Digging* (Amsterdam, 1998), she dug deep into the ground until the site almost collapsed. In *Removing the Cement from the Façade* (Brussels, 1999), she stripped the rendering from the surface of a building, revealing its interior shell. A counter-desire to protect drove performance-based works such as her restoration of the façade of a condemned 1930s marketplace in San Sebastian (1995). Interactivity is central to her *Wastelands Map Amsterdam: A Guide to the*

Empty Sites of the City (1999) and her guided tour of wastelands in Liverpool (2002). Mapping out is usually concerned with defining presence as opposed to exposing absence. Almarcegui's map, however, focuses upon temporal rather than fixed sites: as empty spaces are appropriated, built upon or re-purposed the out-of-date map exposes the flux of the city.

In 1984 Liverpool hosted the International Garden Festival, the first to be held in the UK. With over sixty gardens, public pavilions and a miniature railway, it was one of the first major regeneration projects pioneered by the Merseyside Development Corporation, founded in the wake of the Toxteth riots. Once closed, however, only part of the development plan was realised. Now the domain of skate-boarders and graffiti artists, the site remains an overgrown wilderness with only the occasional exotic plant, remaining ornamental bridges and rusting sculptures providing a link to its past. Almarcegui's photographs at Tate Liverpool explore the hybrid functionality of this currently 'unpurposed' site. Her tenor is not cynical, but probing and searching.

Far from offering a disapproving critique, Almarcegui sees empty spaces and wastelands as places of possibility. She stresses: 'These plots, which have no precise function, offer a huge

potential. They are spaces of freedom, where anything can happen.' With uncomfortable relationships to authority, these 'non-spaces' support unique demographics and life-cycles. Almarcegui's work for *International 04* triggers a sense of intrigue incorporating both disillusionment and possibility, provoking the question: what next?

Laura Britton

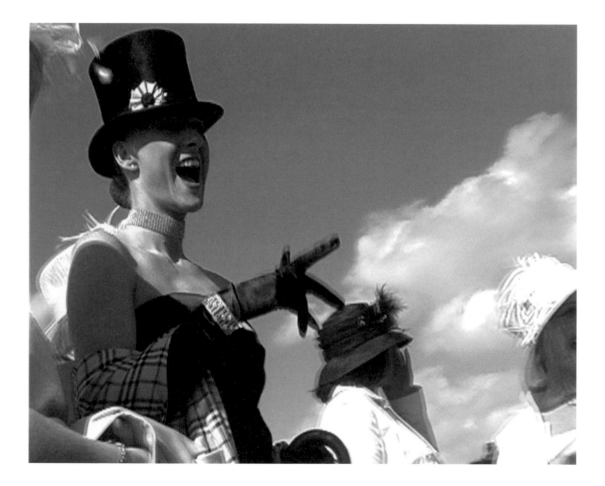

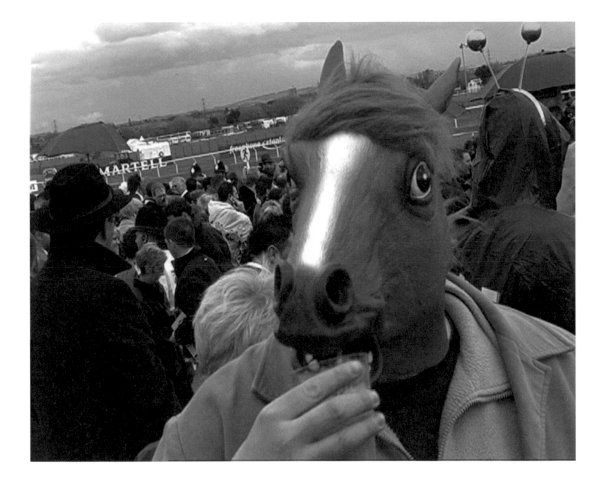

Yael Bartana

You Could Be Lucky

There was a time in England when horse-racing was banned and, to curb royalist insurrection, new laws created a land of joyless conformity where drinking and gambling were punishable offences. It was a time of republican government under Oliver Cromwell. When Cromwell died in 1658, and his son proved a poor successor, Charles II returned to England in 1660 to take the throne. Thus began the Restoration, as England was tired of being without a king.

Charles II restored racing to the realm, fostering the Sport of Kings by encouraging the commoners to attend the races. He jockeyed his own horses, under the alias 'Old Rowley', and was victorious at Newmarket. He introduced the use of racing silks and furlong posts, and offered prize money and numerous trophies to encourage breeders to improve the qualities of their horses.

There is only one surviving equestrian statue of Charles II (1665); it stands in Edinburgh's Parliament Square, and is the oldest in town. Visiting Liverpool for the first time, Yael Bartana felt echoes of the past resonating through the urban landscape, a pervading air of disappearance. Figures on horseback, enduring

symbols of monarchy and power, including Thomas Thornycroft's 1870 equestrian statue of Queen Victoria on St George's Plateau, became markers for her.

This led to Yael Bartana becoming interested in filming the Grand National, perhaps the world's most famous steeplechase race. Run at Aintree on Merseyside since 1839, it's a gruelling two-mile circuit for horses and riders alike. For Yael Bartana it provided an unrivalled opportunity to comment on individual and collective behaviour.

The film alternates between the Parade Ring and the Tattersalls Enclosure. This, the largest area on the course, is where over 30,000 racegoers can be found watching the races from the slope of the exposed Aintree Mound. Here Yael Bartana's crew trained their cameras on the betting process and the expectant crowd.

The footage also captures Ladies' Day, the highlight of the meet for many and a brassy parade of fashion sense and high-heeled stamina. Among the ruffled feathers blowing in the stiff breeze, one contestant stands out. Refined in a black top hat and diamond choker, she has a marked dignity that's countered only by Yael Bartana's cheeky soundtrack, which speeds up the local Scouse accent to make it impenetrable even to an insider.

Themes such as memory and the identity of place are central to Yael Bartana's work. In the past she has focused on nationalism and social behaviour in Israel, witnessing and documenting ceremonial and religious events. At the Grand National, by focusing on the crowd rather than the actual race, Yael Bartana observes some of the codes of English class structure: the 'Tatters' versus the County Stand, old money versus new, the haves and the have-nots.

Mark Daniels

Prologue
Ursula Biemann

When entering the harbour the voyager leaves the exceptional condition of
the boundless sea – this traversable space of maritime immensity – to come
ashore in an offshore place in a container world that only tolerates the
trans-local state of not being of this place – nor of any other really – but of
existing in a condition of not-belonging of juridical non-existence.
He signifies the itinerant body bound to string along a chain of territories
never reaching a final destination.

Probing the protocols of access time and again he moves through non-civil
places waits for status in off-social spaces only to remain suspended in the
post-humanist lapse.

What used to be a state of temporary exemption – survival in the time-space
of legal deferral – has turned into the prime mode of migratory subsistence.
Connected but segregated
it forms the world system of contained mobility.

swims across the river Neisse to Germany, this time half frozen.

Ursula Biemann

Contained Mobility

A curious news story caught my attention during my research for the project. On 25 October 2001, Italian port authorities intercepted an illegal, clean-shaven and smartly dressed Egyptian passenger who used a container to have himself shipped clandestinely to Canada. Much to the surprise of the authorities who discovered the blind passenger, his temporary habitat was equipped with mobile phones, a camera and a laptop computer connected via ethernet to the global network. The container was furnished for a long journey and equipped with a bucket he used as a toilet. Ursula Biemann

Ursula Biemann engages with questions of human displacement and the impacts of a growing global mobility. She aims to make visible the complex web of social, political and gendered relations that constitute place and identity. Her videos track the discursive and iterative ways in which places are produced, whereby roots are always already connected to routes. Her places are temporary, translocal existences not embedded in the local cultural surroundings but operating according to a different sort of logic, such as ports, free-trade zones, refugee centres and transit camps.

Geography here is taken as a system of knowledge formation, an epistemic category determining what we know and how we know it. This theoretical observation opens up a field of relations that is profoundly performative. Informed by feminist critique and postcolonial debates, Biemann has developed a practice in which her own subject position as an image-maker and producer of narratives is reflected. This translates into a particular form called video essay, uneasily situated between documentary film and video art. Like the literary essay, the video essay explores theoretical postulates of fact and fiction, reflecting the acts of writing and image-making as well as the technologies through which they are produced.

In *Performing the Border* (1999), the starting point of the essay is a place on the US/Mexican border called Juarez City. In this essay Biemann explores and performs a transnational zone that is constituted through the movement of political, gendered and sexualised bodies across the border, inscribing the border as a material reality through their actions. The argument she makes is that borders are not given but arise as a result of social and political constructions, which need to be performed and exercised. Where *Performing the Border* proposes the material inscription of movement in the terrain as the constitution of place, *Contained Mobility* explores the reverse: how is the notion of

place presented materially in movement?

Contained Mobility is Ursula Biemann's first double-screen video work, juxtaposing the two spatial realities of the global container transport system and human migration contained as bare life. Popular understanding of cultural identity continues to be fundamentally static, predicated on the nation state. Biemann offers a transformation of this concept from the perspective of mobility. Increasingly sophisticated technologies managing and controlling global flows are countered by equally inventive tactics of evasion by people questioning the prerogative of access to political communities.

The story of Anatol, the asylum seeker in the video, presents a scripted reality in a state of exception beyond the binary of renationalisation and repatriation. Translocal existence appears here as an extra-judicial movement from place to place between the rhetoric of the inalienable rights of human beings and the growing crisis of human rights as understood by the 1951 Geneva Convention. At the same time a global regulatory network is emerging that aims to control the flow of commerce and people on a global scale. *Contained Mobility* gives us an insight into some of the technological operations that constitute this network and the concomitant possibility of self-determined migration.

Paul Domela

Owned and Possessed
Commissioning Biennial Art

Lewis Biggs

The city of Sophronia is made up of two half cities. In one is the great roller coaster with its steep humps, the carousel with its chain spokes, the Ferris wheel of spinning cages, the death-ride with crouching motor-cyclists, the big top with the clump of trapezes hanging in the middle. The other half-city is of stone and marble and cement, with the bank, the factories, the palaces, the slaughterhouse, the school, and all the rest. One of the half-cities is permanent, the other is temporary, and when the period of its sojourn is over, they uproot it, dismantle it, and take it off, transplanting it to the vacant lots of another half-city.

And so every year the day comes when the workmen remove the marble pediments, lower the stone walls, the cement pylons, take down the Ministry, the monument, the docks, the petroleum refinery, the hospital, load them onto trailers...

Italo Calvino, *Invisible Cities*[1]

Calvino well understood that his city of Sophronia would 'count the months and days it must wait before the caravan returns and a complete life can begin again'. But his insight remains: what is unique, memorable and continuous in the life of a city is the investment by its people in their pleasures. That 'the object of work is leisure' is no less true now than it was for Aristotle. The impact on us of our industry, administration and political processes, whether humdrum or grandiose, feels pretty much as it would do in any other city across the world. And beside our pursuit of pleasure it is comparatively sporadic, sometimes distant, even absent.

Do we ever think of our own city as consisting only of concrete and marble? Is it only other people's cities that we think of as Hollywood plywood and Las Vegas canvas? What we remember from the time we were high on the Ferris wheel, when we climbed the cathedral tower, celebrated in the street, lay on the grass in the sun with friends, talked to the man on the corner playing his air guitar for free – these

are as much the material of the city as the granite paving, brick walls, gratings, asphalt, bronze seats and aluminium window fittings. Is the city not also our flesh and blood?

What if this city were a brain, composed of blood vessels and neural pathways? There should be memories locked in its chemical structure. Not only does Liverpool's flesh carry the scars of past wounds – the bomb-sites remain after sixty years – but the totality of streets and buildings, of sewers below and cables above, is the residue of habits, of human events from lives lived over centuries. Feel the crumbling brickwork of this alley, the cold iron of that gate, sense the awkward angle of this turning, the view of the church blocked by that poster site. This road is full of the remembered sound of shipbuilding, that street is silent since its inhabitants travelled to slate the roofs of another city. The neural pathways with their memories are waiting to be fired before they can articulate their stories. The city needs an interrogation as sensitive as a caress before it reveals itself to a human – or civil – being. This has been our ambition with *International 04*.

I want to praise in particular two values of biennial art: the ephemerality that underlies both its affinity with other leisure activities and our transitory experience of the changing city; and, more profound, its potential for revealing realities beyond museum walls. We sense we are in the presence of art when strange truths are served to us mingled with our pleasures. On the way, I want to reflect on the processes of exhibition-making and our relationship to the 'other' in art.

BIENNIAL ANXIETY

The proliferation of large biennial exhibitions around the world over the last twenty years has created new kinds of opportunities for artists, some of whom are kept continuously busy responding to these. As a result, there is now an expression 'biennial art' (for

instance, see my interview with Lynne Cooke published in the catalogue for *International 02*[2]). In the 1960s people noticed that artists had started to make 'museum art', too big to be bought by most private collectors. Collectors just built bigger houses. I won't attempt a precise definition of biennial art, but the expression implies an art targeted at a market (visitors or collectors) bigger than that already served by art museums and art fairs. This was not true of the perennial big exhibitions, such as the Carnegie or Documenta, nor of the biennials founded more than twenty years ago: they were firmly targeted at the 'traditional' market of collectors and existing museum visitors.

The agencies and professionals that serve the traditional art market have to decide, therefore, how they will react to biennial art. Can it be assimilated to the existing market, as 'museum' art has been? (Collectors and museums have always moved in tandem, no matter who is actually driving.) Or does it have to be viewed as a new market operating under different rules set by new agencies? Is biennial art finally simply a route for new talent to break into the traditional market for objects, or is it different in intention (as is, arguably, live art) – about artists giving their audience access to an experience? Despite the fact that many artists work in both these markets simultaneously, critics, curators and collectors remain uneasy about how to deal with biennial art.

A healthy market needs the illusion that value resides within it, that it is the only game in town. A separate system of value is destabilising. The unease produced by biennial art in this context has three faces. First, it is often difficult to collect in a material way: it may be ephemeral and/or site- or context-specific. Museums and private collectors have had just this problem with live art, which has proved much more resistant to entering collections over the long term than has, for instance, video art or language-based conceptual art. Secondly, much biennial art appears to be allied to theatre or spectacle, and is relatively closer to popular culture than to the particular history and theory of art that is illustrated or supported by museum collections. (See Apinan Poshyananda's text in this publication). Thirdly, it is an awkward fact (for art professionals) that biennial art is frequently paid for by public money to serve an agenda (education, inward investment, tourism etc.) not under the control of the art professionals.

In the last two and a half decades, the period of the second-wave biennials, the idea of the museum as an independent guardian of public values has faced serious challenges. The funds available to art museums to acquire art for their collections are no longer derived mainly from public or endowed sources – sources that used to allow museum directors to be relatively adventurous or at least autonomous in their purchases. These have increasingly given way to the direct patronage (and so taste) of trustees, collectors and donors: a market defined by acquisition. On the other hand, the public activity of museums is driven by financial imperative in the direction of making exhibitions that will attract ever larger numbers of people. This often involves attempting to create the same sense of theatre, spectacle and reference to popular culture that the new breed of biennials also engage: a market defined by ephemeral experience. This situation exacerbates the unease of professionals concerning 'biennial' art as against 'collection' art.

There has always been a tension between the 'free' expression of the artist and the need to sell something to live. When the poet Marcel Broodthaers decided to cast his poems in plaster 'in order to have something to sell', he meant, of course, that in contemporary society poetry, whether performed or on the printed page, does not attract as much financial interest as objects do. Our consumer society requires above all else the commodification of ideas. You can read a Shakespeare sonnet for free, but Duchamp's readymades are readymoney. The chief effect of the passing of time on creativity is that material substance wins market dominance over subtlety of ideas. The material residue of the idea proves to have more power

than the idea itself. Leonardo da Vinci's fireworks, Inigo Jones' theatrical displays, Picasso's involvement with the ballet and theatre: these are less to us now than the oils on canvas or the buildings, simply because paintings and palaces last longer, can be collected, and can make money for their owners. But just as the creative spirit of Alexander Calder appears most clearly in his circus performances, perhaps Leonardo's was clearest in his fireworks.

During the last century, quantum physics began to destabilise the natural sciences by moving them away from the conception of matter-as-object towards that of matter-as-event. In economics, the developed world has embraced the immateriality of the service industries and allowed the manufacturing of material objects to pass on to developing economies. And the developed world has not been slow to grasp the forms of ephemeral visual culture that emerged in the last century: new drama, new dance, and film. But for the museums of art that confer value through collecting, the corresponding shift – from celebrating objects to espousing ephemeral or event-based visual art – has been too difficult. Biennial art may look like a challenge.

OWNED AND POSSESSED

In my home hangs a photograph by the artist Touhami Ennadre. Taken in 1995, it shows a fully clothed woman writhing in deep mud. She is a participant in a Voodoo ritual in Haiti and she is in a trance, possessed by a (the?) spirit.

The belief system of art is sustained (just like Voodoo in Haiti) by the effect it produces on its participants. The relationship between Touhami Ennadre's artwork and me is that I own it and, in a reversal of subject and object, it possesses me. Ownership is about accruing things to the self; being possessed is about respect for, fascination for, the other. My interest in an artwork is sustained in so far as I respect and continue to be affected by the 'otherness' of the artist's vision as

manifested in its material presence. If it ceases to possess me, I shall probably cease to own it.

Ronaldo Munck's essay printed here unpacks the values of globalisation and locality. He suggests the degree to which the notions of culture and regeneration are contested in post-industrial cities such as Liverpool, and that these are a context for the *International 04* exhibition. The process for organising the exhibition (described by Paul Domela in his text) was designed with the concept of ownership in our minds. We wanted as many people as possible, starting with the researchers and artists, but also across many different organisations and communities in the city, to buy into the show. We believe that the collaborative process into which we entered contributes to the quality of the commissioned art.

These terms ('ownership', 'buy into') are useful because current. Unfortunately they derive from the vocabulary of business and 'realty' (land, objects, commodities). More accurately, we wanted to create 'possession', where this term carries some sense of an emotional reciprocity between the art and its participants, some spiritual or intellectual nourishment: a curiosity about and respect for 'the other'.

This is what we asked of the researchers and the artists, and equally of our collaborators and ourselves. No-one pretends that anyone's knowledge of a city can be profound after only a few days' research. But first impressions do matter, and particularly because they may fix on that which is unique or surprising in the culture of the city. Alternatively, the impression may be of something that despite being unique in its particularities will link the city to the general conditions shared by others globally. No matter that first impressions may also be clichéd – a cliché is a truth awaiting the new metaphor by which we will refresh our understanding. Like everyone, the people of Liverpool live in our memories as much as in our senses, so we live simultaneously in the past and future: we live in the middle of a continuum of change. The snapshot taken by a visitor, on the other

hand, might be mistaken for an unchanging truth. It will disappear and be replaced by another snapshot, different but equally true.

COMMISSIONING BIENNIAL ART AND MAKING EXHIBITIONS

While our main purpose in designing the process described by Paul Domela was to make a successful exhibition, we also wanted to contribute to a debate about exhibition-making and commissioning artworks. So the values we seek to express through the process described, in addition to the ephemeral and truth-telling, involve collaboration, complexity, embeddedness, specificity, risk. We wanted an adventure for ourselves and our collaborators, something open-ended – not closed, polished, slick. At the end of our show, we shall be left with nothing but an experience – but it will be an experience in which very many people have participated, and that will never leave the city.

Branding is the means by which the consumer economy helps its customers stop thinking. A brand stands for a cluster of feelings: it triggers recognition and impulse buying. We prefer art to be thought-provoking, and regard 'branding' in art as damaging, whether this is effected by an artist's name standing in for the work itself (even the finest names of art have produced indifferent artworks); or by the stale signature artwork unpacked to avoid creating the freshly minted experience; or by the celebrity or personality of a curator being used to cover the inadequacies of a shallow exhibition.

Although there are as many ways to make exhibitions as there are exhibition-makers, I want to emphasise the choice between ownership and possession. There are fundamental differences between the exhibition-maker whose practice is based on the traditional rights and privileges conferred by the stewardship of a collection, and the exhibition-maker (sometimes described in recent years as the 'producer-curator') whose practice has to derive its

rationale from some source other than stewardship or legal title.[3]

It has been a challenge to many museum professionals to admit that stewardship of a collection is not the same thing as ownership of the meaning of that collection. Often it is the lay public that insists on the authority of the museum. This lay public believes that those who have the physical care of the artwork must thereby have the authority to determine its meaning. They don't imagine that they themselves possess this authority, to the extent that they are able to give themselves over to being possessed by the art.

Exhibition-makers working with collections and loans often respond to this faith from the public, and believe that they are the guardians of the artist's viewpoint. They may select artworks by many different artists to create exhibitions on unified themes, using artworks to illustrate their theoretical or aesthetic position. Artworks in a collection in some real sense do 'belong' to the person in whose charge they are placed. Ownership certainly affords the reciprocal opportunity for insights into meaning that comes from being possessed by the artwork. Whether or not the artist is alive, this approach presupposes that their authority passes to the exhibition-maker, and so also the potential for fresh authoritative interpretations. This is so even when the artist, as has frequently happened in the last half-century, explicitly denies that his or her own interpretation of the work has greater authority than anyone else's. The self-value of the exhibition-maker in this situation derives precisely from his or her appropriation of the 'rights' to the artwork's meaning, and his or her ability to control how this meaning is promoted.

The 'producer' exhibition-maker starts from the position of having no collection, no ownership. The meaning of the artworks commissioned has to be brought into being at the same time as the artworks are made manifest. If this process involves a large number of people, the likelihood is that the meaning of the artwork will take

many forms. The producer is therefore a facilitator between the artist and his or her public, or between artist and institution, rather than someone who exercises control.

So exhibition-makers can be located in terms of their attitude on the scale that runs from control to facilitation. The process we designed for generating *International 04* was elaborate in the emphasis it placed on collaboration, parcelling out responsibility as equally as possible between the artist, the site, and the Biennial staff. There was greater risk, more variation, and less control in the trialogue than in the usual dialogue between an artist and a single curator. Many found it difficult, left us with questions.

LIVERPOOL INTERNATIONAL

International art is not made by artists but by the sale-rooms of the Western world. Museums can only validate this process through their collecting policy, although they could do much to critique it through their exhibitions policy. (The discomfort of these policies not being aligned has already been referred to.) The 'received' value of international art takes no cognisance of the values of the plurality of specific art practices taking place across the globe. It inhabits, in effect, a utopia, the utopia of the financial index. The analogy is with the 'received' grammar and pronunciation of the English language, which ignores all the dialects and accents of the English-speaking world. What matters is who speaks, who owns. The received value of international art (across all the overlapping art professionalisms) derives from the recognition that ownership determines value: it is the gentrification of art. Even when a great diversity of individuals and institutions compete in the sale-room, they all agree that the value of art is conferred through ownership, that it is destined to create wealth at least. Whether it also creates other forms of social meaning or is left in a bank vault isn't a consideration in the sale-room.

The title *International* is intentionally ambiguous. As organisers of the exhibition, we enjoy working with artists from many cultures across the globe, and tend to use the word 'overseas' to differentiate them from artists from the plurality of cultures of the UK. But we have no control over whether the art that we commission becomes 'international' in the sense of the market for international art. *International 04* will be seen and judged, as it should be, by art professionals according to their values. But they may also try to guess at its second life, related to the broader cultural context of the city in which it is embedded. Many, perhaps most, people in Liverpool are of Irish or Welsh descent, and have a 'Celtic' outlook that favours event-based over more material forms of culture. Groups of people here generate and are *possessed* by their own culture (the ceilidh, for instance) but restrict their *ownership* of culture to the clothes and cars common to the wider population.

How can we engage artists, through the commissioning process, with the discriminating and sophisticated audience for ephemeral art that exists outside the object-based nexus of the art market and museum? How do international art professionals receive art that has been created in a cultural tradition more concerned to be possessed than to own? Will the Western, collection-based model for valuing art through ownership, which we call international, become the norm across all cultures? Is it necessary or desirable to provide alternatives to this value system? Can the perception of art as owned object coexist with experiencing it as an event?

Liverpool Biennial gives an adrenalin boost to the bloodstream of the city, one dose every two years. It reaches into the city's rattlebag of memories, the great party-bag of pleasant and unpleasant surprises. Like Choi Jeong Hwa's *Happy Together*, it blossoms out of the unnoticed structures of the city. It is a wallflower to the couples on the street on their way to bars to drink or dance. It projects the city's soft double, jumping from artists' imaginations into the reality

of the future. Why not? The Biennial opens up a space in the city that gives place to trial and error, learning from one event to the next. From this soft cityscape of the imagination the future city will grow.

NOTES

[1] Italo Calvino, *Invisible Cities*, London: Picador, 1979, p. 52.
[2] 'Lynne Cooke in Conversation with Lewis Biggs', in *International 2002*, Liverpool: Liverpool Biennial, 2002, pp. 18–22.
[3] See for example *The Producers: Contemporary Curators in Conversation*, Newcastle upon Tyne: Baltic and University of Newcastle Art Department, 2000 onwards.

Art and Artists
Please Wait for a Commission[1]

Sabine Breitwieser

Suppose art were as accessible to everyone as comic books? As cheap and as available? What social and economic conditions would this state of things presuppose?[2]

. . .works operating in real time must not be geographically defined nor can one say when the work is completed.[3]

Taking the model of the Liverpool Biennial *International 04*, my function within it and the questions this has raised, I shall try in this brief essay to reflect on the role and situation of the artists acting within a context of this nature.

In general I do not count myself among those typical nomadic exhibition curators who are now to be met with all over the world and who provide cultural politicians with 'shows', helping to define a place and give it a special identity. I do have to do a lot of travelling, not only because of my occupation in general but also because of the increasing number of major exhibitions (biennials, triennials and so on) that have taken place in the last decade in far-flung venues all over the world. Against the background of this phenomenon, however, I would define myself as a rather 'conservative' curator, having already worked for more than ten years at the same art centre and museum in the capacities of director, curator, exhibition organiser and publications editor, as well as being responsible for establishing the collection. I am one of those cultural workers who still believes that working for an institution in a specific place and context for a longer period is conducive to re-establishing a particular context for the arts. I hope that this practice will generate an important contribution to the production, mediation, preservation and, ultimately, the discourses of art – not only on a given site but also around the world.

So I was rather surprised when I received an invitation to collaborate with the Liverpool Biennial *International 04* as one of four researchers. I even thought the invitation might be a mistake: they might have mixed me up with someone else, perhaps with one of my guest curators who are invited each year to organise a show (which is experimental in some way) at the Generali Foundation in Vienna. Indeed, this series of exhibitions involves precisely the kind of curatorial approach that is often sought after for exhibitions such as the Liverpool Biennial: thematising current topics and involving new or lesser-known artistic talents from all over the world (but also including local artists), who then reflect on the topics of the exhibition in the works they produce. While I am interested in the critical views of artists or non-art-professionals as curators, the normal 'biennial curator' is strongly associated with attributes such as flexibility and mobility. This matches exactly what personnel managers expect from their 'human resources'. It is an expectation that refers not only to physical attributes but also to mental abilities and personal attitudes. Contrary to that position, I would prefer to consider myself as relatively slow and as an 'artists' curator'.

Art exhibitions are part of the globalisation process we have been facing in the last few years. As Miwon Kwon has pointed out in her book on art as a spatio-political problematic,[4] 'itinerant artists' create works in various cities throughout the world. More and more artists are invited to work in a way specially configured for the framework of exhibitions associated with a specified city. Just like entrepreneurs, artists are confronted with customer expectations regarding the special features of a location, so that this place can be distinguished from others, publicised and, ultimately, marketed. At the same time, Kwon continues, frequent travelling has become a sign of self-worth, of success; it also shows that we are – whether we enjoy it or not – culturally and economically rewarded for enduring the 'wrong' place.

In the letter of invitation from the Liverpool Biennial I took special note of the fact that I was not invited to function as a curator but as a 'researcher'. I was asked to 'contribute [. . .] by undertaking research

for the International exhibition' created by 'a new, experimental process' with 'risks attached, as there are to all experiments'. According to the Biennial, the 'curatorial process is divided into research, selection and delivery'. While my understanding as curator is, on the one hand, very critical both in terms of the selection process and in relation to responsibility, it is, on the other hand, strongly service-oriented in relation to the artists, insisting on as much help and support for their projects as possible. I believe that institutional and curatorial support and responsibility, the knowledge and experience of how to collaborate with the artist and production conditions in general, are pivotal to the final artwork. As researcher in this project I would not have – according to the division of labour in this process – any real power regarding the final selection of the artworks. I would have only a very limited influence on the quality of the final production of artworks. In addition, I would have no responsibility either for overall arrangements or for the presentation of the exhibition. I would only 'review the progress of the exhibition and the commissioning of artworks arising from my research. [. . .] The Biennial will finally be responsible for all aspects of the exhibition'. While a well-known exhibition in Chicago conceived the city as a stage,[5] the organisers of the Liverpool Biennial have dedicated this third exhibition to the theme of 'the city as laboratory'. Accordingly, I was asked to visit Liverpool 'in order to do research and to familiarise myself with Liverpool, the Biennial itself, the art organisations and the people involved'. As in a film or commercial production, I would be expected to function as a 'scout', checking potential locations and contexts in order to propose the right protagonists. The final decision would be made by the director and also with regard to the funds finally available for each project. According to the Biennial, this 'experimental process' was also meant to contribute to 'a reconsideration of the relationship of power and the roles of knowledge, information and realisation, production'.[6]

Questions of power are indeed urgent issues in relation to current exhibition-making. On the other hand the curatorial responsibilities of this project were rather diffuse and the whole setting was not as favourable as I would have liked it to be as far as it concerned artists getting involved on the basis of my recommendation. At the same time I saw the research-oriented process, as well as the possibility that new works could be produced, as an opportunity that should not be refused without careful investigation. I also thought that the question of how to deal with an invitation like this could be taken as an active exploration of 'curatorial responsibility' per se. This was the reason why I finally decided to take part in the process. At the same time I tried to set up some rules. In order to protect the artists (and in the long run my relationship to them as well) I tried to settle the most important questions with the Biennial in a contract. According to that agreement, 'the Liverpool Biennial 2004 will be based on 15 artists selected by each of four researchers'. The criteria for the evaluation by the Biennial of the artists' proposals were limited to 'questions of financing the execution of a proposal, technical issues, location, permits and the time scale in relation to the opening date of the exhibition'. Should questions of artistic quality have arisen, I would have had to be consulted in order to mediate the proposal anew. The contract also contained an agreement that each of the artists would definitely be invited to visit Liverpool and get a chance to develop a proposal for an artwork for the Biennial; all costs in relation to this visit and the artists' stay in Liverpool would be covered. It was also agreed that every artist would receive a stipulated fee on the occasion of their initial research and a further stipulated fee on the receipt of their proposal.

At a certain point during this 'experimental process' it seemed that some of my fears would come true. It was very simple: a major sponsor dropped out and it seemed that the number of projects to be realised had to be reduced, some artists could not be commissioned

(also due to a lack of feasibility) and some proposals needed to be adapted.[7]

Despite the numerous and quite complex questions arising in relation to transnational exhibitions with community-specific, audience-specific or relational-specific works of art – to name just a few variations of how the relationship to a site can be defined nowadays (quite apart from questions of the local and the global) – I do not see a real danger in these developments for the arts in general or in the long run. It is still the artist who *has to* decide whether she or he would like to create this relationship to a site, and how she or he would like to define it, with and through her or his work, whether that is within a specific exhibition context or within a group of people. Instead of starting a discourse on questions of the international versus the specific, I would much prefer to question the increasing instrumentalisation of the arts and artists as they are now being 'embedded' in a specific context vis-à-vis the conception and production of works of art. What does it mean for an artist to be invited to work on a proposal for site-specific art and possibly being commissioned (or not) to execute this new work of art?

Since references to conceptual art are very often made by the current generation of artists, it might be useful to do some further re-reading of earlier thoughts on this practice. In 1968, critic Lucy Lippard described the status of art, observing that 'the studio is again becoming a study'.[8] Her forecast was that 'such a trend appears to be provoking a profound dematerialization of art, especially of art as object, and if it continues to prevail, it may result in the object's becoming wholly obsolete'. Lippard saw two causes underlying this development: art as an idea and art as action. The former would negate matter and transform the event into a concept, the latter would transform matter into energy and movement in time.

In his seminal essay from 1989 entitled 'Conceptual Art 1962–1969: From the Aesthetics of Administration to the Critique of Institutions',[9] Benjamin H. D. Buchloh described this shift from the perspective of the production process, whereby the 'object of spatial and perceptual experience' was replaced by its 'linguistic definition alone'. Buchloh analysed this as '[an] assault on the status of the object; its visuality, its commodity status and its form of distribution'. Miwon Kwon has summed up Buchloh: 'While formerly being a producer of aesthetic objects, the artist now acts as facilitator, educator, co-ordinator, and bureaucrat'.

What Lippard and Buchloh did not forecast or simply did not mention in their brilliant analyses is another effect of the declining interest in the physical evolution of the artwork, what was described by some as the 'administration of the aesthetic'. Framed in the current art system and its administrative structure, most artists are only able to execute or even conceive a work of art if they are to be commissioned. The final execution of the work requires approval by the commissioner (patron) with regard to content, budget, permits and production, the 'feasibility' of a work. One could come to the conclusion that the reflection of the visual arts on its physical manifestation, its visuality and finally its publicity, are all directly connected with the dependence of the artist in relation to a specific context as well as to the commission by a curator or an art institution.

This is also the reason why some artists who I would have very much liked to contribute a new piece for this exhibition decided not to accept the invitation, did not deliver a proposal, or were finally unable to execute their proposal in relation to the given conditions of the Biennial. As a matter of fact for some artists the framework of the Biennial exhibition was not clear enough and was also too insecure in terms of outcome. One of them, a film director who has learned the complexity of the artist–client relationship in working with television companies, did not want to have a similar experience in the context of an exhibition, and was concerned about the lack of clarity in relation to budget. Another artist who ultimately decided not to

collaborate with the Liverpool Biennial is a neo-conceptual artist strongly associated with the second generation of 'institutional critique' and has explored the question of artistic freedom by providing 'artistic services'. In relation to this I would like to recall *Services*, a 'working group' exhibition, in which 'conditions and relations of services provision in contemporary project-oriented artistic practice' were analysed and discussed by a group of artists, critics and curators.[10]

I would like to close with another artist statement:

1. The artist may construct the piece
2. The piece may be fabricated
3. The piece need not be built

Each being equal and consistent with the intent of the artist the decision as to condition rests with the receiver upon the condition of receivership.[11]

NOTES

[1] This essay is based on a lecture given by the author at a conference in Liverpool in spring 2004.

[2] Adrian Piper, 'Cheap Art Utopia', *Art-Rite*, 14 (Winter 1976–77), pp. 11–12.

[3] Hans Haacke, 'Provisional Remarks' (1971), reprinted in Kunsthaus Bregenz and Christian Kravagna (eds), *The Museum as Arena: Artists on Institutional Critique*, Cologne, 2000, p. 46.

[4] Miwon Kwon, *One Place after Another: Site-Specific Art and Local Identity*, Cambridge, 2002.

[5] *Culture in Action*, curated by Mary Jane Jacob, Chicago, 1993.

[6] Quotations are from either the invitation issued by the Liverpool Biennial or the contract between the Liverpool Biennial and the author. Included in this contract is the stipulation that 'the Researcher will also write a general and short text with her critique of this process for generating an exhibition and her thoughts about the specific context etc.'.

[7] Considering that the whole project started with zero budget, the question of risk and the negotiation of expectations were to some extent integral to the process, of course, unlike the case of an exhibition starting with a guaranteed budget. Finally the Biennial managed to raise substantially more funds than originally anticipated.

[8] Lucy Lippard, 'The Dematerialization of Art' (1968), in *Changing: Essays in Art Criticism*, New York, 1971, p. 254.

[9] Benjamin H. D. Buchloh, 'Conceptual Art 1962–1969: From the Aesthetics of Administration to the Critique of Institutions', *October*, 55 (Winter 1991), pp. 105–43.

[10] *Services*, organised by the artist Andrea Fraser and the critic Helmut Draxler, took place for the first time in 1994 at the Kunstraum of the University of Lüneberg, and subsequently in other locations.

[11] Lawrence Weiner, 'Statements', in *January 5–31 1969*, New York, 1969.

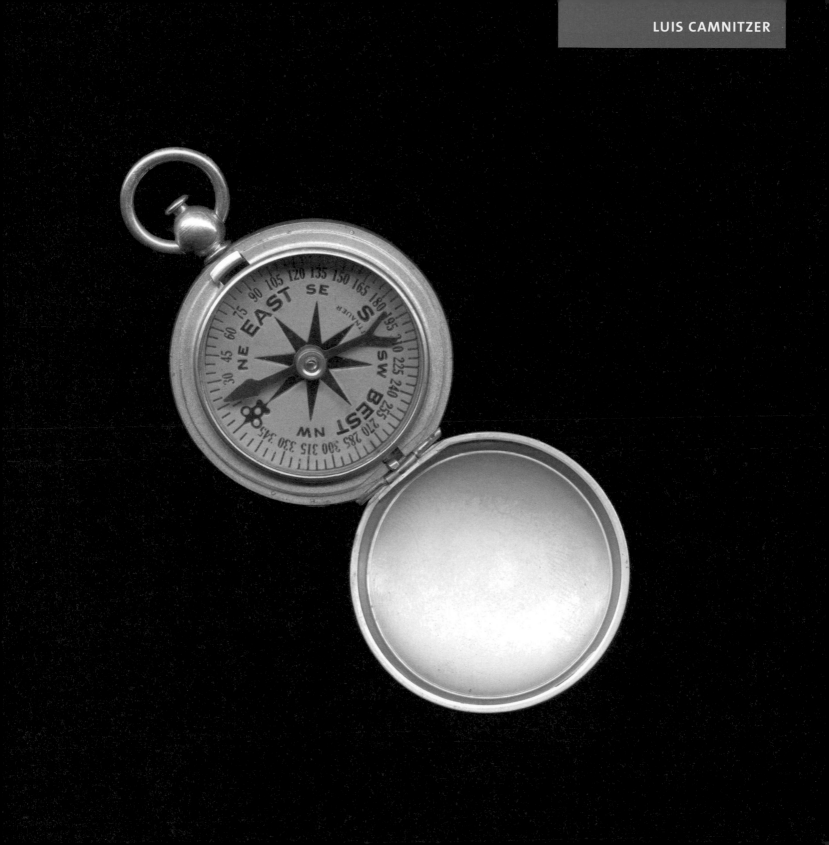

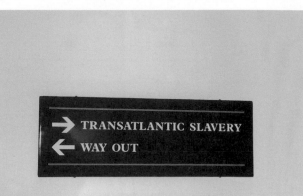

Luis Camnitzer

Luis Camnitzer's long career in art has been
characterised by two main concerns: an
engagement with the political issues present in
the circumstances of his life (his family
emigrated from Germany to Uruguay in the
1930s, and he eventually settled in the USA in
1964); and a meditation on the powers and
responsibilities of the artist as a social
commentator.

His contributions to the Biennale di Venezia in
1988 and to the recent Documenta 11 were
concerned with torture and political
imprisonment. His three new works in Liverpool
are about colonialism and mercantilism, as
suggested by Liverpool's historic status as a
trading centre of Empire. His critical vision is
explosive, but his art has a 'classical' symmetry
and lightness of touch.

At Sefton Park Palm House

Sefton Park Palm House was built in the mid-
nineteenth century to house semi-tropical plant
species brought by the trade routes to Liverpool.
The Palm House and its contents are a
manifestation of the colonial or imperial
impulse: to 'discover' and appropriate whatever
the world has to offer and bring it home.

Christmas Trees
Camnitzer remembers his astonishment on
discovering that European colonials in the
Caribbean, as in many places in the Southern
Hemisphere also, would dress in furs at
Christmas, despite the heat and humidity, to
demonstrate their status. The Christmas trees,
carefully labelled, are as exotic in their northern
provenence to someone from the southern
hemisphere as is the Palm House's little empire
of sothern spices to a native of Liverpool..

North South East Best
The Palm House has four doors aligned with the
four points of the compass. Alignment with the
sun is no doubt a natural instinct for a
horticulturalist, but there is an unavoidable
reference, intended or not, to the compass of
Christopher Columbus (whose statue is outside)
and the other entrepreneurs upon whom the
collection of plants at the Palm House was
ultimately dependent.

Camnitzer's understated intervention at the
Palm House doors comments on the corruption
of the objective convention of the compass by
political ideology. Unknown to the artist, in the
imperial era in Britain there was a common
saying (reproduced on tea-cosies and biscuit tins
and over fireplaces): East West Home's Best.

At Tate Liverpool

The Squaring of the Circle
The ancient conundrum of 'squaring the circle'
has been achieved by market forces supported
by military intervention.

Aristophanes' *The Birds*

With the straight rod I measure out, that so
The circle may be squared and in the centre
A market place; and streets be leading to it
Straight to the very centre; just as from
A star, though circular, straight flash out
In all directions.

(Translation supplied by the artist.)

Lewis Biggs

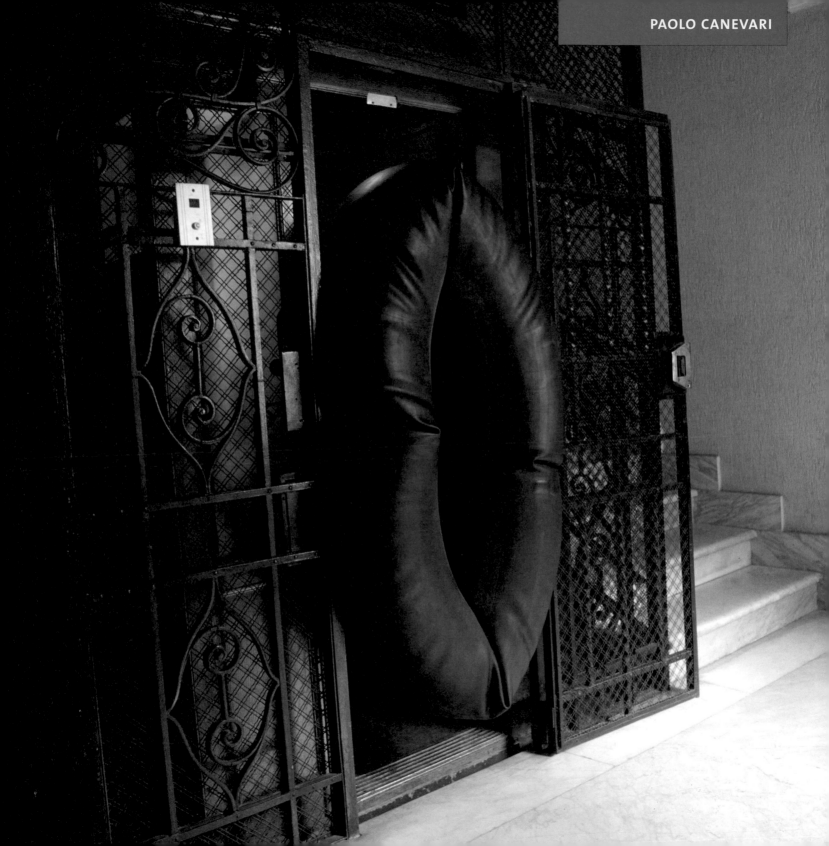

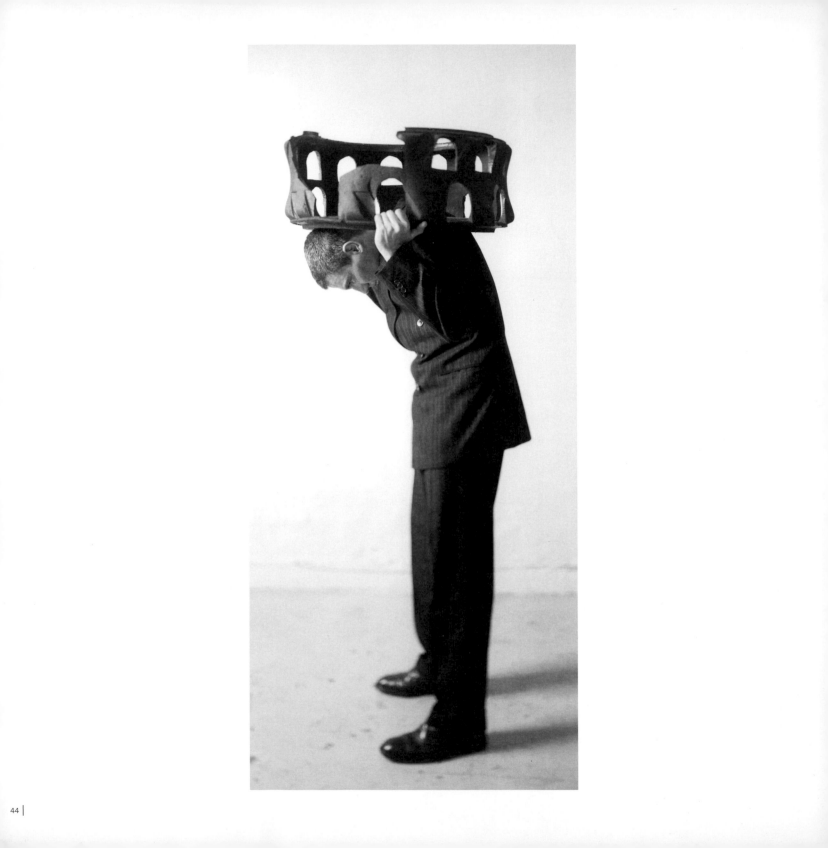

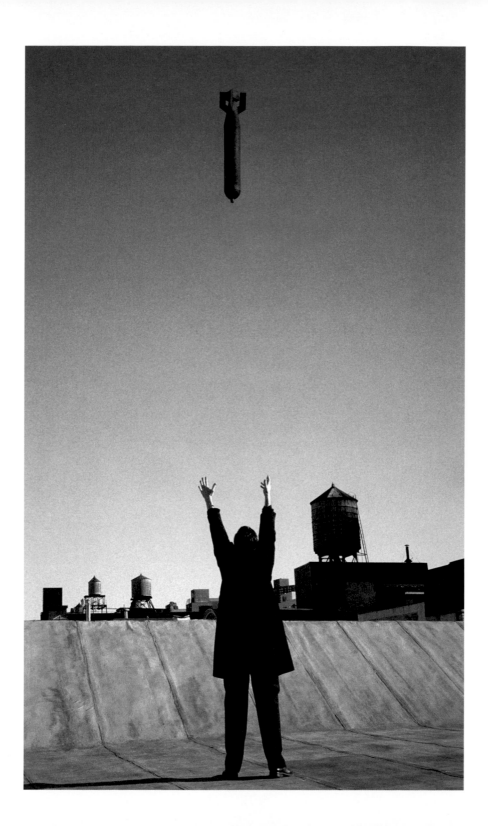

Paolo Canevari

Seed

A sculptor, installation artist and performance artist, Paolo Canevari is well known for his works made from rubber tyres and inner tubing. Canevari is attracted to the material because of its flexibility, its capacity to assume an endless variety of forms. Descended from three generations of artists, and born in Rome, a city famed for its architectural and artistic heritage, Canevari's choice of material is also a conscious rejection of the traditional materials of the 'classical' artist. His work often explores the complex relationship he has with this ancestry – for him, at once a burden and an inescapable influence. In *Colosso* (2002), he covered a gallery floor with miniature copies of Rome's Colosseum cut from tyres, while in an opening performance, he himself took on the role of Atlas, bearing the weight of a colosseum on his shoulders.

Canevari is wary of the monumental, and much of his work is ephemeral. In an early series of sculptures, *Camera d'aria* (1991), he hung sections cut from inner tubing on the wall, and manipulated them so that they took on recognisable shapes (anatomical forms, or objects such as helmets or shells). When removed from display, the sculptures quickly lose their shape, and return to their material state. Canevari notes: 'I don't want my work to be permanent; I want it to be a memory, to have a metaphysical presence'.[1] In a more recent intervention, Canevari created an entrance to the lift in his apartment block by squeezing an inflated inner tube into the doorway, evoking an image of female genitalia. This installation, *Mamma* (2000), recalls the artist's own birth in a lift and invites visitors to reflect upon the idea of birth.

For *International 04*, Canevari has suspended a replica of a World War II bomb over a Liverpool street. As if temporarily frozen in the action of falling, the bomb is a potent reminder of the damage suffered by the city during the war. The bomb has a specific historical context. Yet in a world increasingly faced with the phenomenon of 'invisible' warfare (whether by means of chemical weapons or suicide bombers), Canevari's work also offers a powerful visualisation of contemporary fear.

In a related piece made on the roof of his New York studio (2004), Canevari threw a bomb into the sky, and captured the image in a photograph as it fell. The resulting image is as mysterious as it is arresting. The artist stands with his arms outstretched as the bomb hurtles towards him.

Has he conjured up this icon of destruction? Or is he willingly embracing his fate? Canevari reproduced this image in black and white, and flyposted it, without any explanatory text, on street hoardings around New York. Post-September 11th, this was, needless to say, a highly provocative action, heightened by its anonymity. For Canevari, it was intended to express a collective preoccupation, and to provide an opportunity for the public to reflect on the contemporary climate: 'My intervention was directed towards an audience sensitive to the subject, or even not sensitive to it, but I think the most important thing was to create a question rather than give an answer'.[2]

In titling both these works *Seed*, Canevari alludes to the often unforeseen regeneration which can follow in the wake of destruction.

Sorcha Carey

[1] C. Iles, 'A Conversation with Paolo Canevari', in Emanuela Belloni (ed.), *Paolo Canevari*, Milan: Edizioni Charta, 2002, p. 25.
[2] In conversation with Sorcha Carey, 21 June 2004.

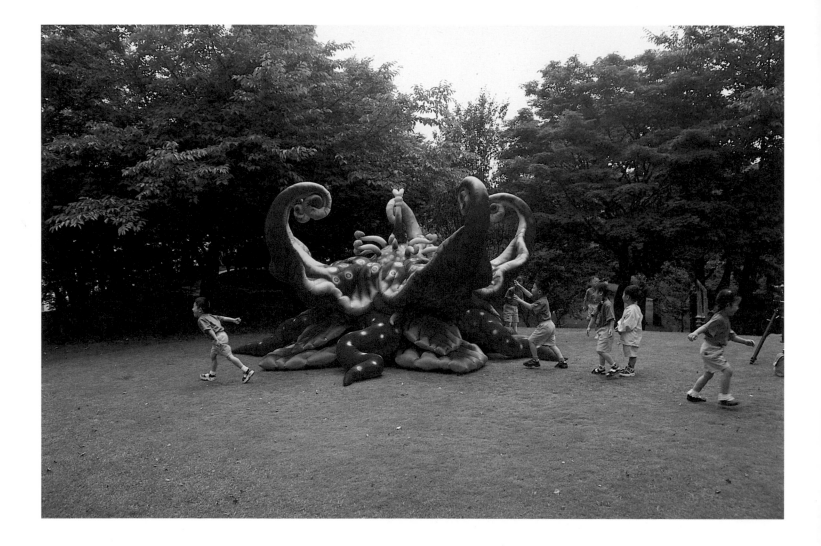

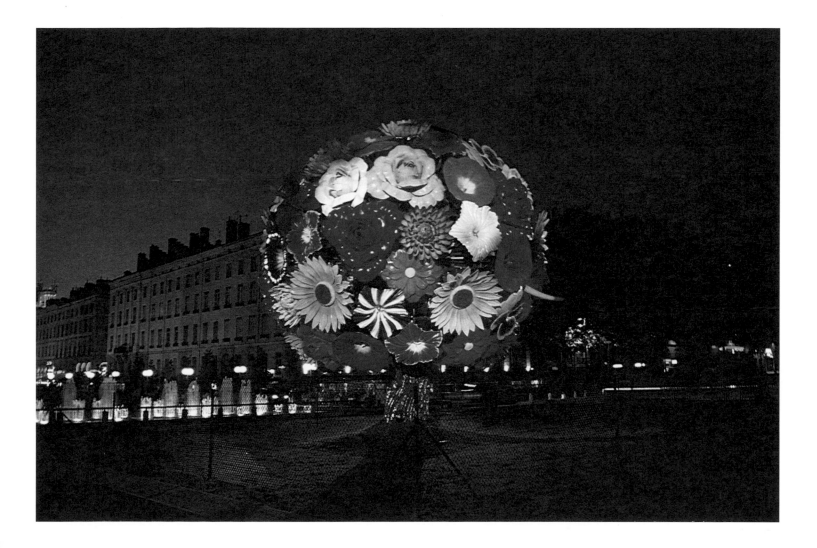

Dragon Flower,
Mori Museum, Tokyo,
2003

Touch Me, Sungkok
Museum, Seoul, 1999

Flower Tree, Lyons, France,
2003

Choi Jeong Hwa

Happy Together

Choi Jeong Hwa's work is hard to resist. Lively, vibrant, even gaudy, his large-scale inflatable fabric or fibreglass sculptures of flowers and fruit offer a riotous explosion of colour. The infectious pleasure which his sculptures induce is often reflected in their titles – from *Happy Together* to *Happy, Happy, Happy* (2003), or two new works for the Mori Art Museum's opening show *Happiness*, Choi Jeong Hwa's sculptures appear infinitely joyful.

Part of the pleasure of his work lies in its simplicity. With their bold colours and easily recognisable forms, the works are accessible to all. But this familiarity of form derives less from the world of nature (despite the frequent occurrence of flowers and fruit) than from the everyday landscape of contemporary consumer culture. This is the source of Choi Jeong Hwa's inspiration and materials (plastic, man-made fabric, fibreglass). A celebration but also a critique of consumerism, if his works are pleasurable to the eye, then they also question the nature of the pleasure they give.

One of his earlier inflatable works, *A Vision of Happiness for 0.5 Seconds* (1995), showed a giant pig with a sack of money on his back. The pig, in Korea, symbolises health, prosperity and good luck. In Western culture, it stands for the opposite, a symbol of unhealthy appetite, of consumption run riot. *Touch Me*, an inflatable sculpture for São Paulo Biennale XXIV (1998), finds a natural model for the destruction that can go hand in hand with consumption. A brightly coloured exotic plant performs a seductive dance, tentacles beckoning gently to the viewer. The plant is a member of the Nepenthes family, an insect-eating species, which entice and then devour their victims.

Happy, Happy, Happy (2003) is a recent piece which symbolically reverses the cycle of consumption and waste. During a residency at the Yerba Buena Center for the Arts in San Francisco, the artist invited local residents to bring plastic objects to the museum which they would otherwise have discarded. These formed the basis for a changing installation, constantly augmented and rearranged by visitors to the gallery. An important element of Choi Jeong Hwa's work is the desire to bring art into the everyday. Here the artist brings the everyday into the gallery, and, in so doing, challenges the public to find beauty amidst the haphazard collection of plastic objects.

For *International 04*, Choi Jeong Hwa has made *Happy Together*, a garland of blossoms for Lime Street station. Fantastic, decorative, eye-catching, it is designed to compete in the sea of information and advertisements which dominate the station concourse.

Sorcha Carey

Amanda Coogan

Beethoven, the Headbangers

In orchestrating a group of local people to
headbang, not to the ear-bleeding sound of
heavy metal, but to the stirring strains of the
final ten minutes of Beethoven's Ninth
Symphony, Amanda Coogan prompts questions
that go beyond the absurd combination of two
seemingly diametrically opposed musical forms.

Filmed at Liverpool's Philharmonic concert hall
(with a live re-staging of the piece during the
Biennial at Bluecoat, this time involving up to
100 headbangers), Coogan set out to 'explore a
collective hysteria and group energy'. What
would happen if the *Ode to Joy* chorus became
the soundtrack to the mosh-pit? For the artist it
was a way of garnering the collective passion
she recognised in Liverpool culture, from the
massed energy of the football crowd to the
group ritual of a karaoke night. Coogan sees the
transference of energy between performer and
audience as the most crucial part of the creative
process, and here the headbanging audience
members become the performers, themselves
watched by an audience on the video screen.

Having deaf parents, Coogan's first language
is Irish Sign Language, a manual/visual language
that she employed in an earlier solo video
performance piece, *Reading Beethoven* (2003), in
which her body became a conduit for a non-
verbal, physically demanding expression of the
music. Referencing, through signing, the
composer's own deafness, the piece attempted
to manifest Beethoven's call to 'jump off the
cliff', a sentiment now echoed in the abandon of
the heads-down, no-nonsense, mindless boogie
of *Beethoven, the Headbangers*.

Dealing with the concept of otherness and
outward manifestations of interior states,
Coogan's work focuses on the live event, followed
directly, and integrally, by photographic images
or video. Involving a group of people rather than
the solo artist, *Beethoven, the Headbangers*
represents a move away from earlier
performative work in which Coogan generated
highly iconic poses, gestures or actions using her
own body. In *50 Ways to Lose your Love Handles*
she sweated her way to the body beautiful in the
jungle of Thailand; in *Molly Bloom*, standing
against the backdrop of Dublin, she aped the
city's statue of Justice and broke wind; naked but
for a kitsch tourist apron in *Self Portrait as David*
she assumed the stance and gender of
Michelangelo's famous figure; and cupping her
breast in another series of performances, she
created a modern-day madonna.

This playful appropriation of the most
hallowed high art – Renaissance painting and
sculpture, classical music – into a contemporary
framework of immediacy is more than a clever
synthesis of past and present, an ironic re-
contextualising of historical cultural values. By
invoking the power of these visual or musical
masterpieces, Coogan also throws light on our
present-day cultural obsessions.

Bryan Biggs

NEIL CUMMINGS
MARYSIA LEWANDOWSKA

www.liverpoolcommons.org www.liverpoolcommons.org www.liverpool

Neil Cummings and Marysia Lewandowska

The Commons

In the publication accompanying their project *Capital* (2001) at Tate Modern and the Bank of England, Neil Cummings and Marysia Lewandowska cite John Locke's classic justification of private property. Locke proclaims that man, by mixing his labour with what nature has provided, may exclude the common rights of other men. However, the 'Lockean proviso' at the end of the passage makes an important reservation: 'at least where there is enough, and as good left in common for others'. [1]

The passage points to the interest in the economy of value that has characterised the collaboration between Neil Cummings and Marysia Lewandowska since 1995. Their research into value, exchange and commodity has queried our understanding of art, material objects and the power of their circulation.

The justification given by Locke also informs their project for *International 04, The Commons*. In this project Neil and Marysia's interest takes on a new urgency, for what is at stake is the possibility of creativity itself.

The Commons refers to the English tradition of common rights and land that came into being with the development of the manorial system in the Middle Ages: 'common' refers to that which is neither sovereign nor noble, but belongs to commoners. Common land is neither publicly owned nor does the public always have access to it; the commons therefore are a hybrid property, and much of Liverpool is built upon a former commons.

The artists propose to reclaim the ontogenesis of community when they define the commons as 'capital over which no one's right may be excluded'. The proposed definition counters the appropriation of what nature has provided and points to the possibility of an *inverse* commons, exemplified on the world wide web, where the value of open-source software *increases* the more people use and refine it. Culture itself could be seen as such a 'commons-based peer production'.

Global changes in intellectual property law suggested by the World Trade Organization would commodify creativity, concepts and ideas through patents, trademarks and copyrights. While such conditions of knowledge production would create economic prosperity for some, creativity would no longer partake in free exchange or circulation. In the cultural domain the enclosure of the imagination beckons the tragedy of the commons as a self-fulfilling prophecy.

How can we negotiate 'regeneration' – public/private development, capital investment, and the instrumental use of culture and creativity on the one hand, and notions of the 'public' for such practices on the other? Through a series of distributed events *The Commons* initiates 'fieldwork' into the nature of cultural production; and in the city of Liverpool, which is reinventing itself as a city of culture, these are pertinent questions.

Paul Domela

[1] John Locke, *Two Treatises of Government* (1679), cited in Neil Cummings and Marysia Lewandowska, *Capital*, London: Tate Publishing, 2001, p. 11.

Rolling Home

Aleks Danko

Rolling Home

Its façade little changed since the building was erected almost 300 years ago, Bluecoat Arts Centre provides the context for *Rolling Home*, a physical set of actions that Aleks Danko intends will 'activate history and memory, and give pause for personal reflection on notions of home'.

The performance involves three archetypal blue houses, made from foam rubber, being slowly rolled from different points in the city centre by students wearing the blue uniform of pupils of the charity school that once occupied the Bluecoat building. Converging on the front courtyard, the houses are welcomed by a brass band, echoing the occasion – depicted in a contemporary print – of the school band leading children in formation out of the front gates of the building on St George's Day, 1843, a school holiday. A sardonic inversion of this historical image, *Rolling Home* leads us back through the gates of the school with a fanfare that is unlikely to rouse the patriotic cheers and banner-waving that no doubt accompanied the earlier celebration, when home and school were one and the same on this site.

The metaphorical use of architecture is a constant theme in Danko's work, which often references institutionalised space as a site for critiquing ideological certainty. Rather than official buildings, however, it is the suburban home – a place both comforting in its familiarity and stultifying in its uniformity – that has become a recurring element. It appears in Danko's installations, drawings and performances as a toylike motif, its pitched roof, central door and twin windows needing only a chimney stack to complete the resemblance to a child's rudimentary schematic of a house.

Its doors and windows resolutely shut, Danko's domestic shell denies access, and in Liverpool the houses take on a sculptural dimension, objects to be manoeuvred by human force like cargo from the docks before the advent of containerisation. Struck by the ad hoc nature of housing in Liverpool, the artist ponders the effects of a postmodern aesthetic upon a historical city environment. His performance, engaging directly with the Saturday afternoon shoppers who throng the streets of a city centre about to undergo wholesale reconstruction, questions what gets 'rolled over' in the process of urban regeneration, and in whose interests.

Playfulness and participation are key to *Rolling Home*, as well as a sense of the absurd – Danko's

homage perhaps to the Liverpool poets of the 1960s, whose surreal pop verse affected him 'not so much by what it was as by what it did' (Edward Lucie-Smith). Like them, *Rolling Home* journeys through the everyday, interrogating specific places and histories, making poetry of our memory on the way.

Bryan Biggs

Dias & Riedweg

in collaboration with Victor Twagira, Liliane Ingabire, Moses R, Abdul-Aziz Liban, Amos Mukumbwa, Nicolette Muzazi, Ariane Muzazi and Sarah Katushbe

Sugar Seekers

Mauricio Dias and Walter Riedweg have worked together on interactive art projects since 1993. They have exhibited internationally over the last decade; *Sugar Seekers* is their first UK commission. Dias & Riedweg are distinctive for the way in which they allow the public actively to influence both the form and content of the final work. Over the years they have collaborated with a diverse range of people, brought together in each work either by their social, political or economic status or because of their own particular way of perceiving the world; the Other is here presented as much in his social-political significance to society as in his own subjective world. Dias & Riedweg do not set out to 'judge, classify, teach, cure, improve or even change anything in the Other's life'; rather, they open up a space in which private, anonymous worlds can be researched, rethought and represented in public space. For them, art is above all a constant exercise in poetic reflection.

Sugar Seekers continues the artists' ongoing exploration of the rights of the individual within the territory of immigration and emigration. The starting point of these investigations is Liverpool, a city that has historically played an important role in the global pattern of migration. The young people with whom Dias & Riedweg have created *Sugar Seekers* are at different stages of the lengthy asylum-seeking process, which categorises them in terms of risk; their personal desires and needs for a new life are negated within this system. Only the individual who has economic and political power can achieve the degree of freedom necessary to migrate at will: the desire to travel is not itself a humanitarian right.

The cameras were in the hands of the participants at all times. Evoking memories through sensorial workshops, collating documentary-style footage of group discussions, interviewing other migrants and compiling image archives from internet word searches, the young people worked intensely with the artists in the execution of *Sugar Seekers*. They redefine the terms of immigration and emigration that seek to label them solely as Refugee or Asylum Seeker. The focus of the collaboration was to move beyond sensitive personal experience to the wider contexts that have affected the participants' lives. Society's tendency to label them as 'victim' was refuted by the artists; instead the young people were given the position of power as Subject that speaks, rather than the Other that remains silent.

The resulting four-channel installation does not set out to document stories; rather, it opens up new definitions of the language of migration. The viewer adds a further layer of interpretive possibilities when he or she interacts with the work: a touch command triggered by key words activates a new set of images and changes the narrative flow of the video. *Sugar Seekers* investigates the ways in which global economy and local politics relate to each other and the ways in which they don't. It seeks a broader comprehension of immigration as an urgent human right beyond the dominance of current capitalist global economy.

Marie-Anne McQuay

The Bounce Factor
Recoding the International

Paul Domela

It matters little to me that these questions should be fragmentary, barely indicative of a method, at most of a project. It matters a lot to me that they should seem trivial and futile: that's exactly what makes them just as essential, if not more so, as all the other questions by which we've tried in vain to lay hold on our truth.

Georges Perec, 'Approaches to What?'[1]

The third Liverpool Biennial International exhibits new work by 42 artists commissioned especially for the exhibition. The catalogue in front of you marks a moment two months before the exhibition opens, a period during which many projects will find their penultimate articulation. Again and again it will be the viewer who will render the work in his or her own image and will produce meaning from and beyond the artists' intentions. The provisional status of the catalogue highlights this fundamental open-endedness of the creative act, Marcel Duchamp's predestination in the infinitive.

Our guiding question has been how to produce the relation between international cultural practices and a specific cultural context. Biennials are famously cast by the three dies of art, money and parties and this one is no different. Liverpool Biennial is a witting accomplice to economic outputs and performance indicators. It is in good company: the Venice Biennale was designed in 1895 to counter a city in decline and received 200,000 visitors thanks to a combicard with the railways. Documenta in Kassel is as much an economic proposition as an intellectual and ethical one, returning €7 to the city's economy for each €1 investment. These large-scale events are jubilations of paralalia, embracing contradiction and feasting on controversy – and perhaps art ought to outrage, as David Edgar recently suggested – in an oscillation of affirmation and reflection. Like the court jester the artist holds the obligation to be profoundly irreverent; in wisdom she or he mirrors the confidence of the sovereign.

Given these imbricated positions and the increasingly fluid conditions that characterise our existence today, taking a stance or pursuing an ideal have become delicate undertakings. The city of Liverpool is leaving the doldrums. Turbulent changes are dawning, bringing a wealth of contradictions. For example, before 2008, Liverpool will see a 43-acre shopping and residential quarter built in the city centre. This £750 million investment will also create a zone of exception, where the responsibility for public order and safety, such as the regulation of peddling and public demonstration, will be devolved to a private company. We can only speculate as to how the appearance of this urban epenthesis will reverberate within the social fabric – the phantom of a collective unconcious? Walter Benjamin understood the passage between the individual and the community through the interiorisation of external signs – he mentions architecture, fashion, billboards and weather conditions. These signs make up the interiority of the collective, just as smells, sounds, feelings and so on make up the interiority of the individual. With ambitious development plans unfolding on a weekly basis, Liverpool is at a critical juncture in regenerating not only its built environment but also its collective identity as a city of people.

There is a real pressure to 'finish' the city before the celebrations as European Capital of Culture in 2008. The creation of such an 'event horizon' as if it were an endpoint is of course a contradiction in terms – but it does galvanise political and financial support. We anticipate its potential as a platform for cultural transformation, to be actualised and sustained in the practice and quality of cultural producers who live and work locally but whose work resonates globally. This is as much a project of physical transformation as a leap of the imagination twenty years forward. To break the 'buzz to bland' cycle, whereby successful regeneration is rapidly followed by homogenisation, the city needs to invest in diversity at the same time as taking into account difference, participation and sustainability.[2] The greatest challenge in

this field will be to deliver not against a certain pre-determined or totalising conclusion but towards the open-ended indeterminacy of conviviality. What might this mean on the upbeat?

In a seminar in March 2003 entitled 'Urban Ecologies'[3] we asked whether we could bring 'trash', 'waste', and the discarded or repressed back into play as creative beginnings. How may the work of artists play a role in the remediation of an urban ecology?[4] Derrida has pointed out how the privilege placed on unity and identity emphasises the homogenising tendencies of communities – the 'we' opposed to 'them' – and deflates our response-ability in the encounter with the other. He introduces the possibility of a community of dissociation, a dissensual community that pushes to its limit condition the contradiction of hospitality predicated on ownership. Hospitality allows communities 'to make their very limits their openings'.[5] Beyond the merely pleasurable, the trajectory of art outcurves established policies and perspectives and proposes new possibilities for the production of subjectivity. At the same time a bricolage of ludic processes by artists operates outside reductive Western discourses (art, non-art or wrong art?), equivocating, 'ducking and weaving' the self-raising, self-erasing canon of the art apparatus. Remixing Yona Friedman's 'structures serving the unpredictable', how do cities juggle the requirements of managerial accountability with the creation of an infrastructure that allows for the emergence of imaginative self-organisation?

Liverpool, as a post-industrial/postcolonial/post-port city, is marked by the decisive shift towards immaterial production. The product is no longer material objects but the constitution of relations. Culture, tourism and knowledge production are the new growth industries. In this field, how to reconcile the transmutation of identity between memory and connectivity, conductivity and place?

The architect Cedric Price suggested 'the word CONCENTRATE as appropriate twenty-first century replacement for CITY'. Among several characteristics he defines 'concentrates' by the intensity of population within a certain time-span rather than an area of density. 'The population can be assumed to be both static and dynamic – rendering the difference between citizen and visitor irrelevant.'[6]

What are the possibilities of an enactive approach to cultural production that is embedded in a specific cultural context and guided by acting in local situations? What forms of organisation may produce new relations between the local cultural context and a global environment of international/transnational practice?

The curatorial process of *International 04* specified the culture of Liverpool as the context for the exhibition. To germinate the process we invited 'researchers' from outside Liverpool to suggest artists whose practices they felt would have an affinity with or bite upon the culture of the city. The development and delivery of projects would be the task of Liverpool-based organisers. Not only did we want to make an exhibition that could not be seen anywhere else, we also wanted to explore the negotiation of place as a practice of difference. The works in the exhibition come out of this process of negotiation as much as they are part of wider and ongoing conversations in which questions of place and identity take on other social, economic, political, aesthetic, racial or gendered dimensions.

The organisational process for *International 04* was divided into research, selection and delivery. As much as these were stages in the realisation of the exhibition, they were also recurrent progressions in the development of artists' projects. The proposal was for a trialogue between three participants: the artist, the site and the International staff. The site is understood to mean the place or organisation where the work of art may be experienced, whether this is a gallery, a public square, an office or the Town Hall.

After consultation with *International 02* curators, the directors and curatorial staff of Tate Liverpool, FACT and Bluecoat Arts Centre, the

International staff appointed four researchers. They were invited to visit Liverpool for seven days to probe the city as a cultural context – the physical, organisational, social, economic and historical characteristics of the city as a location for an exhibition, including the history of the Liverpool Biennial. The researchers' brief was to recommend to the Biennial the practice of twelve artists. Each was asked to write a 'rationale' setting out their reasons for suggesting each artist. In addition, we asked them to revisit Liverpool in March 2004 to review our progress and to contribute their reflections to this catalogue. The four researchers are Sabine Breitwieser (Vienna), Yu Yeon Kim (Seoul/New York), Cuauhtémoc Medina (Mexico City) and Apinan Poshyananda (Bangkok). We invited these four researchers because their practices as curators combined different subject positions with different cultural perspectives. Moreover, we felt they would enjoy the opportunity to engage with Liverpool as a place. Ours was an unusual request: to suggest twelve artists without also having the responsibility of seeing through the delivery of their projects. In accepting, the researchers invested huge confidence in us.

We invited all 48 artists to visit and research Liverpool, to formulate their proposals and to find an appropriate context for their work. The artists were invited to meet as many people as possible, especially those people with whom they might work. From these meetings we hoped that working relations would be established with Liverpool-based curators, educators, scientists or art historians, film-makers or designers. We emphasised the commissioning of new work, but did not exclude showing existing work not previously seen. For their research and project proposals the artists received a contract and a fee.

We discussed the artists' proposals with the curators of Liverpool's contemporary art organisations and those responsible for the sites specified in the proposals. In some cases the nature or form of the original proposal changed entirely as a result of this triangular conversation.

What exactly is the specific culture of a city? Liverpool as a brand commands 80 per cent recognition in Thailand and not just because of football. Throughout the years of the city's decline, Liverpool was stowed in the minds of millions for its extraordinary legacy, from music to slavery, from public parks to workers' rights. Liverpool's current regeneration is predicated on the resonance of these images. The future transformation of the city depends on the projections of those millions of people around the world as well as on the ambitions of its inhabitants.

In the West the appreciation of art continues to be dominated by acts of judgment in which the placement of a work of art in terms of its meaning and critical framework has become more important than our emotional and cognitive engagement. But between experience and interpretation arises a polyphony of ruses. It is as though a case of digital drift is nudging the homogenising synchronization of the global art market into a syncopated beat of local sounds. In this multiplicity the International is envisaged as a multivalent concept and the edict of the list of artists – as an instrument of prestige – is qualified within a process of production and reception. Different voices speak during the progression from research to development to delivery to reception and translate between dreams, partial perspectives, aspirations and a view from the ground. In this process, the inflection of the curator shifts from custodian to producer, from gatekeeper to facilitator, from arbiter to moderator.

Today, the connectivity of the city is its global currency. During the symposium 'Reinventing Britain' Stuart Hall reminded his audience that 'the site on which the redefinition of England or Britain is going to occur, is now irrevocably transnational, irrevocably open at the ends, porous and unable to close its borders and its mind, unable to shut out things that will reach over the barriers that are erected. The re-invention of Britishness is just inescapably taking place on a global plane.'[7] How to translate this on the level of the city?

Within an international cultural context the specification of Liverpool invites a re-evaluation of the implicit assumptions underlying its most dominant articulations. Culture speaks about values, about difference and exchange – it is an economic proposition because it is, before anything else, a relational proposition. *International 04* dislodges the privilege of either/or with a dynamic of 'reciprocal extraterritorialities' where different perspectives in-determine each other.[8] It is from within this uncertain topology, in which habitual contradictions are suspended and annulled, that new meanings may be gleaned and resistance turns resilience, adding a bounce to our step.

NOTES

[1] George Perec, 'Approaches to What?', in *Species of Spaces and Other Pieces*, London: Penguin, 1999, p. 211.

[2] Anna Minton, *Northern Soul: Culture, Creativity and Quality of Place in Newcastle and Gateshead*, London: Demos, 2003.

[3] I am grateful to Jonathon Harris, Kyong Park, Azra Aksamija, Christoph Schäfer/Park Fiction, Leo Fitzmaurice/Further, Lily van Ginneken and Jan Wijle/Stroom for their generous thoughts.

[4] See Felix Guattari, *The Three Ecologies*, London: The Athlone Press, 2000.

[5] Cited in Irina Aristarkhova, 'Hosting the Other: Cyberfeminist Strategies for Net Communities', in Cornelia Sollfrank (ed.), *Next Cyberfeminist Reader*, www.obn.org/reader. Hospitality was the subject of 'Coffee Break: Who is the Host?', a seminar with Nicolas Bourriaud, Irina Aristarkhova and Iara Boubnova, chaired by Ole Bouman and organised in collaboration with International Foundation Manifesta in February 2004. A publication is forthcoming in spring 2005.

[6] Cedric Price, *Re:CP*, ed. Hans Ulrich Obrist, Basle: Birkhauser, 2003, Snack no. 18.

[7] Stuart Hall, 'Closing Remarks', http://www.counterpoint-online.org/themes/reinventing britain/remarks.html, 21 June 2004.

[8] Giorgio Agamben, 'Beyond Human Rights', in *Means without End: Notes on Politics*, trans. Vincenzo Binnetti and Cesare Casarino, Minneapolis: University of Minnesota Press, 2000, p. 24.

A Stay

in

Belfast

Maria Eichhorn

A Stay in Belfast

Since the 1980s Maria Eichhorn's projects have discreetly countered anticipations of definable works of art. Her concise formulations balance finely between conceptual clarity and indeterminacy, expanding the materiality of the art object as event or possibility. They are decidedly open-ended, bringing forth a glimpse of our thinking in process as we struggle to produce meaning.

Her work *Curtain* (1989–2001) could serve as an example of an action with a certain definition that changes its shape and meaning over time. A series of ten differently coloured curtains are hung in sequence in different places over a number of years. Each time the curtain is accompanied by a different element: textual contributions by six different authors, an exhibition or a series of anti-nuclear lectures.

Think of the work of Fluxus, John Cage or Marcel Duchamp as historical data and add an active political dimension. To Eichhorn the event of art constitutes a concrete opportunity to participate in a system of social and political processes. How can this event negotiate between the symbolic and the real? With *Ilan*

Panosu/Billboard (1995) she made a billboard available in Taksim Square, Istanbul to be used by political groups, thus creating a changing display of multiple perspectives.

Multiplicity indirectly subverts the voice of authority. The allusive tactics Maria Eichhorn employs transform the conditioned response within specific cultural and institutional contexts not by opposition but through participation. Her work embraces candour, inference, speculation, humour and intellectual rigour as libertarian possibilities of interpretation, without putting these in a hierarchical organisation. Nor is it necessarily through seeing that we gain our most fulfilling experience; we may need to shift our awareness to the other senses, including thought.

For *International 04* Maria Eichhorn presents *A Stay in Belfast*, the evidence of a two-day sojourn in Belfast by the artist. With seven flights and two boat journeys each day, Liverpool and Belfast are intimately related, but who is travelling and what is the nature of their business? What does this reveal about the action undertaken by the artist?

Can we set free our imagination to construct a new reality? Following the rupture of our anticipation of a definable work of art, can we trust our intelligence to probe this openness or do we hold fast to the traditions of our old

moorings? In setting up questions rather than providing answers, *A Stay in Belfast* creates space for reflection by refuting our preemptive desire for a rationale.

Paul Domela

Carl Michael von Hausswolff

Red Mersey

What lies beneath? Swedish artist Carl Michael von Hausswolff poses this question in a video projection and sound installation that charts the journey of a sub-aqua diver from one side of the River Mersey to the other.

People have been crossing the River Mersey for nearly eight hundred years and the history of the river is inextricably linked to that of the city of Liverpool. A gateway to the world, the river's buoyant economy has been based on the importation and exportation of computer parts, sugar, cotton and coffee – and the trafficking of human life through a lucrative slave trade. A natural border from the estuary on the Irish Sea to the airport at the southern end of the city, thirteen miles of the Mersey define Liverpool's western perimeter. Crossing the river is significant. Subterranean toll tunnels allow cars and trains to journey from point to point and the famous Mersey Ferry makes regular journeys across the surface of the water. Yet you cannot simply walk across a bridge; every crossing entails a financial exchange. A point of departure and of return, the river, with its tidal flow, is part of the physical, economic and psychological life-cycle and identity of the city.

Best known for his post-minimalist sound pieces and 'red projects', Carl Michael von Hausswolff's work is concerned with essences. Exhibiting internationally since the 1970s, his experimental compositions are compiled from found sounds captured on a hand-held recorder and are balanced by hypnotic sonorous drones made from magnetic noise, in which the tiniest low-frequency sounds are magnified. His 'red projects' are light installations that define and alter space by disengaging it from its context. In *Red Pool* (1999) he shone blood-red lights onto a swimming pool in Bangkok. In *Red Night* (1999) in Santa Fe, New Mexico, 11,000 watts of deep red light flooded the Our Lady of Guadaloupe cemetery. In *Red Empty* (2003) in Zagreb, von Hausswolff flooded the interior of the dilapidated ARKO liqueur factory, turning it into a beacon of red light. In each case, the extreme flood of dense red metamorphoses overlooked sites into clearly defined, if temporary, objects.

Shot at night by a local diver who has an intimate knowledge of the river, its tides, treasures, wreckages, pollution and deep black silt, which makes visibility beneath the surface impossible, Hausswolff's Mersey piece is only partly filtered red. The work delves into the very material of the river as a means of grappling with the Mersey's incalculable presence. In this 40-minute looped video, the sound element of the work becomes a metaphor for the eternal return. Von Hausswolff explains that the sound 'is very abstract and non-narrative – it's a flow, a sweep, a state of mind crossing. . . it sounds like a thousand storms, a thousand waves'.[1]

Laura Britton

[1] Email correspondence with the artist, 26 June 2004.

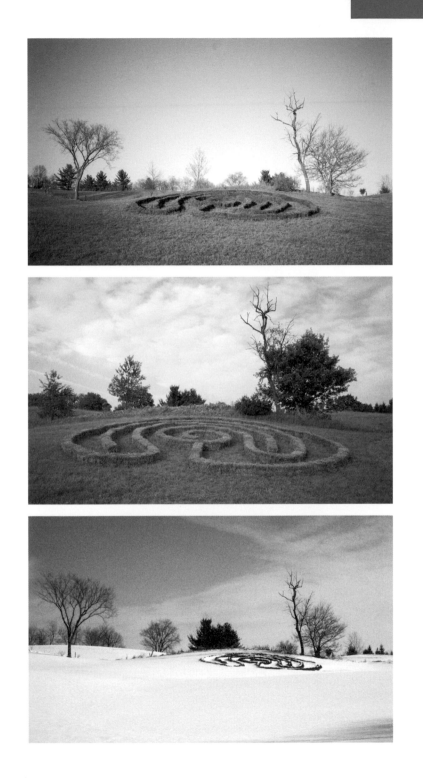

Satch Hoyt

The Triangle

'No slavery, no Liverpool' is a saying heard within Liverpool's black community. At the beginning of the eighteenth century most of Britain's slave merchants were from London and Bristol, but by the time of abolition in 1807 Liverpool had become the dominant European slave-trading port. The growth of the port and the prosperity of the city, its merchants and its citizens were the direct results of the slave trade. This legacy infuses the fabric of Liverpool – its docks and its buildings as well as its street names.

Slavery and the concomitant creation of the African Diaspora are central to Satch Hoyt's contribution to *International 04*. *The Triangle* refers to the triangular trade of raw materials, goods and human cargo between Europe, Africa, the Caribbean and the Americas. Hoyt draws upon the site-specific resonances of Liverpool's Albert Dock to evoke the historical suffering caused in the production of the commodities of cotton, tobacco and sugar. *The Triangle* recalls the 'double consciousness' in what Paul Gilroy has called 'the Black Atlantic' and sounds the cross-cultural rhythms that permeate contemporary questions of black identity.

Labyrinth, Tate Liverpool

The form of the labyrinth dates back to the twelfth-century Holiswara dynasty of India, staging the 'will conundrum' of the Chakravyuh in the *Mahabharata*. The great hero Abhimanyu is gifted with magical powers to fight through the Chakravyuh labyrinth and confront the powers of evil. Although he is gifted to fight to the heart of the labyrinth, he has not been gifted to find his way out and at last ends up betrayed. In the labyrinth we hear the echo of slavery brought up close within poignant loops of plantation chants, sounds of machetes cutting sugar cane, the rustle of tobacco and hands picking cotton.

The Puzzle, Albert Dock

Sixteen tethered pieces of *The Puzzle* floating in the Albert Dock collectively carry a blue triangle on a red background. Moved by the waves and the wind, the parts collide, unresolved, generating percussive and synthesized samples. Taken together, colour, waves, sound and the dock setting – combining natural elements within a man-made arena – perform an oblation. From sunrise to sunset we can behold this ritual; our contemplation and memory of the work can provide rest and relief for our troubled mind or haunted imagination.

The Quiz, Transatlantic Slavery Gallery, Merseyside Maritime Museum

Hoyt's aim, in testing young black people on the history of their ancestors and cultures, is to reconnect them to this history. However, key questions are not only located in the past; today they permeate the unreflective celebration of popular culture and the continued disenfranchisement of people of the African Diaspora. For both black and white, the subject of slavery can never remain neutral. Hoyt's work calls us to re-examine the present in the light of the past; it calls us to action.

Garry Morris

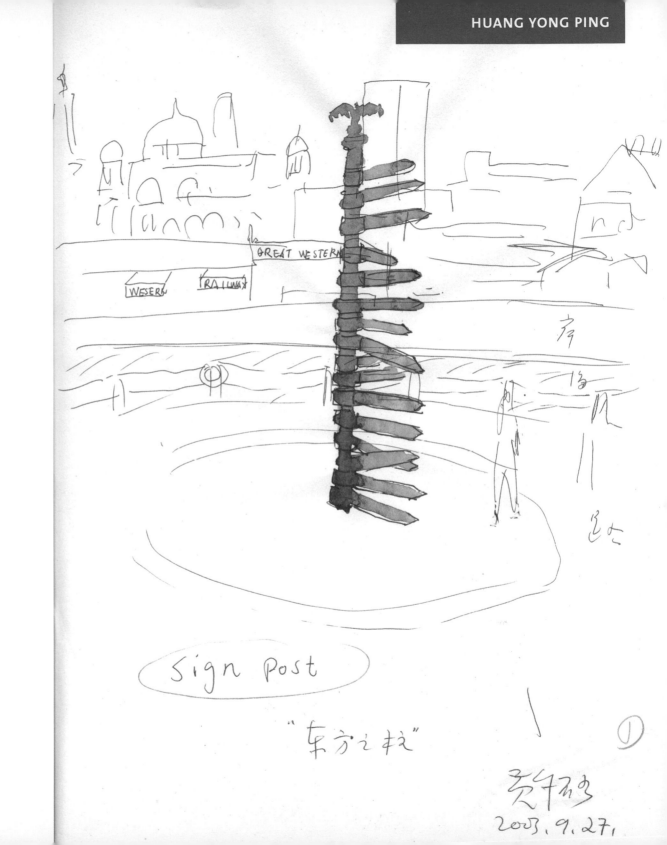

GREAT WESTERN

WESERN RAILWAY

Sign post

"东方之桅"

2003. 9. 27.

welcome

attract

Welcome to Liverpool, one of the most exciting cities in
Europe...

There's a host of major events and festivals throughout the year and with six performing theatres there's something for all tastes. Liverpool is bidding for the coveted title of European Capital of Culture for 2008 and has a very strong chance of winning.

...city centre is compact and easy to walk around. ...class shopping can be found in Church Street, ...treet, Bold Street and the surrounding areas, ...etting the indoor shopping offered by the ...quare, St Johns and Cavern Walks centres.

...music scene is legendary, and ...new bars, restaurants and ...e thriving nightlife, you're ...e. Areas to check out are the ...s and Queen Square, but ...ost anywhere in the city.

NAME
Albert Dock
Beatles Story

Bluecoat Arts Centre
Cains Brewery Tours
Conservation Centre

Empire Theatre
Everyman Theatre
FACT Centre

Liverpool Cathedral
Liverpool Central Library
& Record Office

Liverpool Museum

Liverpool Town Hall

Mersey Ferries Heritage Cru...

Merseyside Maritime Muse...
(& HM Customs & Excise Mu...
Metropolitan Cathedral
Museum of Liverpool Life
Neptune Theatre
Odeon Cinema
Open Eye Gallery

Philharmonic Hall
Playhouse Theatre
Royal Court Theatre
St. George's Hall

Tate Liverpool

Unity Theatre
University of Liverpool Art G...

The Walker

Western Approaches

The Williamson Tunnels

Henry's Premier Lodge	0151 236 1366	
Holiday Inn City Centre	0151 709 7090	
Ibis/Formule 1	0151 706 9800	
International Inn	0151 709 8135	
Liverpool John Moores Univ.	0151 707 8564	
Marriott	0151 476 8000	
Moat House	0151 471 9988	
Thistle	0151 227 4444	
Travelodge	0870 191 1656	
Trials	0151 227 1021	
Youth Hostel	0151 709 8888	

...our

...ty Sight...
...n open t...

...agical M...
...wo hour...
...el : 0871...

...unday C...
...formatio...
...906 68o...

...verpool...
... Liverpool...
...l : 0151 ...

...verpool Heritage Taxi Tours –
...a luxury vehicle. Tel 0151 531 6947.

...ersonalised Car Tours – with qualified
...uides. Tel : 0151 707 9313 or 0151 931 3075.

...rivate Tours – with qualified Blue Badge
...uides.Tel : 0151 237 3925.

...mbers

Events Hotline:	0151 233 3007
Liverpool Direct:	0151 233 3000
Tourist Information:	0906 680 6886 (25p PER MINUTE)
Minicom:	0151 709 4555

National Travel	traveline *public transport info*	0870 608 2 608 National Call Rate	8am till 8pm 7 days a week	
Local Travel	Merseytravel *buses · trains · ferries*	0151-236 7676 Local Call Rate		
Rail Travel	National Rail Enquiries	08457 48 49 50 Local Call Rate	24 hours a day	

Liverpool City Council gratefully acknowledges the organisations who supported the production of this map. If you would like to

The City of Liverpool

LIVERPOOL Leisure & Stores Committee

the mersey PARTNERSHIP Tourism

Mer...
KEEPING MERS...

Huang Yong Ping

The Pole of the East

In Britain, cast iron signposts are regarded as an important part of the country's heritage and its landscape. Huang Yong Ping, the Paris-based Chinese artist, has created an artwork for *International 04* mimicking the signpost but at odds with its function.

Huang moved to Paris, where he now lives and works, after the political upheavals in China in 1989. He has often used irony to address current affairs. From the outset, his oeuvre has involved critique, deliberately questioning the conflict between the so-called centre and peripheral cultures. His project *The Pole of the East*, a newly commissioned work in Liverpool's city centre, is a good example of this questioning.

In this work, Huang converts a common signpost into a city sculpture. The work merges a part of the roadside landscape with burning political issues, which creates tension. The signpost directs pedestrians to 17 countries: Afghanistan, Iraq, North Korea, Iran, Syria, Pakistan, Kazakhstan, China, the Philippines, Libya, Sudan, Lebanon, Egypt, Jordan, India, Russia, and Germany. As indicated from the signs, these countries are all located east of Liverpool (and of Britain).

The images employed in the work are taken from British newspapers and European magazines from 2003, illustrating the movement of coalition troops before the outbreak of the Iraq war. A hawk atop the crown has replaced the seagull in the signpost. The figure of the pedestrian has been changed into a soldier holding a gun. According to Huang, the hawk and the crown represent the American and the British armies respectively. The green soldier is an embodiment of the military awaiting the command. The first four countries on the signpost are labelled by the United States as members of the 'Axis of Evil', while the first two have even experienced war. Based on this logic, the artist raises a question in the form of a prophecy – he foresees that the remaining countries might eventually share the same fate.

In its engagement with this sensitive political context, Huang's work is perhaps a proposition of global positioning vis-à-vis the dominant Western power. It is no longer a city signpost, but an indication of Britain's position relative to the rest of the world, and particularly to the East. The artist explained, 'the work is inspired by and transformed from the signposts in Liverpool. It comes from the place but it also questions this place'. We used to follow signposts to find our direction. Should we pursue *The Pole of the East* to find the way?

Stella Wing Yan Fong

Can we imagine a
future after capitalism?

90% NO

10% YES

Is love all we need?

85% YES

15% NO

Sanja Iveković

Liverpoll

Feminist and political activist, Sanja Iveković has from the very beginning embraced the mass media in her work, which explores gender, memory and identity. Her early use of magazines and newspapers as a medium was prompted by a desire to comment on the portrayal of women in these media. In *Double Life* (1975), she juxtaposed advertisements featuring women with photographs taken from her own album which captured her, coincidentally, in similar poses. This interweaving of commercial and personal photography revealed the extent to which advertising can condition our perception of self.

Iveković has continued to work in mass media throughout her career, and while her work still explores the nature of media coverage (*Works of Heart*, 2001), the choice of medium also reflects a concern to extend the reach of her work and to present ideas in a form and context accessible to all. In 1997, recognising that Croatia's 'National Heroines' (women killed or imprisoned for their role in the anti-fascist resistance, the artist's mother among them) no longer formed part of the country's collective memory, she created a series of magazine advertisements (*Gen XX*)

which reintroduced these women into contemporary consciousness.

Her project for *International 04* develops directly out of this aspect of her practice, and explores the multitude of differences often concealed or obscured by our use of the term 'public'. *Liverpoll* is prompted by a text by Roger M. Buergel which considers how modern-day usage of the term 'the public' can embody two entirely contradictory concepts: 'social totality' ('The police appealed to the public') and 'specific audience' ('the theatre-going public'). Buergel contrasts developments in art practice, 'indisputably a public activity, oriented towards debate and confrontation with others', with developments in the public sphere, increasingly dominated by marketing statistics, 'where the critical and emancipating dimension of cultural experience is eliminated in favour of false participation'.[1]

Liverpoll harnesses an essential tool for determining public opinion – the newspaper poll – to examine the true nature of 'the public' and 'public participation'. The project presents 'the public' (that is to say the *Liverpool Echo*-reading public, or the internet-using public) with a series of yes/no questions, some posed by the artist herself, some posed by members of the Liverpool 'public'. The results of these polls will be

published throughout Liverpool Biennial 2004 as a series of 2D and 3D pie charts (needless to say, displayed in the 'public realm').

Iveković's questions derive very much from her own personal interests and practice, already familiar to her own loyal 'public'. She asks us 'Do we want gender democracy?' or 'Is there a future after capitalism?' (an ironic reversal of the artist's own experience as a native of a post-communist country). Questions to be posed by the Liverpool public were yet to be determined at the time of writing (July 2004), though the artist's speculation as to what these might be ('Do we want to pull out of Iraq?') is in itself revealing. No doubt much of what is deemed to be of public interest in July will seem inconsequential in September.

Liverpoll presents us with a multitude of fractions and divisions, of segments demarcating who said yes from who said no. It reveals what the all-too-familiar construction '87% of people said. . .' conceals: that there is no such thing as the public, only myriad 'members of the public'.

Sorcha Carey

1 Letter from Roger M. Buergel to Manuel J. Borja-Villel, director of MACBA, Museu d'Art Contemporani de Barcelona, on the occasion of the exhibition *How Do We Want to be Governed?*, 2004.

*Natura: The Mersey Valley
Case*
Film (35min),
photographs, drawings

Francesco Jodice

Natura: The Mersey Valley Case

*A little girl and a psychopath are walking through
the woods, hand in hand. As they get deeper and
deeper into the woods, the girl says, 'This place
scares me', and the psychopath replies, 'You're
scared? I've got to walk back on my own!'*

Since 2002, Italian artist Francesco Jodice has
been working on a collection of projects under
the collective title of *Natura*. Each project
investigates a crime or mysterious phenomenon
that has taken place in a 'natural' environment:
in the countryside, wilderness or outback.
Jodice's proposition is that settings of this kind
allow us to 'cut the cord of civilised living', that
they form an 'ideal architecture' for absurd,
criminal or transgressive experience. The first
Natura project was *The Crandell Case*. On the
evening of Saturday 13 December 1986, Wyley
Gates watched a film called *Heartbreak Ridge* at
his local cinema, the Crandell Theater. He then
went home and murdered his entire family. The
second project, *Il caso Montemaggiore*, was set
in the Montemaggiore woods of southern Italy,
where five elderly people disappeared, without a
trace, between 1998 and 2002. The latest *Natura*
project, commissioned for *International 04*,
investigates the unusually high incidence of UFO
sightings in the Mersey Valley in the north west
of England.

In his *Natura* projects Jodice employs two
interlocking approaches: that of the private
investigator and that of the entomologist. As
private investigator, he visits and documents the
'crime scene', and interviews protagonists,
witnesses, anyone and everyone with a
perspective on the events in question. His gallery
installations take the form of reconstructions,
like the climactic scene in a detective story in
which the facts are laid out before the
assembled cast. Jodice produces photographs,
maps, video and sound recordings, but no
culprit, no solution. The pieces of Jodice's jigsaw
do not fit together. There is no narrative
resolution, no restoration of order.

Akira Kurosawa's film *Rashomon* (1950) is an
inevitable reference point for Jodice's projects. It
is composed of a series of irreconcilable
eyewitness accounts of a single event: the
murder of a samurai. The connections between
Kurosawa's film and *Natura*, however, go beyond
Kurosawa's paradigmatic story of multiple
perspectives. The first witness account in
Rashomon, shown in flashback, is that of the
woodcutter. His opening journey into the woods
suggests a journey into another realm of reality.
Later in the film there is a suggestion that the
emotions worked out in the forest clearing – the
scene of the murder – are so powerful that they
somehow transcend rational explanation.

As entomologist, Jodice patiently observes the
minute patterns and procedures of human life.
For *Natura*, he focuses on specific cases as points
of entry into the intimate social world of a
particular community or group. The ostensible
subject matter – the terrible or inexplicable
event – is a pretext. The real subjects of Jodice's
study are the representations and behaviours
produced by the 'witnesses' themselves. He is
particularly interested in practices through
which reality is invented or performed in
everyday life. De Certeau called these practices
'procedures of everyday creativity',[1] popular
strategies that permit us all to reclaim some
autonomy from the dominant meaning-making
structures of commerce, politics and culture.

A central preoccupation in all this is the point
at which the surface of everyday experience gives
way to the extraordinary, the fantastic, even the
horrific. The *Natura* projects open onto the
familiar territory of Stephen King novels, *The X-
Files* and John Carpenter films, and beyond them
to fairy tales, myths and legends. Jodice is
fascinated by such narratives, and by the
compulsion we have to invest our immediate
environments with forces and images of this kind.
Like the woodcutter who opens *Rashomon* with
the words 'I just don't understand', Jodice reminds
us in his *Natura* projects of our desire to know,
and of the limitations of knowledge and
understanding. He also reminds us of our desire
not to know, to invoke and to retain the unknown.

Patrick Henry

[1] Michel de Certeau, *The Practice of Everyday Life*, Berkeley:
University of California Press, 2002, p. 3.

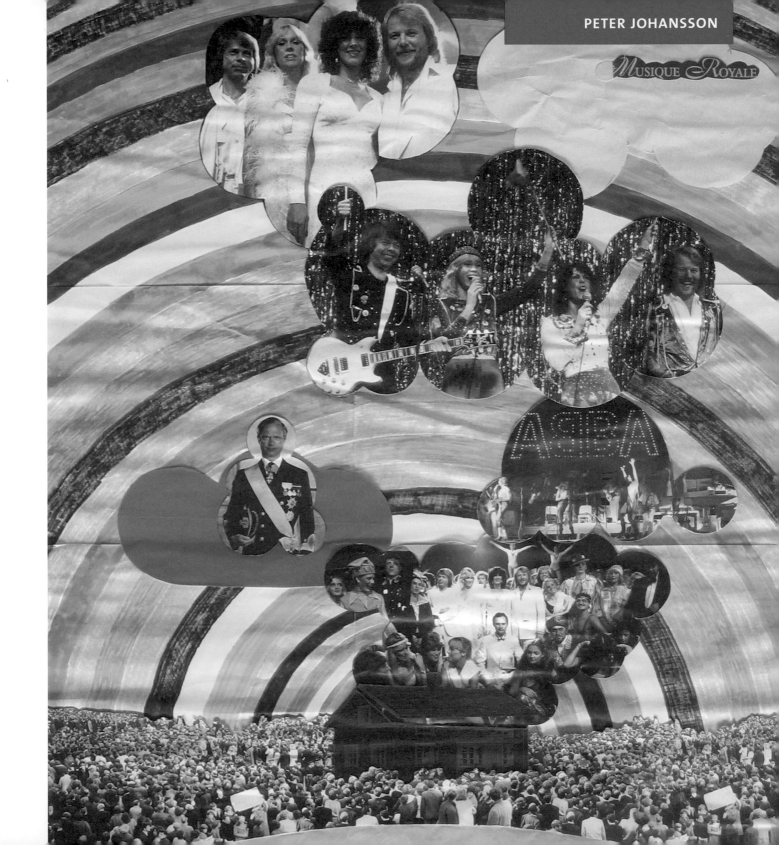

Musique Royale

Illustration by
Peter Johansson

Musique Royale
Music (ABBA, 'Dancing
Queen'), music
equipment and
loudspeakers, lacquer and
paint, prefab house made
of wood, glass, metal.
Interior: kitchen, wet-
room facilities, etc.

Photo: Tord Lund

Peter Johansson

Musique Royale

Things work well in Sweden. Bureaucrats deliver their services on schedule and national flags are taken down at sunset. This is a country where individuality is not much celebrated; where, instead, people are educated to agree with each other, to find sensible middle-of-the-road solutions; where neutrality is a virtue, and where nothing much can change that outlook.

Things are pretty safe in Sweden. All is regulated to fit the norms and prefab thrives. In terms of Sweden's own industries, not only the cars but music, fashion and design are safe too. H&M does not deliver the most cutting-edge fashion statements but works as a safe substitute. The same can be said about IKEA, which is certainly not known for its exclusive design but rather as a brand capable of delivering inoffensive and practical solutions. Early on both H&M and IKEA found ways of producing merchandise more cheaply than their competitors. Mass production and low prices were competitive tools inherent to both companies' structures. Both were founded during the 1940s, the decade in which three of the four members of ABBA were born.

As a group, ABBA sold a total of 300 million albums and became the most successful Swedish musical export ever. When the then crown prince Carl Gustaf married Silvia Sommerlath in 1976, a party in their honour was thrown at the Royal Opera in Stockholm. ABBA were invited and 'Dancing Queen' was written and performed in honour of Silvia.

ABBA danced us through the 1970s and into the '80s, only to reappear in the late 1990s when their songs were remixed and sold all over again. Even today, ABBA are still appearing, in various forms, in the listings of music releases. The musical *Mamma Mia!*, telling the life-story of an ABBA character and featuring ABBA songs, continues to sell out at a London West End theatre.

Musique Royale, hosted in a Swedish prefab house on the South Lawn at the Pier Head, plays ABBA's 'Dancing Queen' night and day. The house is painted bright red. It has a kitchen and a bathroom, but no furniture. It landed on this piece of ground and with it came the music, all in one sturdy package. In the tradition of the ready-made, this mass-produced object highlights notions of consumer culture and identity. Its prefabricated origin alludes to the premeditated packaging and delivery of experiences. As a sculpture, this shiny music-box works as bait, luring us inside.

Friday night and the lights are low
Looking out for the place to go
Where they play the right music, getting in the swing
You come in to look for a king. . .

Cecilia Andersson

BeWitched (2001–)
Ongoing project, 135mm
multi-slide projection
Projection size: 2.5 x 2m

Yeondoo Jung

BeWitched (2001–)

Since 2001, South Korean artist Yeondoo Jung has visited six different countries and made 14 people's dreams come true. His *BeWitched* project will continue until he has realised 40 such dreams. He questions local young people about their wishes for their future and then makes them come true in the form of a pair of portrait photographs: the first a portrait of the subject in their everyday life, and the second the 'realisation' of their dream or fantasy.

BeWitched is presented in the form of a slide-show. Each pair of portraits is projected onto a single screen, with a slow dissolve from the 'real' image into the 'fantasy' image. The number of portraits is added to in each location it is shown, in this instance with portraits made in Liverpool and presented at Bluecoat Gallery.

The project was inspired by the 1960s American TV sitcom *Bewitched*. The long-running series starred Elizabeth Montgomery as Samantha Stephens, a seemingly ordinary and typical suburban housewife who was in fact a witch. The show's central premise was the struggle between her endeavour to live as a normal, mortal wife and mother, and her usually unsuccessful attempts to suppress the use of her supernatural powers in solving the problems of everyday domestic life. Her (mortal) husband Darrin, an advertising executive, disapproved of her use of witchcraft, yet was inevitably rescued from a sticky situation in each episode by Samantha's magic, which was achieved with a simple 'witch twitch' of her nose and mouth, or a snap of her fingers. Samantha's magic was in reality accomplished with rather basic and prosaic television special effects: at the point when her witchcraft came into play, the cameras stopped for the actors to change costumes, or for the sets or props to be switched.

Yeondoo Jung's transformations are also achieved with his camera. He takes the hopes and dreams of his subjects and produces photographs in which they too are transformed with the aid of costumes, settings and props.

Contrasting with the humorous situations in the TV show, these images are poignant and personal, revealing that the surface facts of life belie the rich, imaginative interior world of the individual. But the portraits represent more than just personal wishes; they also symbolise the social and cultural conditions of a generation and its aspirations. *BeWitched* also uses the theme, much explored in the history of psychoanalysis, of the mirror image, the multiple personality and the metamorphosis and dissolution of the self.

The desire to escape from reality seems to be universally symptomatic of the pressures of contemporary culture. In an increasingly perplexing society, with the social networks of the past losing their solidity and reliability, fantasy and escapism have become fundamental strategies for locating our identity and ourselves in a meaningful way. Witness the current popularity of *The Lord of the Rings* and Harry Potter, and the ever-increasing number of 'life swap' and make-over 'reality' television programmes. Added to this, the acceleration of technology has led to a sense of impatience and urgency – we want change and we want it now.

However, *BeWitched* also demonstrates an age-old human impulse. The disappointments and frustrations of everyday experience have always led people to the creation of works of art, with their alternative agenda of enlightenment, adventure, romance and mystery. Fantasy and the realm of the imagination are the sources of radical, utopian visions, liberating the human spirit and questioning the world and its systems and authorities. They make visible that which is excluded and silenced, and invent alternative realities.

Catherine Gibson

Brian Hatton
Keinbahnstrassen/
No-Way Streets

The contradiction is concealed in different codes: a name says avenue, but an abstract sign beside it says 'blind alley'. The perspective looks grand and long, but leads only to a dead end. A highway looks straight and clear, but is barred and turned aside into a maze of sidestreets. Our map shows a road, but this road is no longer a route. We are nearly lost in a tour of detours. Where are we? Somewhere in the inner fringe of an English city; in this case Liverpool, where the traces of the former clarity and grandeur are unusually notable, and their loss therefore is especially confounding. When Walter Benjamin wrote his allegorical guide to the modern city, he called it *Einbahnstrasse*: 'One–Way Street'. The traffic engineers invented that device to speed the cars in centres where Haussmann's boulevards were too

the departed returned, #1

the newly arrived, # 1

costly; but now they have spread across the suburbs and moreover compounded with a pattern whose name also has Parisian provenance, though one more Victor Hugo than Louis Napoleon: *cul-de-sac*. It is curious that whereas the opening of boulevards was a measure against the barricaded courtyards and alleyways, now we are told that they must be closed against the lawless, so that once open suburbs become a new defensive ring of sometimes even gated so-called 'communities'. The edges of Liverpool, where it is hardly Liverpool any more, but anywhere, are sown with these misleading compounds. As at Croxteth Park, where a single road is entrance and exit to a winding, ramified labyrinth of 150 'closes'. 'Dead End Streets' was once a synonym for hopeless urban life; now it seems the preferred residence for eventless suburban life.

But not yet in Liverpool, which has never lost a flair for drama. The TV soap opera *Brookside* broadcast from an actual Liverpool 'close' the most realistic, if melodramatic, narratives of that genre. It showed the ruination of its inhabitants' hopes for a happy uneventful life away from the city traffic. It was thus, in Benjamin's term, allegorical: 'Allegories are in the realm of thought what ruins are in the realm of things'. If now the thoroughfares that were once the medium whereby the public experienced the narratives of the city are ruined by detours, *Brookside* showed their likewise detoured interior lives. Benjamin today would find no way along these now muted *Einbahnstrassen*; to find their allegory he would have to turn aside into the private soap opera of the closes and the *Keinbahnstrassen*.

Werner Kaligofsky

*The Departed Returned, the Newly Arrived
and the Guest*

Exploring his position as a self-conscious
'outsider' to Liverpool, Vienna-based artist
Werner Kaligofsky used this as the starting point
for his work. Prospective artists for *International
04* were invited to the city to conduct
preliminary research. Fascinated by his 'guest'
status, Kaligofsky has produced a set of
photographic images that document his
journeys around the city and the surrounding
areas, led by two guides. His work calls attention
to the role of personal and subjective histories in
shaping the ways in which individuals see,
understand and talk about the world around us.

Personal and public identity is a central issue
in Kaligofsky's work. Recently, at the Galerie im
Taxispalais, Innsbruck, Tyrol, he juxtaposed
photographs and live film footage of streets and
squares in Innsbruck with text detailing the
biographies of the opponents and victims of
National Socialism after whom the streets are
named. For his Liverpool piece, Kaligofsky asked
to be led by a person who had lived in the city in
the past, moved away and then returned, and a
person who had recently moved here. He sought

difference in ethnicity, gender, profession, age
and class – symbols of identity that can easily be
reduced to stereotypes. The first guide
('departed returned'), Brian Hatton, came from a
working-class family in Widnes and is an art
historian living in London who returns to
Liverpool to teach. The second guide ('newly
arrived'), Kwan May Ling, was born in Hong
Kong, and is an art student who also runs her
family home in Birkenhead. The guides'
perspectives on the city focused upon very
different themes: Hatton showed Kaligofsky
historic buildings and critiqued town planning
decisions, while May Ling reflected on places
with atmosphere, places that inspire her artwork
or remind her of 'home', and places where she
shops for food.

Within this process, Kaligofsky insists that
although he uses the methods of documentary
photography, his work does not attempt to
rationalise objectively the subjective experience
presented to him by his guides. In clarifying his
position he turns to Lacanian ideas, stating that
'an image is like a screen between the gaze and
the subject of representation, and vice versa'.
While he has tried to record the views of his
guides as accurately as possible, his photographs
are ultimately interpretative. They are his way of
making sense of the information that was

presented to him in Liverpool. A tension is
established, then, between the subjectivity of
the guides and the guest and the photographic
objects themselves.

Laura Britton

Identifying the Monitor
A Crisis of Individuality in the Twenty-First Century

Yu Yeon Kim

If transparency has become a distinguishing trait of the Information Age, then it has placed the personal in a quandary. Shot through from every aspect with delivery and access points, contemporary society can no longer be a safe haven for the privately inclined individual. The tragic events of 2001 in America resulted in an acceleration of the trend towards tracking personal behaviour and movement, so that shortly every action and habit will be documented, one way or another. Though not quite synonymous with each other, both the Information Age and globalisation have been facilitated by communication technologies that use the Internet as a vehicle (the latter being a principal accelerator of globalisation). In Wim Wenders' film *Until the End of the World* (1991) people are tracked around the world through their electronic purchase of transport tickets. Late-twentieth-century fiction has become a reality in this new millennium and some airlines have already started to employ screening technologies that may allow governments and other entities to go beyond mere tracking of individuals to burrow down to their most personal information.

Although, at its inception, the Internet represented to many a kind of free-thinking academic and cultural utopia, maintained largely by an academic community, its unprecedented growth since the mid-1990s has been underwritten by the commercial sector. The 'Information Revolution' has therefore been a process determined, in part, by the combined forces of multinational corporations, and it has changed the nature of our participation in all spheres of society. It has affected the way in which, and the means by which, we perceive these activities. The integration of digital technologies in daily life has especially reconfigured the relationship between the areas of work and leisure, which may share the same tools of information access, but modified for the different contexts. These technologies not only facilitate access to information, but control, and record, how it is accessed and by whom. Therefore data banks for all purposes proliferate and surveillance technologies have been developed and employed for efficient measurement and monitoring. This data flows constantly through the networked social body, and implicates it at all levels in the exercising of power and control. The utopian ideal here might be the democratisation and decentralisation of power, but the reality is a networked marketplace, where the enfranchised are those who possess the latest and fastest in computerised technology. This informational consumerism acts as the conduit for industry and capital interests to permeate through education, entertainment and industry to our very thinking processes, substituting for our innermost reverie consumerist desires. The ideologues have heralded the Information Age as virtuously encouraging decentralisation and fragmentation of power, and indeed, this appears to be occurring both nationally and internationally. But the conclusion of decentralisation is not necessarily diminished control – on the contrary, the pragmatic industrialist or politician is able to coordinate the decentralised constituency through his or her communication networks, with a gain of flexibility, responsiveness, *and* control. The Internet is therefore a contradictory mechanism, one that has the potential for enhanced democracy in the hands of critical users, and yet simultaneously may afford the corruption of knowledge by a systematic manipulation of information to serve political and commercial interests.

The Internet and the acceleration of economic and cultural globalisation share a close relationship – one that is founded not on philanthropic ideals but on transactional relationships, competition and the drive for market dominance. It can also be argued that globalisation has its roots in colonialism and imperialism and that this legacy continues to limit the regard dominant nations have for the people and resources of other nations. In the postcolonial era, the protagonists may in essence be the same, though their positions are less clear. In this transitional phase, in which the oppressed and the

'wretched of the earth' are becoming stronger, the waters of international capital and political influence are somewhat muddied. In the twenty-first century the process of decolonisation necessitates more than a meander across the shores of other cultures: it requires an awareness of the economic and political influence that is married to funding provided from governments and powerful consortiums to former colonies, territories or strategic 'backyards' – for example from Britain, France and the Netherlands to Africa, or from the US to Asia, South America and the Middle East.

Perhaps the real persuader of international culture is not (or not only) the new focus on art from the global diaspora of so-called Third World artists, but who funds what and why. Despite the cynicism implied in this view, artists can still lay bare the pattern of persuasion and influence in which they are caught up, especially if a guarded and critical position is adopted in relation to the legacies and burdens of our cultures and what we hold as static truths. Caught in these crosscurrents, art still has the potential to visualise and concretise a culture's sense of itself and its relationship to its history and the world it connects to. Following from this, a curator's concern today might be to negate both the absolute and the absent by exploring an intersection where cultures interact, producing new forms and languages.

Nevertheless, it is precisely these contradictions that have supplied artists with a rich ground to manipulate and subvert. From the mid-1990s artists have been quick to realise the potential of the Web by forming online organisations and creating artworks that explore its dynamics and emerging contradictions. Artists and others have combined programming skills and conceptual thinking to produce online artworks that have mapped network space and juxtaposed its content to create new meanings or highlight existing lines of influence. Both the Internet and the globalist perspective hinge on a concept of 'non-location' – a kind of universal space in which everyone is brought together through the technological wonders of hypermedia and shared multi-cultural values. The reality of this is that the Internet, despite its diversity and contradictions, has a tendency to present a 'world view' sponsored by Euro-American capital and hi-tech industries, which increasingly resembles that of Modernist internationalism. The globalist perspective assumes that non-Western cultures will absorb Western values while they placidly abandon their own cultural practices in favour of hi-tech globalism.

How is individual identity framed, dismembered and reconstituted by the perspectives, evaluations and registration methods a person encounters in the course of negotiating a transactional society? We are all formally 'registered' in society – even to the extent that our official identity, or at least a good portion of our personal data, can be compressed into a digital plastic palimpsest – a smart-card, or a veneer covering a passport photograph. Each transactional interaction adds to a profile collected by government or consumer data-collection agencies. Assumptions are made according to race, age, gender, annual income and so on, in the hope of targeting individuals with specific 'consumer information' adjusted to their profile to further tune their innermost needs and wants in alignment with market products. Can we truly distinguish any more between consumerist wants – implanted information – and real desire? Is informational profiling really accurate or does it only create a fictitious target? Or have we unwittingly surrendered our uniqueness and become informational androids fashioned by marketing techniques – part human, part electronic media noise?

In order to accentuate a political or social contradiction it is not necessary for art to be precise or literary. It is the poetic that finds greater access to the mind than the didactic and obvious. The problem is that we are all defined in some way by the legacy of our interlinked histories as well as by shared consumerist values. The Internet may be a universal contact area where ideas and values can be exchanged, repossessed, mutated, revalued and so on – not an

area with a centre and a periphery but a whole comprising a randomly dynamic, shifting structure. However, it seems that the reality – particularly in recent times, when the separation of our cultures has become increasingly evident – is that while there is certainly exchange, there is also an entrenchment of local identity. Each location redefines the package according to its own uses and imperatives, and in turn the package redefines its host. This is not really a mix of cultural dilution, but of diversification, repossession and change, as ideas are exchanged, assimilated, re-exported and re-imported. For a diaspora there is the potential for an interlocking of values and practices in which the co-present cultures are incidentally manoeuvred to examine the articulations of power that are contained in their cultural exchanges with the host culture, thus highlighting the mechanisms of control.

Every cultural contact or exchange between nations or individuals is loaded with histories and values that have evolved from them. All parties are affected or 'infected' by this contact – though some may be materially exploited and others profit by it. This idea of contact and exchange is also pertinent to the use of surveillance, tracking and monitoring systems in contemporary societies, systems that have become part of the transactional mechanisms of consumerism. They seek to monitor as well as to evaluate and determine the individual according to prejudgments that are based on other legacies (i.e. race, gender and other biases). Both society and the individual are irrevocably changed by these practices.

The assembly of art and artists from various continents in a foreign location affords an opportunity, not always acted on, for a rethinking of the relationship of local culture and values to a broader frame. By centring the dialogue on the concept of exchange as a kind of liminal zone where new ideas are formed, there is at least a possibility that these international exhibitions can encourage new possibilities and a broader awareness of the contemporary condition.

Germaine Koh

Marks and *Relay*

What does it mean to be marked? This is the question Koh's work asks and, it seems, many answers can be condensed into just one – to be marked is to identify ownership or possession and in turn power.

Koh's initial investigations, in preparation for *International 04*, gave rise to a complex of issues linking the history of the port of Liverpool with the current burgeoning urban youth culture. Koh became fascinated by diverse references to marking she encountered within a comparatively small geographical location. Tate Liverpool's proximity to the old customs buildings emphasised for Koh the city's role as an international port and further research revealed numerous systems of marking import/export documentation for goods as well as passports for migrants.

Graffiti artists' tags, the very fabric of the city as a canvas, fix an identity in the social consciousness and simultaneously define a territory. The continued renaissance of tattooing identifies the power of individuals over their own bodies – the skin being their canvas. Marks made on a body by another can be celebratory,

indicating a successful rite of passage, a transition to adulthood or commitment to an ideology or a group. Such marks confer authority and power; however, just as often, marks can define ownership and in that way become disempowering.

Less permanent marking of the skin can also bestow certain rights – the use of UV ink stamps to signify admission to certain venues, for example, identifies the individual as worthy of that club or the VIP lounge and thus 'cool by association'.

Working with the admission staff at Tate Liverpool, Koh produced a series of self-inking personalised monogram stamps, given to staff with the option of marking the hand (or any agreed body part for that matter) with one of the designs. The designs and information on the person who created the stamp are presented in book form, printed in ink visible only under UV light. Such subtle, almost invisible actions are central to Koh's artistic practice. The fact that the same stamp can mark many people, its continued use and re-use, are important motifs. The potential for visitors to return to the gallery with the aim of 'collecting' the marks is an element of the work, as is the fact that these stamps are carried away from the building, extending Koh's reach beyond the gallery walls.

The physical boundaries of the gallery are no concern for Koh's other work *Relay*, one part of which is presented at Tate, the other in Liverpool Town Hall. A utilitarian lamp, seemingly innocuous among the many light fittings in the gallery, blinks on and off in a series of long and short flashes. A loose electrical connection, maybe – but for those with the right cipher these rhythmic patterns can be easily translated from Morse code. Mobile phone messages sent from the city centre (or from anywhere else in the world) are converted to code and flashed out for the world to see, messages from Tate Liverpool sent to the Town Hall. Source and destination may be miles apart but, perhaps unknowingly, participants create an invisible connection between two distinct points in the city. Intimacy – a mark on your body, a private message sent to an unknown recipient. Invisibility – a mark seen only in certain lights and messages only recognised when decoded. Koh's work has its roots in the everyday but through her subtle gestures marks the everyday as uncanny.

Adrian George

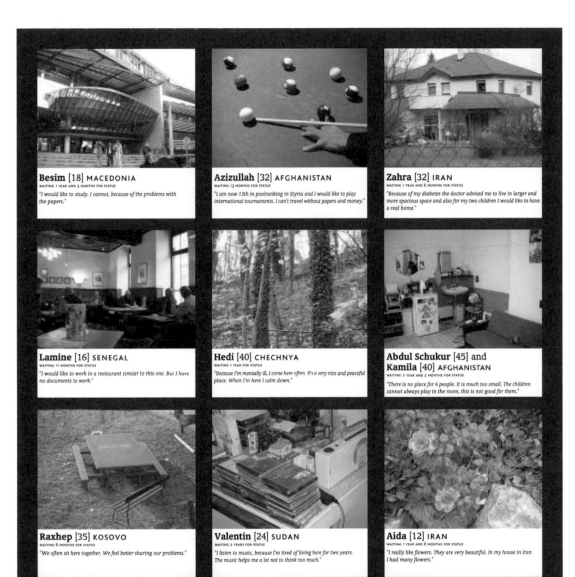

Besim [18] MACEDONIA
WAITING 1 YEAR AND 3 MONTHS FOR STATUS
"I would like to study. I cannot, because of the problems with the papers."

Azizullah [32] AFGHANISTAN
WAITING 13 MONTHS FOR STATUS
"I am now 13th in poolranking in Styria and I would like to play international tournaments. I can't travel without papers and money."

Zahra [32] IRAN
WAITING 1 YEAR AND 6 MONTHS FOR STATUS
"Because of my diabetes the doctor advised me to live in larger and more spacious space and also for my two children I would like to have a real home."

Lamine [16] SENEGAL
WAITING 11 MONTHS FOR STATUS
"I would like to work in a restaurant similar to this one. But I have no documents to work."

Hedi [40] CHECHNYA
WAITING 1 YEAR FOR STATUS
"Because I'm mentally ill, I come here often. It's a very nice and peaceful place. When I'm here I calm down."

Abdul Schukur [45] and **Kamila** [40] AFGHANISTAN
WAITING 2 YEAR AND 2 MONTHS FOR STATUS
"There is no place for 6 people. It is much too small. The children cannot always play in the room, this is not good for them."

Raxhep [35] KOSOVO
WAITING 6 MONTHS FOR STATUS
"We often sit here together. We feel better sharing our problems."

Valentin [24] SUDAN
WAITING 2 YEARS FOR STATUS
"I listen to music, because I'm tired of living here for two years. The music helps me a lot not to think too much."

Aida [12] IRAN
WAITING 1 YEAR AND 6 MONTHS FOR STATUS
"I really like flowers. They are very beautiful. In my house in Iran I had many flowers."

sight.seeing

"During the asylum procedure, the applicant has no right to work in Austria."
IMMIGRANTS' COUNCIL OF GRAZ

Sight.Seeing, Graz, 2003
4th Austrian Triennial on
Photography

*Nama: 1908 Employees,
15 Department Stores,*
Zagreb, 2000
Posters

Distributive Justice,
2001–2004
Multidisciplinary project.
Website and art
installation
Documenta 11, Kassel/
Big Torino Biennial
www.distributive-
justice.com

Andreja Kulunčić

Teenage Pregnancy

Croatian artist Andreja Kulunčić creates
multidisciplinary artworks whose nucleus is a
strong element of social engagement. Occupying
the spaces in international cities usually
reserved for the visual cacophony of advertising,
she gives space, and a voice, to the 'mute'
citizens of society – those who can be seen to
have the least political power, such as asylum
seekers, the unemployed, or teenage mothers.

In June 2000, at ten sites in the centre of
Zagreb, Andreja installed posters featuring
photographic portraits of redundant female
employees of the department store chain NAMA,
'The People's Store', which had been very
successful during the era of Real Socialism, but
was bankrupted during the economic transition.
Realised after consultation with members of the
workers' union, each poster featured the caption
'NAMA: 1908 employees, 15 department stores',
which also served as the title of the piece. The
implications of the ambiguous text, and the
scale of the individual and nationwide struggle it
represented, were grasped only with an
understanding of the problems engendered by
the national social and economic reforms.

In another work, *Sight.Seeing* (Graz, 2003),
Andreja presented photographs of city 'sights'
taken by asylum seekers held in detention
centres, along with their name, age, country of
origin, and the length of time that they had
been waiting to hear confirmation of their
status (frequently over a year). Underneath each
image she presented, in the photographer's own
words, a brief statement about their experience
of the city. The work provided a platform for
these people, so often judged as invisible or
undesirable, to claim their subjectivity and
validate their ownership of the city.

Andreja's proposal for Liverpool developed
from her visits to Speke – a geographically
isolated community, and previously the second
most deprived ward in the country, although
now improving since it has become the focus of
regeneration schemes. She has elected to focus
on the thoughts, feelings and aspirations of the
young people from the area, using posters as a
starting point for communication.

Andreja's poster works target a wide audience
by mimicking the communicative methods of
advertising, presenting strong visual information
that can be absorbed in a limited amount of
time. However, each image is unique rather than
belonging to an endlessly reproduced campaign,
and instead of raising public awareness of a

product the artist is attempting to raise social
awareness, and initiate debate. While we are no
longer naïve enough to believe that art can bring
about massive social change, it is certainly true
that it can provide a significant arena for this
type of provocation.

In an established tradition of the co-opting of
new media as vehicles for political protest,
Andreja has also produced a series of websites
and conferences, in consultation with teams of
professional economists, scientists and
philosophers, which have dealt with such issues
as global citizenship and the ethics of genetic
engineering (http://www.andreja.org).

Eschewing personal expression for the role of
the facilitator, Andreja often creates works
contingent on a degree of interactivity and
audience participation, whereby they encourage
a vital intellectual activism.

Cressida Kocienski

'Terrible Beauty'
Art and Actuality

Declan McGonagle

Suddenly, there seems to be a new energy around the idea of art and social engagement – a new heat in the discourse about the relationship of art and social space. And it is curious to me how this debate is emerging as if there were a choice open to artists and curators for art to be 'social' or not; as if art were not already in society and socially functional. Art has always been social, in the sense that the transaction between self and other – the self of the artist and the other of the non-artist – is explicit in the art process, and that this transaction is social. If there is no transaction then, in my view, art is not present in that experience, no matter what material or immaterial form the experience takes. It is what happens post-production, in the distribution processes, that 'makes' art, as much as what happens in the 'studio' or in the production processes. Artspace is already social space.

If we take the long view, rather than the shorter, Modernist, view of art and its role in the human project, art has not only always been social, it has also always been political. It has been political in the sense that, if politics is the organisation of power in society, art has been one of the important ways in which power, and powerlessness, have been articulated in society. If, historically, art has been political in that sense, the response is not a requirement for artists or curators in the present to make political art, but, in Thomas Hirschorn's words, 'to make art politically'. Making art politically is to make art and stimulate discourse and experience without innocence and to take responsibility for that art, for that transaction, in the world – and not simply in the world, but connected to the actualities of specific places. The gallery, after all, like a railway station, like a street, like a community centre, is just another place, albeit one privileged in certain ways, a construct determined by the social/economic/cultural interaction of human beings.

It has become commonplace for many large-scale exhibitions and biennials around the world to claim an engagement with their context, their place, in most cases a city context. But there is a real danger that these projects worldwide will merely describe a sort of transnational map, triangulated on a global scale, along whose routes only the art world's increasingly nomadic artists, curators and followers will travel – brushing up against rather than engaging with the actualities of place(s). Their engagement will be wide and shallow rather than narrow but deep – sightseeing rather than insight, yet pretending to a sort of universality.

Processes of urban regeneration and renewal, to which many biennial events are unavoidably attached (in Liverpool as in other places), and the multi-dimensional functions of art, can represent difficult partnerships and can lead to tension. But this tension has a dynamic and has to be addressed and negotiated as a 'space between' for new work, because that tension embodies the key arguments for art and social engagement in this era. The extended curatorial process adopted by Liverpool Biennial for *International 04*, with initial engagement by four overseas researchers/curators, was intended to create a dialogue which would deal with that tension – between uniqueness and universality, between the global and the local – without surrendering to the dominant model of globalisation based on narrow consumerism and an unreal universality.

The idea that what is local and particular about place(s) – the social and behavioural 'accent' of place(s) – can, and should, be redefined and reconfigured as universal is a pillar of Modernism, as is the presumption that this is what momentum in society means. Where that model is applied, as in all colonised situations, the local context then internalises an alienation from its actual culture. The result for those cities and communities is social and cultural and therefore economic stagnation, becalmed in a sea of disempowered alienation which turns places into non-places. Only an investment by culture can cut across and reverse that.

In the early nineteenth century, after the Act of Union, the English

army was charged with carrying out a comprehensive Ordnance Survey of the whole island of Ireland. Even the most localised of place-names in Irish, frozen by oppression at an earlier poetic stage of development, were translated directly into English or given phonetic equivalents in English. In the course of the survey place-names and related information were extensively recorded and catalogued, not because of an interest in preserving the information but in order to transfer 'ownership' and control of places. The coloniser used language to enter the mind of the colonised, which resulted – incompletely in the Irish case – in the colonised colonising themselves. In Ireland this mapping process was dependent on a new and technically innovative procedure which involved cartographers and military engineers creating new equipment that could mark and measure, with great accuracy, a one-mile equilateral triangle on an area of flat ground in a particular location. The equipment was first used and the first measurements taken on a large flat area to the north-east of Derry City, adjoining Lough Foyle. Once the first triangle was established it was then a relatively simple matter of using one side of the first triangle as the baseline for the next triangle, plotting its apex point in relation to the other two points, and so on. The triangulation process was then rolled out over the whole island and allowed for a high degree of precision in mapping the areas triangulated. In order to attempt to own the ground it was necessary to map and measure it accurately, including the human transactions which took place on it.

The island of Ireland was mapped and measured as English, in the sense that the Amish people in the United States use the term 'English', to mean 'modern', or more precisely 'modernist'. However, the ownership resulting from this remapping was only enacted at an incomplete, abstract level. It never managed to obliterate, as intended, life on the ground or the actual culture of place(s). The Ordnance Survey simply crystallised a duality – which had been present since England first took a serious interest in Ireland – into a collision which eventually became literal and violent; a collision between a long story and a short story, where the long story – a sense of identity and place – was forcibly reconfigured as a short story of modernist governance.

This may seem a distant reference, born of a preoccupation with a specific history, but the process of abstracting, through mapping and naming within the dominant value system, through discourse, if you like, which was intended to obliterate actuality on the ground and in people's heads, is a useful metaphor for the critical mapping of contemporary art and experience now emerging, of the terrain of social engagement. What was needed in the nineteenth century and, I would argue, is certainly needed now, in the face of a new universality – globalisation – based on consumerism, is a reconsidered sense of modernity, rather than a reconfiguration of place(s). We have to rediscover the fact that modernity is not synonymous with Modernism.

Yet the reality is that our places are being reconfigured daily, and the tensions which arise are exactly what the new negotiation between art and society, in the context of the Biennial, should be about. What I am recommending is not a replacement, nor the next 'new' thing, but a parallel process which consciously empowers itself to intersect the social, the political, and the economic as well as the cultural, as necessary, to achieve its intentions in a given place at a given time. It is in these moments when intention, practice, social process and time and place intersect that new forms arise which are not disconnected, universalised or abstracted.

If the emerging critical discourse around art and social engagement is allowed to settle, name, shape and totalise activity that is otherwise fragmentary, untidy and unnameable we will merely have a reiteration of the historical and formal conditions this emerging discourse purports to critique. Its tendency is to identify the

inevitable rather than to foreground a process which has to be negotiated and renegotiated afresh each time and therefore cannot be settled into a grammar of practice. A counterblast needs to be positioned in relation to this emerging discourse; otherwise, and paradoxically, disconnection will be preserved because this thinking also proposes a field that is uninhabited and is available for artists or curators to decide to inhabit, or not.

This emerging discourse also projects the idea of social engagement as the next new stage in an inevitable process, a progressive momentum – thinking which still honours the inevitability of the Modernist model and values. Without a commitment to context, to the local, actualised in place(s), this body of thought and practice will merely abstract and hold the art process in a continuing desocialised and therefore disempowered position. This leaves celebrity and transgression as the only ways in which to connect with social space, and there is an increasing orthodoxy of transgression in art as a result of frustration about the inability of inherited distribution mechanisms to connect art productively to the social.

Yet there are many artists who want, and are trying, to advance practice on the understanding that aesthetics have to be made actual – the real over the ideal – in specific place(s). I believe that these artists and these contexts have to be supported. The task is to support artists and contexts together through provision, infrastructure, debate and discourse; the necessity is to see and understand place(s), not as abstract or typical of the universal, but as actual in their own right, and on their own terms.

Most people, most of the time, live by negotiating social space and processes in order to survive, but it is as though this capacity has to be suspended somehow when they enter the inherited models of the 'artspace', metaphorically and literally. However, the potential exists for the art, the artist and/or the artspace to be in negotiation with the civil space (that is, the space belonging to citizens), with the result that the artist becomes a participant in the social space and the non-artist becomes a participant in the artspace. The idea of the artist as negotiator rather than genius producer undermines the standard question asked of art in the received model – what does it mean? – and proposes another question instead: what do we mean by it? This is the shift, the new question which has to be asked and supported in practice and provision in the public domain. And the question 'what do we mean by it?' does not deny object-making, nor the idea of the genius producer. It allows for another way of thinking about the artefact and its status: as a catalyst for meaning rather than a repository of meaning, and as something that exists in the post-production transaction, in the triangulation between artist/artwork (production), distribution (post-production) and viewer (experience) – who in this model becomes a performative reader, a participant in the art process.

This model of participation relates directly to other models of participation in the larger social and political contexts. If it can be inscribed in the art process with anything like the same support and conviction reserved for the signature/genius production, then genuinely new forms of production and distribution will generate a 'terrible beauty' – but only if the process is seeded and grown in specific contexts and place(s). What is being rolled out now over the landscape of contemporary art practice and experience is an approach to art and its social relations which does not triangulate to place(s) and which honours a redundant, quasi-Marxist avant-gardism – abstracted from place(s), context and lived experience. The task, therefore, for the more thoughtful and considered exhibition projects and biennials, which understand place as an ongoing commitment and not just a convenient location, is to answer this by providing specificity and actuality in the relationship between art and a particular social space.

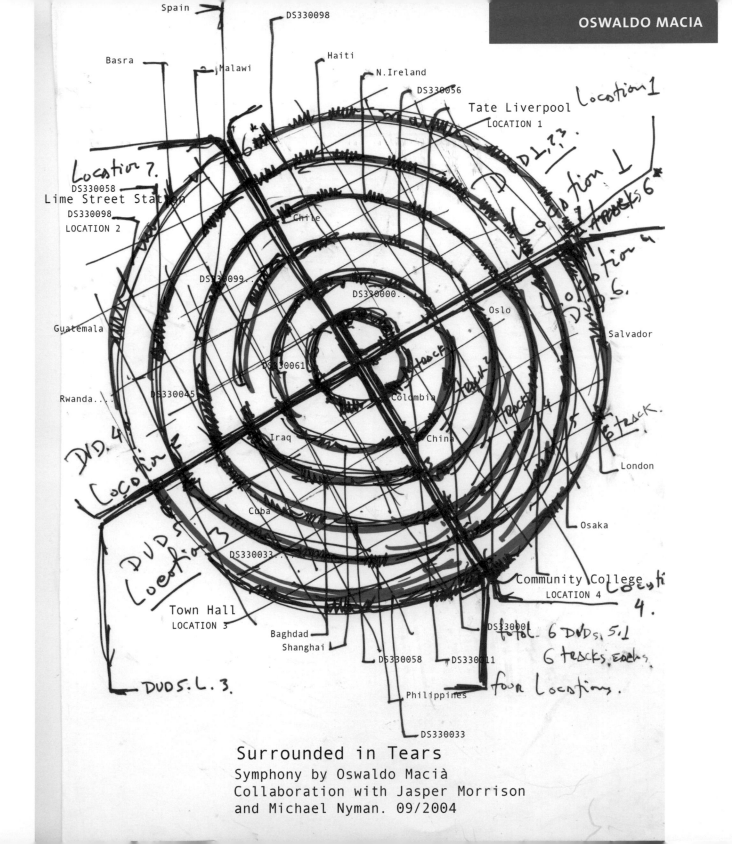

Surrounded in Tears

Symphony by Oswaldo Macià
Collaboration with Jasper Morrison
and Michael Nyman. 09/2004

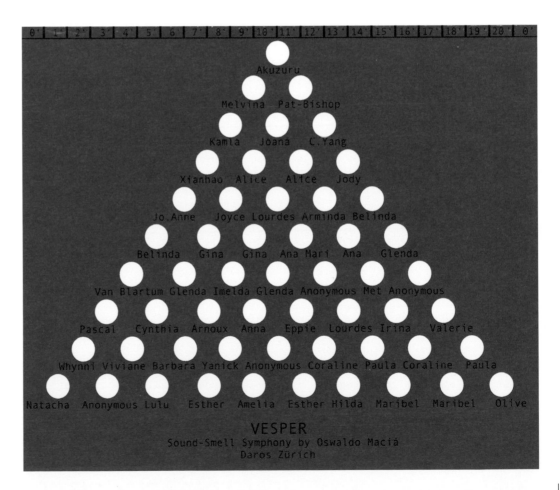

VESPER
Sound-Smell Symphony by Oswaldo Maciá
Daros Zürich

Oswaldo Macià

Surrounded in Tears

Heaven knows we need never be ashamed of
our tears, for they are rain upon the blinding
dust of earth, overlying our hard hearts.
Charles Dickens, *Great Expectations* (1860)

The English language has developed an
extensive vocabulary to classify and understand
the act of crying: weeping (associated with deep
emotion) is very different from blubbering
(colloquial, derogatory) or bawling (associated
with children). Bypassing this mass of carefully
nuanced and culturally specific linguistic
signifiers, Colombian-Caribbean artist Oswaldo
Macià has turned to the semiotics of the raw
material of crying itself. In collaboration with
renowned composer Michael Nyman and
designer Jasper Morrison, Macià has created a
sound installation compiled from one hundred
individual cries.

For the last decade, Macià has made work
that mobilises the senses. *Memory Skip*, for
example, is an industrial skip filled with five tons
of pine-scented soap. The pungent odour of the
thick detergent forces the viewer to
psychologically link the senses of sight and smell
into one conceptual whole. Smell is associative,
it triggers the memory, and the work links
personal subjective histories with art's grand
narrative. In *Algae Garden*, 150 varieties of floral
aroma (natural and artificial) were infused into
mini tampons hung on a rotating circular
hanger; botanical categories were deliberately
mixed. Similarly, *Provokes/Evokes* is a scent trace
of Noah's Ark made from animal faeces, the
essences of which are contained in rotating
vessels designed by Jasper Morrison. This work
humorously critiques the inventory of animals
catalogued by seventeenth-century natural
philosopher John Wilkins. Comic and ironic,
Macià's work deliberately confuses associations
and undermines taxonomies and
epistemologies. He stresses that his work 'is
composed of things we miss or omit through
orthodox classification and factual knowledge'.

Crying is an elemental human expression,
beyond words. Marking moments of extreme
emotional and physical pain as well as intense
pleasure, it is a universal language.
Psychoanalytic theories suggest that the sound
of the voice is related to the formation of 'self'
and 'other'. Macià's sources range from
ethnographic and anthropological studies to
informal sound-bites from everyday life – he
asked midwives to record the screams of
newborn babies. The work includes the oldest
known wax cylinder recordings of crying, stored
in the British Library: Australian Aborigines'
death wails from the Torres Strait, collected in
1898. A four-part composition, *Surrounded in
Tears* is sited in Liverpool Lime Street station, the
Town Hall, the Community College and Tate
Liverpool. Associated with regression and
vulnerability, crying is usually a private activity,
making its location in the public domain
uncomfortable. A counterpart to another
symphonic piece, *Vespers*, made of one hundred
women's testimonies of joy in nine different
languages, the work does not aim to rationalise
crying but draws together personal and
universal experience.

Laura Britton

Dear Observer,

Make me a diary and keep it safe. Take care it is mine.
Hold this photograph of my face. Keep all our entries
in order. Put the letters in your desk file and the images
in your evidence locker. You can edit everyone else out.

I will fill in the gaps, the parts of my diary you are missing.
Since you cannot follow me inside, I will record the inside
for you. I will mark the time carefully so you will never
lose me.

Don't worry about finding me. I will help you. I will tell you
what I was wearing, where I was, the time of day...
If there was anything distinguishing about my look that day,
I will make sure you know.

Hold onto my diary for at least seven years.

I am enclosing a cheque. Use it for whatever expenses
you have.

Sincerely,

Jill Magid

JSM

Jill Magid

Retrieval Room and *Evidence Locker*

Jill Magid is attracted to situations from which she is excluded, whether they are spaces, systems or ideas; she looks for a point of entry and invents a means and a methodology for access, participation, revelation, or exchange.

Seeking out intimate spaces within the public domain, Magid began working with closed-circuit video cameras, interposing her own body within that of the social and institutional. She bought her first lipstick-camera to explore the surface of her body in public space, by intervening in localised surveillance systems. In 2002 she started the ongoing project *System Azure*, reinventing herself as 'Head Security Ornamentation Professional', transforming security cameras into architectural ornaments, and persuading the police to hire her to decorate their outdoor security cameras with fake jewels (*Rhinestoning Headquarters*). This marked a shift in Magid's practice, from focusing on her own body to focusing on the body of institutions and their relative systems of authority.

Magid combines these lines of investigation in the work made for both FACT (*Retrieval Room*) and Tate (*Evidence Locker*) in *International 04*. The work represented within these two different contexts is the result of a relationship built with Citywatch (Merseyside Police and Liverpool City Council), whose function is city-wide CCTV surveillance – the largest system of its kind in England.

There are 242 CCTV cameras in Liverpool, monitored by Citywatch from an unmarked control room located in the city centre. CCTV footage, taken by the police and obtained from all 242 cameras, is kept for 31 days, after which it is erased (unless pulled out as evidence). The footage retained is held for seven years in an evidence locker – a file that usually contains selected, 'suspect' video-recorded incidents, occurring in public space.

Magid developed a relationship with the Citywatch police (whom she refers to as 'the Observer') during her 31-day stay in Liverpool – one complete cycle of memory – in order for them to create her very own evidence locker. She subverted the CCTV process through the staging of footage that would be submitted to the evidence locker: wearing a bright red trench coat and knee-length boots, ensuring she was easily identifiable throughout the city, she would call the police on duty with details of where she was going to be and ask them to film her in particular poses and places, or even guide her through the city with her eyes closed, as in *Trust*, shown at Tate.

To view and retrieve footage, one must complete a 'Subject Access Request Form', and Magid completed 31 of these, writing them as though they were letters to a lover – who eventually becomes embodied within the Observer. In addition to detailing the facts of where she was and what she was doing, she expressed how she was feeling and what she was thinking. These 'letters' form an intimate portrait of the relationship between herself, the

Observer and the city, and an intrinsic part of this new body of work.

The relationship with the police or 'Observer' was a vital part of Magid's process. Their rapport became an intimate, mutually dependent exchange mediated through, and eventually beyond, the camera. The resulting installations (which include video footage, diaries and a website) form two chapters of one work – one grounded in real time, from the perspective of the Observer (Tate), and one based around retrieved and recorded information (FACT). Through Magid's and the Observer's memories and reflections, the viewer enters the intimate, romantic space they have created between them.

Liverpool's city-wide surveillance system, reflected in cities all over the world, is designed for monitoring crime and disorder; through this project Magid transcended this prescribed function, using the system as a film crew and the city as a stage. Liverpool Citywatch operators' willingness to participate in, collaborate with and facilitate Magid's project, along with the UK's Data Protection Act of 1998, enabled her to blur the line between reality and fantasy, social control and mutual trust. This is particularly pertinent given the current global paranoia regarding individual and collective security. Magid reveals systems of technology, limited by our fears, as offering poetic potentials and new forms of human interaction.

Ceri Hand

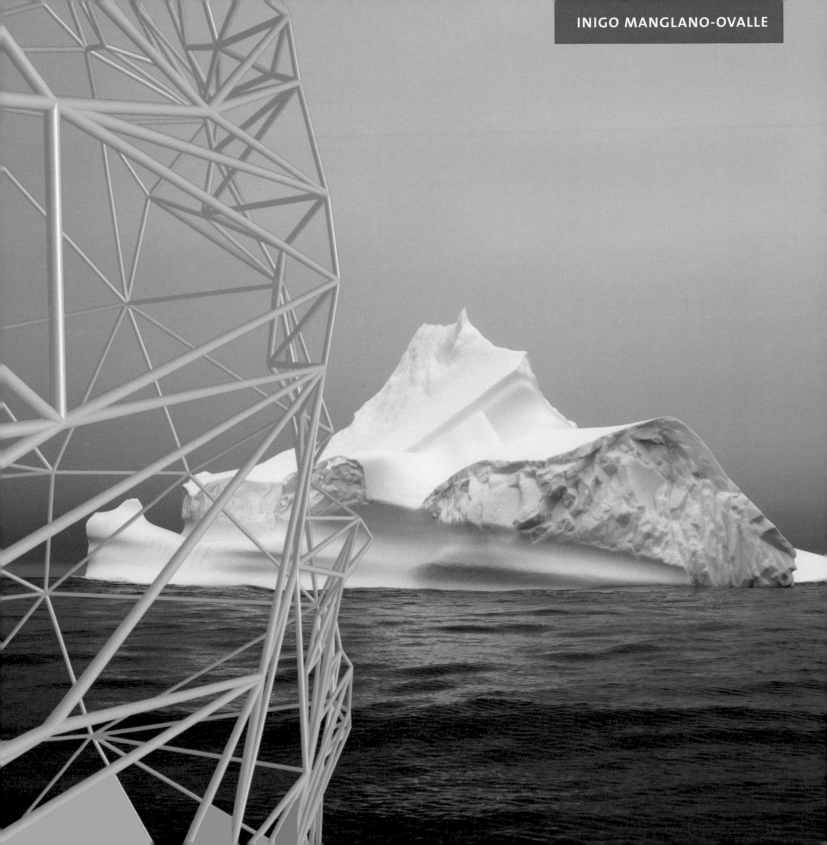

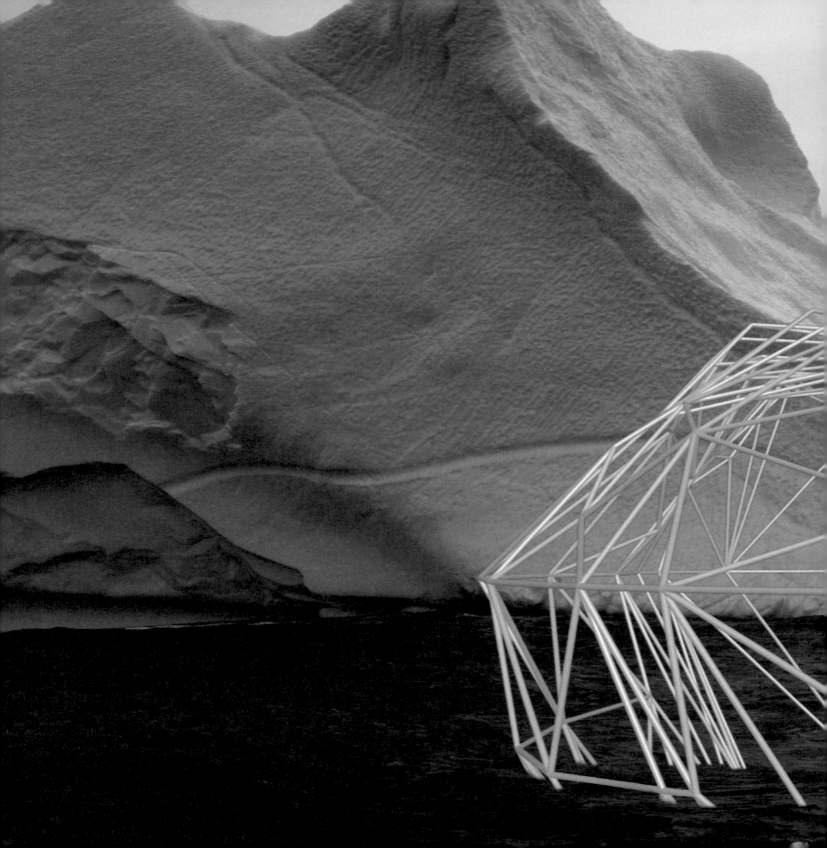

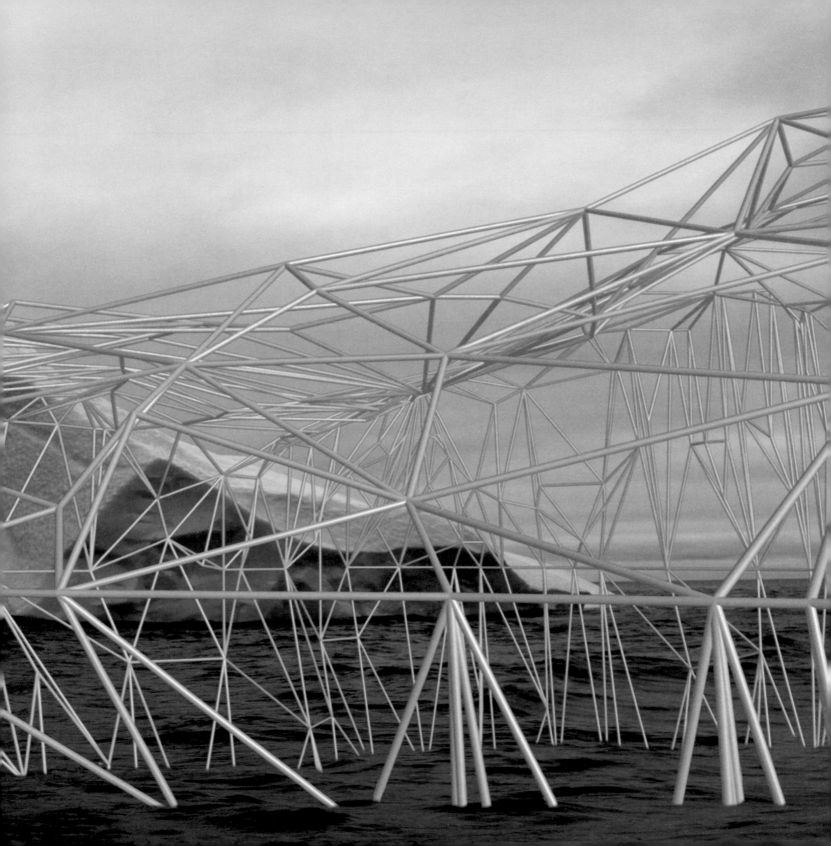

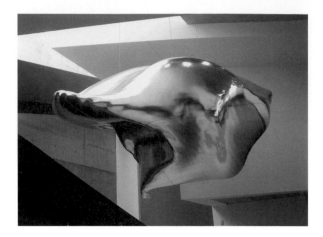

Iñigo Manglano-Ovalle

Iceberg(s)

Apart from sport (and in England house prices), the weather is probably the main subject of our small-talk. The weather forecast has to be the staple news of the world, yet we understand very little of it. Opinions on global warming and climate change are slowly beginning to converge, but the ways in which our actions are bound up with the earth's climate are mind-bogglingly complex. Even the most logical measures, such as those presented in Kyoto, are mired in controversy. Weather acts indiscriminately but our image of it is structured both socially and politically; in other words, our image is not a neutral representation of a reality 'out there' but cognition brought forth through the process of living itself.

Iceberg(s) is a set of two metal sculptures modelled from data of iceberg scans provided by the Canadian Hydraulics Center of the Canadian National Research Council. Conceived as the continuation of a body of work begun with *Titanium Clad Cloud Sculpture* (2003), the work has developed as an open crystalline network. *Iceberg(s)* has two corresponding parts, one suspended in the atrium of the Port of Liverpool

building, surrounded by text from Psalm 107 ('They that go down to the sea in ships. . .'), and a smaller companion in Tate Liverpool. 'In creating the physical sculpture we capture the phenomena of an ephemeral iceberg, rendering it back into a frozen moment, "refreezing" it as a moment suspended in time.'

Iñigo Manglano-Ovalle has a long-standing interest in Modernism's opposition between life and form. Form is fundamental to cognition as an act of distinction differentiating a unity of elements from its environment. It is the interface through which we grasp the indivisible process of life. But rather than attempting to arrive at an essence of life through the removal of form, Iñigo takes pleasure in the contradiction, rendering life as form. Form then becomes a metaphor for social and political networks which participate in the production of meaning and whose organisation can be characterised through operational closure. That is, the effects of interaction are contained within the network and co-determine its form.

The work is apprehended as the arrested translation between different media and knowledge domains. Thus, aside from its cultural, political or environmental reading, it is equally relevant that *Iceberg(s)* is rendered through complex computational software, mutating an

initial set of data through into a set of coordinates making up 2400 tubes and 800 joints.

In Liverpool, *Iceberg(s)* will remind many of the *Titanic*, whose owners, the White Star shipping line, had their offices in Liverpool and whose victims are commemorated in a monument at the Pier Head. But as we remember this tragedy, *Iceberg(s)* is also a poignant and uncanny allusion to global processes of transformation. Knowable only as fragment, irreversibly broken off from a larger whole, this symbol of hidden dangers points to the unstable equilibrium of our existence. Increasingly frequent, icebergs affect the global thermoline circulation, or Great Ocean Conveyor, the inter-oceanic current that keeps the UK from freezing over, with consequences perhaps as spectacular as those depicted in *The Day After Tomorrow*.

Paul Domela

Details from
*Organised Freedom:
Liverpool Edition*, 2004

Courtesy of the artist

Esko Männikkö

Organised Freedom: Liverpool Edition

Altbridge Park is on the edge of Liverpool. It consists of three tower blocks by the side of a dual carriageway. Esko Männikkö's introduction to Altbridge Park came when he met up with residents at one of their weekly art classes. This meeting involved whisky, ladies and laughter. The art classes don't usually involve whisky but the women naturally showed hospitality to a visitor from Finland.

Esko Männikkö is a photographer whose work often involves his spending time with a community and sharing in their everyday lives. Subjects of his work have included bachelors in Finland, immigrants in Texas and workers at a cashmere mill in Scotland. He returned to Altbridge Park to stay in a flat and to photograph the people and the place for his project for *International 04*. In his proposal for the project Esko noted: 'probably for the first and last time during my career I will let people smile in my pictures'.

He photographed people as they were busy enjoying community activities: crocheting, exercising or having their hair done. These photographs are mainly of older women, because most of the residents are older women.

They have lived in the tower block since it was first built, having been rehoused in the 1960s. In the pictures the women aren't just smiling, they are laughing. The photographs show that living in a tower block is not necessarily the depressing experience that people may think it is.

The subject of Esko's photographs is not so much the place as what is happening to the place. He photographed deserted flats (two thirds of the flats at Altbridge Park are empty). In these empty flats we get to see the things that have been left behind. He also photographed nearby buildings which are being knocked down or are falling down. The view from the flats' windows shows some of what is to come: a plot of land where another tower block once stood. The views from the windows, the feeling of safety and the close-knit community are all part of what the residents love about high-rise living.

The installation of the photographs at Tate Liverpool further emphasises the contrast between the people and the place. The portraits have colourful hand-made frames and a 'home sweet home' feeling that shows care and affection. The surrounding images are unframed and fragmented and are coming from all directions.

Altbridge Park will be demolished in 2005.

Sharon Paulger

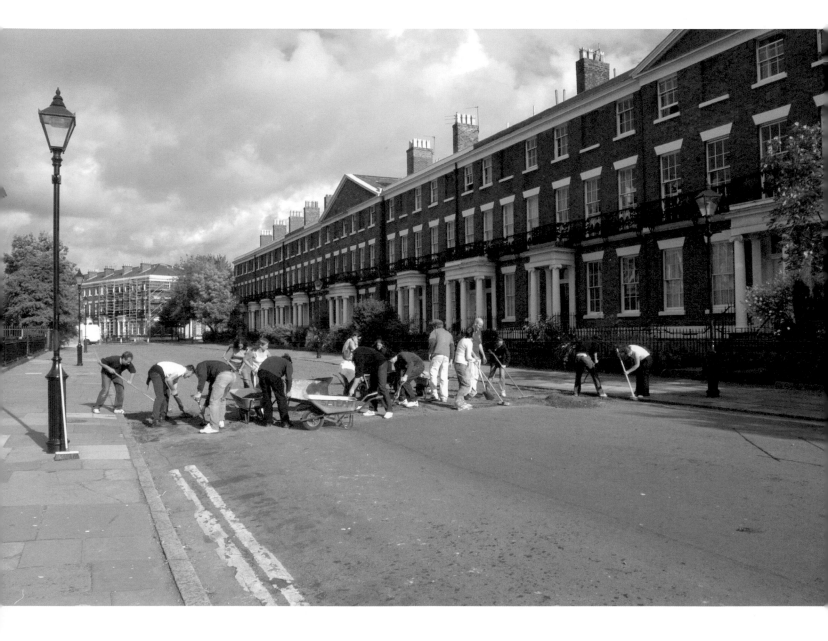

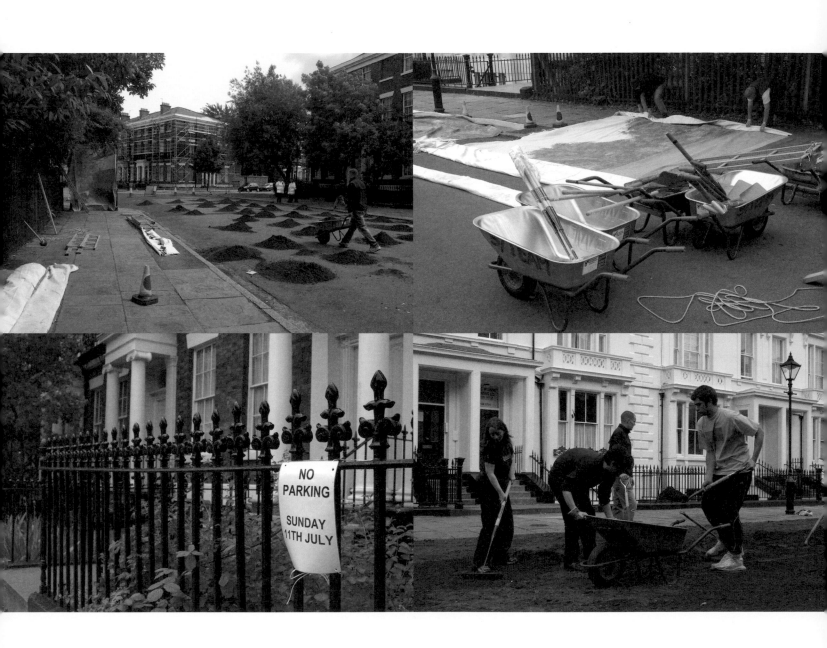

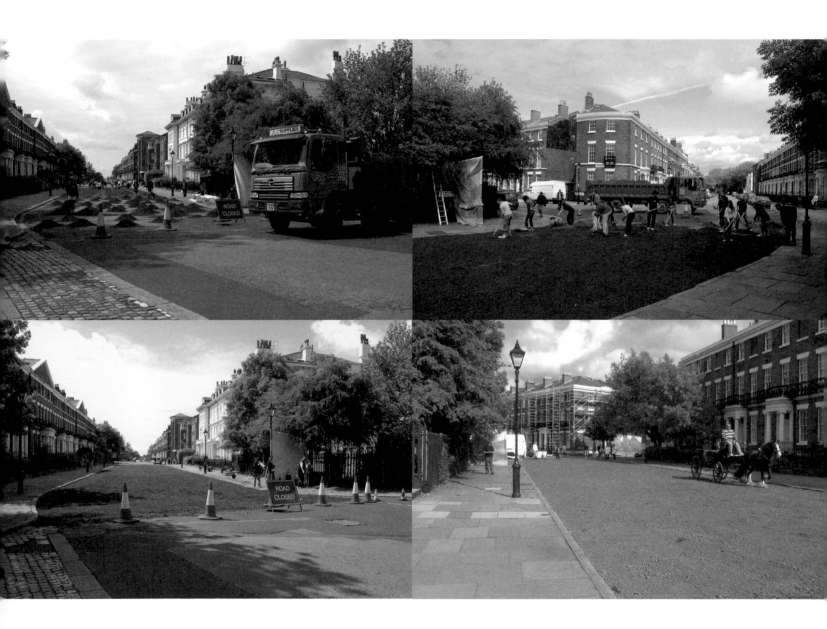

*Grandeur et décadence
d'un petit commerce de
cinéma*

2-channel projection
16mm transfer to DVD
and video to DVD

Production stills

Courtesy Galerie Krobath
Wimmer, Vienna

Lumière Brothers,
Church Street (1897)

Dorit Margreiter

*Grandeur et décadence d'un petit commerce
de cinéma*

Liverpool is a chameleon. Its streets and buildings have appeared as the backdrop in films as diverse as *In the Name of the Father* (starring Daniel Day-Lewis), *The Hunt for Red October* (starring Sean Connery) and *The 51st State* (starring Samuel L. Jackson and Robert Carlyle). In none of these films does the city appear as itself. Its faded neo-classical grandeur makes it the perfect 'double' for cities such as Dublin, Paris, Moscow and early-twentieth-century Chicago or New York. The city's 'other life' as a stage-set, however, raises the question: what defines place?

It is this question that Vienna-based artist Dorit Margreiter addresses in her work *Grandeur et décadence d'un petit commerce de cinéma*. Her starting point is film footage of Liverpool by Alexandre Promio, itinerant cameraman for the inventors of cinematography, the Lumière Brothers. Taken on his way to show Lumière Brothers films in Ireland in 1897, the resulting short films, collected as *Scenes of Liverpool*, show the city in its prime. In its infancy in 1897, the moving image was extraordinarily powerful, its mimesis of reality seemingly faultless.

Margreiter's work starts with the medium itself. In a recent piece, *Short Hills* (2000), she explores the place of television soap operas in the lives of her Chinese-American aunt and cousin. For her aunt, who left Hong Kong in 1972 long before it was returned to China, a soap opera set in the city provides her with a 'window' to the world. She claims: 'This way I have the feeling that I know what's going on there'. The fictional story, because of its location, becomes a foil to the imagined 'real'; she relishes glimpses of the city's streets and bridges, and its new airport. The aunt's disembodied communication with Hong Kong is, however, defined by the seductive and imprecise medium of television. Margreiter's work explores the way that, increasingly, her aunt's television set dominates even the design of her home.

For *International 04* Margreiter has remade the Lumière Brothers' film footage of Liverpool, but in this case showing Liverpool as Dublin. Shifting the emphasis from the original documentary to Liverpool's dubious cinematic career as a stand-in, she films the transformation of the city from Liverpool to Dublin, including the set-building required. Her video peels away the artifice of the place/performance, exposing the fact that 'location' in all film, whether for television or cinema, is performed and manufactured. The architectural 'facts' of a place and the seductive mimetic qualities of film suggest 'reality', but 'reality' in film is constructed. Margreiter's work points to the complexity of site and locational identity and the polemics associated with authenticity and film.

Laura Britton

The Lure of Dystopia
(Notes on Global City Art)

Cuauhtémoc Medina

CONSTELLATIONS AND SUPERNOVAS

In the last decades, culture has undergone a significant topographical shift. To be sure, we would be naïve to think that the old dichotomy that divided the art world between the metropolitan centres of Paris, London and New York and the postcolonial peripheries of dusty art communities such as Cairo, Mexico City or Liverpool has vanished. But it would be equally mistaken (and intellectually sterile) to overlook the fact that such geography has been pierced and complicated. Whereas the former hierarchies depended, largely, on the exercise of a monopoly of exclusion, new conditions emerge when symbolic power is played in great part around the pursuit of a concentrated staging of inclusion.

One of the most important features of this process is the prevalent view that artistic practice is globally structured as a flowering of urban centres, which to begin with seems bound to displace the old modern conception of art as a means of national representation. For if, in fact, the idea of 'international art' suggested the mirage of an ordered and consensual, legally sanctioned form of artistic representation that had its best expression in the 'national pavilions' of the early biennials such as Venice or São Paulo, modern artists were customarily poised to appear as virtual agents of sovereign national cultures, which were set to compete constantly in terms of sports, war and culture. And as nations were, by definition, bound to create forcefields of submission and autonomy, the modern geographies of art were organised around the fantasy of concentric orbits of avant-garde invention, gravitational dependence and orbital influence stemming from the imperial centres of Western Europe and the USA,[1] which in turn 'influenced' (like the stars for the astrologists) the artist-representatives of other nations. The two neurotic models typical of such a system (the pursuit of 'true' identity and of 'true' cosmopolitanism) were expressions of a dichotomy whereby aesthetic 'value' was mapped as a dialectics of 'the universal' and 'the provincial'. In other words, all art was 'national' while in the process of becoming either internationally viable, or merely parochial.

We all know that in the current global/local cultural system, the measure of cultural significance has changed at least in this: the taste of 'the global' consists precisely in a particular form of being locally significant. Specificity becomes the prerequisite of any general or metaphorical claim, and – not by chance – at the very moment when the brutal universality of global capitalism erases the brutality of the former national borders. Quite logically, instead of having the museum as its fixed, universal, metropolitan point of reference, contemporary art started to behave as a permanent epidemic of unstable, unpredictable, constantly growing, ephemeral crossroads, which appear at any particular moment as the global art network. It goes without saying that both biennials and cities appear as those locations/moments of concentration-contagion that define the current art circuit.

In fact, it may well be that the networks of global culture operate in very much the same terms as those maps with which airlines describe their routes crossing oceans and continents. The astronomical charts coming from different civilisations,[2] different airlines and different cultural brokers tend to offer their customers slightly different versions of the very same clusters. Some of those points in the constellation are huge terminals with five or six interconnected airports and enormous facilities, minutely subjected to a structure of critique and surveillance. Others are no bigger than most of the clandestine airstrips in the jungle built by drug dealers and/or guerrilla armies. The important thing, however, is that the participants of those exchanges are cities. A biennial is a fleetingly bright point in that network; in fact, biennials have become a means by which a specific city sparks as a particular concentration of artistic activity. In that sense, biennials are something like a supernova.

SCAFFOLDING

Cities are records of social energy: they are living organisms that inscribe in their buildings and infrastructure, and in the memory of their inhabitants, traces of their cycles of progress and stagnation. In this sense, a city is, to a great extent, a coded object of economic and political history. For the last hundred years, Liverpool has been losing its population, from more than 850,000 inhabitants in 1930 to the little more than 400,000 living in the city today. It is hard for the visitor not to conceive it as one of the main loci of the volatility of modern history: once centre of the world economy, to the point that still today a fashionable department store in Mexico is called El Puerto de Liverpool,[3] Liverpool is today a city full of boarded-up houses, semi-abandoned docks and greenhouses, and endless mountains of scrap metal. At the same time, some quarters of the city are the targets of accelerated property speculation, whereby luxury flats are sold at a remarkable speed to a new middle class that promises to reactivate the metropolis. Any interaction with Liverpool ought to address the extraordinary volubility of life under capitalism. One of the reasons why contemporary art has a penchant for transient and specific interventions is precisely the need to mirror such a historical process. In this sense, artistic interventions in the context of the city seem to behave in a similar way to scaffolding: against our standard architectonic and sociological prejudices, they attempt to be both structural and temporary.

COMMUTERS

Early in 2004 the Jack S. Blanton Museum of Art of the University of Texas at Austin reorganised its permanent exhibition to adopt a 'pan-American' narrative that fuses the formerly separated sections of Latin American and US art histories into a single installation. Once the collections were no longer split along national borders, the curators felt it was convenient to symbolically free the artists from their subjection to any specific nation-state. They modified the labels on the walls so that the artists in the collection are no longer identified according to their place of birth or their nationality. Instead, the labels provide the visitor with an outline of the artists' nomadic pilgrimage between different cultural centres and (sometimes) different lands of exile. Responding to the fact that most of their careers involve migratory routes, artists are now described by a list of the cities where they lived, and their years of residence: Cildo Meireles, for instance, is identified as 'Born 1948, Rio de Janeiro; lived in New York 1971–1973; residing in Rio de Janeiro since 1973'.[4]

It would seem that, as with so-called 'international brands', the prestige and meaning of artists are partly associated with the number of cities in which they have operated: the metropoles they activated, the networks they knitted between centres and peripheries, and in general the number of different communities they traversed. This seems to suggest that citizenship is bound to become an episodic condition.

'HIGH-VOLTAGE'[5] CENTRES

Just as in the Renaissance, when Europe orbited around Venice, Florence, Amsterdam or Constantinople, once again cities (and not countries) are the main economic and cultural competitors. Under capitalism, it would seem that the nation-states were just ephemeral agents of cultural representation and identity. In any case, by contrast to the way in which countries pursued their mythical origins in an essentialist frame of reference around the imaginary communities of similar ethnic roots, kinship with the land and its nature, urban belonging appears as a matter of adoption or circumstances. One could even say that whereas the nation is, ideologically speaking, an indelible biological trait, belonging to a city might be a matter of opportunism. The commonality of its members is, ultimately, the experience of sharing a similar fate under the highs and lows of modernisation.

Small surprise that in the last decade 'city exhibitions' and 'city-specific' events have become pervasive forms of artistic exploration. More than picturing or producing the spiritual community of a people, the artist cultivates and intervenes through specific communities, fleeting economic moments and temporary social structures. In any event, 'cities' have become something close to a curatorial standard, the bearers of artistic representation beyond such modernist coordinates as art movements, styles and national components. We all know to what extent our participation in the global/local art system is predicated on our belonging to a specific city, and mediated by its tourist and cultural stereotyping, even if this entails taking advantage of the poverty, criminality and malaise of our urban context.

TIDES AND TEARS

Were we to chart the transformation of exhibitions in the late twentieth century, it would be necessary to discuss the rise of the 'city exhibition'[6] as the site of at least two curatorial displacements. On the one hand, we have seen the emergence of a brand of global taste consisting in the systematic contemplation of sites of economic, postcolonial, political and cultural crisis, and parallel to this, the development of a notion of art history as a succession of city cultural waves. On the other hand, the emergence of the global city as cultural paradigm might suggest a different notion of cultural history structured around discontinuities and intensities; one that, instead of conforming to a linear sequence of formal or technical innovations, maps the geographical flux of waves of creativity, which – very much like epidemics – migrate from city to city, marking different cultural ages.[7] This was the intention behind *Century City*, the first major exhibition produced by Tate Modern in 2001, a review of the history of art of the twentieth century seen as the succession of decades defined by the creative output of specific cities. Irrespective of its

mixed reception, *Century City* exemplified well an increasingly shared view of cultural history as ruled by energy fluctuations, not unlike those of economic cycles.[8]

Implicit in these curatorial views is the notion that 'creativity' is to a great extent synchronized with social tension, defining art history as a succession of sublime moments of crisis. It is not by chance that the image chosen by the curators of *Century City* to illustrate the cover of the exhibition catalogue was a photograph of Tokyo covered with a dense cloud of pollution, as if to underline that city culture is, above all, a *modernised* taste that developed from and in the face of social anomies. This penchant of city representation for the recording of urban angst was already central to Hou Hanru and Hans Ulrich Obrist's project *Cities on the Move* (1997), their massive exhibition of art, architecture and culture from East Asian cities, which involved both Asian nationals and European artists and architects such as Rem Koolhaas, who had worked in cities including Shanghai, Singapore and Bangkok. Hanru and Obrist saw the emergence of 'global cities' as a flowering of the 'impulsive and almost fanatical pursuit of economic and monetary power' – in fact, as a feature of what they called the 'totalitarian modernisation' of the 'globalising consumer economy'. Even the 'new freedoms and social, cultural, and even political claims' with which those same societies tried to resist the violent forces of modernisation seemed to them products of the same forces. Their approach explicitly discarded the city as an ideal model, calling instead for an embrace of the brutal paradoxes of the process of modernisation:

The City as locus of conflict. [. . .]
Today's Utopian projects are based on a consideration of reality, and confrontation with the chaotic, disordered nature of our world. In other words, the aspiration and efforts to imagine a new Utopia are indeed leading to a new understanding of the

notion of utopia itself. It is here that the new term 'Dystopia' is introduced in present urban and cultural debates to describe such a tendency.[9]

In fact, the chances of participation of artists coming from the South have been to a great extent defined by their ability to intervene in, document and in general take advantage of the conditions of social and economic crisis of their urban locations. Without the emergence of a new taste for dystopia, critical practices from places such as Mexico City[10] or Lebanon would have had little chance of dissemination in the global cultural market. In that sense, despite the risks involved in any kind of stereotyping, the social voyeurism embedded in the aesthetics of 'global cities' differs radically from the apologetic or idealising tendencies of any kind of structure of national representation. These aesthetics always seem to call for a curatorial *genre noir*.

No doubt there is a certain ethical ambivalence in the way that the social and political awareness of specific artists and artworks implies that they obtain a certain advantage in operating from points of global friction. But it would seem that today such a predicament is almost a condition of artistic poignancy.

THE VIRTUES OF NEGATIVITY

Every now and then the curator suspects that city art is at risk of becoming an assimilated form of culture. With the deflation of studio practice, a greater number of contemporary artworks are commissioned and, therefore, may become subject to mechanisms of social control not entirely remote from those that applied to state monuments or history painting. At the same time, as the idealised space of high culture vanishes, contemporary art is under increasing demands to serve a number of social and economic purposes, from attracting revenue from the tourist, and furthering the reactivation and promotion of certain urban centres, to pursuing the empowerment of specific social communities. In fact, funds and institutional support for biennials and festivals are increasingly attached to educational and social agendas, which replace the old largesse of 'philanthropy' with sophisticated means of accountability.

We are far from the times when Theodor Adorno could state that it was 'through its mere existence – indeed precisely through its impractical nature – that art manifests a polemic, secretly practical character'.[11] Struggling to become socially relevant, art is subordinated to structures that grant a greater importance to the alleged needs of the audience than to the uncertainties of the producer. Were we to take curatorial discourses at face value, we would conclude that the practice of art has become another means of social agency, one that considers artworks as sociological, promotional and pedagogical tools.

Luckily, that 'ignominious figure of the expert'[12] (the curator and culture administrator) is frequently an accomplice of the artist's anti-sociability. One of the main challenges for art organisations today is to simulate the fulfilment of the social demands made on art practice, to ensure a certain level of artistic freedom – above all, to resist the temptation of considering the artwork as an educational component of the entertainment industry.

By assuming a negative-critical role, city art tries to avoid its total assimilation as an instrument. But that ability to criticise largely depends on art practice being granted a certain level of irresponsibility. It may well be that, for the time being, artistic autonomy has migrated from the artwork to the artist. As long as there is a social need for the artist to represent a 'professional amateur' as an implicit critique of a civilisation of specialists, suggesting a level of immediacy and creativity forbidden to the rest of us, artists will remain in some sense experts on the ordinary.[13]

NOTES

[1] For a classic and, at times, still current critique of the constrictions of the centre/periphery dialectics see Luis Camnitzer, 'Wonderbread and Spanglish Art' (1988), in *Luis Camnitzer: Retrospective Exhibition 1966–1990* (organised by Jane Farver), New York: Lehman College Art Gallery, 1991, pp. 44–47.

[2] I took this from the implications of Lévi-Strauss's discussion of South American Indians' astronomical myths in the first of the *Mythologiques* (1964). See Claude Lévi-Strauss, *The Raw and the Cooked*, London: Jonathan Cape, 1970.

[3] It goes without saying that for the high-class consumers of the periphery, Liverpool was once the place where elegance came from, as formerly they had consumed the luxury goods brought by boat from Manila. In a similar vein, the Dutch traditionally believe that Santa Claus brings all his presents from Madrid, their former colonial metropolis.

[4] I would like to thank Gabriel Pérez-Barreiro, Curator at the Blanton Museum of Art, for generously providing me with the information regarding the change of labels in that institution.

[5] I borrow this expression from the historian Fernand Braudel, who described the world economy on the basis of 'differences of voltage and current', which linked 'backward' regions with 'high-voltage' major capitalist urban centres. See Fernand Braudel, *Civilization and Capitalism, 15th–18th Centuries III: The Perspective of the World*, Berkeley: University of California Press, 1984, passim, esp. pp. 51, 180.

[6] Of course, the concept of 'city exhibitions' has been developing for decades. We should point to the shows organised by Pontus Hulten in the Centre Pompidou in the 1970s that explored the relationships between the avant-garde centres in the early twentieth century: *Paris–New York* (1977), *Paris–Berlin* (1978) and *Paris–Moscow* (1979).

[7] It is worth seeing how these notions are reflected in the dialogue between the curators of the show, published in *Art Journal*: 'Iwona Blazwick: [. . .] throughout the twentieth century there's been a symbiotic relationship between the modern, modernism, and the metropolis. Seeing that there are many modernisms was part of our project. The exhibition features cultural flashpoints. It is neither a chronology, nor a survey of the twentieth century. It looks at simultaneities. [. . .] the nine idiosyncratic perspectives make transparent the way museology and curatorship work – there is no single story, no one official version. What connects the whole thing is the relationship with the city – both the exhilaration of wanting to be immersed in it and the desire to escape from it.' Janet A. Kaplan, *'Century City:* Conversations with the Curators', *Art Journal*, 60.3 (Fall 2001), pp. 50–51. (http://www.findarticles.com/p/articles/mi_m0425/is_3_60/ai_79350870/pg_1)

[8] See Iwona Blazwick (ed.), *Century City: Art and Culture in the Modern Metropolis*, London: Tate Gallery, 2001. Exhibition website: http://www.tate.org.uk/modern/exhibitions/centurycity.

[9] Hou Hanru and Hans Ulrich Obrist, *Cities on the Move*, Vienna: Secession; Bordeaux: CAPC Musée d'art contemporain de Bordeaux; Ostfildern: Verlag Gerd Hatje, 1997, pp. 13, 18.

[10] For another influential example of a city exhibition based on an openly dystopic taste, see Klaus Biesenbach et al., *Mexico City: An Exhibition about the Exchange Rates of Bodies and Values. A Thematic Exhibition of International Artists based in Mexico City*, New York: P.S.1 MoMa; Berlin: Kunst-Werke, 2002. A similar view on the aesthetics of Mexican city art is presented in Cuauhtémoc Medina, 'Zones de Tolérance: Teresa Margolles, SEMEFO et (l')au-delà/Zones of Tolerance: Teresa Margolles, SEMEFO and Beyond', *Parachute*, 104 (Mexico City/Montreal, October–December 2001), pp. 31–52.

[11] Theodor W. Adorno, 'Culture and Administration', in *The Culture Industry: Selected Essays on Mass Culture*, ed. J.M. Bernstein, London: Routledge, 1991, p. 101.

[12] Adorno, 'Culture and Administration', p. 111.

[13] I would like to thank Jean Fisher and Paul Domela for their observations on the various drafts of this text.

The Ballad of John and Yoko

Standing in the dock at Southampton
Trying to get to Holland or France.
The man in the mac said you've got to go back,
You know they didn't even give us a chance.

(text overlaid and interwoven, forming a portrait — largely illegible through the densely overlapping lyrics)

The way things are going,
They're going to crucify me.

Photo: Flávio Lamenha

Cildo Meireles

LiverBeatlespool

At the height of the British Empire Liverpool's reputation as an international port marked the city's geographical location and its sometimes uncomfortable place in history. August 1960 marked a significant change: the Beatles hit the headlines, and from that day to this Liverpool has been known worldwide as the birthplace of the most famous pop group of all time. Meanwhile 1960s Brazil was subsumed by the samba and bossa nova rhythms of artists such as Vinícius de Morães, Gilberto Gil and Carlos Jobim, who blended musical styles from Africa, India and Portugal. Although they attracted international attention, none of these artists had the incredible global impact of the Fab Four: John, Paul, George and Ringo.

Merseybeat, the Beatles and their birthplace, Liverpool, inspired one of Brazil's most significant living artists to create a new project for *International 04*. A pioneer of installation art since the 1960s, Cildo Meireles is best known for his dramatic and politically charged walk-in environments, which often incorporate sound, smell and touch alongside an all-encompassing visual experience, requiring the viewer's full perceptual involvement. For several decades Meireles' work has been included in the most significant international surveys, from the landmark *Information* exhibition at MOMA, New York, in 1970, to the XXIV Biennial of São Paulo in 1998. A major retrospective of Meireles' work opened in 1999, organised by MOMA, New York, in association with the Museums of Modern Art in Rio de Janeiro and São Paulo.

Taking the top 27 Beatles songs (from the album *The Beatles 1*, released in November 2000), Meireles has layered one track on another around the central note of each. In this way, the longest song ('Hey Jude' at 7 minutes 4 seconds) starts to play and continues uninterrupted until almost four minutes later when 'Come Together' begins. Another song is added after a few seconds and gradually more are added until all 27 tracks are playing simultaneously. The sounds blur into an indistinguishable white noise. Gradually, as the shortest track comes to an end ('From Me to You' at 1 minute 56 seconds), followed by the end of the next and the next, individual chords become recognisable. Short phrases trigger the memory and suddenly the dying moments of 'Hey Jude' are heard before a silence and the whole cycle starts again.

Through this project Meireles succeeds in creating a tangible, physical presence for the music, a solid form condensed from sound – a parallel to the very real and continued 'presence in absence' of the Beatles in Liverpool.

Adrian George

'The Poets are, as Always, in the Vanguard'

Ronaldo Munck

Thus spoke the Brazilian economist Maria Concepção Tavares when contemplating the 'lost decade' of the 1980s in Latin America and the failure of economists such as herself (and the social sciences generally) to comprehend its significance and impact. Social scientists, with their rational knowledge paradigms, simply failed to grasp how the world was changing under their feet and insisted on the continuing relevance of the old thought patterns. It was mainly within the cultural and artistic domains that creative imaginations were able to grasp the depth and complexity of social transformation unleashed by the forces of globalisation and democratisation. In the dark night of the military dictatorships the poets dared to imagine a better world and did not simply bemoan the failure of the existing rational paradigms. Perhaps we can draw from this the idea that artists and cultural workers generally are oriented towards the opening of new possibilities rather than towards the defence of vested interests.

I hope and expect that the Liverpool Biennial *International 04* will, in a similar way, unleash the imagination and lead the way forward. It is clear how desperately we need to see the cultural reconstruction of public space in Liverpool (as elsewhere). The International is situated squarely in the domain of globalisation, which has mixed effects, but among other things contains the possibility of creating a new multicultural democratic politics. My contribution will hopefully be to provide some conceptual clarifications around the role of the city in the era of globalisation and some hints at the cultural politics contextualising the International.

ART IN THE CITY

Just as the 'great globalisation debate' is polarised between optimists and pessimists, and never the twain shall meet, so too the debate on art in the city is equally polarised. When Liverpool succeeded in the competition to become European Capital of Culture 2008 it seemed that the optimistic predictions of a 'renaissance city' were being borne out. According to its organisers, this success 'will accelerate the rebirth of Liverpool. . . It will transform the physical fabric of the city. It will grow its cultural capacity and regenerate its economy' (http://www.liverpoolculture.com). At least 14,000 new jobs are predicted in the culture, tourism, sports, heritage and creative industries, and 1.7 million visitors generating an extra £50 million per year. Culture as an economic resource is also a theme of the University of Liverpool, which is currently offering 'world class opportunities for world class candidates' (www.liv.ac.uk/100-opportunities). The university aims to lure potential professors to a 'region reborn', characterised as a 'culturally rich region' where we can find 'centuries of history on show' and encounter a 'huge variety of popular festivals and rich culinary delights'. The region is said to be the 'arts spend capital of Britain', where three times more money is spent on galleries and museums than in London but 'childcare costs around £50 per week less' than in London and travel costs are half what they are in the capital (www.liv.ac.uk/100-opportunities/region_reborn.htm).

There is also a strong general case made for the role of arts in regeneration by Comedia, a dedicated think-tank or consultancy. In 'Releasing the Cultural Potential of our Core Cities' this group argues that culture is, or should be,

- A source of prosperity and cosmopolitanism in the process of international urban competitiveness. . .
- A means of spreading the benefits of prosperity to all citizens, through its capacity to engender social and human capital. . .
- A means of defining a rich shared identity and thus engendering pride of place. . .[1]

We can note here the preponderance of an economic logic based implicitly rather than explicitly on the neo-liberal nostrum of competitiveness. It would seem that the default mode for

conceptualising the role of culture in the city is an economic one. Even 'pride of place' can be seen as part of the competitiveness perspective. Alan Kay takes the argument a step further and proposes that '[if] we accept that the arts can be an integral part of the regeneration process then they can be an important tool in empowerment'.[2] Perhaps so, but there is surely a big leap from a utilitarian logic for 'art in the city' to an emancipatory logic of social liberation.

Having presented the upbeat side, what about the more 'traditional' negative view of the city and the role of the arts? Liverpool City Council has itself conducted a thorough baseline report on socio-economic deprivation in the city that makes depressing reading.[3] Using a sophisticated 'index of multiple deprivation', the Council concludes that all but two of the city's Neighbourhood Renewal Areas are among the worst 10 per cent of deprived areas in England. In 2004 the national government carried out another study of deprivation that found Liverpool coming in at number 2 in the ranking of all local authorities in terms of indices of deprivation, beaten only at number 1 by Knowsley.[4] The unemployment rate in Liverpool is still 50 per cent above the UK average. Life expectancy levels are among the lowest in the country – and even more damning, the gap is expected to *grow* in the years to come. My own research into Speke and Dingle[5] testifies amply to what it is like to live in a city that is always 'regenerating' but whose people continue to suffer. Coping and 'making ends meet' takes up most of people's time, but perhaps surprisingly (or perhaps not), they do also aspire and work towards a better future. Going beyond all the rhetoric of 'participation' and 'social inclusion', the people of Liverpool have not lost hope in a better future and have the political imagination to reinvent the city if conditions allow.

To consider the role of art in the city we can turn to a 1991 book entitled *Whose Cities?*,[6] sponsored, incidentally, by a Labour Party then in opposition. For one contributor, Ruth Wishart, 'many of the benefits [of arts in the city] are intangible', while David Lister argued more directly that while the arts might 'improve the quality of life' they can in fact 'become an irrelevance for those whose daily life is needlessly fatiguing, frustrating and dangerous'.[7] We are a long way here from the language of 'empowerment'; rather, art and people seem to live in different domains. That theme of separation becomes more specific in the contribution by playwright David Edgar to *Whose Cities?*.[8] Edgar looked at those cities previously chosen as European Cities of Culture and found that artistic and cultural events were both overpriced for ordinary citizens and 'elitist' in content; he concluded that cultural regeneration only 'yuppifies' city centres, and that the arts neglect the most deprived parts of cities.

Some of these problems might be addressed in practice, and indeed have been, albeit with varying degrees of success. Nor are any of the problems inevitable. However, the arts have generally not penetrated beyond the middle classes and the rural/urban divide has not been broken down. The rhetoric of inclusivity and entitlement to access cannot disguise the fact that many people still perceive the existence of cultural barriers preventing their participation in arts events. The concept of cultural democracy has still not made much real headway, and this is perhaps not surprising if the underlying problems are political ones. What is thus relevant is the more sceptical tone characteristic of a social or political perspective on arts in the city, as compared to more triumphant or complacent artistic or economic visions.

THE CITY IN THE GLOBAL

Comedia argues that Britain's 'core cities' (a group including Liverpool, Manchester, Birmingham and Sheffield) 'uniquely combine the advantages of international cosmopolitanism with local distinctiveness, authenticity, originality and pride of place'.[9] In this conception the *local* is seen as static and unique, a place of fixity,

tradition and continuity. It is contrasted, either explicitly or implicitly, with the *global*, seen as a realm of unfettered mobility and dynamism, a space of flows, instantaneous time and continuous transformation. However, in practice this counterposing of the local to the global cannot be sustained. The global is always 'localised': it is constituted by the many 'locals' and is not a nebula hovering ominously or benignly (according to one's viewpoint) 'above' the world. We must also reject a notion of culture as rigidly place-bound, where place acts as a prison and cultural identities act as markers of 'tradition' – by which we actually mean backwardness compared to the new 'modern' world of globalisation. While the global needs to be localised to make sense of how it operates (and is contested), there is no longer any pure local place, insofar as globality is a condition of place.

It might be useful to start an alternative explanation from the assumption that cities are characterised above all by 'mixity'. Different cultures and dynamics come into play in cities in a truly postmodern way. Social relations are complex and fluid, order gives way to chaos and meaning is decentred. The city is not an object but a site of social, political, economic and cultural interaction. The city is a text that must be constructed and is interpreted in various diverse ways; it is above all a *representation*. The city today is, in many ways, a metaphor for the postmodern globalised world we are entering. It is a decentred city that can only be grasped through the critical and pluralist tools of an affirmative postmodernism. The rhetoric of regeneration (economic and cultural alike) seeks, instead, to recover and refurbish the old modernisation paradigm of the 1950s. But the world has changed and that particular meta-narrative no longer has any purchase, based as it was on methodological nationalism and – even more limiting – on a city nationalism that can only advance at the expense of others.

THE GLOBAL IN THE CITY

Lewis Biggs, in the Liverpool *International 2002* catalogue, argues clearly and correctly that 'Liverpool *was* the city of Empire. And it has become *the* city representing the loss of Empire'.[10] Liverpool is a potent cultural signifier for an empire that was and a cultural scapegoat for its decline. Whether embarrassed by the history of slavery or by post-imperial decline, many prefer to blank out this 'global' past. Yet Liverpool is as much a 'postcolonial' city as any in the formerly colonised world. The meaning of Liverpool as a city simply cannot be generated outside the global flows of money, power and people that have shaped it since its origins. Liverpool is clearly inseparable from the history of empire, colonialism and slavery, and the era of globalisation is thus nothing new for Liverpool. We should, I would argue, turn that history/present to the city's advantage and join the postcolonial call to 'provincialise Europe', a continent made 'universal' by colonialism as much as by the Enlightenment. In that regard we need to interrogate François Matarasso's proclamation that 'culture can save the city' on the basis of 'Western European cultural traditions that are vital expressions of core values'.[11] From a postmodern and postcolonial perspective we must be sceptical of Matarasso's proposition that 'we do not live in a relativist world', with its implication that we must reject cultural pluralism, and hence fall into the dangerous trap of believing that 'our' values are 'better' than somebody else's. Where that leads us is clear from world events today as well as from the history of colonialism and racism.

So Liverpool, like globalisation itself, must be seen as complex and contradictory, characterised by mixity and hybridity. However, it is not enough to just note this and leave it as a problem for an 'objectivist' social science. Liverpool is constructed discursively through language, images and representations. A city is 'named' in different ways by different people, and Liverpool, as we saw above, is no exception. Liverpool has a 'label', be it positive or negative, for everyone who has

heard that name, and it is constantly (re)constructed by people's reactions to those labels. As Amin and Thrift put it most succinctly: 'People and places script each other'.[12] People create the places, but the places also make the people. Myths are created about cities, but these are never simply untruths, insofar as they gain discursive credibility and effectivity. Indeed, this emphasis on the discursive construction of Liverpool – which the International is of course contributing to – should make us beware of any truth claims about a place, or about the people who live there for that matter.

Liverpool's *International 04* can be seen as both an example and a promoter of hybridity, understood both as an organising principle for international cultural activities and as the basis of a democratic global cultural politics today. It is through an embrace of hybridity that identity (social, political and cultural) is constructed through a negotiation of difference. As against modernist cultural myths, the concept of hybridity stresses the impure and disorderly combinations that culture, as much as social development, always advances through. Hybridity must be seen as dynamic and eclectic; it is universal and it is local. It is based on new social, intellectual and artistic networks across localities, nations and cultures. García Canclini's work (according to Fredric Jameson) develops these themes to advance 'the most vital utopian vision of our times', namely that of 'an immense global intercultural festival without a centre or even any longer a dominant cultural mode'.[13] We can only hope that the Liverpool Biennial can be part of this utopian project as affirmation of the lifeworld against the depredations of a resurgent militarist imperialism and its crass vision of a 'global culture'.[14]

NOTES

[1] Comedia, 'Releasing the Cultural Potential of our Core Cities' (2002), www.comedia.org, p. 8.

[2] Alan Kay, 'Art and Community Development: The Role the Arts Have in Community Regeneration', *Community Development*, No. 35 (2000), pp. 414–24 (p. 419).

[3] Liverpool City Council, *Liverpool Neighbourhood Renewal Strategy Baseline Report*, Liverpool: City of Liverpool, 2002.

[4] See Indices of Deprivation, 'Creating Sustainable Communities' (2004), www.odpm.gov.uk.

[5] Ronaldo Munck (ed.), *Reinventing the City? Liverpool in Comparative Perspective*, Liverpool: Liverpool University Press, 2003.

[6] M. Fisher and U. Owen (eds), *Whose Cities?*, London: Penguin Books, 1991.

[7] Ruth Wishart, 'Fashioning the Future: Glasgow', in Fisher and Owen (eds), *Whose Cities?*, p. 50; David Lister, 'The Transformation of a City: Birmingham', p. 58 in the same volume.

[8] David Edgar, 'From Metroland to the Medias: The Cultural Politics of the City State'.

[9] Comedia, 'Releasing the Cultural Potential of our Core Cities', p. 14.

[10] Lewis Biggs, 'Ducking and Weaving', in *Liverpool Biennial: International 2002*, Liverpool: Liverpool Biennial, 2002, p. 32.

[11] François Matarasso, 'To Save the City: The Function of Art in Contemporary European Society', www.comedia.org, p. 4.

[12] Ash Amin and Nigel Thrift, *Cities: Reimagining the Urban*, Cambridge: Polity Press, 2002, p. 23.

[13] Fredric Jameson, 'Notes on Globalisation as a Philosophical Issue', in F. Jameson and M. Myoshi (eds), *The Cultures of Globalisation*, Durham, NC, and London: Duke University Press, 1998, p. 66; see Nestor García Canclini, *La Globalizacion Imáginada* [Imagined Globalisation], Buenos Aires: Paidós, 1999.

[14] Thanks to Paul Domela for most helpful comments and support, and to AM for inspiration.

P-chan

RURI-Kabuto
& his friends

Takashi Murakami

Jellyfish Eyes Characters and billboard

In the 2004 exhibition *Seeing Other People* at Marianne Boesky Gallery in New York, each gallery artist selected an additional artist to show alongside their own work. Takashi Murakami chose Andy Warhol, and a 1986 silkscreen on canvas entitled *Camouflage*.

Animals use camouflage as a natural part of both their defensive and attacking strategies. In 1915, the French army first introduced camouflage on the Western Front. Professional artists were asked to suggest how judiciously applied colour could be used to break up the shape of military objects so as to confuse and confound. A strong influence on the French *camouflageurs* was the work of the Cubist painters, who used the slow graduation from light to dark colours to break up and flatten out the shape of an object.

Zoologists became involved with what was perhaps the most prominent camouflage exercise of the Great War: the dazzle-painting of both warships and merchant vessels, whereby the whole of the ship above the waterline was painted with angular patterns, or curved lines, in primary colours. Over the course of the war over 4,000 merchant ships and naval escorts were so painted.

The dazzle-painting deployed by Takashi Murakami is often called Superflat. He trained for nine years in the traditional nineteenth-century Japanese technique of Nihon-ga painting, where the emphasis is on surface with no perspective. His paintings are produced along with sculptures, prints, products and animations by teams of artists in factory-like studios in Brooklyn and Tokyo, the HQs of his Kaikai Kiki Corporation.

Murakami plays with the oppositions in Eastern and Western culture. He sees no difference between high art and popular culture. He has borrowed from the pleasures of theme parks and Japanese *otaku* (geek) culture, and has given the world his trademarked character, Mr DOB, a mutant Mickey Mouse.

Like Andy Warhol, he has been accused of being too commercial. His ongoing collaboration with French label Louis Vuitton has seen new life breathed into their range of handbags and leather goods, and many millions into the cash tills. It is said that some modern soldiers do not feel they are real soldiers unless they are wearing camouflage uniforms and most armies now have their own particular camouflage pattern. The original LV logo was a product of nineteenth-century French Japonisme. The dazzling reimagining in the candy colours of twenty-first-century Japanese Anime became the fashion must-have for armies of fashionistas. 'Genuine' imitations of this cutest of camouflage still work wonders on eBay. Takashi Murakami, forever Mouseketeer, Marketeer and Musketeer. All for one, one for all.

Mark Daniels

MY MUMMY WAS BEAUTIFUL Y.O. 04

Yoko Ono, *Music of the
Mind and World Premiere
of the Fog Machine*,
Bluecoat Arts Centre,
1967

Photo: courtesy Sheridon
Davies
info@sheridondavies.com

Yoko Ono

My Mummy Was Beautiful

Yoko Ono, artist and composer, made her name as one of the most original performance and installation artists associated with the Fluxus movement in the 1960s. Having produced language-based art since the early 1960s, she is also viewed as one of the founders of conceptual art. Her work is poetic and constantly evolving, and marked by a humorous irony that makes it both light and biting. Many works are characterised by an element of audience participation.

Always interdisciplinary in approach, and always committed to alternative and radical ways of thinking about contemporary life, her work has contributed to feminism and to the ecological and peace movements. It has been highly influential on younger and particularly women artists in the fields of live art, film, music and the underground club scene.

Yoko Ono lived between Tokyo, Paris, London and New York in the 1950s and 1960s, settling in New York in 1971. Her first appearance in Liverpool was on 26 September 1967, when a large audience was attracted to an event billed as 'Yoko Ono, *Music of the Mind and World Premiere of the Fog Machine*' in the Concert Hall at the Bluecoat Arts Centre. She gave a lecture at the Art School during the same visit.

The artist was married to John Lennon, who was raised from the age of five not by his mother but by his aunt Mimi. He adored his mother, who was killed when he was eighteen in a car accident when she was visiting the house on Menlove Avenue, Liverpool, where he lived. Lennon's mother was English but he identified with his Irish father. As a pacifist, he hated his middle name Winston (after Winston Churchill) and changed it to Ono when he and Yoko married.

John's memories of Liverpool were in Yoko Ono's thoughts when she decided how to respond to the invitation to participate in *International 04*. The project *My Mummy Was Beautiful* (2004) consists of the widespread distribution in the city of two images: of a woman's breast and a vagina.

The project can be linked thematically with many earlier works by the artist that present an objectified and dislocated view of the body. For instance, *Cut Piece* (1964) was a performance in which members of the audience were invited to cut away the artist's clothing. A number of her films focus on bodily details, including Film No 4 *Bottoms* (1966), showing the naked bottoms of people walking. *In Celebration of Being Human*, realised in 1994 in Langenhagen, Germany, displaced political campaign posters and saturated every advertising site throughout the small town, as well as being distributed through newspaper advertising, postcards, umbrellas and so on.

A work called *Mommy Was Beautiful*, created for Yoko Ono's retrospective at the Museum of Modern Art, Oxford, consisted of 21 canvases one metre square, depicting breasts and vaginas arranged on the ceiling of the gallery so that (in the artist's words) 'one has to look up the vagina and the breasts on the ceiling – rather like looking up at your mom's body when you are a baby'. The mother's vagina and breast are the child's introduction to the rest of humanity.

Lewis Biggs

Actualité, 2001
16mm film, colour,
sound, 7:48 min, DVD
transfer
16mm frame
enlargements

Images courtesy Galerie
Meyer Kainer, Vienna/
Richard Telles Fine Art,
Los Angeles

Mathias Poledna

Academy

The work of Austrian artist Mathias Poledna is informed by historical research, by archives and collections. His work investigates various diverse histories – avant-garde cinema, modernist architecture and design as well as the intersection of popular culture and art. His recent projects have taken the form of minimalist film reconstructions that suggest ephemeral moments in twentieth-century popular culture.

In *Actualité* (2001) Poledna attempts a quasi-ethnographic visual investigation of a moment in post-punk history, circa 1979. *Western Recording* (2003) moves backwards in time and shows a recording studio that appears to be from the 1960s and is very obviously located somewhere in the USA (it is in fact the former Western Recorders studio in Los Angeles where the Beach Boys produced their album *Pet Sounds*, first released in 1966). The camera position shifts between two static views – one inside the studio and one through the glass separating the recording and control rooms. Both show a singer performing a succession of takes of a song's vocal track.

By planting visual mnemonics Poledna suggests a specific moment in time, a style and a meaning, but allows the audience to complete the narrative, a strategy that collapses the distinction between production and reception, artist and viewer. In this way Poledna's work not only engages viewers but implicates them in the making of the work, for they are led to 'recall' (or imagine) moments they may not have experienced in reality.

Poledna's film work has sought to reflect minor yet emblematic scenes from the history of popular culture through blending research and reconstruction. His most recent project attempts historical specificity while withholding factual evidence, a contradictory and perhaps impossible notion. This relationship between historical background and what potentially could be an elaboration thereon, or variation thereof, lies at the root of Poledna's project for *International 04*.

Taking as one of his starting points the well documented interest in American soul music that has pervaded England since the late 1960s, Poledna has produced a new 16mm black and white film. Using contemporary performers, the artist filmed scenes in the semi-abstract, ahistorical setting of a Los Angeles sound stage – hence the high production values and extremely condensed quality of the work. The 'look' and costumes of the performers hint at a time between the late 1960s and early 1970s, while their movements and gestures blend vernacular dance moves with vestiges of postmodern choreography from approximately the same period.

The 'controlled aimlessness' of the dancers in Poledna's film, along with shifts between moments of stasis and motion, between improvised and staged forms of performance, further amplifies the project's ambiguities and subjects its viewers to continued uncertainty over what they are seeing – fact or fiction?

Adrian George

The Passion for Fascination
Art as Spectacle

Apinan Poshyananda

In the dazzling visual show *The (M)art Castle*, directed by Navin Rawanchaikul, a traditional Thai soap opera by *likay* Makhampom performers is based on gossip about contemporary Thai art and culture. The building of the Art Castle has caused debate and feuds among councillors and the art mafia as Curatorman from Paris tempts the Thai government in selling the project through his Biennale Franchising campaign under the label SUPER(M)ART. The drama thickens as Uncle Navin, an old, out-of-date artist, and a group of resistance artists plan to protest against the government. They are supported by Princess Marayat ('politeness'), an art patroness who is to marry Prince Kot ('principle'), but she has a jealous elder sister, Princess Katika ('rule'), who betrays her in the forest. Curatorman and Katika attempt to kidnap Marayat and take over the Art Castle establishment.

The (M)art Castle, performed in four parts during the French Festival in Bangkok in 2004, is a revival of traditional Thai soap opera that attracted a large audience from the Thai art circle. A satire on the Thai art circus, the hilarious show parodies the art establishment and power balance. It also draws parallels with the cultural policy of many Asian capitals to promote art-as-spectacle in order to be part of the international art network and cultural goodwill exchange.

Marxist cultural criticism laments the increasing commodification and bureaucracy of everyday life. From the Marxist point of view, consumption of a highly technologised mass culture can alienate the majority from their real needs. The tradition of spectacle in Asia provides a counter to this: resisting mass media and hi-tech production methods, Thai spectacles such as *likay*, *nang talung* and *morlum* are local forms of entertainment that stress low-tech methods, dialects and folklore.

The culture of spectacle in Asia has been transformed since the nineteenth century, when troupes of performers, dancers, acrobats, art objects, textiles, jewellery, antiques, animals and food were sent to the World Fairs and Great Expositions in Europe and America. Foreign villages were reconstructed to display heritage and exoticism – modes of cultural production in the present that have recourse to the past. Human showcases – the display of people, customs and ceremonies – meant applying the positive epithet 'civilised' while casting the 'other' as 'savage'. Japan's desire to display culture alongside Europeans and Americans through 'oriental artefacts' and fanciful pavilions was evident at the Crystal Palace in 1851, the Parisian Exposition Universelle in 1855, the British International Exhibition in 1862, the Vienna Exhibition in 1867 and the Philadelphia Centennial Exhibition in 1876. By 1885, Japan had participated in no fewer than twenty international exhibitions, including those in St Petersburg, Antwerp, Edinburgh, Barcelona, Sydney and Melbourne.

National pavilions at international exhibitions became arenas for *spectacles vivants* or theme parks as the country represented took up a position alongside the world powers. In this fashionable form of international public relations a country's self-representation and national identity were elaborated through various packages of spectacle. With the Biennale Exhibition in Venice the concept of national pavilions was intended to display cultural hegemony, as European nations had priority in recreating their own spectacle and world art hierarchy. Japan and South Korea were the only two Asian representatives in the main official pavilions, the Giardino. This limited Asian participation meant that at Venice, one of the international centres of the art world, Japan and South Korea were privileged over other Asian nations. With more recent representation of Taiwan, Hong Kong, Singapore, China, Indonesia and Thailand in Venice, the reconstruction of the Asian spectacle has added a dazzling strangeness to the art-world arena.

With the shift of international focus to Second and Third World cultures, postmodernism and cultural diversity have paved the way

for new forms of spectacle at alternative sites. The swing towards the display of spectacle at nodal points such as Istanbul, Havana, Dakar, Johannesburg, Helsinki, Cairo, New Delhi, Brisbane, Fukuoka, Osaka, Shanghai, Guangzhou and Yokohama marked the new centre/periphery paradigm. The trend of biennials and triennials has been criticised as merely providing another cultural commodity for leisure-time consumption, and the art network has been criticised because of the curatorial power exercised over artists and their work. However, it can also be argued that the creation of alternative sites for international art exhibitions does provide opportunities for diverse local spectacles to take place.

As art festivals and biennials reflect the insatiable human appetite for sensory saturation and thrilling strangeness, the places where they occur are important parts of the cultural delights they represent. Foreign destinations mean travel, discovery, education and entertainment for visitors. The uniqueness of each place provides a showcase for local heritage and history, boosting the tourist industry and local income. The cycle of spectacles at a specific site every two or three years provides funding and demand for local artists, curators, managers and art workers. Conversely, art festivals and biennials offer hosts, sponsors and local audiences the opportunity to proudly display their cultural wares on the international stage of the art world.

The International Triennale of Contemporary Art in Yokohama in 2001 was an international spectacle that attracted record-breaking crowds to indulge in leisure-time consumption at the historical port town. During the three-month event Yokohama became the attraction as viewers flocked to witness works by international artists along with Japanese artists. With the theme 'Mega-Wave: Towards a New Synthesis', spectacular displays transformed the place into a theme park for contemporary art. A giant insect made of fibre-reinforced plastic by Noboru Tsubaki and Hisashi Muroi was

suspended on the façade of the Pan Pacific Hotel. In Yayoi Kusama's *Narcissus Garden* (2001) thousands of metallic balls floated in the bay of Yokohama. Yoko Ono's *Freight Train* (2000), a German National Railways freight carriage peppered with bullet marks, with a spotlight shining in the night sky, was placed outside the Red Brick Warehouse. The most spectacular project planned, which did not in the end take place, was Cai Guo Qiang's thousands of fireworks intended to signify the Chinese invasion of Yokohama.

As art fairs, biennials and triennials have become increasingly synonymous with the spectacle, each venue strives to display innovation and difference. In most cases budget dictates the scale and creativity of the spectacle. During the bubble economy in the mid-1990s in Asia the phenomenon of spectacle through art extravaganzas spread through cities such as Tokyo, Fukuoka, Osaka, Shanghai, Taipei, Gwangju, Singapore, Bangkok, Jakarta, New Delhi and Guangzhou.

In some cases the spectacle is intended to be a permanent public display. In Niigata, Japan, the Echigo-Tsumari Triennale is designed for art commissions to attract viewers and tourists to spend time in the depopulated prefecture. Visitors can stay overnight in residences designed by James Turrell and Marina Abramovic. At the Mori Art Museum in Tokyo, visitors enter Roppongi Hills to experience fun, entertainment and leisure. Louise Bourgeois's giant female spider *Maman* (2002), Takashi Murakami's cartoon characters and Choi Jeong Hwa's moving plastic flowers are placed in public space. Spectacle is intertwined with awe, relaxation and consumerism. The proliferation of invented image-objects such as Murakami's *Kaikai Kiki*, *Mr DOB* and *Sacho* is spectacle in the realm of the simulacrum. These images, with no referent outside themselves, are products of larger-than-life icons. In Murakami's cartoon world on the Roppongi Hills the spectacle is invented through digital beauty, *manga* and mass culture.

Like the spectacle, the exotic is a place where nothing is ordinary. Hence, dazzling visual shows travel to extraordinary places. *Cities on the Move: Urban Chaos and Global Change, East Asian Art, Architecture and Film Now*, curated by Hou Hanru and Hans Ulrich Obrist, displayed the spectacle by Asian artists at venues in Vienna, London, Copenhagen, Helsinki and Bangkok. *Beyond Paradise: Nordic Artists Travel East*, organised by David Elliot and curated by Apinan Poshyananda, was the largest contemporary Nordic art project to travel to Asia, with venues in Bangkok, Kuala Lumpur and Shanghai. Strangeness and exoticism produce the spectacle that plays the seductive role of desiring machine, luring the spectators to become engrossed in a time and place of excitement and infatuation.

Spectacle-oriented exhibitions tend to thrive on publicity, media hype, outrage and obsession with sex and death. While young British artists (YBAs) such as Damien Hirst and the Chapman brothers grabbed headlines with their sensational works, Asian artists experimented with the body as spectacle: macabre images of cannibalism by Chen Chieh-Jen and Zhu Yu; dead babies and torsos in performances by Sun Yuan and Peng Yu; flesh and animals by Cang Xin, Xiao Yu, Yang Maoyuan and Huang Yan. Body as spectacle in relation to place is seen as foreignness in dislocation and juxtaposition.

Sites play a major part as cultural backdrops that emphasise the notion of difference. Peripheral crossroads such as Sollentuna in Sweden and Limerick in Ireland displayed works by Asian artists in *Floating Chimeras: Asian Artists Travel North and EV+A 2002: Heroes and Holies*, respectively. Limerick saw Chandrasekaran's ritualistic performance with hooks pierced through his tongue and nipples as he was suspended in the aisle of St Mary's Cathedral. Cai Guo Qiang exploded gunpowder in the shape of flying dragons over the river outside Limerick Castle. In Bangkok, Marina Abramovic performed and lectured on her project *Cleaning the House*; Yasumasa Morimura

danced in front of his self-portraits as *Olympia, Marilyn Monroe* and *Mona Lisa*; Orlan displayed her self-portraits inspired by African/Mayan sculptures and Bernini's *Ecstasy of St Theresa*. In Chiang Mai, Amanda Coogan held her bare breast in her performance *Madonna* in front of the bewildered Thai audience.

When I visited Liverpool in 1999 to give a lecture at the Liverpool Biennial of Contemporary Art, parts of the city were in a state of dereliction and decay. I saw damp, grimy cobbled streets, shabby warehouse districts, public houses with unemployed locals discussing the boy wonder Michael Owen, souvenirs of the Beatles and the Chinese Arch in Chinatown. At the Biennial, outstanding works by Ernesto Neto, Nicola Constantino, Montien Boonma, Doris Salcedo, Pierrick Sorin, Alastair MacLennan and Adriana Varejao contributed to the Liverpool spectacle despite the scepticism of visitors who expected outrageous and scandalous pieces.

Liverpool is currently in a state of transition in preparation for becoming European Capital of Culture in 2008. Regenerating areas including Cornwallis Street, Chinatown and Great George Square are being redeveloped to attract investment and to improve public spaces. In relation to the Liverpool Biennial, local voices from Toxteth and Anfield have raised pertinent observations regarding some Liverpudlians' lack of interest in being involved with the event. To many of them the Biennial is a spectacle for the international art network which has little in common with their tastes, interests and daily life. In contrast, Liverpool and Everton Football Clubs are important focal points in the life and landscape of Liverpool. Sport as spectacle draws large crowds every week to cheer their favourite players, such as Michael Owen, Wayne Rooney and Steven Gerrard. A suggestion was made for football and art to merge in a friendly match between an International Biennial XI and Liverpool FC at Anfield. But the proposal was withdrawn for fear that the artists might cause injury to the Liverpool players.

In 2004, Liverpool featured in countless headlines in Thai newspapers as the prime minister Taksin Shinawatra announced his interest in buying shares in Liverpool FC. In addition, Chang Beer (*chang* meaning 'elephant'), product of a famous Thai brewery, became the sponsors of Everton FC. Speculation has been made that Everton players wearing elephant beer branding will produce a spectacle of dazzling and trumpeting visual display on the pitch.

Both art and sport as spectacle generate wonder and awe among their many and varied audiences. The passion for fascination accounts for the spectacle and the viewers' expectations of the Liverpool Biennial.

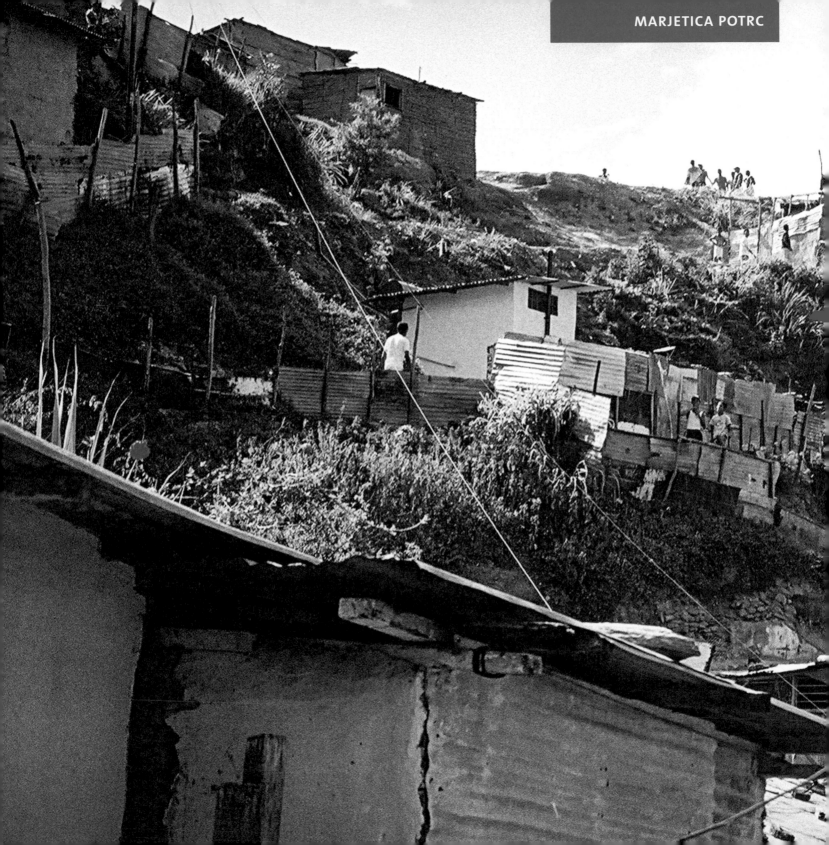

Dry Toilet, 2003

Building materials and
sanitation infrastructure

Courtesy of Liyat Esakov
and Marjetica Potrč
Supported by La Vega
community, Caracas;
Caracas Case Project and
Federal Cultural
Foundation of Germany;
Ministry of Environment,
Venezuela

Photo: Marjetica Potrč

Individual Empowerment,
2003

Building materials, energy
and communication
infrastructure

The Fifth System: Public
Art in the Age of Post-
Planning
The 5th Shenzhen
International Public Art
Exhibition, Shenzhen

Photo: Marjetica Potrč

Courtesy Max Protetch
Gallery, New York and
Nordenhake Gallery, Berlin

Marjetica Potrč

Balcony with Wind Turbine

Marjetica Potrč is a Ljubljana-based artist and
architect whose work has been featured widely
in exhibitions throughout Europe and the
Americas and who has received numerous
awards, including the Hugo Boss Prize (2000)
and a Caracas Case Project Fellowship (2002)
from the Federal Cultural Foundation, Germany,
and the Caracas Urban Think Tank, Venezuela.

Marjetica Potrč is often described as an urban
anthropologist: her work identifies cities as
living and breathing entities, highlighting their
changing landscapes and how they redefine and
reinvent themselves. Potrč is interested in cities
in transition, and in the actions of individuals
aiming to take control of their lives and to create
self-sustaining solutions to the problems they
face. Her work promotes the drive of individual
initiative and self-organisation that exists within
global urban settings and illustrates the shifting
of power – and the tensions this can create –
from central institutions to individual self-
determination in urban planning. A good
example of this is the *Dry Toilet* project, a
collaboration between Potrč and Liyat Esakov in
La Vega barrio within Caracas. The project
involved the construction of a dry, ecologically
safe toilet in an area of Caracas without access
to the municipal water supply. The toilet reduces
water consumption, providing a long-term,
sustainable solution to the problem of waste
water. The project contributes to increasing the
general awareness within poor communities of
self-sustainable technologies, and thereby points
to a shift in power away from institutions and
towards individuals.

As has been described elsewhere, Potrč's work
illustrates the differences between 'urban
planning' and 'urban nature'. For Liverpool,
Potrč's work is of critical interest, her subject
matter helping to remind us of the complexity of
dealing with the evolving urban organism. For
Liverpool, a city redefining itself and embracing
its radical population decline, her work helps to
highlight the need for more individual action
within the context of urban regeneration. In
many parts of Liverpool, disenfranchised
communities will need to be at the heart of the
emerging change to the urban landscape. At the
present time it is clear that these changes are
still driven by central institutions who have yet
to unleash the creative spirit and self-sustaining
nature within individuals.

Paul Kelly

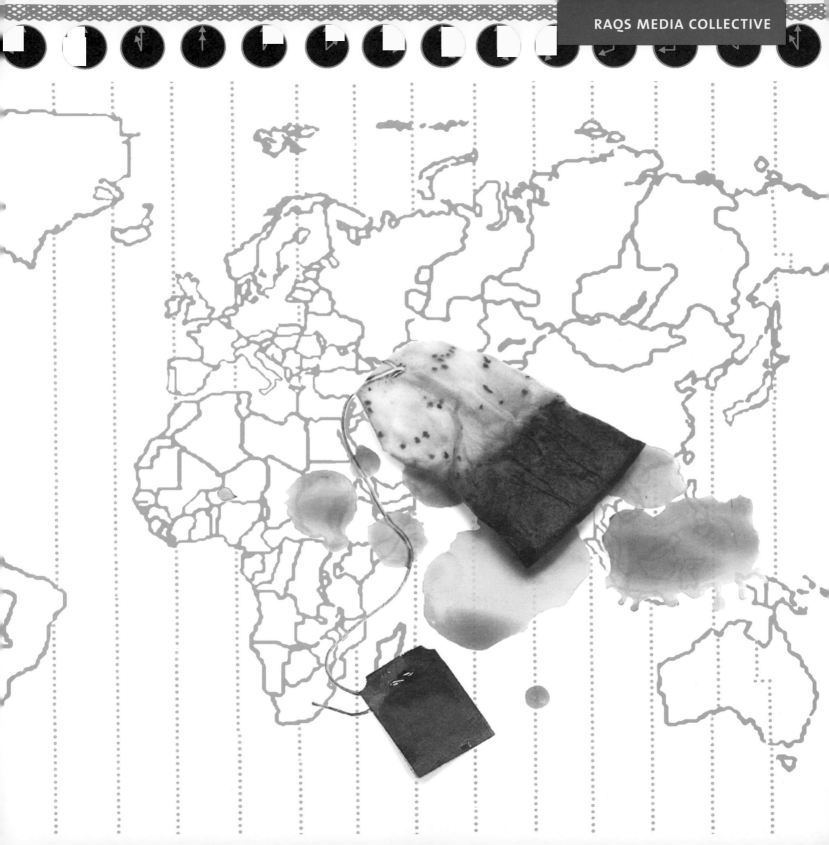

The extraction of value from any material, place, thing or person, involves a process of refinement. During this process, the object in question will undergo a change in state, separating into at least two substances: an extract and a residue.

Tea leaves and tea dust, tea dust and a tea bag, a tea bag and a cup of tea, a cup of tea and a shot of caffeine, a shot of caffeine and a slight spike of energy, a spike of energy and a decision, a decision and its consequences, the consequences and a fragment of history, a fragment of history and a tea economy, a tea economy and tea leaves, tea leaves and tea dust, and so on.

With respect to residue: it may be said it is that which never finds its way into the manifest narrative of how something (an object, a person, a state, or a state of being) is produced, or comes into existence. It is the accumulation of all that is left behind, when value is extracted.

ALL THAT CAN BE VALUABLE IS ACCOUNTED FOR. RESIDUES

ge perforations begin to appear in chronicles, ...endars and maps, and even the minute agendas of ...ividual lives, as stretches of time, tracts of land, ...ys of being and doing, and entire clusters of ...erience are denied substance.

...re are no histories of residue, no atlases of ...ndonment, no memoirs of what a person was but ...ld not be.

Everything is valuable, yet all things can be laid waste.

The sediments that precipitate at the base of our experience of the world can, however, decompose to ignite strange sources of light, like will o' the wisps in marshlands by night. Sometimes, this is all the illumination there can be in vast stretches of uncertain terrain.

...AIN, AWAITING ESTIMATION. OCCASIONALLY GLOWING.

Sketch for *With Respect to Residue* (Table Maps for Liverpool)

Raqs Media Collective

With Respect to Residue (Table Maps for Liverpool)

Active since 1991, Raqs Media Collective (Jeebesh Bagchi, Monica Narula and Shuddhabrata Sengupta) is a group of media practitioners. In 2001, Raqs co-founded Sarai (www.sarai.net), an interdisciplinary programme concerned with urban space, the media and the public domain. Raqs' work has been shown at such major international art venues as Documenta 11 (Kassel), Itaú Cultural (São Paulo), Walker Art Center (Minneapolis), Generali Foundation (Vienna), the Roomade Office for Contemporary Art (Brussels), the Venice Biennale 2003 and the Palais des Beaux-Arts (Brussels).

In its installations, media works, essays, internet projects and print objects, Raqs Media Collective addresses issues of legality and illegality, location and movement, property and dispossession, and processes of identification and effacement. These works are based on close readings of different histories arrived at through an examination of networked forms of production, creative practices and information flows.

With Respect to Residue (Table Maps for Liverpool) is a work designed to provoke reflection about all the things, the states of being and the histories that end up being abandoned. The table maps are paper mats meant to be placed in restaurants in Liverpool, destined to be thrown away after a meal, embellished with the traces of peanut shells, fish bones, used teabags,and tobacco ash.

Spaces, activities and ways of life that are seen as obsolete or redundant are a particularly marked feature of many post-industrial spaces, particularly in cities that have been left on the wayside by the detours of global capitalism. Large parts of Liverpool, like depressed districts in many other former industrial or port cities facing long periods of decline (such as Calcutta, Danzig, Lille, Dresden, Kamaishi or Detroit), continue to exist in our times as reminders of the detritus of the nineteenth and twentieth centuries. Though often invisible, the production of such 'residue' is only intensified by the accelerated, networked market of the contemporary era.

Like the heaps of scrap metal piling up in the Liverpool dockyards, or the ruins of layer upon layer of abandoned habitation buried under the grass in Everton Park, the 'residue' lurks silently, in unexpected corners, as an embarrassment to history. It can yield neither a narrative of 'heroic resistance' by labour, nor a paean to triumphant capital. It is this thing, ubiquitous and yet amiss, impossible to memorialise and difficult to forget, that this work wishes to pay respect to.

Table maps produced at the Sarai Media Lab, designed by Mritunjay Chatterjee.

Rana Dasgupta

LIVERPOOL BIENNIAL 2004

NAVIN PRODUCTION Co.,LTD.

HOW TO BE A SUCCESSFUL CURATOR: A GAME

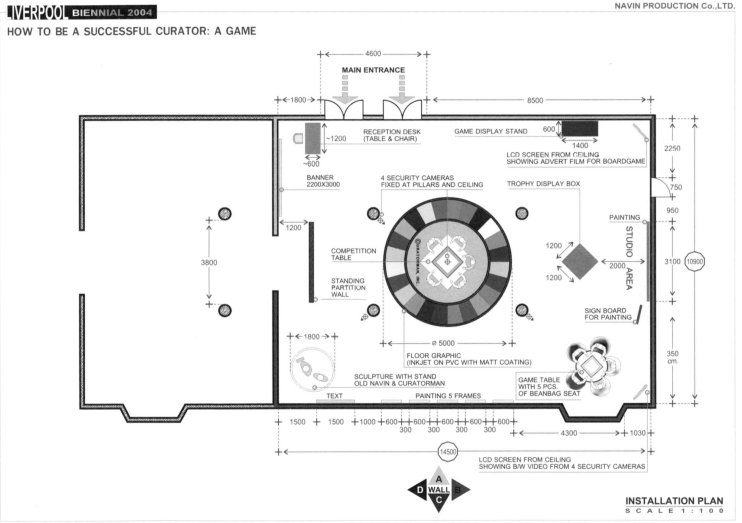

MAIN ENTRANCE

RECEPTION DESK
(TABLE & CHAIR)

GAME DISPLAY STAND

LCD SCREEN FROM CEILING
SHOWING ADVERT FILM FOR BOARDGAME

BANNER
2200X3000

4 SECURITY CAMERAS
FIXED AT PILLARS AND CEILING

TROPHY DISPLAY BOX

PAINTING

COMPETITION
TABLE

CURATORMAN, INC.

STUDIO AREA

STANDING
PARTITION
WALL

SIGN BOARD
FOR PAINTING

Ø 5000

FLOOR GRAPHIC
(INKJET ON PVC WITH MATT COATING)

SCULPTURE WITH STAND
OLD NAVIN & CURATORMAN

GAME TABLE
WITH 5 PCS.
OF BEANBAG SEAT

TEXT

PAINTING 5 FRAMES

LCD SCREEN FROM CEILING
SHOWING B/W VIDEO FROM 4 SECURITY CAMERAS

A
D WALL B
C

INSTALLATION PLAN
S C A L E 1 : 1 0 0

Navin Rawanchaikul

SUPER(M)ART – How to be a Successful Curator:
A Survival Game

Fact and fiction blur into one in Navin
Rawanchaikul's complex work. Working in
collaboration with diverse groups of people
(taxi-drivers in New York, gallery-goers in Paris,
elderly villagers on the outskirts of Chiang Mai,
Thailand, where he was born), Rawanchaikul
puts audience participation at the centre of his
work. Concerned with art as communication, he
explores the exchange of ideological
(mis)understandings, both intergenerational and
cross-cultural. His work is infused with colourful
humour, mixing traditions of high art, such as
large-scale oil painting, with popular culture,
such as manga and American comic-book
cartoons. A story-teller, he weaves intricate
narratives that centre on the adventures of semi-
fictional characters and his own alter egos.

Rawanchaikul's work for *International 04* is
based upon the concept of the *SUPER(M)ART*, an
installation (displayed at the Palais de Tokyo,
2002) that included a vast painted comic strip
charting the adventures of Old Navin, an ageing
once-famous artist and a CEO from the fictional
company *©uratorman, Inc.* Playing with art as

commodity and the commercialisation of the art
world, this work invited the audience to
'Participate in the Future of Art' via a pin-board,
part soap-box and part market research for
©uratorman, Inc. In Rawanchaikul's Liverpool
installation, *©uratorman, Inc.* launches *How to*
be a Successful Curator: A Survival Game, an
interactive board game which takes players
through a series of 'real-life' art-world situations.
Players make decisions which determine
whether or not they can 'make it' and become a
freelance international curator. The game is
competitive and a league table will be displayed
throughout the exhibition.

While satirising and critiquing the art world
and its players, Rawanchaikul's glossy
'edutainment' product, available for sale,
nevertheless taps into a fascination with the
glamour of this elitist community. The
environment he creates is slick and professional.
The issues he raises are particularly pertinent to
Liverpool and the Liverpool Biennial.
Rawanchaikul builds the fact that the city has
recently been awarded the status of European
Capital of Culture 2008 into the narrative of his
work. What does it mean to be a Capital of
Culture? How does art relate to culture? How, in
a global economy, do art, culture and money
interrelate? This year, a short-list of artists was

drawn up for *International 04* by independent
curators. Rawanchaikul, an artist who enjoys
significant international recognition, is not a
surprising suggestion. His work is self-reflexive, a
microcosm of the very world in which he, as a
contemporary artist, is a player. Ironically, it sets
up a mirror to the systems of patronage that
support and secure his own success.

This project has been created in collaboration
with Helen Michaelsen.

Laura Britton

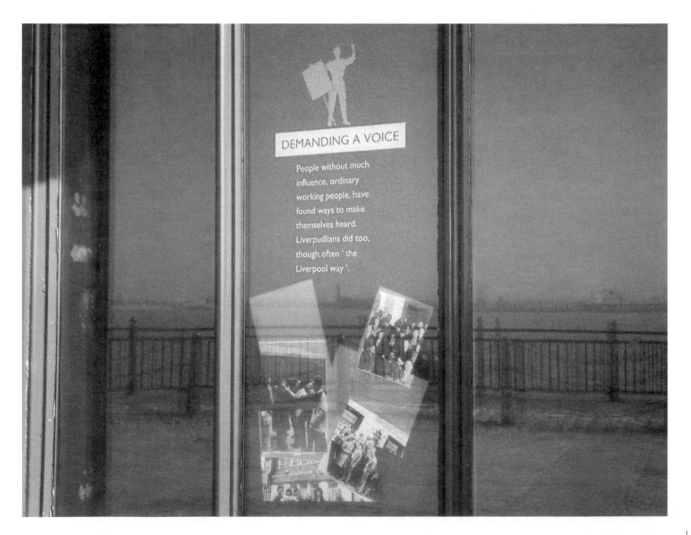

Scale metres

0 15 30 45 60

Signal Box

Platform

Shelters

Ticket Office

Subway

Stairs

Train direction

Mersey ferry at Liverpool

Museum of Liverpool Life

Brick retaining walls from
fully enclosed commercial
harbour, the world's first
(1715)
© Oxford Archaeology
(North)

Irish immigrants

Mersey tunnel, 2003

Liverpool street, 2003

Construction of Mersey
tunnels

Dingle Station (1896) of
the Liverpool
Underground Railway,
then Britain's largest
underground station

Merseyside Maritime
Museum, basement, 2003

Bus tour, Liverpool, 2003

Martha Rosler

Liverpool Delving and Driving

From her pioneering feminist and anti-war
works of the 1970s to the present, Martha
Rosler's art occupies a seminal position in recent
radical art practice. With analytical precision and
wit, her practice has embraced multiple media,
critical writing and public interventions,
engaging with pressing social and political
issues of the day. The parameters of art – its
subject matter, its production and its reception –
are all there to be contested. In works such as
the video *Domination and the Everyday* (1978)
the inseparability of personal experience from
political control is exposed. Rosler's large-scale
collective projects include *If You Lived Here*
(1989), whose diverse participants – artists,
community groups, activists and others –
interrogated housing, homelessness and
planning in New York, Los Angeles and
elsewhere, revealing the possibility of art as a
forum in which to challenge simplified
representations of urban reality.

Rosler regards the city as 'art's habitat', and
for *International 04* she continues her
examination of the urban landscape. Seeking to
make visible underground elements of Liverpool
history, she guides visitors through the city by
means of a bus tour. This metaphorical
subterranean mapping of the city draws on the
rich layering of events and indeed myths that
have helped to construct our view of Liverpool.
What is left unsaid interests Rosler as much as
the visible evidence of imperial expansion
reflected in buildings and street names. The
port's slave history, for example, remains mostly
hidden. What we see instead are 'the effects of
the capital generated by the commodification of
Africans, accreted in Liverpool's architecture and
public works'.

The story of the flood of Irish immigrants into
the city is also largely concealed – obliterated
long ago, like the desperate underground digs
sheltering many of the new arrivals. Rosler's
archaeological approach to Liverpool, 'rich with
burrowings and tunnellings on the one hand
and cover-ups and uncoverings on the other', is
apt in a city whose built environment extends
below ground, with subterranean engineering
matching constructions above ground: road and
rail tunnels under the Mersey; Williamson's
mysterious warren of tunnels beneath Edge Hill;
the War Room, from where the Battle of the
Atlantic was orchestrated; and the cellars of the
Maritime Museum telling stories of enslavement
and emigration.

The original underground site of the Cavern
Club has long since been filled in; however, the
Beatles' Magical Mystery Tour bus still trundles
on and a Yellow Duckmarine guides you through
an amphibious sightseeing tour of Liverpool's
waterfront. In this context of a city – now World
Heritage Site and European Capital of Culture in
2008 – anxious to tell its stories to the world,
Rosler's bus tour makes for a less comfortable
ride, in which contradictions of the past are
revealed in the excavations of the present.

Bryan Biggs

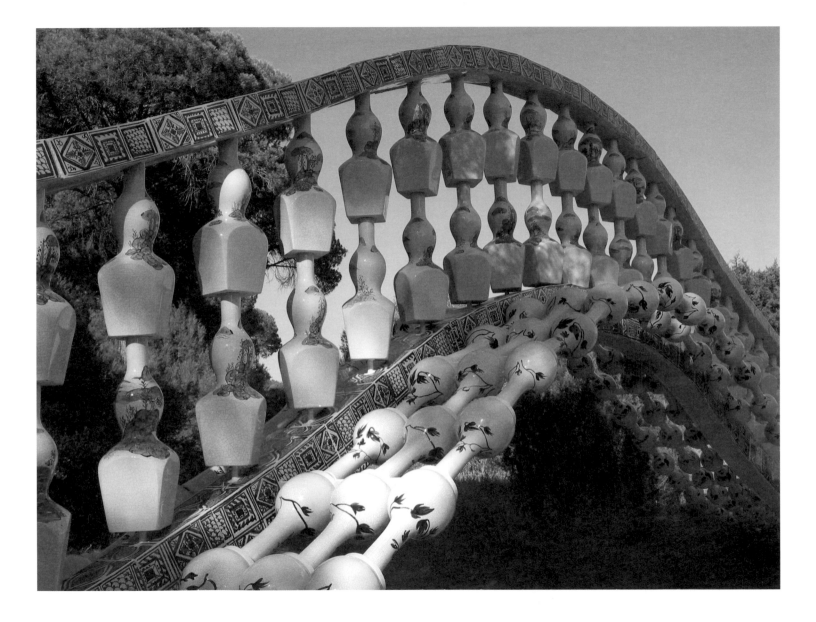

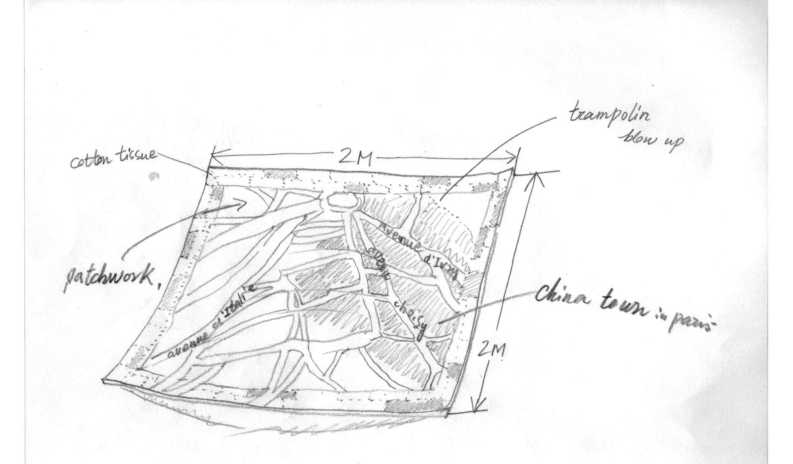

cotton tissue

2M

trampolin
blow up

patchwork,

avenue d'Italie

avenue d'Ivry

choisy

China town in paris

2M

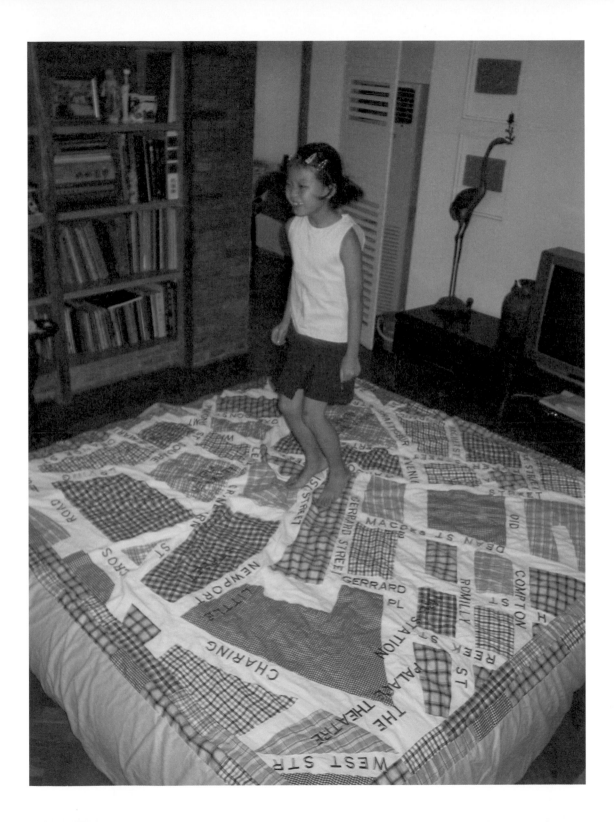

Bridge *Trampoline 12345*, 2004
Installation
10 x 1.25 x 2.6 m
Arab tiles, Chinese vases
Foundation NMAC
Montenmedia Arts Centre
Cadiz, 2004

Shen Yuan

Trampoline 12345

Shen Yuan's work ranges from large-scale site-specific interventions, such as room-sized installations inspired by a toy whistle, to discreet, intuitive objects encapsulating universal themes. In 1999 her work *Fingerprints* presented a slice of cooked ham embroidered with fine gold thread tracing the pattern of the artist's fingerprints – the body's unique identification code. This project simultaneously fixes identity and emphasises fragility and impermanence. Shen's work reinterprets the everyday, presenting the viewer with poetic, disturbing visual meditations on contemporary issues such as migration, death, memory and language.

Born in Fuzhou, China, Shen Yuan has lived and worked in Paris since 1990. She travels extensively and in each country or city she visits Shen makes a point of exploring the Chinese district. Liverpool is home today to the oldest Chinese community in Europe and each year over 100,000 visitors attend the Chinese New Year celebrations. Is it any wonder that Shen Yuan chose to investigate this aspect of Liverpool city culture when she came on a research visit in advance of *International 04*?

Shen's project consists of five traditional Chinese-style patchwork quilts embroidered with street maps of the Chinatown areas of the biggest European cities. Both embroidery and quilting are references to Shen's origins as well as developing themes presented in her previous work. The Chinese were the first to discover the use of silk and the oldest reference to embroidery as a decorative technique is from a 4000-year-old Chinese manual on etiquette and the correct form of dress.

While embroidery was born out of a desire for surface decoration, quilting is much more utilitarian, arising from the need for softness, warmth and protection. Quilting, the technique of stitching together layers of padded fabric, can be traced back to Roman times. The Latin word *culcita* (thought to be the root of the word 'quilt') refers to a padded pallet – a simple form of mattress common in Roman households. In the 1500s, high-ranking Japanese soldiers often wore embroidered, quilted vests over their metal armour. This style became modified as it travelled the globe, and by the seventeenth century quilted jackets were worn as protection during fencing tournaments across Europe.

As well as referencing Shen's cultural legacy these motifs are linked to the project's location in Liverpool's Albert Dock: both silk and quilted fabrics were imported through the port of Liverpool and the warehouse that is now home to Tate Liverpool once stored, among other things, silk and fabrics en route to merchant cities across the UK. The Roman *culcita*, a large pillow, may have led Shen Yuan to consider laying her embroidered street maps over a series of large air-filled cushions. The artist has suggested that children visiting the exhibition should be able to clamber over the cushions and in that way make a physical/virtual tour of the Chinatowns of other cities.

Adrian George

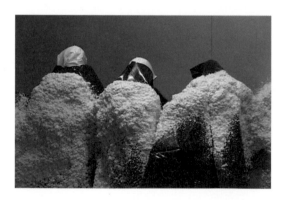

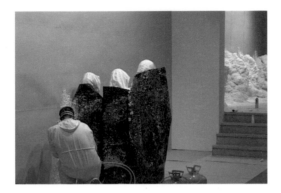

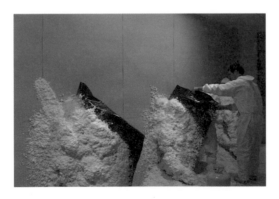

Santiago Sierra

'Due to the controversial nature of Sierra's work, we are unable to disclose details of this project until the time of opening.'

Immortal, matter-of-fact words relating to Santiago Sierra's work *Polyurethane Sprayed on the Backs of Ten Workers* at the Lisson Gallery in July 2004. For this action the artist hired ten Iraqi immigrants, provided them with Hazchem protective clothing and plastic sheeting, lined them up in the gallery and sprayed their backs with polyurethane foam until the material hardened into large free-standing forms. They then carefully emerged from their cocoons leaving the residual elements abandoned in the space for all to view.

On 13 October 2003 Santiago Sierra's action entitled *El Degüello* (*The Slaughter*) was due to take place for 24 hours from 12 noon in front of the New York Stock Exchange building on Wall Street. However, the police prevented the action from happening.

In December 1835 during the occupation of the then Mexican State of Texas the city of San Antonio was taken and with it the military fort of El Alamo. Tradition holds that on the morning of 6 March 1836 the Mexican troops, headed by El Generalissimo Antonio Miguel López de Santa Anna, surrounded El Alamo for thirteen days without recapturing it. During those thirteen days the uninterrupted performance of an old Spanish military bugle tune, inherited by the Mexican army, was ordered. That tune was *El Degüello*.

The melody was recreated in 1959 for director Howard Hawks in his film *Rio Bravo*, but instead of using the original bugle tune the composer Dimitri Tiomkin, who later scored the 1960 film *The Alamo*, was asked to invent a melody with the same title and symbolic use. A Russian émigré, Tiomkin was born in 1894 and raised in the Ukraine. He became a US citizen in 1937 and is best remembered for his scores for Hollywood Westerns. When asked why a Russian composer should be so easily able to depict the Wild West, Dimitri Tiomkin would joke that there was little difference between the steppes and the prairies.

On 25 June 2000, the Institute of Popular Music at the University of Liverpool conducted an exercise centred on the suggestion that music can, in a split second, relay not only moods but also a sense of place. Twenty-five short unidentified musical extracts that exemplify this phenomenon were played. The test group were asked to write down what location, if any, they thought was being communicated through each example. On listening to an extract from Dimitri Tiomkin's prelude from the 1947 film *Duel in the Sun*, the largest percentage wrote down the words

'American', 'Western' or 'film'. Santiago Sierra used Dimitri Tiomkin's version of *El Degüello* in his action of 2003, which, despite the intervention of the authorities, was nevertheless performed a couple of streets down from Wall Street in Battery Park. Twelve buglers played the tune in shifts over the 24-hour period. Liverpool Biennial will exhibit for the first time the documentation of this action and a CD of the soundtrack is included with this catalogue.

Santiago Sierra sees the differences in society. He initiates actions that refer to and intervene directly in everyday life. He undermines systems and ordered structures to reveal the mechanisms of economic and cultural exploitation. His actions are tests, of process and permissions, that challenge the host and provide a surprise, a surreal turn, for the audience.

Mark Daniels

swirl

Valeska Soares

Swirl

Much of Valeska Soares' work deals with entropy: for example *Untitled (from Fall)* (1994), a room filled with red roses, ephemeral and temporal metaphors for love and beauty. These flowers fade and are slowly overtaken by death and decay, their heady perfume invading the gallery beyond.

Originally trained as an architect, Soares is fascinated by space, non-space and the interstices. For her project *Picturing Paradise* (2000) she installed a series of mirrors on the border between the United States and Mexico. The mirrors created illusory openings in the border as well as articulating the ideas presented in Italo Calvino's book *Invisible Cities* – a novel based on two cities, existing side by side, each looking out but only seeing itself reflected. Soares' interest in reflections extended to her 2002 project *Detour*, where she created a mirrored room – an endless, looped space, a simple yet striking spectacle of false infinity. Mirrors, having been set at a slight angle in the space, curve reflected images to one side, where they vanish into the distance while voices emanating from hidden speakers relate the story of a shared dream. For the artist the narrative, as well as the reflection and distortion of images, echoes the trichotomy she has created – fiction and thought versus reality. What a viewer perceives, how a viewer thinks something is and how it is in reality may be very different.

Occasionally described as having 'Borgesian inclinations', Soares' grand-scale projects engage with a complex nexus of ideas, many of them linked to the effects of time – be that evidenced by gradual decay or by the presence of a temporary physical action. In 2002 Soares produced her first video installation, *Tonight*, consisting of digitally superimposed images of dancers who meet by chance on screen. Simultaneously using and deconstructing the traditional codes of social dance, the video evokes not only desire but also projection and incompleteness.

The time-based aspect of dance and the recurring motifs of mirrors and light appear in Soares' project for *International 04*. *Swirl* takes the form of a large mirrored ballroom, illuminated by sparkling chandeliers, and activated by the confident and coordinated movement of dancers. The artist considers the physical space of this extravagant installation to be a folly, a partial reference to the English tradition of buildings created purely for the pleasure of the construction. In an interview with the artist Vik Muniz, Soares says: 'A folly has no sense to it beyond the pure desire underlying its construction'.[1]

For Soares dance is about dialogue and negotiation, not only with the partner, but with space and those objects that may interrupt that space. Intrigued by the continued interest in social dance, particularly in the north west of England, Soares hints in *Swirl* at the social minefield formal dances can be. Visitors to Tate Liverpool have the opportunity of engaging with the project, not only through viewing the performances, but also through a series of planned events. These events are an intrinsic element of the project since people are an important part of Soares' work, their participation essential in fully exploring the complex mix of allusions she creates.

Adrian George

1 *BOMB* (Winter 2001).

OR A CLEANER ENVIRONMENT

(IN SHOP) SHOP²

Torolab

In-Shop (Shop)

Torolab's projects start out with a contextual analysis by which they negotiate their way into a situation, defining temporary zones, while their interventions trigger critical debates between disciplines. The results are often hybrid constellations involving spaces, designs, target groups and functions.

In their operations Torolab administer a skilful division of labour. They take on diverse tasks, some of which are explicitly functional and located on the boundary of architecture and design, while others are of a more strategic nature involving socio-political commitments.

Torolab look at borders as a type of material. They are particularly interested in examining and moulding borderline positions, such as those between art and social or geopolitical situations, between art and advertising or between art and architecture. They challenge the borders defining the public and the private; corporate and virtual space; neighbourhoods and countries. In their practice Torolab engage with redefining, moving and dissolving borders. The fact that they operate out of the trans-border region of Tijuana/San Diego in many

ways explains their choice of material.

Founded in 1995 by architect and artist Raúl Cárdenas-Osuna, Torolab includes artists, designers and musicians. Their main focus of attention has been the quality of life in the communities in and around Tijuana. Their commitment is to these people's everyday lives and how they are affected by the existence of the nearby border.

One of their ongoing projects is ToroVestimenta, now on display in the *In-Shop (Shop)* trawling the streets of Liverpool. The shop operates (temporarily) out of a converted rubbish collection vehicle in the so-called Gold Zone in the city centre. ToroVestimenta, Torolab's clothing line, includes the multi-pocketed Transborder Trousers, perfect for holding a passport, the new 'laser visa' issued by the US, or credit cards. Such functions draw attention to a specific social and economic reality: the use of these trousers depends on the specific needs of the wearers, be they from the US or Mexico.

The rubbish collection vehicle, usually operated by street cleaners employed by Liverpool City Council, has been re-engineered and re-fitted into a moving shop. The artists drive it and instead of picking up litter in the streets, they sell their own manufactured clothing line and other items selected by Torolab

collaborators. This parasitic action exposes some of the processes and strategies involved in Torolab's ways of working. The *In-Shop (Shop)* makes use of one functional design, converts and applies it to a different purpose. Implicitly the message remains clear: please keep the streets clean. In the meantime, trust the parasite to do its job.

Cecilia Andersson

TRIGGER LOOKING DOWN INTO STAIR WELL

TRIGGER GOING UPSTAIRS

TRIGGER IN RECEPTION AREA

TRIGGER IN LOUNGE

TRIGGER AT BANQUET ENTRANCE

Evening Express,
8 March 1954

Photo courtesy of the
Liverpool Daily Post
and Echo

GEE, WHAT
A MIGHTY
FINE HOSS

Wong Hoy Cheong

Trigger

Roy Rogers Riders' Club Rules:

1. Be neat and clean.
2. Be courteous and polite.
3. Always obey your parents.
4. Protect the weak and help them.
5. Be brave but never take chances.
6. Study hard and learn all you can.
7. Be kind to animals and take care of them.
8. Eat all your food and never waste any.
9. Love God and go to Sunday school regularly.
10. Always respect our flag and our country.

Involved in both social activism and art, Wong Hoy Cheong uses political and social metaphors of great significance, yet his work transcends cultural and geographical boundaries and speaks with universal relevance. He uses an extraordinary range of media and materials, bringing an imaginative and often humorous sensibility to the examination of serious and pressing issues.

In March 1954, Roy Rogers, his wife Dale Evans and their horse, Trigger, stayed at Liverpool's Adelphi Hotel following their successful appearance at the city's Empire Theatre. As the singing cowboy movie star lay in bed with influenza, he was paid a visit by his horse, who had made his way through the hotel and up to the room, to present his master with a get-well bouquet of flowers. Beforehand, Trigger had signed the hotel register with a pencil between his teeth and later appeared on an outside balcony, to the cheers and excitement of 4,000 fans.

Exactly half a century on, Wong Hoy Cheong has re-enacted the event (albeit with a different horse), filming Trigger's journey through the hotel, recording the route through the marble-clad and elaborately decorated corridors of the building via cameras attached to the animal. The resulting edited film is presented as an installation at Bluecoat Gallery, with large-scale multiple video projections and a soundtrack of Roy Rogers' songs.

Bringing a naïve 'iconic' moment into the present, *Trigger* flirts with the symbolism and subtext of the Great American Cowboy on his horse, trotting through an emblem of empire, the Adelphi Hotel. This becomes especially resonant in the current, rather complex and divisive context of world politics and Britain's intertwined relationship with the US. Furthermore, the filming technique, with horse-mounted cameras, invigorates the way in which the environment of the Adelphi is seen spatially. The fields of vision from the viewpoint of the cameras, which are attached to the horse's tail and its curiously moving head, are disrupted by the horse's gait and its negotiation of corridors and staircases, unsettling our ways of seeing and comprehending.

The work provokes – 'triggers' – a series of open-ended readings. On a simple level, it retrieves a cultural memory, and projects an entertaining event from the past into the present. Memory and history, after all, form the certainty with which we understand the present and peer into the future. On another level, the resulting film projections disintegrate both the iconic and the real, and turn the event inside out. The images refer to, but are not about, Roy Rogers and Trigger. They present a fresh and original perspective on a moment in history in which popular culture collided with, and embodied, both a past and a present heavily loaded with the legacy and consequences of American and British empires and their continuing relationships and agendas.

The ghostly soundtrack of rhythmic and sentimental cowboy songs becomes a counterpoint to the fragmented, constantly shifting views on the screens and provides an atmospheric contrast to the contemporary technology of the digitally recorded and processed film.

Catherine Gibson

Jiaer's Livestock, 2002
Two-screen video
installation

Courtesy of the artist

S10, 2003
Video and photograph

Courtesy of the artist

Close to the Sea, 2004
Video installation, 24–28
mins, 10-screen

Courtesy of the artist

Yang Fudong

Close to the Sea

Yang Fudong lives and works in Shanghai, a coastal city renowned as a filmmaking centre in the 1920s and 1930s. Cinema and the Yuefen style, typical of the Shanghai *petite bourgeoisie* of the early twentieth century, are important references for Yang. This influence is evident in his nostalgic and poetic works, which display stylistic references to films such as Yuan Muzhi's *Street Angel* (1937) and Fei Mu's *Spring in a Small Town* (1948).

While Yang's works have a strong cinematic, narrative component, the stories he recounts are never explicit or conclusive, but are characterised instead by fundamental change – from the overwhelming changes of personal life, urban environment and society, to the resulting disaffection of urban youth. Alienation and perception are major themes; in all of his work Yang creates a beautifully poignant, and at times melancholy, sense of *ennui* that reflects the inconsistency of everyday life and the reflective desires of his subjects. His videos, films, and photographic series can be read as allegories of the alienated city-dwellers' lives. Indeed, seen as a whole, the films, in their overwhelming seductive beauty, present a cautionary portrait of China, with its shifting definition of contemporary identity.

Yang speaks of negotiating the past while imagining the present. In his films protagonists in Western dress are shown in contrast to traditional role models; the streets and buildings of the old Chinese city are replaced by modern skyscrapers; the uniform dress of the Maoist era clashes with the extreme fashion of the younger generation. The narratives unfold sometimes in high-rise apartments and office buildings, for example in *City Lights* (*Chengshi zhi guang*), and sometimes in dreamlike settings reminiscent of traditional Chinese gardens and the Chinese literary landscape, as in *Su Xiaoxiao, Tonight's Moon* and *Liulan*. The observation of individual and collective attitudes and approaches to life, along with the juxtaposition of traditions and conventions of society with states of transition and transformation, are recurring themes in Yang's films.

In his ten-screen installation at FACT, Yang again explores some of these issues through the relationship of a young couple in love and their life by the sea – a setting he chose to connect Shanghai and Liverpool, and which he describes as 'conveying beauty and generosity'. Threatened by death, they continue to talk about their ideals, beliefs and expectations of life.

The musical score by Jing Wang, specially commissioned to accompany the piece, assists in conveying a strange, dreamlike, disturbing quality. This feels particularly relevant to Liverpool as the city undergoes transformation and regeneration, processes bringing tensions and the contradictions of reality and desire.

Ceri Hand

Yuan Goang-Ming

City Disqualified – Liverpool

For almost a century (1279–1368) the Mongol Empire ruled China, giving rise to the Yuan Dynasty. Considered by many to be barbarians, it was nonetheless during the time of the Mongols that some of the most famous Chinese artists produced their most beautiful and challenging work. Historians have suggested that the Four Great Masters of the Yuan Dynasty foreshadowed abstraction, while one artist in particular, Ni Tsan, took a stark and minimal approach to his landscape paintings, removing all aspects of human presence from his work.

In 1948 Japanese author Dazai Osamu published his book *Human Disqualified* – an uncomfortable translation of the title from the original language. The novel expands on the idea of what it means to lose one's humanity, hence to be 'disqualified' from the status of human. The sense of this is held in the Japanese characters that make up the book's title, but it requires further explanation in English. This is just one example of how language (perhaps all language) is in some way flawed, and how the problems of translation go far beyond understanding the literal meaning of words.

Yuan Goang-Ming, a Taiwanese artist, works predominantly with new media, digital photography and video. Although a powerful tool for contemporary artists, digital and computer technology brings its own set of problems: in transferring video footage to digital media, through the use of a computer, it is often the case that frames are 'dropped' or lost in the transfer (although this is entirely dependent on the power and processing speed of the computer). It is this potential for elements or even whole sequences to be 'lost' that fascinates Goang-Ming and allows him to cross the centuries in his references – from Yuan Dynasty Chinese landscape painting at one extreme to twenty-first-century digital technology at the other.

Taking more than 300 photographs over the course of two weeks from the top of one of Liverpool's landmark buildings, the St John's Beacon (Radio City tower), the artist produced a large-format, high-resolution digital film depicting the urban landscape. Seen from a high angle, distinctive architecture, street layout, lights and signs clearly mark the place as the city centre of Liverpool. But the silence of the scene is strangely disconcerting and it becomes quickly apparent that there is something wrong: every vestige of human presence has been painstakingly removed by Guang-Ming. No cars, no people, just an empty urban landscape – an incomplete city, a city disqualified.

Is it possible for a city to function in any way without its cast of players? Advertising, for example, a particular set of symbols, relies on its viewers; it has no function without the potential to communicate the desire for some product or (un)necessary consumable. Without us the language of advertising, and adverts themselves, become redundant, disempowered. Guang-Ming is fascinated by failure, and in removing the human element from a city proves that it is our presence that gives a city its life. While Danny Boyle's recent success with his cult film *28 Days Later* shows us the empty city as a signifier of apocalyptic disaster, Guang-Ming's empty city is a powerful statement of the need for our continued survival.

Adrian George

after hours museum

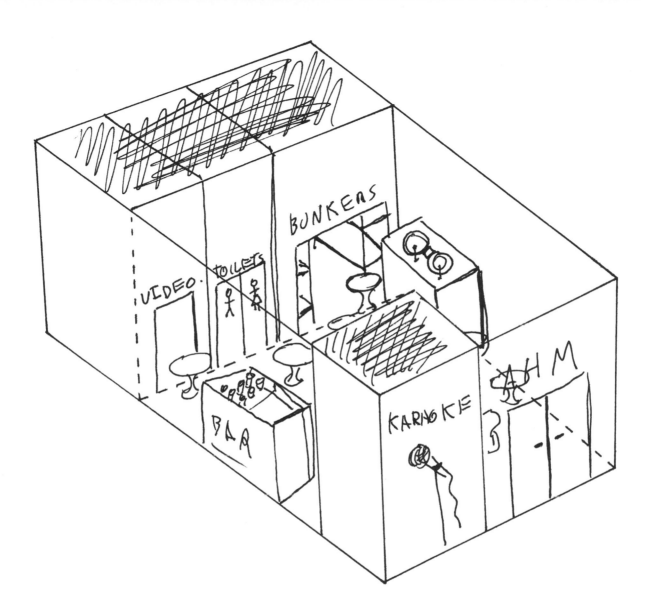

AFTER HOURS MUSEUM
YES, WE ARE OPEN
Museum of Contemporary Art

The After Hours Museum first opened in Finland last summer. Probably the best Museum in the world, the AHM opens from 2 AM till 10 AM. Smoke is permitted, the bar is always open and it even has beds available. The Museum will move to Liverpool on the dates of the biennial (or part of them). For Liverpool, it will have a special karaoke service and it can be used for bachelors parties. The space can show pieces from the biennial artists as an information center. The AHM usually invites local artists to show their work in the space (video projections or digital presentations). The AHM has an archive of already done projects to show as well.

AFTER HOURS MUSEUM
Museum of Contemporary Art

The needs of the AHM: a place to exist (because of the beds, kitchen and fridge, a living space is always more suitable), printed matter (invitation, 20 t-shirts, postcard, posters, etc.) Connection to internet, computer with CD burner, a VCR, an audio system with CD player, a DVD player and monitor, beers and karaoke system. Two local artists to work as hosts. Two artists/hosts from Mexico. Ashtrays.

After Hours museum

international +

Liverpool Biennial generates opportunities for active participation in the art process. We believe it is vital to address and engage the city and its communities as much as we do the world of international art. We strive to give people the chance to discover and express their own creativity as well as accessing the creativity of others.

Declan McGonagle

Despite the central role education and community groups enjoy in the mission statements of arts organisations, quite often the reality is that the programmes aimed at these groups are run separately from the exhibitions programme and are perceived as an 'add-on' to the core business of exhibition-making. In an effort to address this, in 2002 Liverpool Biennial took a first step towards incorporating the Learning and Inclusion activities into its exhibition programme. The title 'International +' refers to the ongoing negotiation of the place of these activities within the art process, as 'add-on', augmentation and connection between different communities of both artists and non-artists.

I became a member of the Programme Team for *International 04*. This time, participating artists were contractually required to participate in Learning and Inclusion activities. The programme of Learning and Inclusion work developed in step with the process for the exhibition. Key to the approach was dialogue. Publishing some of the work produced through the Learning and Inclusion programme in the *International 04* catalogue signifies our intention that these activities be accepted on equal terms with the other aspects of the exhibition. I wanted the diversity of the groups we work with, the diversity of their voices and their concerns, to be valued in their own right. However, there remains a perceived need for mediation, an anxiety about unmediated voices. The transition towards a different model of practice is far from complete.

Sharon Paulger

Ways of Seeing
Photo: Alan Dunn

WAYS OF SEEING

Ways of Seeing is a series of live webcast discussions on the theme of Liverpool Biennial, hosted by community-driven webcasting channel tenantspin, in which artists, funders, community representatives, curators and invigilators explore the Liverpool Biennial from numerous angles and points of view. All twelve *Ways of Seeing* webcasts since April 2002 are archived at www.tenantspin.org.

I can recall very clearly the beginnings of *Ways of Seeing*. Former high-rise tenant Steve Thomas says 'Hello everyone and welcome to Ways of Seeing Programme 1' before introducing himself, fellow tenant Paul and Liverpool Biennial Executive Director Lewis Biggs. The date is 10 April 2002, the location is the Cunard Building on Liverpool's waterfront, and the three men sit in front of a white backdrop adorned with the tenantspin honeycomb logo. Steve's first question to Lewis is direct: '*What* – and *why* – is the Liverpool Biennial?'.

Ways of Seeing has been dealing with these two questions ever since. In the six shows that comprised Volume 1 the *whats* and *whys* were unpicked from the point of view of organisers, viewers, participants, funders, invigilators and policy-makers. Volume 2 focused on the artists, establishing six webcast scenarios in which social housing tenants, young artists and *International* artists discussed the impact of the city – and of some of its inhabitants – on the work.

During the live webcasts there was no mediation between the professionals and the 'ordinary citizens'. For example, 72-year-old tenant John McGuirk was not a guest on the webcast featuring artist Amanda Coogan – he *researched*, *led* and *chaired* the discussion.

Ways of Seeing was about the relationships between professionals and volunteers and in both series of *Ways of Seeing* there were occasions when different people's terms of reference were poles apart.

Closing my eyes, I hear *research visits, proposals, curators, technical problems, Tabac, artistic practice, deconstructivist thinking, in Liverpool in the fifties, changing city, awaiting funding decisions, Sydney Biennial, working on numerous projects, shown this piece before, when tenantspin was in Copenhagen, installation work, Anfield, new commission, only in town for a few days, Capital of Culture, exciting city, Bold Street.*

From Programme 1 there was a shared commitment to arriving at some genuine debate around the *whats* and *whys*, and watching the shows again it strikes me that the bridging of the international and the local resembled a slowly crashing cymbal. *Ways of Seeing* discussions consistently waver from the incredibly specific to the general and back again.

CRASH: Which Radio Merseyside DJ would be best to announce info about a Biennial event? Snelly?
WITHDRAW: What about architecture?
CRASH: Which is the best floor of the Adelphi to stay on?
WITHDRAW: What else do you do?

This is the beat and rhythm of webcasting that flavoured *Ways of Seeing*. tenantspin could deal with material that was relevant only within a three-mile radius and immediately follow it with a sentence relating to the global. The thread running through *Ways of Seeing* became the placing of *experiences* at the heart of talking about art. People's life experiences – primarily Liverpool experiences – were sucked by the reverberations of the clashing cymbal into the lives of contemporary artists. The *Ways of Seeing* artists – conscious of being somehow *away from home* – were drawn into the warm vortex of people's genuine needs to see themselves reflected in the (artistic) world around them.

tenantspin is a community-driven Internet TV channel co-managed by FACT's Collaboration Programme and city-wide high-rise tenants, the

majority of whom are over the age of 50. First piloted in 1999 in conjunction with the Liverpool Housing Action Trust, tenantspin delivers live webcasts on subjects as diverse as anti-social behaviour, Elvis, rent increases, the Hillsborough Justice Campaign, e-democracy, Will Self, smart homes, care, Margi Clarke, money, CCTV and the paranormal. Everything seen on the channel is developed by and with tenants and is archived at www.tenantspin.org.

Alan Dunn

WILD!
The Liverpool Experience

Through this 18-month collaborative project artist Andy Weston and a group of adults with learning difficulties from Halewood Resource Centre in Knowsley have explored the experience of being a visitor in Liverpool.

The *International 04* artists have each visited Liverpool to absorb its unique atmosphere and to gain inspiration for their proposed pieces of work. During the Biennial, artists and audiences from all around the world flock to Liverpool as visitors. The group took 'visiting' as a starting point, visiting arts and cultural venues in the local area and acting like tourists in their own city.

Carefully documenting their 'Liverpool Experience' through photographs, the group often attached special memories to particular images based on actual experiences or very personal associations. From the resulting archive of photos each group member selected one favourite image and worked to enlarge and simplify it through a process using sheets of acetate and a projector. Once the group had decided on a composition, the images were transferred onto MDF boards with pencil. Finally, using masking tape and acrylic, the group members painted their images in a selection of colours. The finished product is a mural twelve feet square representing the highlights of the *WILD!* 'Liverpool Experience'.

An important feature of this project has been the 'ownership' of the images used. When visiting the art galleries, museums and other cultural venues, each member of the group selected several views that they wanted to capture. In this way each individual could feel directly connected to a group of images. At Bluecoat Arts Centre one member of the group was drawn to the brickwork in the corner area of the front courtyard because he thought it looked like

Wild! The Journey
Photo: Leo Fitzmaurice

'chocolate blocks'. A photograph was taken and whenever the image is viewed the group associates it with chocolate blocks. The group members have talked about the project with support staff and other users of their Resource Centre – now virtually everyone at the Halewood Resource Centre knows the chocolate blocks image! This and other memory triggers and associations have been vital elements of the project.

The mural will tour to venues including a city centre location, libraries and other resource centres accompanied by a photographic display, information about the processes used and six lightboxes showing further images associated with the *WILD!* project. The group members are excited at the prospect of seeing the mural in different places and experiencing people's responses to their work. After the tour the mural will be permanently sited in a prominent position inside Halewood Resource Centre.

Rebecca Jones

WILD!
The Journey

Artist Leo Fitzmaurice worked with adults with learning difficulties from L8 Resource Centre and Fazakerley Croxteth Day Services to create a short film of people's journeys to an exhibition at Bluecoat Arts Centre.

Initially, the group decided to visit contemporary art exhibitions in Liverpool and to create their own work in response. Having looked at a good deal of work they concluded that contemporary art, rather than being a highbrow thing, is essentially about everyday experience. Leo describes the moment of realisation:

> We'd been to the *Shopping* exhibition at Tate and the *From a Distance* exhibition at Bluecoat and were looking at how artists used consumer culture. It was now lunchtime and we had returned to our room at Bluecoat to talk about what we had seen. We were inspired to produce our own work photographing the products in our packed lunches, each taking it in turns to arrange our lunch on the table and photograph it. Then we all went home. To our surprise, next week one of the group members came in with some photographs he had taken. He had spent the week photographing most of the possessions in his house. The photographs he produced were at the same time strangely exotic and oddly normal. I think it was things like this that gave us the confidence to look at our own lives as Art.

The group wanted to create a piece of work about their everyday experiences on the project and decided to make a film of their individual journeys to a gallery. As the participants live in different areas of Liverpool, the journeys approach the city centre at varying angles from the peripheries, allowing the group to explore the

physical relationship each member has to the city and at the same time to produce a portrait of the city itself. Leo said: 'I think it has become quite psychological, about how a journey allows our thoughts to wander and about how arriving can be like waking from a dream.'

The most important aspect of the project has been its longevity. The group members have worked together for 18 months, making it necessary for them to focus on a long-term goal and work towards it in a fairly systematic way. They are looking forward to the climax of the project, which will be a glitzy premiere of their film at Bluecoat on 25 November. The group members are keen to continue and their support workers have obtained funding for training that will enable them to develop arts projects themselves, leaving a definite legacy.

Rebecca Jones

CITYSCAPES

Artists Yael Bartana, Francesco Jodice, Wolfgang Müller and Susan Hefuna were introduced to a group of young people from Merseyside. The young people took inspiration from the artists and from exhibitions in the city.[1]

Yael's work is about Israel. And Israel is complicated. But Yael shows us a way in and opens our eyes. We watch footage from a religious festival in Jerusalem and Tel Aviv. The imagery is engaging. It's completely new to us and surprises or shocks us. It's interesting because it's so unfamiliar. Yael uses techniques that intensify the atmosphere: slow motion and slowed-down voices; a girl in a white gown who keeps reappearing. It seems to affect our perception of time passing.

Francesco's 100 stories. Tiny stories made from photographic stills. Tiny gestures between people. Fragments of movement from the briefest of moments in someone's life. The images flow into one another: small, slowly moving portraits from all over the world. In other artworks we see the camera follow someone across the city, from the place they leave to the place they arrive. The subjects don't know they are being followed and we feel we are experiencing something of their lives, their world, in secret.

Wolfgang Müller. Portraits. Young people. Homeless. Taking drugs. Sleeping rough. Hanging out in derelict buildings. Running across rooftops or staring directly into the camera. The place is St Petersburg, it's Russia. We find the images disturbing, sad and also beautiful. And we think of people we know, experiences we have had, real life.

Susan Hefuna places a camera looking down on a dusty view. The colour is warm, not bright or chaotic. It's a simple cross-roads in a quiet village in Egypt. Things happen slowly here. We watch a camel

Tracking
Project participants'
artwork
Photo: Patricia
Mackinnon-Day

walk by and, much later, someone on a bike. Stillness. A cat appears in the tree, and a tall woman passes carrying a parcel on her head. Two long minutes. Someone enters from the west, someone from the north. They pass in the middle of the cross. It's quiet.

Working with myself and a video producer, the groups developed ideas in response to the artists' work. They learned the technical skills of video recording and editing to create two short films reflecting their own experiences of Liverpool. Shopping, the city centre, young people and clothing, identity. Quiggins as a cultural hotspot for young people; portraits putting themselves at the centre of the work.

Andrea Lansley

¹ Wolfgang Müller's exhibition *Karat: Sky Over St Petersburg* was shown at Open Eye Gallery, 19 June–28 August 2004. Susan Hefuna's exhibition *X Cultural Codes* took place at Bluecoat Arts Centre, 29 May–17 July 2004.

TRACKING

Crowds pushing, hectic corridors, loud bells. All evoke the atmosphere of a typical comprehensive until you pass through the double doors of the art department at Sutton High School. The department is inspired by Derek Boak, artist and teacher. Derek greets students wearing overalls spattered in paint; his world revolves around not only his own work, but also making exciting projects happen for his students.

The entrance foyer of the art department has been transformed into a small gallery. Classical music plays quietly in the background. Young artists (pupils) move around the space with serious intent. The space is visually dramatic. Skylights illuminate objects large and small – from old boots to window frames, from chairs to trumpets – suspended from the ceiling.

A group of nine sixth-form students sit in the middle of the gallery space animatedly discussing their ideas for the Biennial exhibition, *Tracking*.

Tracking is about these nine students working in collaboration with artist Amanda Coogan, the Liverpool Philharmonic Orchestra, pyrotechnics experts and filmmakers, to research and produce art for the Liverpool Biennial. Tracking focuses on the idea of students breaking out of the classroom, exploring new territory and making the impossible happen.

Six months ago the students met the musicians from the Philharmonic. At the meeting they heard Amanda Coogan explain her proposal for the Liverpool Biennial, entitled *A Choir of Performers Headbanging for Approximately Seven Minutes of Beethoven's Ninth Symphony*.

A lot has happened since. Students Amanda Houghton, John Harley, Lisa Robinson and Claire Corfield are describing to the group their current negotiations with the Philharmonic. They explain how they

Buddies
Photo: Cath Stevenson

want to film the encore at the end of a performance and then project it as a continuous loop, so that 'the bowing and applause will go on and on forever'.

Nicola Ellis, Kerry Burns and Heather Farquhar produce a series of elaborate drawings, translating the words used in Beethoven's Ninth Symphony into hieroglyphics. They joke about their recent price-haggling meeting with the sales rep at St Helens Glass for a better deal for sandblasting the symbols onto glass panels. More serious deliberation follows as they discuss how to display the glass safely in an open and busy space.

The students plan a schedule and budget to work with the filmmaker and pyrotechnics experts to explode a cello with fireworks. The Philharmonic have just granted permission for the group to project the finished film onto the wall of the entrance hall. This is great news.

Patricia Mackinnon-Day

BUDDIES

International 04 artists staying in Liverpool are matched with a 'buddy'. The 'buddy' is a student who has an interest in art and who knows Liverpool well. This scheme is designed to give the volunteer experience regarding contemporary arts production as well as providing assistance for the artist.

The proposal to set up visiting artists with undergraduate Fine Arts students from Liverpool conjures up visions of a cross between a blind date and a script for a road movie. The potential for both success and disaster is there in equal measure. Whichever way, the experience would be an education. Many of the visiting artists have worked on major international projects prior to coming to Merseyside. The vast majority of the Liverpool Community College Fine Arts students have experience of previous Liverpool Biennial events, some invigilating at city centre venues in 2002. Both expectations and concerns would be high for both parties.

> I was apprehensive meeting Azra. . . However, I need not have been concerned, as before the end of the day we had become friends; we briefly shared our life stories. At the finish of the project we shared a personal moment when a woman in the café took a photo of us. . . I look forward to seeing and working with her again.
>> Cath Stevenson, HND Fine Arts, working with Azra Aksamija

For a successful liaison, the aim would be to pair needs, interests and skills.

> As Ursula explained her intentions about her work I realised that her interests had an identity with my own background and experiences as an asylum seeker. It was exciting to be part of a work in progress, being able to assist with many of the technical

problems that arose and finding the right locations. I feel really privileged to be a part of this and it will definitely influence the way that I work in the future.

 Aboubaker Abdullah, HNC Fine Arts, working with Ursula Biemann

All the 'buddies' felt part of the process and were able to witness at first hand the drive and enthusiasm of the artists in the realisation of their works over and above everything else. The words most frequently used by the 'buddies' in describing the attitude of the visiting artists were 'planning', 'preparation' and, above all, 'professionalism'.

 Jill knew exactly where she wanted to go and how she wanted to work. One of the memories I have was standing in front of the door leading into the main room of the Philharmonic pub, so that the landlord and the barmaid could not see Jill with her tripod and camera filming the room and the customers having a drink – Jill's confidence and friendliness ensured the cooperation of everyone being filmed within minutes.

 Des Shaw, HNC Fine Arts, working with Jill Magid

None of the students involved in this initiative had any hesitation in recommending the Buddies scheme to others.

Geoff Molyneux
HND/HNC Fine Arts course leader, The Arts Centre,
Liverpool Community College

VIRAL TREATS

In January 2004, BA (Hons) Multimedia Arts students at Liverpool School of Art & Design, Liverpool John Moores University, embarked upon a brief set by the Liverpool Biennial and Love Creative to design and create a series of 'viral treats' to promote the Liverpool Biennial 2004. Viral treats are digital entities, designed to be forwarded by email, to promote events, artists and specific exhibitions in the Biennial. 'Treats' included interactive playthings and games, animations and screensavers.

A key requirement of a viral treat is that it can be distributed by email; another is that the recipient would choose to forward it – perhaps to everyone in his or her address book. Successful viral treats include those which engage, inform, challenge or entertain the user. It was proposed that a selection of treats would be emailed to promote the event. The treats were designed to be quickly shared locally, nationally and internationally, promoting the Biennial, the city and also the student designer.

 Sharon Paulger of the Biennial met up with the students to introduce the history and philosophy of the Liverpool Biennial and to present artists' projects and previous work. She provided a full set of artists' proposals for the forthcoming Biennial and, since many of the students had not been living in the city in 2002 and had not attended the previous event, she also provided a catalogue and information about the Liverpool Biennial 2002. This helped to contextualise the event and provided a useful starting point for seminar discussions.

 Although the project was initially proposed for Level 3 students, interest quickly grew and staff decided to open the project up to all three years. This proved to be very successful, increasing communication, support and healthy competition between levels. Students responded well to the fact that this was a live brief and that

Wild! STATIC
'Who is our Audience?'
seminar
Photo: Becky Shaw

their work might actually be used as part of the campaign or as part of an exhibition.

Representatives of the Biennial and Love returned to critique the work on completion and all Level 3 students and a selection of Level 2 students presented their work to the panel. This was a valuable opportunity for students to gain feedback from industry representatives and the panel were extremely impressed by the quality of work presented.

Working on this project has made the Biennial a much more personal event for those involved and there is a high level of anticipation from students eager to see how their proposals have actually been realised. The project was considered a success by all involved and the body of work will provide staff with a useful resource with which to introduce the next group of students to the Liverpool Biennial – and so the promotion continues. . .

Carole Potter

WILD!
Static

Through discussion and experiment, eight recently graduated art students critically explored what it is to build an audience, starting with building an audience for their own work.

Since its inception Static has sought to question the parameters of artistic practice, so an inquiry into audience presented a relevant challenge. Static was invited to work with recently graduated artists, reflecting the organisation's interest in building critical structures that support practice. However, Static was uneasy about entering into such a partnership, not wanting to serve the agendas of another organisation, nor to enter into a relationship that was unquestioning. When Jo Lansley began to recruit the group and gently initiate dialogue it became apparent that Static's questions also lay in the minds of the artists forming the group. Just why should a group of self-defining young artists serve the needs of other artists or even other organisations, including Static? In the early weeks of discussion it became clear that these artists wouldn't function as unpaid researchers. However, the act of developing an audience for their own practice, as artists who may be in the Independent or International shows one day, was a task worth their while.

During months of visits, discussions, interviews, socials and surgeries with expert curators and artists, Jo Lansley provoked the group to consider how they might take practical steps to develop their own audience. Democratic decision-making and group action were difficult and Jo experimented with ways to foster decisions, through constantly changing the relationship between individual and group, and the emphasis placed on one or the other. It became apparent that one single group work was not going to happen. The reasons for this remain unknown. Some speculate that artists are

historically self-seeking and unable to work as a group, but it seemed that far from being selfish, these artists were too sensitive to each other's needs and this was limiting progress. Finally, any hand-holding stopped and the project was put firmly back into the artists' hands. They were commissioned to make their own work, but with a greater consideration of audience.

Some of the artists made no work, reaching the conclusion that being an artist was not the life they wanted to lead. While this was an unexpected, and of course indirect, outcome of the project, it seems a healthy and positive result. The other artists developed a range of activities. Barbara Jones closed a city-centre road and met over 500 people in her project to study the current political distribution of peace and disease. Laura Pullig produced a faux-promotional set of postcards for mass distribution while Steven Lloyd invented a web-based alter ego for himself. John Borley made football matches, Caroline Black organised tea parties, while Andy Poole proposed a late-night discussion on love and hate. Steven Renshaw, with the help of the whole group, organised an event, 'Who is our Audience?', inviting international speakers to explore ideas of audience, and generating Static's biggest audience for live discursive events so far. However, more importantly than numbers, the event and the project as a whole gave Wild! and Static grounds for serious thought about audience, access, ownership and the problems of generating healthy debate.

Becky Shaw

Artists' Biographies

Azra Aksamija

Born 1976, Sarajevo, Bosnia. Lives in Boston, USA and Graz, Austria

Selected Group Exhibitions

2004 *Video as Urban Condition* at the Visual Arts Program of the Austrian Cultural Forum, London, UK

Noch einen Wunsch, Gallery for Contemporary Art, Leipzig, Germany

2003 Participant at the 6th Biennial of Architecture and Media, Graz, Kunsthaus Graz, Austria

Art Fair Berlin, Germany, presented by the Gallery for Contemporary Art, Leipzig, Germany

micro-UTOPIAS. Art & Architecture, Valencia Biennial, Valencia, Spain

Introducing Sites/Cultural Territories, Gallery for Contemporary Art, Leipzig, Germany

2002 *Designs for the Real World*, Generali Foundation, Vienna, Austria

Selected Collaborations and Projects

2004 Judge for the international competition *Reinventing Urbanism*, organised by archplus as part of the *Shrinking Cities* project in cooperation with Domus

Curator of *Balkan Urbanism* at the Gallery for Contemporary Art, Leipzig, Germany

Collaboration in institution, communication and urban design of the projects *XLA* and *Battersea* for Atopia, New York, USA

2002 Collaboration in research project *Habitat 2000 plus* and in editing the publication *In the Boat*, Vienna, Austria

2001–2002 Conceptual design with interdisciplinary research group *Su.N* (Spaceunit.Network)

Collaboration with Andreas Mayer on the project *Arizona Road*

2001 Collaboration in editing the publication of European 6 Austria, Vienna, Austria
Organisation and location design for the final party of the festival *Steirischer Herbst*, Graz, Austria

2001 Organisation of the symposium *Perfekte Location*, House of Architecture, Graz, Austria

Organisation of the exhibition *The Private House*, House of Architecture, Graz, Austria

Further Reading

Azra Aksamija, 'Arizona Road', in Sabine Breitwieser (ed.), *Designs für die wirkliche Welt. Designs for the Real World*, Vienna: Generali Foundation; Cologne: Walther König, 2002, pp. 36–79

Azra Aksamija, 'Arizona Road. The Discovery of the Urban Phenomenon: *Arizona Road* in Bosnia', *Artelier – Contemporary Art Magazine*, 8 (2003), pp. 139–45

Azra Aksamija, 'The Fallen Angel: The Building of Oslobodjenje in the Context of Post-War Reconstruction of Bosnia and Hercegovina', *Artelier – Contemporary Art Magazine*, 8 (2003), pp. 146–54

Lara Almarcegui

Born 1972, Zaragoza, Spain. Lives and works in Rotterdam, the Netherlands

Selected Solo Exhibitions

2004 FRAC Bourgogne, Dijon, France

2003 INDEX, Stockholm, Sweden

Chantiers ouverts au public, Le Grand Café, Saint-Nazaire, France

Demolition in Front of the Exhibition Room, Gallery Marta Cervera, Madrid, Spain

2001 Etablissement d'en Face, Brussels, Belgium

Gallery Marta Cervera, Madrid, Spain

2000 Gallery Ray Gun, Valencia, Spain

1999 Stedelijk Museum Bureau Amsterdam, with Birthe Leijmeier, Amsterdam, the Netherlands

1998 Gallery Marta Cervera, Madrid, Spain

Selected Group Exhibitions

2004 *Le Prochain et le Lointain*, Domaine de Kerguéhennec, Bignan, France

LAB, Kröller Müller Museum, Otterloo, the Netherlands (curated by Nathalie Zonneberg)

1 x 1 realité, quantité, temps, FRAC Bourgogne, Dijon, France (curated by Eva González-Sancho)

2003 *Idealism*, De Appel, Amsterdam, the Netherlands (curated by Theo Tegelaers)

Antirealismos, Australian Centre for Photography, Sydney, Australia (curated by P. Barragan)

Sin Título, Sala Montcada de la Caixa, Barcelona, Spain (curated by Moritz Küng)

2002 *Big Torino 2002*, Torino Biennial, Torino, Italy

Últimas Adquisiciones, CGAC, Santiago de Compostela, Spain

2000 *Scripted Spaces*, Witte de With, Rotterdam, the Netherlands (curated by Bartomeu Marì)

Espacio como Realidad, como Proyecto, Pontevedra Biennial, Pontevedra, Spain (curated by Maria del Corral)

Projects in Public Spaces

2003 *Allotment Gardens*, Urban Festival, Zagreb, Croatia

Making a Wasteland, Rotterdam Port, Rotterdam, the Netherlands

2002 *Wastelands Tour*, British Architectural Week, FACT, Liverpool, UK

Looking for Wreckage, FRAC Lorraine, Metz, France

2000 'Guided Tours to Allotment Gardens that will Disappear', within the project *Becoming an Allotment Gardener*, Witte de With, Rotterdam, the Netherlands

Opening of a Wasteland, Container Project Nicc, Brussels, Belgium

Further Reading

Jeroem Boomgaard, 'An Injection of Planlessness', in *One Year in the Wild*, edited by Lectoraat Art in Public Space, Gerrit Rietveld Academie, University of Amsterdam, 2004

Ole Bouman, 'The Emancipation of Nowhere Land', *Pasajes de Arquitectura y Crítica*, Madrid (February 2004)

Santiago Cirugeda, 'Lara arreglatodo', in *Subrosa*, Brussels: Editions La Lettre Volé, 2002

Beatrice Josse, 'La Tentation de l'espace/ouvre ou comme échapper à l'architecte', *Cahier teorique*, 1, FRAC Lorraine, Metz (2003)

Anne Pontégnie, 'Lara Almarcegui Takes Apart the Gallery', *Artforum Digital* (May 2001)

Ramon Tio Bellido, 'Lara almar lara al campo', in *Lara Almarcegui*, exh. cat., Brussels: Etablissement d'en Face; Saint-Nazaire: Le Grand Café, 2003

Gustavo Artigas

Born 1970, Mexico City, Mexico. Lives and works in Mexico

Selected Solo Exhibitions

2002 *Emergency Exit/Salida de emergencia*, Museo de Arte Carrillo Gil, Mexico City, Mexico

Art 33 Basel, Basel, Switzerland

Duplex, Project Room, ARCO, Madrid, Spain

2001 *Locals Hate U.S.: Gustavo Artigas in South Africa*, Iturralde Gallery, Los Angeles, USA

Locals Hate U.S., BagFactory, Johannesburg, South Africa

2000 *Porqué You Have Not Called To Me*, Intervention, Art in Situ, the Tower of Winds, Mexico City, Mexico

1998 *To Clock. The Shape of Time*, Basel, Switzerland

1997 *Ritual and Rhythm Installations*, The Other Gallery, Banff Centre for the Arts, Alberta, Canada

Reading and Installation Ritual and Video, Gallery Unodosiete, Mexico City, Mexico

1996 *Desalojo/Muro of Sound*, pirate radio transmission/sound installation, Jesus Maria 42, Historico Center, Mexico City, Mexico

Selected Group Exhibitions

2002 *Mexico City: An Exhibition about the Exchange Rates of Bodies and Values*, P.S.1, New York, USA/Kunstwerke, Berlin, Germany

Body Power/Power Play, Württembergischer Kunstverein, Stuttgart, Germany

Axis/Mexico, San Diego Museum of Art, San Diego, USA

Fair Play, De Nouveau règles du jeu Guerlain Foundation, Paris, France

The X Files, La Panadería, Mexico City, Mexico

2001 *Blind Spot*, Blow Up Gods Gallery, Johannesburg, South Africa

49th Venice Biennale, Venice, Italy

Tent, Centrum Beelende Kunst, Rotterdam, Amsterdam

2000 7th Havana Biennial, Havana, Cuba

InSite 2000: Binational Art Project in Public Spaces, San Diego, USA/Tijuana, Mexico. Action videos, Artists' Space, New York, USA

The Friendship, Holguin, Cuba

1999 *Noise: First Festival of Sonorous Art*, Ex Teresa Arte Actual, Mexico City, Mexico

1998 *Non-Lieux: Poésie des Nich-ortes*, Exposition of International Art in Public Spaces, Kaskadenkondensator Alternative Space, Basel, Switzerland

In the 90s: Mexican Contemporary Art, Mexican Institute of Culture, Washington DC/New York, USA

Everyday Life Objects, The CAP, Post d'Art, Fribourg, Switzerland

After the Body, Gallery Unodosiete, Mexico City, Mexico

Further Reading

Cecilia Bembibre, 'InSite 2000', *Latinarte* (December 2000–January 2001)

Collette Chattopadhayay, 'InSITE 2000', *ArtNexus*, 39 (January–March 2001)

Pamela Echeverria, 'From the Tijuana/San Diego Border', *Flash Art* (January–February 2001)

José Jiménez, *El final del eclipse*, exh. cat., Madrid: Fundación Telefónica, 2001, pp. 110–17

Rachel Weiss, 'The Orbit of the Seventh Biennial of Havana', *ArtNexus* (February–April 2001), pp. 49–55

Yael Bartana

Born 1970, Afula, Israel. Lives and works in Israel and Amsterdam

Selected Solo Exhibitions

2004 MIT List Visual Arts Center, Cambridge, MA, USA

Büro Friedrich, International Venue for Contemporary Art, Berlin, Germany

Prefix Institute of Contemporary Art, Toronto, Canada

2003 P.S.1 Contemporary Art Center, New York, USA

Herzliya Museum for Contemporary Art, Herzliya, Israel

Annet Gelink Gallery, Amsterdam, the Netherlands

Kerstin Engholm Galerie, Vienna, Austria

2002 Museum Beelden aan Zee, Scheveningen, the Netherlands

The Israeli Center for Digital Art, Holon, Israel

2001 Caermersklooster, Ghent, Belgium

Selected Group Exhibitions

2004 *Time Zones: Recent Film and Video*, Tate Modern, London, UK

Wherever I Am, Modern Art Oxford, Oxford, UK

Lonely Planet, Contemporary Art Gallery, Art Tower Mito, Ibaraki, Japan

2003 *After-Life*, Vane, Newcastle upon Tyne, UK

Territories, KW-Berlin, Berlin, Germany

The Promise, The Land, OK Centre for Contemporary Art, Vienna, Austria

2002 *Rendez-Vous*, Musée d'Art Contemporain de Lyon, Lyons, France

Manifesta 4, European Biennial of Contemporary Art, Frankfurt am Main, Germany

4th Gwangju Biennale, Gwangju, Korea

2000 *Greater New York*, P.S.1, New York, USA

Open Ateliers, Rijksakademie van beeldende kunsten, Amsterdam, the Netherlands

Selected Film/Video Festivals

2004 *Transmediale 2004*, International Media Art Festival, Berlin, Germany

33rd International Film Festival, Rotterdam, the Netherlands

2003 Kasseler Documentarfilm und Videofest, Kassel, Germany

Festival Bandits Images, Bourges, France

Macau Arts Festival, Macau

2002 *Story Agent – Video Zone*, 1st Video Biennial, Tel Aviv, Israel

Videotage, Microwave International Media Art Festival 2002, Hong Kong

VIPER Basel 2002, International Competition Film/Video Programme, Basel, Switzerland

Cité des Ondes, 5th International Manifestation of Video and Electronic Arts of Montreal, Montreal, Canada

Media Forum 2002, XXIV Moscow International Film Festival, Moscow, Russia

Further Reading

'Yael Bartana – Interview with Danila Cahen', in *Quicksand*, Amsterdam: De Appel Foundation, 2004

Charles Esche, 'Yael Bartana', in *Cream 3 – Contemporary Art in Culture*, New York: Phaidon, 2003, pp. 56–59

Anselm Franke (ed.), *Territories: Islands, Camps and Other States of Utopia*, Berlin: KW-Institute for Contemporary Art, 2003

Essays by Linda Grant and Galit Eilat in Miria Swain (ed.), *Wherever I Am: Yael Bartana, Emily Jacir and Lee Miller*, Oxford: Modern Art Oxford, 2004

Ursula Biemann

Ursula Biemann studied art and cultural theory in Mexico and at the School of Visual Arts and the Whitney Independent Study Program in New York. Her art and curatorial work focuses on gender relations in economy, media and geography, including a two-year project,

Kültür, on gender and urban politics in Istanbul and videos on the US–Mexico border, the global sex industry and the Spanish Moroccan borderlands. Her video-essays *Performing the Border* (1999), *Writing Desire* (2000), *Remote Sensing* (2001) and *Europlex* (2003) have been shown at biennials in Geneva, Istanbul and Havana and at festivals in Kassel, Duisburg, Chicago and Werkleitz, as well as at international art exhibitions *Manifesta 3* in Ljubljana, *InSite* Los Angeles, and at the Modern Art Museum in New York, MACBA Barcelona, the Centre Pompidou in Paris and Tate Modern in London. In 2003 she curated the exhibition and catalogue *Geography and the Politics of Mobility* at the Generali Foundation in Vienna. She has also published *been there and back to nowhere: gender in transnational spaces* (b_books, Berlin) and *Stuff It: The Video Essay in the Digital Age* (Springer, Vienna/New York, 2003). She is currently producing a video complex entitled *The Black Sea Files* on Caspian oil politics, and will conduct a group project in Cairo in 2005–2006. Biemann researches at the Institute for Theory of Art and Design at HGKZ, Zurich, and teaches seminars and workshops internationally. www.geobodies.org

Luis Camnitzer

Born in Germany, 1937. Emigrated to Uruguay in 1939. Citizen of Uruguay. Has lived in USA since 1964

Selected Exhibitions

2003 Retrospective Exhibition, Kunsthalle, Kiel, Germany

2002 Documenta 11, Kassel, Germany

2001 The Kitchen, New York, USA

Versiones del Sur, Museo Reina Sofía, Madrid, Spain

2000 Whitney Biennial, New York, USA

1999 Liverpool Biennial of Contemporary Art, Liverpool, UK

1997 Bienal de Mercosur, Porto Alegre, Brazil

1996 *Universalis*, XXIII Bienal de São Paulo

Face à l'histoire (1970s and 1980s sections), Centre Pompidou, Paris, France

Permanent Collections

Museum of Modern Art, New York. Metropolitan Museum, New York. Whitney Museum, New York. The Public Library, New York. Museo de Arte Moderno, Buenos Aires. Museo del Grabado, Buenos Aires. Museo de Bellas Artes, Santiago de Chile. Museo Universitario, Mexico. Museo de Bellas Artes, Caracas. Museo de Arte Contemporaneo, São Paulo. Museo of Malmö. Museum of Trenton. Yeshiva University, New York. Bibliothèque Nationale, Paris. Biblioteca Communale, Milan. National Library, Jerusalem. RCA Corporation. ARCO Corporation. Wagstaff Collection, Getty Museum. Museo de Arte Moderno, Bogotá. Museo de Arte Moderno, Cartagena. Museo La Tertulia, Cali. Museum Wiesbaden. National Museum of Modern Art, Baghdad. Casa de las Américas, Havana. Blanton Museum, Austin, Texas. Museum of Skopje. Centro Wifredo Lam, Havana. Museo Nacional de Bellas Artes, Havana. The Jewish Museum, New York. Museo Nacional de Artes Plasticas, Montevideo. Museo del Barrio, New York. Cabinet of Drawings and Prints of the Uffizi, Florence, Italy. Queens Museum, New York. Museum of Fine Arts, Houston

Further Reading

Arte y Enseñanza: La ética del poder, Casa de América, Madrid, 2000

New Art of Cuba, University of Texas Press, 1994/2003

Essays in *Marcha*, Montevideo, *Third Text*, London, *Art in America*, New York, *New Art Examiner*, Chicago, *Art Nexus*, Bogotá, *Brecha*, Montevideo, *Spiral*, New York, *Nacla*, New York, *Trans*, New York, *Lápiz*, Madrid, *Drawing Papers*, New York

Paolo Canevari

Born 1963, Rome, Italy. Lives and works in Rome

Selected Solo Exhibitions

2002 *Colosso*, Galleria Christian Stein Milano, Milan, Italy

2001 *13*, Center for Academic Resources, Chulalongkorn University, Bangkok, Thailand

Before Extasy, Galerie Cent8, Paris, France

Papa, Palazzo delle Papesse, Centro Arte Contemporanea, Siena, Italy

2000 *Mama*, Associazione Volume!, Rome, Italy

1999 *Radio Londra*, Accademia Britannica, Rome, Italy

Chiuso, Ponte Project, Rome, Italy

Gesellschaft der Freunde junger Kunst, Baden-Baden, Germany

1998 *Campo*, Galleria Stefania Miscetti, Rome, Italy

Fosso, Instituto Austriaco di Cultura, Rome, Italy

Ho Fame, Galleria Otto, Bologna, Italy

1997 Shoshana Wayne Gallery, Los Angeles, LA International – Biennial Invitation

Selected Group Exhibitions

2003 *Artefiera Bologna*, Galleria Christian Stein Milano, Bologna, Italy

In Tutti i Sensi, Superstudio, Milan, Italy (curated by Gabi Scardi and Patrizia Brusarosco)

Moltitudini/Solitudini, Museion, Bolzano, Italy (curated by Sergio Risaliti)

2002 *EV+A: Heros + Holies*, Limerick, Ireland (curated by Apinan Poshyananda)

Tutto Normale, Accademia di Francia, Villa Medici, Rome, Italy (curated by Jerome Sans and Ludovico Pratesi)

Third International Biennal, Gyumri, Armenia (curated by Dobrila de Negri)

Tutti i nomi di Dio, Artandgallery, Milan, Italy (curated by Manuela Gandini)

Fuori Uso, Ferrotel, Pescara, Italy (curated by Mario Codognato)

ArtCologne, Galleria Christian Stein Milano, Cologne, Germany

Working Insider, Meccano Tessile, Florence, Italy (curated by Sergio Risaliti)

2001 *Muoviti Segno*, Palazzo Poli, Rome, Italy (curated by Marco Giusti)

Marking the Territory, Irish Museum of Modern Art, Dublin, Ireland (curated by Marina Abramovic)

2000 *Playground and Toys for Refugee Children*, Museo Andersen, travelling exhibition: Geneva, Rome, New York, Lugano, New Delhi, São Paolo

Giganti, Fori Romani, Rome, Italy (curated by Ludovico Pratesi)

Tirannicidi, Istituto Nazionale per la Grafica, Rome, Italy (curated by Luigi Ficacci)

Window onto Venus, Havana Biennial, Havana, Cuba (curated by Associazione per L'Arte Contemporanea Zerynthia)

1999 *Lavori in Corso*, Galleria Comunale di Arte Moderna e Contemporanea, Rome, Italy

XIII Quadriennale di Roma, Palazzo delle Esposizioni, Rome, Italy

Public Art in Italy, Viafarin, Milan (curated by Patrizia Brusarosco and Alessandra Pioselli)

Biennale di Lubiana, Ljubljana *Instrumenta Imaginis*, San Martino Valle Caudina, Italy

Special Projects

1997 *Snow Man*, unauthorised installation, Kunstmuseum, Berne, Switzerland

Herren, unauthorised installation, Stedeljik Museum, Amsterdam, the Netherlands

1996 *Sussurri*, Grida, Blobcartoon, Rai 3 (curated by Marco Giusti)

Outdoor Works

2001 *Colonna*, fountain, Lamezia Terme, Italy (curated by Barbara Tosi)

2000 *Uomoerba*, Sculpture Park Villa Glori, Rome, Italy

Further Reading

Paolo Canevari, Milan: Edition Charta, 2002

Mario Codognato, *Paolo Canevari. Volume!*, *Artforum*, 9 (May 2001)

Cheryl Kaplan, *Paolo Canevari*, *Flash Art* (October–November 2001)

Achille Bonito Oliva, in *Gratis a bordo dell'arte*, Milan: Edition Skira, 2000

Choi Jeong Hwa

Born 1961, Seoul, South Korea

Selected Solo Exhibitions

1998 *Dislocation and Relocation*, Kukje Gallery, Seoul, South Korea

1997 OZ Gallery, Paris, France

Center of Academic Resources, Chulalongkorn University, Bangkok, Thailand

Selected Group Exhibitions

2003 *Happiness*, Mori Art Museum, Roppongi Hills, Tokyo, Japan

Flower Tree, Biennale de Lyon, Lyons, France

Korean artists' exhibition, BizArt Art Center, Shanghai, China

Happy Together, Kagoshima Open Air Museum, Kagoshima, Japan

2002 *World Cup Art Soccer Korea and Japan*, Gwangju Biennale, Gwangju, South Korea

2001 Yokohama Triennale, Japan

1999 Tachigawa Festival, Tachigawa, Japan

Slowness Speed, National Gallery of Victoria, Melbourne, Australia

1998 XXIV Bienal de São Paulo, Ciccillo Matarazzo Pavilion, São Paulo, Brazil

Amanda Coogan

Born 1971, Dublin, Ireland. Lives in Ireland

Selected Group Exhibitions and Projects

2004 *Performance Loop*, P.S.1, New York, USA

Molly: Bloomsday #3, Context Gallery, Derry, Northern Ireland

Art4Amnesty, IMMA, Dublin, Ireland

West Cork Arts Centre, Skibbereen, Ireland

2003 *Flix*, Rubicon Gallery, Dublin, Ireland

Asiatopia, Concerte House, Bangkok, Thailand

Recycling the Future, Venice Biennale, Venice, Italy

As Soon as Possible, PAC, Milan, Italy

Reading Beethoven, Location, Playforum, Firestation Artists' Studios, Dublin, Ireland

2002 *Eurojets Futures*, Royal Hibernian Academy, Dublin, Ireland

Eisge Arts Festival, CIT, Carlow, Ireland

Intermedia, Triskel Arts Centre, Cork, Ireland

EV+A 02, Limerick City Centre, Ireland

Marking the Territory, IMMA, Dublin, Ireland

Further Reading

Marina Abramovic, *Marking the Territory*, Dublin: Irish Museum of Modern Art Video Catalogue, 2001

Marina Abramovic, *Student Body*, Charta, 2003, pp. 33, 178–85, 499–500

Patrick T. Murphy, *Eurojets Futures 02*, Dublin: Royal Hibernian Academy, 2002, pp. 16–19

Paul M. O'Reilly, *EV+A 99 Reduced*, Limerick: Gandon Editions, 1999, pp. 16–17, 56–57, 132

Paul M. O'Reilly, *EV+A 2002 Heros + Holies*, Limerick: Gandon Editions, 2002, pp. 10, 54–55

Neil Cummings and Marysia Lewandowska

Selected Projects

Neil Cummings and Marysia Lewandowska have collaborated together since 1995. Their first project was a book *Lost Property*, published by Chance Books and Public Art Development Trust in 1996. In October 2000 a long-term book project *The Value of Things* was published by August/Birkhauser; it traced the parallel history of the public museum and the department store. In December of the same year a series of events *Documents* marked the culmination of a year-long residency at the Design Council Archive. *Capital*, a series of seminars, publication and gift, is the inaugural project in the Contemporary Interventions series at Tate Modern, which involved the cooperation of the Bank of England Museum in May–September 2001. *Free Trade* was launched with the reopening of the Manchester Art Gallery, with an exhibition installation, lecture programme, series of guided walks and catalogue. In July 2004 *Enthusiasts*, an exhibition involving amateur film clubs, opened at the Centre for Contemporary Art in Warsaw. It will travel to the Whitechapel, London, in 2005. liverpoolcommons.org will be our contribution to the Liverpool Biennial in September–November 2004.

Selected Publications

Capital, London: Tate Publishing, 2001

Documents, Brighton: PhotoWorks, 2000

Enthusiasts, Warsaw: Centre for Contemporary Art, 2004

Free Trade, Manchester: Manchester City Galleries, 2002

Give and Take, London: Serpentine Gallery/Victoria & Albert Museum, 2001

Lost Property, London: Chance Books/PADT, 1996

Reprise, London: South London Gallery, 2003

The Value of Things, August/Birkhauser, 2000

For more information visit http://www.chanceprojects.com

Aleks Danko

Born 1950, Adelaide, SA, Australia. Lives and works Daylesford, Victoria, Australia

Selected Individual and Collaborative Exhibitions

2004 *SONGS OF AUSTRALIA VOLUME 16 – SHHH, GO BACK TO SLEEP (an un-Australian dob-in mix)*, Contempora Fellowship 2002–2004, The Ian Potter Centre: NGV Australia, Melbourne, Victoria, Australia; Bendigo Art Gallery; Swan Hill Regional Art Gallery, Victoria, Australia

SONGS OF AUSTRALIA VOLUME 14/2 – ANYWAY WHATEVER (there must be something somewhere?. . .remix), Sutton Gallery, Melbourne, Victoria, Australia

2003 *SONGS OF AUSTRALIA VOLUME 14 (there must be something somewhere?)*, Gitte Weise Gallery, Sydney, NSW, Australia

2001 *SONGS OF AUSTRALIA VOLUME 12 – WARNING: CARDIAC AT REST (the Adelaide remix)*, Contemporary Art Centre of South Australia, Adelaide, SA, Australia

SONGS OF AUSTRALIA VOLUME 11 – WARNING: CARDIAC AT REST (analgesic mix), Gitte Weise Gallery, Sydney, NSW, Australia

SONGS OF AUSTRALIA VOLUME 10 – WARNING: CARDIAC AT REST, Sutton Gallery, Melbourne, Victoria, Australia

2000 *SONGS OF AUSTRALIA VOLUME 9 – UH-OH THE CHINESE ARE COMING (takeaway mix)*, Art Gallery of New South Wales Contemporary Projects, Sydney, NSW, Australia

Selected Group Exhibitions

2003 *MCA Unpacked II*, curated by Joan Grounds, Museum of Contemporary Art, Sydney, NSW, Australia

This Was the Future. . . Australian Sculpture of the 1950s, 1960s, 1970s and Today, Heide Museum of Modern Art, Melbourne, Victoria, Australia

Journey to Now: John Kaldor Art Projects and Collection, Art Gallery of South Australia, Adelaide, SA, Australia

Experimenta House of Tomorrow, Melbourne, Victoria, Australia

SONGS OF AUSTRALIA VOLUME 15 – THE HOUSE THAT JOHN AND WENDY BUILT (another STOLEN generation mix-up), Clemenger Award of Contemporary Art, The Ian Potter Centre: NGV Australia, Melbourne, Victoria, Australia.

2002–2003 *SONGS OF AUSTRALIA VOLUME 13 – WIDE LAWNS AND NARROW MINDS (the John and Wendy Headache Mix)*, Meridian, Museum of Contemporary Art, Sydney, NSW, Australia

Fieldwork – Australian Art 1968–2002, The Ian Potter Centre: NGV Australia, Melbourne, Victoria, Australia

Further Reading

Melissa Chiu, *A Red Brick House and Chinese Takeaway: Aleks Danko's Songs of Australia*, exh. cat, *Songs of Australia Volume 9: Uh-Oh The Chinese are Coming (Takeaway Mix)*, Sydney: Art Gallery of New South Wales, Contemporary Project, 2000

Aleks Danko (artist's pages), 'Performance Research', *On Place and Praxis*, 3.2 (Summer 1998), London: Routledge

Juliana Engberg, *A History of Happiness*, exh. cat., Melbourne Festival Visual Arts Program, Australian Centre of Contemporary Art, Melbourne, 2002

Adam Geczy and Benjamin Genocchio (eds), *What is Installation? An Anthology of Writings on Australian Installation Art*, Sydney: Power Publications/University of Sydney, 2001

Charles Green, *Peripheral Vision: Contemporary Australian Art 1970–1994*, Sydney: Craftsman House, 1995

David Thomas, 'At Home, Aleks Danko, Born Adelaide 7th April 1950', *Art and Australia*, Olympic Issue, 38.1 (2000)

Dias & Riedweg

Mauricio Dias, born 1964, Rio de Janeiro, Brazil

Walter Riedweg, born 1955, Lucerne, Switzerland

Since 1993, Dias & Riedweg have worked together in collaborative interdisciplinary public art projects

Selected Solo Exhibitions

2004 *Possibly Speaking about the Same*, Kiasma Museum of Contemporary Art, Helsinki, Finland

2003 MACBA Museum of Contemporary Art, Barcelona, Spain

2002 *The Other Begins Where Our Senses Meet the World*, Centro Cultural Banco do Brasil, Rio de Janeiro, Brazil

Recipients of the John S. Guggenheim Memorial Foundation Fellowship

2000 *Dias & Riedweg*, Kunsthalle Palazzo, Liestal, Switzerland

1997 *Devotionalia*, Stroom, The Hague, the Netherlands

1996 Musée d'Art Moderne et Contemporain, Geneva, Switzerland

Museu de Arte Moderna, Rio de Janeiro, Brazil

Selected Group Exhibitions

2004 5th Shanghai Biennial, Shanghai Art Museum, Shanghai, China

Body & Nostalgia, Museum of Modern Art, Tokyo, Japan

2003 8th Havana Biennial, Havana, Cuba

4th Mercosul Biennial, Porto Alegre, Brazil

2002 XXV Bienal de São Paulo, São Paulo, Brazil

Arte Cidade 4, São Paulo, Brazil

2001 Johannesburg Art Gallery, Johannesburg, South Africa

L'Etat des Choses, Kunstwerke Berlin, Berlin, Germany

2000 *InSite 2000*, San Diego, USA/Tijuana, Mexico

Centre d'Art Contemporain Genève, Geneva, Switzerland

1999 Istanbul Biennial Foundation, Istanbul, Turkey

49th Venice Biennale, Venice, Italy

1998 XXIV Bienal de São Paulo International Biennial, São Paulo, Brazil

1996 *Conversations at the Castle*, Atlanta, USA

1995 Shedhalle Zurich, Zurich, Switzerland

Public Art Projects, Video Installations and Commissions

2004 *Sugar Seekers*, FACT, Liverpool, UK © 2004

Throw, Kiasma, Helsinki, Finland © 2004

The Game of Black & White in Colours, Itaú Cultural, São Paulo, Brazil © 2004

Dancing Camera, CCBB, Rio de Janeiro, Brazil © 2004

2003 *Maximal Voracity*, MACBA, Barcelona, Spain © 2003

We Were Not All Made For the Same Ways, in Grupo ReColectivo, Argentina © 2003

God's Lips, Recipient of the Vitae Foundation Art Grant, São Paulo, Brazil © 2002

2002–2005 *Marble and Iron Break*, Kunstprojekte Riem, Munich, Germany © 2002–2005

2002 *Beautiful is Also that which is Unseen*, XXV Bienal de São Paulo, São Paulo, Brazil © 2002

Mere Vista Point, Arte Cidade, São Paulo, Brazil © 2002

2001 *Because I Might Lose*, Rio Arte, Rio de Janeiro, Brazil © 2001

Night Shift, Recipient of Pro Helvetia South Africa Art Grant © 2001

Video Wall, Recipient of Pro Helvetia South

Africa Art Grant © 2001

2000 *Mama & Vicious Rituals, InSite 2000*, San Diego, USA/Tijuana, Mexico © 2000

My Name On Your Lips, Rio de Janeiro, Brazil © 2000

1999 *Tutti Veneziani*, 48th Venice Biennale, Venice, Italy © 1999

This is Not Egypt, Recipient of Pro Helvetia Egypt Art Grant © 1999

Mustafa's Feast, Recipient of Pro Helvetia Egypt Art Grant © 1999

1998 *The Raimundos, Severinos and Franciscos*, 24th São Paulo Biennial, São Paulo, Brazil © 1998

Inside and Out the Tube, Zurich, Switzerland © 1998

1996 *Question Marks*, Arts Festival of Atlanta, Atlanta, USA © 1996

1995 *Inner Services*, Shedhalle, Zurich, Switzerland © 1995

1994–2004 *Devotionalia*, Rio de Janeiro, Brazil © 1994–2004

Further Reading

Dias & Riedweg and Catherine David, *The Other Begins Where Our Senses Meet the World*, Rio de Janeiro: CCBB, 2002

'Dias & Riedweg: Querschnitte durch die Realität', in Paolo Bianchi (ed.), *Lebenskunstwerke (LKW)*, Berlin: Kunstforum International, vol. 142 (1998), vol. 143 (1999)

'Dias & Riedweg: Tutti Veneziani', in Harald Szeemann (ed.), exh. cat. for 49th Venice Biennale, 1999

Mary Jane Jacob, Michael Brenson and Homi Bhabha, *Conversations at the Castle: Changing Audiences and Contemporary Art*, Cambridge, MA: MIT Press, 1997

Sebastian López, Maureen Sherlock, Martina Wohlthat and various authors, *Mauricio Dias & Walter Riedweg*, Collection Cahier d'Artistes, Switzerland: Pro Helvetia/Lars Müller, 1997

'Raimundos, Severinos and Franciscos', in Homi Bhabha and Paulo Herkenhoff (eds), exh. cat. for XXIV Bienal de São Paulo, 1998

Suely Rolnik, Catherine David and Dias & Riedweg, *Possibly Speaking about the Same/Possiblemete hablemos de lo mismo*, Barcelona: Actar/MACBA, 2003/2004

Maria Eichhorn

Born 1962, Bamberg, Germany. Lives in Berlin, Germany

Selected Solo Exhibitions

2003 *Prohibited Imports*, Masataka Hayakawa Gallery, Tokyo, Japan

korrespondenz@maria-eichhorn.de, Kunstverein Kassel, Kassel, Germany

Restitutionspolitik/Politics of Restitution, Lenbachhaus München, Munich, Germany

2002 *23 Shortfilms/23 Filmposters*, Galerie Hauser & Wirth & Presenhuber, Zurich, Switzerland

2001 *Ausstellung vom 21. August bis 29. September 2001/Ausstellung vom 4. September 1999 bis 16. Oktober 1999/Ausstellung vom 9. September bis 7. November 1997/Ausstellung vom 12. September bis 28. Oktober 1995*, Galerie Barbara Weiss, Berlin, Germany

Money at the Kunsthalle Bern, Kunsthalle Bern, Berne, Switzerland

1999 *Museum Street*, Sprengelmuseum Hannover, Hanover, Germany

May First Film Media City, Portikus, Frankfurt am Main, Germany

1998 *Curtain (Denim)/Lectures by Yuko Fujita, Mika Obayashi*, Center of Contemporary Art, Kitakyushu, Japan

Selected Group Exhibitions

2002 Documenta 11, Kassel, Germany

40 Jahre: Fluxus und die Folgen, Wiesbaden, Germany

Quobo, Museum of Contemporary Art, Tokyo, Japan

2001 *Arbeit Essen Angst*, Kokerei Zollverein/Zeitgenössische Kunst und Kritik, Essen, Germany

Yokohama Triennale 2001, Yokohama, Japan

Lost and Found, apexart, New York, USA

Werke aus der Sammlung, Generali Foundation, Vienna, Austria

First Story – Women Building/New Narratives for the 21st Century, Galeria do Palácio, Biblioteca Municipal Almeida Garrett, Porto, Portugal

2000 *Amateur. Variable Research Initiatives 1900 & 2000*, Kunstmuseum, Göteborg, Sweden

– voilà – le monde dans la tête, Museé d'Art Moderne de la Ville de Paris, Paris, France

La Ville, le Jardin, la Mémoire – 2000, Academie de France, Villa Medici, Rome, Italy

Ein/räumen: Arbeiten im Museum, Kunsthalle Hamburg, Hamburg, Germany

1999 *Pro Lidice*, Kunsthalle Fridericianum, Kassel, Germany

Chronos & Kairos, Kunsthalle Fridericianum, Kassel, Germany

Further Reading

Maria Eichhorn, *Das Geld der Kunsthalle Bern/Money at the Kunsthalle Bern*, 2 volumes, Berne: Kunsthalle Bern, 2001/2002

Maria Eichhorn, *Maria Eichhorn Aktiengesellschaft/Maria Eichhorn Public Limited Company*, Kassel: Documenta 11, 2002

Maria Eichhorn, *1. Mai Film Medien Stadt/May Day Film Media City*, Frankfurt am Main: Portikus, 2003

Maria Eichhorn, *Restitutionspolitik/Politics of Restitution*, Munich: Lenbachhaus München, 2004

Carl Michael von Hausswolff

Born 1956, Linköping, Sweden. Lives in Stockholm, Sweden

Selected Solo Exhibitions

2004 Chiangmai Contemporary Art Museum, Chiangmai, Thailand

Brändström & Stene, Stockholm, Sweden

Portikus, Frankfurt am Main, Germany

2003 Galerija Miroslav Kraljevic, Zagreb, Croatia

Nicola Fornello, Prato, Italy (with John Duncan)

2002 Pierogi Gallery, New York, USA (with L. Elggren)

Kisa Konsthall, Kisa, Sweden (with L. Elggren)

Galleri Thomas Ehrngren, Stockholm, Sweden

2001 CCA, Kitakyushu, Japan

Andrehn-Schiptjenko, Stockholm, Sweden

2000 Artspace 1%, Copenhagen, Denmark (with Bigert & Bergström)

Norrtälje Konsthall, Norrtälje, Sweden (with Bigert & Bergström)

Selected Group Exhibitions

2004 *SonarMatica*, Sonar, Barcelona, Spain

Making Differences, Historiska Museet, Stockholm, Sweden

2003 *Invisible Wealth*, Färgfabriken, Stockholm, Sweden

Modesty, Skuc Gallery, Ljubljana, Slovenia

Undercover, Museet för Samtidskunst, Rosklide, Denmark

I Moderni, Museo d'Arte Contemporanea, Castello di Rivoli, Italy

Temporary Spaces, Charlottenborg, Copenhagen, Denmark

Somos Todos Pecadores, Museo de Arte Contemporáneo, Monterrey, Mexico

Beyond Paradise, Shanghai, China

Utopia Station, 50th Venice Biennale, Venice, Italy (with L. Elggren)

2002 *I Promise it's Political*, Museum Ludwig, Cologne, Germany

Somos Todos Pecadores, Museo Rufino Tamayo, Mexico City, Mexico

Beyond Paradise, National Gallery, Bangkok, Thailand

2001 49th Venice Biennale, Nordic Pavilion, Venice, Italy (with Elggren, Grönlund, Nisunen & Tomrén)

2000 *Volume*, P.S.1., New York, USA

Sonic Boom, Hayward Gallery, London, UK

1999 2nd International Biennial, Los Angeles, USA

3rd International Biennial, SITE, Santa Fe, USA

Further Reading

Carl Michael von Hausswolff, *142 Reasons For Still Being Alive*, Kitakyushu: CCA, 2002

Carl Michael von Hausswolff, *Alamut*, Stockholm: Firework Editions, 2004

Satch Hoyt

Born in London, UK. Lives and works in New York, USA

Selected Solo Exhibitions

1997 *Star Worshippers*, Ileana Bouboulis Gallery, Paris, France

Satch Hoyt, Galerie de l'Autre Côte de la Rue, Brussels, Belgium

Selected Group Exhibitions

2004 *Open House: Working in Brooklyn*, Brooklyn Museum of Art, New York, USA

Brown v. Board of Education 1954–2004, Gallery 138, New York, USA

Galerie Anne de Villepoix, Paris, France

2003 *Black President: The Art and Legacy of Fela Anikulapo-Kuti*, New Museum of Contemporary Art, New York, USA

The Squared Circle: Boxing in Contemporary Art, Walker Art Center, Minneapolis, USA

Re-Do China, Ethan Cohen Fine Arts, New York, USA

2002 *Artnew York*, Kunsträume auf Zeit, Linz, Austria

Body Power/Power Play, Württembergischer Kunstverein, Stuttgart, Germany

Where the Boys Are, Clementine Gallery, New York, USA

2001 *Boxer*, Kunsthalle Tirol, Hall, Austria

Encounters, Monterrey, Mexico

SportCult, apexart, New York, USA

1999 *Art of Latin America and the Caribbean*, UNESCO, Paris, France

Further Reading

Jonathan Adams, 'King of Cool and Kalakuta', *Newsweek International* (August 2003)

Helen Allen, 'SportCult, apexart, New York', *Flash Art International* (November/December 2002)

Trevor Schoonmaker (ed.), *Black President: The Art and Legacy of Fela Anikulapo-Kuti*, New York: New Museum of Contemporary Art, 2003

Deirdre Stein Greben, 'A Multimedia Tribute to an African Icon', *Newsday*, New York (July 2003)

Huang Yong Ping

Born 1954, Xiamen, Fujian Province, China. Has lived and worked in Paris since 1989

Selected Solo Exhibitions

2003 *Un cane italiano*, Galerie Beaumontpublic, Luxembourg

2002 *Xian Wu*, Art & Public, Geneva, Switzerland

Om Mani Padme Hum, Barbara Gladstone Gallery, New York, USA

2000 *Taigong Fishing, Willing to Bite the Bait*, Jack Tilton Gallery, New York, USA

1999 *Crane's Legs, Deer's Tracks*, Project Gallery at CCA, Kitakyushu, Japan

1997 *Pharmacie*, Jack Tilton Gallery, New York, USA

Huang Yong Ping, De Appel, Amsterdam, the Netherlands

Da Xian – The Doomsday, Art & Public, Geneva, Switzerland

Le Sage suivant l'exemple de l'araignée qui tisse sa toile, Galerie Beaumont, Luxembourg

Péril de mouton, Fondation Cartier pour l'Art Contemporain, Paris, France

Selected Group Exhibitions

2004 *Le Moine et le démone*, Musée d'Art Contemporain de Lyon, Lyons, France

All Under Heaven, Ancient and Contemporary Chinese Art: The Collection of the Guy & Myriam Ullens Foundation, MuHKA (Museum of Contemporary Art Antwerp), Antwerp, Belgium

A l'ouest du sud de l'est/A l'est du sud de l'ouest, Villa Arson, Nice, France

This Much is Certain, Royal College of Art, London, UK

2003 *Left Wing*, Left Bank Community, Beijing, China

New Zone – Chinese Art, The Zacheta Gallery of Contemporary Art, Warsaw, Poland

Yankee Remix: Artists Take On New England, MASS MoCA, North Adams, MA, USA

Z.O.U. – Zone of Urgency, 50th Venice Biennale, Venice, Italy

2002 *Reinterpretation: A Decade of Experimental Chinese Art (1990–2000)*, Guangdong Museum of Art, Guangzhou, China

Art Unlimited, Art 33 Basel, Basel, Switzerland

Bienal de São Paulo, São Paulo, Brazil

2001 *Huang Yong Ping & Shen Yuan*, Centre for Contemporary Art, Montreal, Quebec, Canada

International Triennial of Contemporary Art Yokohama 2001, Yokohama, Japan

Re-Configuration: Work on Paper, The Courtyard Gallery, Beijing, China; Modern Chinese Art Foundation, Ghent, Belgium

2000 *Paris pour escale*, Musée d'Art Moderne de la Ville de Paris, Paris, France

Shanghai Biennial, Shanghai Museum of Art, Shanghai, China

Voilà, le monde dans la tête, Musée d'Art Moderne de la Ville de Paris, Paris, France

Continental Shift, Musée d'Art Moderne et d'Art Contemporain, Liège, Belgium

Parcou, Saint-Germain-des-prés, Maison de la Chine, Paris, France

1999 *Jean-Pierre Bertrand et Huang Yong Ping*, 48th Venice Biennale, French Pavilion, Venice, Italy

Passage, Watari-Um, Tokyo, Japan

Global Conceptualism: Points of Origin 1950–1980, Queens Museum of Art, New York, USA

Unfinished History, Museum of Modern Art, Chicago, USA

Inside Out: New Chinese Art, Asian Art Museum, San Francisco, USA

Sanja Iveković

Born 1949, Zagreb, Croatia. Lives and works in Zagreb

Selected Solo Exhibitions

2002 *Personal Cuts*, NGBK, Berlin, Germany

2001 *Personal Cuts*, Galerie im Taxipalais, Innsbruck, Austria

Works of Heart, Galerija Josip Racić, Zagreb, Croatia

2000 *S.O.S. Nada Dimić*, Karas Gallery, Zagreb, Croatia

1999 *Delivering Facts, Producing Tears*, ROOTS 98, Hull, UK

1998 *Lice jezika, Attack*, Park Ribnjak, Zagreb, Croatia

Selected Group Exhibitions

2002 *Getting Personal*, 36th Zagreb Salon, Zagreb, Croatia

The Misfits: Conceptualist Strategies in Croatian Contemporary Art, Moscow, Russia; Skopje, Republic of Macedonia; Berlin, Germany

Documenta 11, Kassel, Germany

Attitude 2002, Kumamoto Art Museum, Kumamoto, Japan

2001 *Double Life*, Generali Foundation, Vienna, Austria

Televisions, Kunsthalle Wien, Vienna, Austria

2000 *Re-Play*, Generali Foundation, Vienna, Austria

What, How & For Whom, HDLU, Croatian Association of Artists, Zagreb, Croatia

1999 *After the Wall: Art and Culture in Post-Communist Europe*, Moderne Museet, Stockholm, Sweden

Aspects/Positions: 50 Years of Art in Central Europe, 1949–1999, Museum Moderner Kunst Stiftung Ludwig, Vienna, Austria

Further Reading

Documenta 11 Platform 5: Ausstellung, Ostfildern-Ruit: Hatje Cantz, 2002

Primary Documents: A Sourcebook for Eastern and Central European Art since the 1950s, New York: The Museum of Modern Art, 2002

Sanja Iveković: Is This My True Face?, Zagreb: Museum of Contemporary Art, 1998

Sanja Iveković: Personal Cuts, Innsbruck/Vienna: Galerie im Taxispalais, 2001

Sanja Iveković: Women's House 1998–2002, Zagreb: Museum of Contemporary Art, 2003

Sanja Iveković: Works of Heart, Zagreb: Moderna Galerija Studio/Josip Racić, 2001

Francesco Jodice

Born 1967, Naples, Italy. Lives and works in Milan, Italy. Founding member of the network *Multiplicity*

Selected Projects

2002 (ongoing) *Natura. The Crandell Case*, Upstate New York, USA, August 2002, and *Il Caso Monte Maggiore*, Caserta, Italy, June 2003

1998 (ongoing) *The Secret Traces*

1997 (ongoing) *What We Want*

Selected Solo Exhibitions

2004 *Private Investigations*, Mudimadue Gallery, Berlin, Germany

2003 *What We Want*, Galeria Marta Cervera, Madrid, Spain

The Crandell Case, Photo & Contemporary, Turin, Italy

The Random Viewer, Galleria Spazio Erasmus, Milan, Italy

Selected Group Exhibitions

2003 *Il Caso Monte Maggiore, IN-Natura*, X Biennale Internazionale di Fotografia, Turin, Italy

Border Device (Multiplicity), 50th Venice Biennale, Venice, Italy

100 Stories, XIV Quadriennale di Roma, Naples, Italy

2002 *Solid Sea (Multiplicity)*, Documenta 11, Kassel, Germany

Tokyo Voids (Multiplicity), VOID, Rice Gallery/G2, Tokyo, Japan

The Secret Traces, Side Effects, Triennale di Milano, Milan, Italy

The Crandell Case, Artomi, Omi, New York, USA

2001 *What We Want, Instant City*, Museo Pecci, Prato, Italy

2000 *USE: Uncertain States of Europe (Multiplicity)*, Mutations, CAPC, Bordeaux, France

Further Reading

Francesco Jodice, *Cartoline dagli altri spazi*, Milan: Federico Motta Editore, 1998

Francesco Jodice, *USE: Uncertain States of Europe (Multiplicity)*, Milan: Skira, 2003

Francesco Jodice, *What We Want*, Milan: Skira, 2004

Various authors, *Mutations*, Barcelona: Actar, 2000

Various authors, *Instant City*, Milan: Baldini & Castoldi, 2001

Various authors, *Side Effects*, Milan: Silvana Editoriale, 2002

Peter Johansson

Born 1964, Transtrand/Sälen, Sweden. Lives and works in Stockholm, Sweden

Selected Solo Exhibitions

2004 Dak' Art Biennial 2004, Maison de vieux Combatants, Dakar, Senegal

2003 *Udda Veckor*, Moderna Museet, Stockholm, Sweden

Guten Heute alle Leute. Es ist Unser in der Luft. Bald kommen die Löwen und die Bären, Kunstbanken Hamar, Norway, and Andréhn-Schiptjenko, Stockholm, Sweden

In Shallah, Konstens Hus Luleå, Sweden

2002 *Hembygdsmuseet*, Nässjö Kulturhus, Sweden

2001 The Watari Museum of Contemporary Art, Tokyo, Japan

Excellent Taste – Our Reward!, Arendal Kunstforening, Oslo Kunstforening, Agder Kunstnersenter Kristiansand, Rogaland Kunstnersenter Stavanger and Hordaland Kunstsenter, Bergen, Norway

2000 *In the Best of All Possible Worlds*, Porin Taidehalli, Pori, Finland, Kunsthallen Brandts Klædefabrik, Odense, Denmark and Borås Konstmuseum, Sweden

1999 *Schlaraffenland*, Wewerka Pavillon, Münster, Germany, Västerås Konstmuseum, Västerås, Sweden, and Stockholm Art Fair, Stockholm, Sweden

1998 *Bruno*, Galleriet (with Roger Svensson), Växjö, Sweden

Peter of Sweden®, Konst överallt/Stockholm – Cultural Capital of Europe 1998, PUB, Stockholm, Sweden

1997 *The Scandinavian SAUNA Project*, The Cable Factory, Helsinki, Finland

Northern Encounters, Grunwald Gallery, Toronto, Canada

1996 *Souvenirlära (Souvenir Science)*, Botkyrka Konsthall, Tumba, Sweden

Chop Suey – The Final Solution to the Problems of Sculpture, Malmö Konstmuseum, Malmö, Sweden

Selected Group Exhibitions

2004 *Zorn och Nordisk Samtidskonst*, Arken-Museum for Moderne Kunst, Ishøj, Denmark

2003 *Puzzles and Mestisos*, Espacio C, Camargo, Santander, Spain, Wunderland, Kiruna, Sweden, and Ostrova, Czech Republic

2002 *Beyond Paradise*, Shanghai, China, Kuala Lumpur, Malaysia, and Bangkok, Thailand

Second International Art Biennial, Buenos Aires, Argentina

Den Haag Sculptuur 2002, The Hague, Netherlands

Umedalen Skulptur 2002, Umeå, Sweden

2001 *Trans-form*, Konstnärernas Hus, Stockholm, Sweden, Stenersenmuseet, Oslo, Norway, Overgaaden, Copenhagen, Denmark, Narva Artgallery, Estonia, and Riga Artmuseum, Riga, Latvia

Hypnosis – Seven Swedish Stories, Art Moscow, Moscow, Russia

2000 *Super Split*, Büro Friedrich, Berlin, Germany

ÄtbArt, National Museum, Stockholm, Sweden

Shout & Scream, Städtlischen Ausstellungshalle am Hawenkamp, Münster, Germany

Displaced, Sophienhof, Kiel, Germany

1998 *Hermot (Hometown)*, Pinakothek, Athens, Greece

Parkbänkar (Park Benches), Wanas Exhibitions and Waldemarsudde, Stockholm, Sweden

Rauma Biennale Balticum 98, Rauma Art Museum, Rauma, Finland

1997 *Index Edition*, Galleri Index, Stockholm, Sweden

Shelter, Trondelag Kunstnersenter, Trondheim, Norway

Beach Art – 97, Northlands Festival, Scapa House, Caithness, Scotland

1996 *Internationella Kulturdagarna (International Culture Festival)*, Konstcentrum, Gävle, Sweden

Alone – Together, Liljevalchs Konsthall, Stockholm, Sweden

Fågel, fisk eller mittemellan (Bird, Fish or Somewhere Between), Västerås Konstmuseum, Västerås, Sweden

Art Against Aids, The Fife Foundation, Stockholm Smart Show, Stockholm, Sweden

Further Reading

Ole Kunst, text by Tone Jörstad, made for the Ole Kunst Museum by Peter Johansson/Hem Art–97 in Hamar, Norway

The Scandinavian SAUNA Project – I ord och bild (with Olle Wilson), Stockholm: Tago Förlag

Yeondoo Jung

Born 1969, South Korea. Lives and works in Seoul, South Korea

Selected Solo Exhibitions

2003 *BeWitched*, Gallery Loop, Seoul, South Korea

2002 *Tokyo Brand City*, Koyanagi Gallery, Tokyo, Japan

Chinese Lucky Estate, 1a Space, Hong Kong

Beat It, Insa Art Center, Seoul, South Korea

2001 *Borame Dance Hall*, Alternative Space Loop, Seoul, South Korea

Selected Group Exhibitions

2004 Hermes Korea Art Awards, Art Sunjae Centre, Seoul, South Korea

The Ten Commandments, Deutsches Hygiene-Museum, Dresden, Germany

Stranger than Paradise, Total Museum, Seoul, South Korea

Absent Voices, Korean Culture Center, New York, USA

Wall Works, Cais Gallery, Seoul, South Korea

2003 *5 Art Collection*, Art Sunjae Centre, Seoul, South Korea

Poetic Justice, Istanbul Biennale, Istanbul, Turkey

Facing Korea: demirrorizedzone, De Appel Museum, Amsterdam, the Netherlands

Every Day – Contemporary Art from Asia, Kunstforeningen, Copenhagen, Denmark

Photo Report from Korea, Guardian Garden, Tokyo, Japan

The Wedding, Sungkok Art Museum, Seoul, South Korea

2002 *Under Construction*, Tokyo Opera City Gallery, Tokyo, Japan

Shanghai Biennale, Shanghai Art Museum, Shanghai, China

Oriental Extreme, Le Lieu Unique, Nantes, France

Busan Biennale, Busan, South Korea

Pause, Gwangju Biennale, Gwangju, South Korea

Fukuoka Triennale, Fukuoka, Japan

Living Like a Lover from Radarphone, Project Space 4, Dublin, Republic of Ireland

Fantasia, Eastern Art Gallery, Beijing, China

Urban Utopia, Ilmin Museum, Seoul, South Korea

Ssamzie Open Studio, Ssamzie Art Space, Seoul, South Korea

2001 *Invisible Touch*, Art Sunjae Centre, Seoul, South Korea

Tirana Biennale, National Museum, Tirana, Albania

Detached House, British Embassy, Seoul, South Korea

Mass-Life, Space Big Art, Yokohama, Japan

Crossing Parallels, Ssamzie Art Space, Seoul, South Korea; Lance Fung Gallery, New York, USA

The Lunchtime of Necktie Force, Posco Art Museum, Seoul, South Korea

2000 *Wowproject*, Seoul subway, Seoul, South Korea

din/DIN, art project space 4 x 4, Amsterdam, the Netherlands

1999 *Mixer & Juicer*, The Korean Culture & Art Foundation

Elvis gungjungbanjum, Sungkok Art Museum, Seoul, South Korea

Radio Asia, Galangga Club, London, UK

Further Reading

Patricia Ellis, 'Shall We Dance?', *Flash Art* (March–April 2000)

Makiko Hara, 'Tokyo Brand City Review', *Bizutzu Techo* (March 2003)

Yukie Kamiya, 'Deamweaver', *Art Asia Pacific* magazine, 39 (2004)

Kiyong Kim, 'Borame Dance Hall Review', *Art in Culture* (March 2001)

Kuroda Raiji, *BT* magazine *100 Artists Worldwide Special Issue* (2004)

Zing magazine, 16 (Winter 2002)

Werner Kaligofsky

Born 1957, Wörgl, Tirol. Lives and works in Vienna, Austria

Selected Solo Exhibitions

2002 *Nachbilder*, Galerie Fotohof, Salzburg, Austria

2001 *Werner Kaligofsky*, Galerie im Taxispalais, Innsbruck, Austria

1998 *Die Arbeit verschwindet im Produkt*, Galerie Grita Insam, Vienna, Austria

1995 *Baby, Lucy und Cléo*, Galerie Grita Insam, Vienna, Austria

1991 *Ad Kaligofsky*, Galerie Grita Insam, Vienna, Austria

Selected Group Exhibitions

2004 *Der Widerstand der Fotografie*, Camera Austria–Kunsthaus Graz, Graz, Austria

2003 *Zugluft*, Aktuelle Kunst aus Wien, Zurich, Switzerland

2002 *Erlauf erinnert sich. . .*, public art project, Erlauf, Lower Austria

1999 *Moving Images, Film – Reflexion in der Kunst*, Galerie für zeitgenössische Kunst, Leipzig, Germany

FunktionsSystemMensch, Kunstverein Bochum, Bochum, Germany

1996 *White Cube/Black Box*, Generali Foundation, Vienna, Austria

Freeze Frame, Instituto Cultural Cabañas Guadalajara, Guadalajara, Mexico

Found Footage, Galerie Clemens Gasser und Tanja Grunert, Cologne, Germany

Further Reading

Reinhard Braun, *Media, Images, Modes of Disciplining: Associative Interventions in Werner Kaligofsky's Works*, Graz: Camera Austria 76, 2001

Werner Kaligofsky, *Die Arbeit verschwindet im Produkt*, Cologne: Walther König, 1998

Werner Kaligofsky, *Verkehrsflächen/ Trafficways*, Salzburg: Fotohof Edition, 2004

Germaine Koh

Born 1967, Malaysia. Lives in Canada

Selected Solo Exhibitions

2004 *Stall*, Para/Site Art Space, Hong Kong

2003 *Germaine Koh*, FADs art space, Tokyo, Japan

Homemaking, Artspace, Sydney, Australia

Field Work, The Western Front, Vancouver, Canada

2002 *Open Hours*, McMaster Museum of Art, Hamilton, Ontario, Canada

Germaine Koh, Catriona Jeffries Gallery, Vancouver, Canada

Knitwork, The British Museum, London, UK

2001 *Germaine Koh: Around About*, Plug In Institute of Contemporary Art and Gallery One One One, Winnipeg, Canada

Germaine Koh, Contemporary Art Gallery, Vancouver, Canada

Watch, Solo Exhibition, Toronto, Canada

2000 *by the way*, Arte in Situ/La Torre de los Vientos, Mexico City, Mexico

1999 *En busca del nivel del lago*, Ex Teresa Arte Actual, Mexico City, Mexico

Germaine Koh: Living Room, Los Angeles Contemporary Exhibitions, Los Angeles, USA

Selected Group Exhibitions

2004 *Sobey Art Award Exhibition*, Art Gallery of Nova Scotia, Halifax, Canada

Entre ciel et terre: Biennale nationale de sculpture contemporaine, Trois-Rivières, Quebec, Canada

Sense, Edmonton Art Gallery, Edmonton, Canada

2003 *I Sell Security*, Catriona Jeffries Gallery, Vancouver, Canada

Our Mutual Friend, Bloomberg SPACE, London, UK

MosiaCanada: Sign & Sound, Seoul Museum of Art, Seoul, South Korea

Psychotopes, YYZ Artists' Outlet, Toronto, Canada

2002 *IN THROUGH THE OUT DOOR*, Power Plant, Toronto, Canada

Signage, Catriona Jeffries Gallery, Vancouver, Canada

2001 *Visualeyez* performance festival, Latitude 53, Edmonton, Canada

FREQUENCitY, ÖRF Kunstradio, Vienna, Austria

2000 *Recollection Project*, Gendai Gallery, Toronto, Canada

Tout le temps/Every Time: La Biennale de Montréal 2000, Montreal, Canada

Further Reading

Dave Dyment, *Germaine Koh: STALL*, exh. cat., Hong Kong: Para/Site Art Space, 2004

Peggy Gale, *Tout le temps/Every Time: La Biennale de Montréal 2000*, Montreal: Centre International d'Art Contemporain, 2000

Bryce Kanbara and Richard Fung, *Recollection Project*, exh. cat., Toronto: Gendai Gallery

Robin Laurence, 'Koh Invites Us to Explore Electronics', *The Georgia Straight*, Vancouver, 12–19 June 2003, p. 64

Laura U. Marks, *Germaine Koh*, exh. cat., Vancouver: Contemporary Art Gallery, 2001

Steve Reinke and Rosemary Heather, *Germaine Koh: Open Hours*, exh. cat., Hamilton: McMaster Museum of Art, 2002

Andreja Kulunčić

Born 1968, Subotica, former Yugoslavia. Lives in Zagreb, Croatia

Selected Solo Exhibitions

2003 The Art Centre, Silkeborg Bad, Denmark

Gallery of Extended Media, Zagreb, Croatia

2002 Artspace Visual Art Centre, Sydney, Australia

2001 Gallery Multimedia Cultural Centre, Split, Croatia, working space installation and discussion

2000 *Closed Reality-Embryo*, Gallery Miroslav Kraljević, Zagreb, Croatia

Selected Group Exhibitions and Festivals

2004 *Passage d'Europe*, Museum of Modern Art, Saint-Etienne, France

2003 *U3 Exhibition*, Moderna Galerija, Ljubljana, Slovenia

Poetic Justice, 8th International Istanbul Biennial, Istanbul, Turkey

The American Effect, Whitney Museum of American Art, New York, USA

2002 Multidisciplinary project *Distributive Justice*, Documenta 11, Kassel, Germany

In-situ project *Artist From. . .*, Manifesta 4, European Biennial of Contemporary Art, Frankfurt am Main, Germany

Here Tomorrow, Museum of Contemporary Art, Zagreb, Croatia

Big Torino 2002, Torino Biennial, Torino, Italy

2001 *To Tell a Story*, Museum of Contemporary Art, Zagreb, Croatia

Double Life exhibition, Internet/CD-ROM part, Generali Foundation, Vienna, Austria

10th Triennale-India (awarded piece), New Delhi, India

2000 5th International Festival of New Film, Split, Croatia. Grand Prix in the new media category

What, How & For Whom, international art exhibition, in-situ project NAMA, Zagreb, Croatia

FILE Electronic Language International Festival, invited work, São Paulo, Brazil

EMAF (European Media Art Festival) 2000, Osnabrück, Germany

1999 Biennale of Young Artists of Europe and the Mediterranean, Rome, Italy

VIPER, International Film, Video and Media Festival, Lucerne, Switzerland

Further Reading

Nada Beros, *Andreja Kulunčić: Volume-Up*, exh. cat. for The Art Centre, Silkeborg Bad, Denmark; Zagreb, 2003

Matthias Dusini, 'Crossing the Publicity Border: The Work of Croatian Artist Andreja Kulunčić', December 2002–February 2003, published in *Springerin* 4/02, Far Eastern

Branko Franceschi, 'www.andreja.org', Zagreb, September 2001, published in *Život umjetnosti*, Zagreb, 2002

Natasa Ilic, 'Introduction: Interview with Andreja Kulunčić', in *Distributive Justice*, exh. cat., Zagreb: PM Gallery, 2003

Janka Vukmir, 'Andreja Kulunčić', Documenta 11, Zagreb, 2002

Oswaldo Macià

Born 1960, Cartagena de Indias, Colombia. Lives and works in London, UK

Selected Solo Exhibitions

2003 *Vesper I*, VTO Gallery, London, UK

Something Going On Above My Head VI/Algo pasa por encima de mi cabeza, Museo Nacional Centro de Arte Reina Sofía MNCARS, Madrid, Spain

2002 *Provokes/Evokes* (with Jasper Morrison), Artlab, Imperial College of Science, Technology and Medicine, London, UK

1996 *'Familiares Anónimos'. Nuevos nombres. La lógica de los sentidos*, Biblioteca Luis Ángel Arango, Bogotá, Colombia

Bajando y Cayendo, Museo de Arte Moderno, Bogotá, Colombia

1995 *Memory Skip*, Museum of Installation, London, UK

Selected Group Exhibitions

2004 *Animals*, Haunch of Venison, London, UK

Vesper IV. Sound-Smell Symphony, Shanghai Biennale 2004: Techniques of the Visible, Shanghai, China

2003 *Something Going On Above My Head VII. Stretch*, The Power Plant, Contemporary Art Gallery, Toronto, Canada

Vesper II. El viaje inútil, II Bienal de Lanzarote, Arrecife, Spain

Vesper III, 8th Havana Biennial: El arte con la vida, Havana, Cuba

Es que no me oyen o es que no me ven, 8th Havana Biennial, Espacio Aglutinador, Havana, Cuba

Vesper performed at The Place; choreographer Rafael Bonachela

2002 *Something Going On Above My Head V, AfricAméricA*, Ile Forum Multiculturel d'Art Contemporain, Port-au-Prince, Haiti

2001 *Para mañana tendremos un día nublado – Sinfonía anal auditiva*, Tercer Festival Internacional de Arte Sonoro (FIAS), Mexico City, Mexico

Something Going On Above My Head IV, 1st Tirana Biennale, Tirana, Albania

Ventana, Office in Madrid, Madrid, Spain

2000 *John, I'm Only Dancing*, Margaret Harvey Gallery, St Albans, UK. Travelled to Collective Gallery, Edinburgh, UK

Something Going On Above My Head III, 12th-century Church of Gamla Uppsala, Uppland, Sweden

Continental Shift: A Voyage between Cultures, Ludwig Forum für Internationale Kunst, Aachen, Germany

1999 *Something Going On Above My Head I. Cartucho. Cuatro artistas de Colombia* (Fernando Arias, Carlos Blanco, Oswaldo Macià, José Alejandro Restrepo), Ex Teresa Arte Actual, Mexico City, Mexico

Something Going On Above My Head II, Whitechapel Art Gallery, London, UK

1998 *From Within*, Juliet Gallery, Trieste, Italy

1996 *Touch Me*, Museum of Contemporary Art, London, UK

V Bienal de Bogotá, Museo de Arte Moderno, Bogotá, Colombia

Jill Magid

Born 1973, Bridgeport, Connecticut. Lives and works in Amsterdam and New York

Selected Performances

2003 *Kafkahouse*, Manifestação International de Performance, Belo Horizonte, Brazil

2002 *Rhinestoning Headquarters*, performance and permanent installation, Police Headquarters, Amsterdam, the Netherlands

2001 *Unmade, Façades*, Museum van Loon, Amsterdam, the Netherlands

Intimates Unfolding, Xth Ave. Lounge, New York, USA

2000 *Monitoring Desire*, video intervention, Harvard Science Center, MIT Thesis Performance, Cambridge, MA, USA

Lobby 7, video intervention, Main Lobby, Massachusetts Institute of Technology, Cambridge, MA, USA

The Lap Cushion, public performance, Boston, MA, USA

1999 *Kiss-Mask*, public performance, Cambridge, MA, USA

Selected Solo Exhibitions

2004 *Thomas Makes a Wish*, Maison Gregoire, Galerie L'Observatoire, Brussels, Belgium (curated by Florence Derieux)

2003 *Tall Tale Small Scale*, Galerie van Gelder, Amsterdam, the Netherlands

2002 *Security in Azure*, security ornamentation, Rijksakademie, Amsterdam, the Netherlands

2001 *Façades*, Museum van Loon, Amsterdam, the Netherlands

Vanity Shoes, Kissmasks, and Cushions, Seven, New York, USA

2000–2001 *Intimates Unfolding*, Steinholf and Stoller, New York, USA

1998 *The Proper Urban Attire*, installation, Samuel Beckett Theater, New York, USA

Selected Group Exhibitions

2004 Video programme, De Balie, Façade Screen, Amsterdam, the Netherlands

2003 *Film@33*, film and video screenings, TURF, Brooklyn, NY, USA

Yellow Pages, Turm Gallery, Brunswick, Germany (curated by John Armeleder)

2002 *Surveillance and Control*, World-Information Exhibition, Oude Kerk, Amsterdam, the Netherlands

Museum Night: Home Movies, Museum van Loon, Amsterdam, the Netherlands

Married by Powers (in collaboration with Paulina Olowska), TENT, Rotterdam, the Netherlands

2001 *Unmade*, video and photography installation, PAN, Amsterdam, the Netherlands

Further Reading

'Flying Dutchman', *House*, 83.5 (March 2003)

'System Azure Observed', *Metropolis* magazine (October 2003)

RAIN Artists' Initiatives Network, *Shifting Map*, Rotterdam: NAi, 2004

Thresholds, 'Recognizing Desire', Project Pages, *MIT Biennial Journal of Art, Architecture, and Critical Theory* (1999)

Iñigo Manglano-Ovalle

Born 1961, Madrid, Spain. Lives and works in Chicago, USA

Selected Solo Exhibitions

2003 *Iñigo Manglano-Ovalle*, La Caixa Foundation, Madrid, Spain

Purgatory, Max Protetch Gallery, New York, USA

Iñigo Manglano-Ovalle, Museo Tamayo de Arte Contemporáneo, Mexico City, Mexico

2002 *White Flags*, Barcelona Pavilion, Mies van der Rohe Foundation, Barcelona, Spain

2001 *Iñigo Manglano-Ovalle*, Cranbrook Art Museum, Bloomfield Hills, MI, USA

Selected Group Exhibitions

2004 *5 Jaar SMAK*, Stedelijk Museum voor Actuele Kunst, Ghent, Belgium

2003 *Moving Pictures*, Guggenheim Museum Bilbao, Bilbao, Spain

2002 *Tempo*, Museum of Modern Art–QNS, Queens, New York, USA

2001 *InSite 2000–2001*, San Diego, CA, USA and Tijuana, Mexico

2000 *Biennial 2K*, Whitney Museum of American Art, New York, USA

1999 *Transmute*, Museum of Contemporary Art, Chicago, IL, USA

1998 *XXIV Bienal de São Paulo*, São Paulo, Brazil

Selected Further Reading

Ralf Christofori and James Rondeau, *Iñigo Manglano-Ovalle*, Barcelona: Fundación 'la Caixa', 2003

Holland Cotter, 'Iñigo Manglano-Ovalle', *New York Times*, 21 April 2000

Irene Hoffman and Anna Novakov, *Iñigo Manglano-Ovalle*, Bloomfield Hills, MI: Cranbrook Art Museum, 2001

Ken Johnson, 'Iñigo Manglano-Ovalle, Purgatory', *New York Times*, 14 February 2003

Cuauhtémoc Medina and Victor Zamudio-Taylor, *Iñigo Manglano-Ovalle*, Mexico City: Museo Tamayo Arte Contemporáneo, 2004

Michael Rush, *Video Art*, London: Thames & Hudson, 2003, pp. 178–81

Esko Männikö

Born 1959, Pudasjärvi, Finland. Lives Oulu, Finland

Selected Solo Exhibitions

2004 Finsk-norsk kulturinstitutt, Oslo, Norway

Galleria Suzy Shammah, Milan, Italy

Galerie Rodolphe Janssen, Brussels, Belgium

Galerie Nordenhake, Stockholm, Sweden

2003 Galerie CENT8, Paris, France

2002 *Flora & Fauna*, Galerie Nordenhake, Berlin, Germany

2001 Galleria Monica de Cardenas, Milan, Italy

Galerie Nordenhake, Stockholm, Sweden

2000 *Organized Freedom*, Oulu City Art Museum, Finland

Galeria Estrany-De La Mota, Barcelona, Spain

Galerie CENT8, Paris, France

Galleri F 48, Stockholm, Sweden

1999 *Photographs 1980–1998*, Hasselblad Center, Göteborg, Sweden

Selected Group Exhibitions

2004 *Anders Zorn and Contemporary Nordic Art*, Arken, Ishöj, Denmark

2003 *Migration*, Kirkkenes, Norway

Beyond Paradise, Shanghai Art Museum, Shanghai, China

Zeitgenössische Fotokunst aus Finland, Neuer Berliner Kunstverein, Berlin, Germany

2002 *Cardinales*, Museo de Arte Contemporáneo, Vigo, Spain

Eight Nordic Stories, Centro Galego de Arte Contemporáneo, Santiago de Compostela, Spain

Fotografia: I Festival Internazionale di Roma, Galleria Nazionale d'Arte Moderna, Rome, Italy

The Great Divide, Fruitmarket Gallery, Edinburgh, Scotland

2001 *ARS 01*, Kiasma, Helsinki, Finland

2000 *Anti-Memory: Contemporary Photography II*, Yokohama Museum of Art, Yokohama, Japan

Some Parts of This World, The Finnish Museum of Photography, Helsinki, Finland

Gwangju Biennale, Gwangju, South Korea

1999 *Finnish Line: Starting Point*, Musée d'Art Moderne et Contemporain de Strasbourg, Strasbourg, France

1998 XXIV Bienal de São Paulo, São Paulo, Brazil

1997 *Truce*, Santa Fe Biennial, Santa Fe, USA

Johannesburg Biennale, Johannesburg, South Africa

Further Reading

100% Cashmere, 2003

The Female Pike, 2000

Mexas, 1999

Dorit Margreiter

Born 1967, Vienna, Austria. Lives and works in Vienna and Los Angeles

Selected Solo Exhibitions

2004 *Four Phases in the Combining of Two Negatives to Make One Complete – Unusual – Picture*, Kunstforum Montafon, Austria

10104 Angelo View Drive, Museum of Modern Art, Vienna, Austria

2002 *Event Horizon*, Galerie Krobath Wimmer, Vienna, Austria

2001 *Everyday Life*, Galerie im Taxispalais, Innsbruck, Austria

2000 *Short Hills*, Plattform, Berlin, Germany

Selected Group Exhibitions

2004 *BODY DISPLAY: Performative Installation No. 4: Bodies and Economics*, Secession, Vienna, Austria

2003 *el aire es azul/the air is blue*, Museo Luis Barragan, Mexico City, Mexico

2002 *Hausordnungen*, Stadthaus Ulm, Ulm, Germany

2001 *20/35 Vision*, MAK Center for Art and Architecture, Los Angeles, USA

2000 *Screen Climbing*, Kunstverein Hamburg, Hamburg, Germany

1998 *The Making Of*, Generali Foundation, Vienna, Austria

Further Reading

Silvia Eiblmayr (ed.), *Dorit Margreiter: Everyday Life*, Innsbruck: Galerie im Taxispalais, Triton Verlag, 2001

Christian Kravagna (ed.), *Das Museum als Arena*, Kunsthaus Bregenz, 2001

Hans Ulrich Obrist (ed.), *Dorit Margreiter/Kaucyila Brooke: Two or Three Things You Know About Me/Beaded Curtains*, museum in progress, 2003

Mathias Poledna (ed.), *The Making Of*, Vienna: Generali Foundation, 1998

Florian Pumhösl (ed.), *Some Establishing Shots, Montage 4, Leporello*, 1999

Eva Stadler (ed.), *Dorit Margreiter: Short Hills*, Grazer Kunstverein, Revolver, 2002

Cildo Meireles

Born 1948, Rio de Janeiro. Lives and works in Rio de Janeiro

Selected Exhibitions

2004 *Inverted Utopias*, Museum of Fine Arts, Houston, Texas, USA

Beyond Geometry: Experiments in Form, LACMA, Los Angeles, USA

Occasion, Portikus, Frankfurt, Germany

2003 Istanbul Biennial, Istanbul, Turkey

Musée d'Art Moderne et Contemporain, Strasbourg, France

2002 Documenta 11, Kassel, Germany

2001 *Minimalism Past and Presence*, Galerie Lelong, New York, USA

Da Adversidade Vivemos, Musée de la Ville, Paris, France

2000 *Versiones del Sur: Eztetyka del sueno*, Museo Nacional Centro de Arte Reina Sofía, Madrid, Spain

South Korea Biennial, South Korea

Making Choices, Museum of Modern Art, New York, USA

Worthless, Moderna Galerija Ljubljana, Ljubljana, Slovenia

Cildo Meireles (retrospective organised by the New Museum of Contemporary Art, New York, USA), Museu Moderna Arte de São Paulo, São Paulo, Brazil; Museu de Arte Moderna do Rio de Janeiro, Rio de Janeiro, Brazil

Cildo Meireles, Museu de Arte Moderna do Rio de Janeiro, Rio de Janeiro, Brazil

Cildo Meireles, Kunstverein Köln, Cologne, Germany

Galeria Luisa Strina, São Paulo, Brazil

1999 The Queens Museum of Art, New York, USA

Ku Kka Ka Kka, Kiasma Museum of Contemporary Art, Helsinki, Finland

Global Conceptualism: Points of Origin, 1950s–1980s, organised by Jane Farver, Queens Museum of Art, New York, USA; travelling to Walker Art Center, Minneapolis, USA; Miami Art Museum, Miami, USA

1998 XXIV Bienal de São Paulo, São Paulo, Brazil

The Garden of the Forking Paths, Kunstforeningen, Copenhagen, Denmark

Camelô, Galeria Luisa Strina, São Paulo, Brazil

1997 *You Are Here*, Royal College of Art, London, UK

Cildo Meireles (retrospective organised by IVAM, Spain), Institute for Contemporary Art, Boston, USA

1996 *Retrospectiva*, Museu de Arte do Porto, Porto, Portugal

1995 *Cildo Meireles*, IVAM, Valencia, Spain

1994 *Volátil* and *Entrevendo*, Capp Street Project, San Francisco, USA

Takashi Murakami

Born 1962, Tokyo, Japan

Selected Solo Exhibitions

2004 *Inochi*, Blum & Poe, Los Angeles, CA, USA

Satoeri Ko² Chan, Tomio Koyama Gallery, Tokyo, Japan

2003 *Reversed Double Helix*, Rockefeller Center, New York, USA

Superflat Monogram, Galerie Emmanuel Perrotin, Paris, France

Superflat Monogram, Marianne Boesky Gallery, New York, USA

2002 *Kaikai Kiki: Takashi Murakami*, Fondation Cartier pour l'Art Contemporain, Paris, France, travelling to the Serpentine Gallery, London, UK

2001 *summon monsters? open the door? heal? or die?*, Museum of Contemporary Art Tokyo, Tokyo, Japan

WINK, Grand Central Station, New York, USA

Mushroom, Marianne Boesky Gallery, New York, USA

Takashi Murakami: Mad in Japan, Museum of Fine Arts, Boston, MA, USA

2000 *Second Mission Project Ko2*, P.S.1 Contemporary Art Center, Long Island City, New York, USA

KaiKai Kiki: SUPERFLAT, ISSEY MIYAKE MEN, Tokyo, Japan

1999 *Love & DOB*, Gallery KOTO, Okayama, Japan

Superflat, Marianne Boesky Gallery, New York, USA

Selected Group Exhibitions

2004 *Walker Without Walls*, Walker Art Center, Minneapolis, USA

Monument to Now: The Dakis Joannou Collection, Deste – Nea Ionia, Athens, Greece

Floating Worlds, Beacon Cultural Foundation, Beacon, NY, USA

Optimo, Ballroom Marfa, Marfa, TX, USA

2003 *Supernova: Art of the 1990s from the Logan Collection*, San Francisco Museum of Modern Art, San Francisco, CA, USA

Pittura/Painting: Rauschenberg to Murakami, 1964–2003, Museo Correr, Venice Biennale, Venice, Italy

On the Wall: Wallpaper and Tableau, Rhode Island School of Design, Providence, RI, USA, and The Fabric Workshop and Museum, Philadelphia, PA, USA

Pulp Art: Vamps, Villains and Victors from the Robert Lesser Collection, Brooklyn Museum of Art, Brooklyn, NY, USA

2002 *Drawing Now: Eight Propositions*, Museum of Modern Art, New York, USA

POPJack: Warhol to Murakami, Museum of Contemporary Art Denver, Denver, CO, USA

Chiho Aoshima, Mr, Takashi Murakami, Galerie Emmanuel Perrotin, Paris, France

2001 *Form Follows Fiction*, Castello di Rivoli Museum of Contemporary Art, Torino, Italy

Casino 2001, 1st Quadrennial of Contemporary Art, Stedelijk Museum voor Actuele Kunst, Ghent, Belgium

Beau Monde: Toward a Redeemed Cosmopolitanism, SITE Santa Fe Fourth International Biennial, Santa Fe, NM, USA (curated by Dave Hickey)

Public Offerings, Museum of Contemporary Art (LA MOCA), Los Angeles, CA, USA (curated by Paul Schimmel)

2000 *'00*, Barbara Gladstone Gallery, New York, USA

5th Biennale d'Art Contemporain de Lyon, Lyons, France

1999 *Ground Zero Japan*, Contemporary Art Centre, Ibaraki, Japan

The Carnegie International 1999/2000, Carnegie Institute, Pittsburgh, PA, USA

Further Reading

'Artists Without Borders', *Brutus*, Special Murakami/Nara issue (September 2001)

Jamie Huckbody, 'Shooting from the Hip', *i-D Magazine* (February 2003), pp. 80–85

Kay Itoi, 'Japanese Generation Takes Off', *Artnews* (Summer 2002), p. 90

Cheryl Kaplan, 'Takashi Murakami: Lite Happiness + Super Flat', *Flash Art* (July–September 2001), pp. 92–97

John Kelsey, 'Takashi Murakami', *arText*, 74, p. 78

Frances Richards, 'Takashi Murakami', *Artforum* (September 2001), pp. 192–93

James Roberts, 'Magic Mushrooms', *Frieze* (October 2002), pp. 66–71

Yoko Ono

Yoko Ono, the multi-media artist, was born in Tokyo, Japan in 1933. During the 1950s and 1960s she lived and worked in New York, Tokyo and London, settling in New York with her husband John Lennon in 1971. Yoko Ono has been credited with being one of the originators of Conceptual Art, with works created in 1960, 1961 and 1962 which are language-based, and use the idea of instructions and participation as well as licence and performance structures. At the time she called these works *Insound* and *Instructure*. These ideas were a strong influence in the formation of Fluxus in 1961. Her events and sound pieces in the early 1960s laid the groundwork for major developments in music and performance art of the later part of the century. From the 1980s to the present her artwork has been shown internationally in one-woman shows and retrospectives. Yoko received the Skowhegan Award in 2002. Reflecting on her reputation for being outrageous, Yoko smiles and says, 'I do have to rely on my own judgment, although to some people my judgment seems a little out of sync. I have my own rhythm and my own timing, and that's simply how it is.'

Selected Works

Performance Works

1965; London and Liverpool, UK, 1967; Paris, France, 2003

Cut Piece, Yamachi Hall, Kyoto, Japan, 1964; Carnegie Recital Hall, New York, USA,

Films

Gimme Some Truth: The Making of Imagine, 2000. Grammy Award Winner

2001 Best Long Form Video. Yoko Ono: Executive Producer

Fly, 1970

Rape, 1969

No. 5 ('Smile'), 1968

No. 4 ('Bottoms'), 1966

Music/Sound Recordings

Blueprint For A Sunrise, 2001

Rising, 1995

Onobox, 1992

Season of Glass, 1981

Double Fantasy, 1980. Grammy Award Winner Best Album 1981

Approximately Infinite Universe, 1972

Two Virgins, 1968

Cough Piece, 1962

Billboard/Public Space Works

Imagine Peace, 2001–2004 worldwide

War Is Over!, 1999–2000 Times Square, New York, USA

Have You Seen the Horizon Lately?, 1997, England

In Celebration of Being Human, 1994, Germany

War is Over!, 1969–70 in eleven cities worldwide

Photography-Based Works

From My Window, 2002

Mommy Was Beautiful, 1997

Vertical Memory, 1997

Portrait of Nora, 1992

Installation Works

Odyssey of a Cockroach, 2003

Imagine Peace, 2001

Freight Train, 2000

Morning Beams, 1997

ExIt, 1997

Wish Tree, 1996

En Trance, 1990

Half-A-Room, 1967

Blue Room, 1966

Current and Recent One-Woman Exhibitions

Women's Room, 2003–2004, Musée d'Art Moderne, Paris, France; Museum Kampa, Prague, Czech Republic; Women's Museum, Aarhus, Denmark

Odyssey of a Cockroach, 2003–2004, Deitch Projects, New York, USA; ICA, London, UK

YES YOKO ONO, 2000–2004, retrospective organised by The Japan Society, New York; currently on tour in the USA, and travelling to Seoul, Korea, and five cities in Japan

From My Window, 2002, Vienna, Austria

My Mommy was Beautiful, 2002, Santa Monica, CA, USA

Open Window, 1999–2000, Um El Fahem, Israel

Impressions, 1999, Bergen Kunstmuseum, Norway

Wish Trees For Brazil, 1998–99, Brazil

Have You Seen the Horizon Lately?, 1997–2000, retrospective organised by the Museum of Modern Art, Oxford; toured Europe

Entrance-Ex It, 1996–99, organised by The Generalitat Valenciana, Spain; toured South America

Books

Grapefruit, first published in 1964 with new editions starting in 1970, republished with new introduction in 2000

Museum of Modern (F)Art, 1971

Instruction Paintings, New York: Weatherhill, 1995

Pennyviews, California: Turkey Press, 1995. A collection of drawings

Acorns, 1996. A book created specifically for the web/internet

Spare Room, Wunternaum Press with Paris Musées/Onestar Press, 2003

Other Works

Strawberry Fields International Peace Garden, 1985. Yoko dedicated a section of Central Park as a tribute to John Lennon, with plants and trees donated from 121 countries

Mathias Poledna

Born 1965, Vienna, Austria. Lives and works in Los Angeles, USA

Selected Exhibitions

2004 Galerie Meyer Kainer, Vienna, Austria

Quodlibet, Galerie Daniel Buchholz, Cologne, Germany

20/20 Vision, Stedelijk Museum of Modern Art, Amsterdam, the Netherlands

3rd Berlin Biennial for Contemporary Art, Berlin, Germany

2003 *Adorno: The Possibility of the Impossible*, Frankfurter Kunstverein, Frankfurt, Germany

History Lesson Part II, Film Program by Mathias Poledna, Museum of Modern Art Foundation Ludwig, Vienna, Austria

Western Recording, Museum of Modern Art Foundation Ludwig, Vienna, Austria

Mixtapes, CCAC Wattis Institute for Contemporary Art, San Francisco, USA

2002 Richard Telles Fine Art, Los Angeles, USA

Tu m', Galerie Meyer Kainer, Vienna, Austria

2001 Grazer Kunstverein, Graz, Austria

Further Reading

Sabine Breitwieser (ed.), *Occupying Space*, Generali Foundation Collection, Vienna: Generali Foundation/Cologne: Walther König/New York: DAP, 2003

Christian Meyer and Mathias Poledna (eds), *Sharawadgi*, Vienna: Felsenvilla/Cologne: Walther König, 1998

Mathias Poledna: Actualité, Frankfurt: Revolver – Archiv für aktuelle Kunst, 2002

Mathias Poledna (ed.), *The Making Of*, Vienna: Generali Foundation/Cologne: Walther König, 1998

Mathias Poledna, *Western Recording*, New York: Lukas & Sternberg/Vienna: MUMOK, 2004

Stedelijk Museum Bulletin, Amsterdam: Stedelijk Museum of Modern Art, 2004

3rd Berlin Biennial for Contemporary Art, exh. cat., Cologne: Walther König, 2004

Marjetica Potrč

Born Ljubljana, Slovenia. Lives and works in Ljubljana

Selected Solo Exhibitions

2004 *Urban Growings*, De Appel Foundation for Contemporary Art, Amsterdam, the Netherlands

2003 *Caracas: House with Extended Territory*, Nordenhake Gallery, Berlin, Germany

Marjetica Potrc: Urgent Architecture, PBICA, Lake Worth, FL, USA; MIT List Visual Arts Center, Cambridge, MA, USA, 2004

Next Stop, Kiosk, Museum of Modern Art, Ljubljana, Slovenia

Urban Negotiation, IVAM, Valencia, Spain

2002 *Extreme Conditions and Noble Designs*, Orange County Museum of Art, Newport Beach, CA, USA

Barefoot College: A House, Max Protetch Gallery, New York, USA

2001 Hugo Boss Prize 2000, Guggenheim Museum, New York, USA

Selected Group Exhibitions

2004 *Born of Necessity*, Weatherspoon Art Museum, UNC, Greensboro, NC, USA

2003 *The Fifth System: Public Art in the Age of Post-Planning*, the 5th Shenzhen International Public Art Exhibition, Shenzhen, China

Arte all'Arte 8, Associazione Arte Continua, San Gimignano, Italy

Poetic Justice, 8th International Istanbul Biennial, Istanbul, Turkey

GNS, Palais de Tokyo, Paris, France

Somewhere Better than this Place, CAC, Cincinnati, OH, USA

PARA>SITES: Who is Moving the Global City?, Badischer Kunstverein, Karlsruhe, Germany

The Pursuit of Happiness, Kunsthalle Bern, Berne, Switzerland

2002 *Designs for the Real World*, Generali Foundation, Vienna, Austria

Further Reading

Carlos Basualdo and Reinaldo Laddaga, 'Rules of Engagement', *Artforum International* (March 2004), pp. 166–70

Eleanor Heartney, 'A House of Parts', *Art in America* (May 2004), pp. 140–43

Livia Paldi (ed.), *Marjetica Potrč: Next Stop, Kiosk*, exh. cat., Ljubljana: Moderna Galerija Ljubljana, 2003

Michael Rush (ed.), *Marjetica Potrč: Urgent Architecture*, exh. cat., Lake Worth, FL: Palm Beach Institute of Contemporary Art, 2003

Ana Maria Torres (ed.), *Marjetica Potrč: Urban Negotiation*, exh. cat., Valencia: Instituto Valenciano de Arte Moderno, 2003

Raqs Media Collective

Jeebesh Bagchi, Monica Narula and Shuddhabrata Sengupta

www.raqsmediacollective.net

Selected Projects

Forthcoming projects include *The Impostor in the Waiting Room*, Bose/Pacia Modern, New York, USA, autumn 2004

2003 *5 Pieces of Evidence*, The Structure of Survival, Venice Biennale, Venice, Italy

A/S/L, Generali Foundation Gallery, Vienna, Austria

Temporary Autonomous Sarai (in collaboration with Atelier Bow Wow, Tokyo), Walker Art Center, Minneapolis, USA

Utopia Station, Venice Biennale, Venice, Italy

2002 *Co-Ordinates of Everyday Life – 28.28N/77.15E::2001/2002*, Documenta 11, Kassel, Germany; Roomade Office for Contemporary Art, Brussels, Belgium

Location", Itau Cultural Centre, São Paulo, Brazil

OPUS, a web-based system designed for the sharing of creativity and print projects for *Utopia Station*, *Soda*, *Data Browser* and the Sarai Readers

Raqs has exhibited at the 50th Venice Biennale, Documenta 11 (Kassel), Palais de Beaux Arts (Brussels), Emoção Artificial (São Paulo), Generali Foundation Gallery (Vienna), Ars Electronica (Linz), the Walker Art Center (Minneapolis) and the Roomade Office for Contemporary Art (Brussels)

Essays by Raqs Media Collective

http://www.raqsmediacollective.net/texts.html

'Call Centre Calling: Technology, Network and Location', in *Sarai Reader 03: Shaping Technologies*, 2003
http://www.sarai.net/journal/03pdf/177_183_raqsmediac.pdf

'A Concise Lexicon of/for the Digital Commons', in *Documenta 11, Platform 5: Exhibition Catalogue*, Ostfildern: Hatje Cantz, 2002; *World Information.Org: The Network Society of Control Conference Reader*, Amsterdam, December 2002; *Sarai Reader 03: Shaping Technologies*, 2003

'The First Information Report', in Karin Gludovatz and Clemens Krummel (eds), *Texte Zur Kunst*, September 2003

'New Maps & Old Territories: A Dialogue between Yagnavalkya & Gargi in Cyberia', in *Sarai Reader 01: The Public Domain*, 2001
http://www.sarai.net/journal/pdf/152-158%20(body).pdf

Shuddhabrata Sengupta, 'The Future of Art', Anthology-of-Art.net website, curated by Jochen Gerz
http://www.anthology-of-art.net/generatio/03/sengu.html

'The Signature of the Apocalypse: The Politics of Surveillance in Contemporary India', text by Shuddhabrata Sengupta, images by Monica Narula, *Mute* magazine, 26 (Summer/Autumn 2003), www.metamute.com

'The Street is the Carrier and the Sign', in *Sarai Reader 02: The Cities of Everyday Life*, 2002
http://www.sarai.net/journal/02PDF/05streetsign/street.pdf

'Value and its Other in Electronic Culture: Slave Ships and Pirate Galleons', DIVE CD-Rom and text collection compiled for Armin Medosch (ed.), *Kingdom of Piracy: An Introduction to Free Software and Free Networks*, Liverpool: FACT, 2003

Essays in Marina Vishmidt and Melanie Gilligan (eds), *X Notes on Practice*,

Immaterial Labour: Work, Research & Art, London/New York: Black Dog Publishing, forthcoming. ISBN 1901033848

Selected Interviews/Conversations/Transcripts

http://www.raqsmediacollective.net/conversations.html

How Latitudes Become Forms: Art in a Global Age, Walker Art Center, Minneapolis, USA, February 2003
http://latitudes.walkerart.org/texts/texts.wac?id=295&textid=295&pageno=1

Interview of Raqs by Laurent Rollin (for the Tour du Monde du Web, Centre Pompidou)
http://www.raqsmediacollective.net/conversations3.html

Translocations: An Online Conversation between Steve Dietz, Gunalan Nadarajan, Yukiko Shikata and Raqs Media Collective

Selected Essays and Review Articles

For extracts, see
http://www.raqsmediacollective.net/comments.html

Nancy Adajania, 'Net Culture: Between the Fast Lane and the Slow', *Art India*
http://www.artindia.co.in/leadessay.php (extract)

Ranjit Hoskote, 'Global Art: Of Catastrophes, Redemptive Gestures', *The Hindu*, 24 November 2002
http://www.hinduonnet.com/thehindu/mag/2002/11/24/stories/2002112400420100.htm

Geert Lovink, 'New Media Culture in India: A Visit to Sarai, The New Media Initiative', *Fine Art Forum*, 16.12 (December 2002)
http://www.msstate.edu/Fineart_Online/Backissues/Vol_16/faf_v16_n12/reviews/lovink.html

Anna Munster, 'Travelling at the Speed of Life: World Time and Global Politics in New Media', posted on Fibreculture, 16 December 2002
http://www.fibreculture.org

Navin Rawanchaikul

Born 1971, Chiang Mai, Thailand. Lives and works in Fukuoka, Japan and Chiang Mai, Thailand

Selected Solo Exhibitions and Projects

2002 *SUPER(M)ART*, Palais de Tokyo, Paris, France (in collaboration with Helen Michaelsen)

2001 *I Love Taxi*, P.S.1 Contemporary Art Center (in collaboration with Public Art Fund), New York, USA

2000 *Taximan*, About Studio/About Café, Bangkok, Thailand

Fly With Me to Another World, Le Consortium, Dijon, France

1999 *Asking For Nothingness*, Satani Gallery, Tokyo, Japan

1997 *Navin And His Gang (Visit) Vancouver*, Contemporary Art Gallery, Vancouver, Canada

Selected Collaborative Projects

2004 *Fly With Me to Another World*, Lamphun, Thailand

1996–98 *EX/CHANGE (Murozumi Danchi Art Project)*, Murozumi Danchi, Fukuoka, Japan

1995–98 *Navin Gallery Bangkok (Taxi Gallery)*, Bangkok, Thailand

Selected Group Exhibitions

2004 *Here & Now*, About Studio/About Café, Bangkok, Thailand

2003 *Traffic: Art Exchange between Fukuoka and Kitakyushu*, Fukuoka Art Museum and Kitakyushu Municipal Museum of Art, Fukuoka and Kitakyushu, Japan

2002 *The Gift: Generous Offerings, Threatening Hospitality*, Scottsdale Museum of Contemporary Art, Arizona, USA. Travelled to Bronx Museum of the Arts, New York, USA (2002–2003); Mary and Leigh Block Museum of Art, Evanston, Illinois, USA (2003)

4th Shanghai Biennale, Shanghai Art Museum, Shanghai, China

Busan Biennale, Busan Metropolitan Art Museum, Busan, South Korea

2001 *Facts of Life: Contemporary Japanese Art*, Hayward Gallery, London, UK

Yokohama 2001: International Triennale of Contemporary Art, Yokohama, Japan

2nd Berlin Biennale, Berlin, Germany

2000 2nd Taipei Biennale, Taipei Fine Arts Museum, Taipei, Taiwan

Over the Edges, SMAK, Ghent, Belgium

5th Biennale de Lyon, Lyons, France

As It Is, Ikon Gallery, Birmingham, UK

1999 *Zeit Wenden*, Kunst Museum, Bonn, Germany

1998 *Memorealism*, Museum City Fukuoka, Fukuoka, Japan

To The Living Room, Watari Museum of Contemporary Art, Tokyo, Japan

Every Day, 11th Biennale of Sydney, Sydney, Australia

1997 *Cities on the Move*, Wiener Secession and Museum in Progress, Vienna, Austria (in collaboration with Rirkrit Tiravanija). Travelled to CAPC Musée d'Art Contemporain de Bordeaux, Bordeaux, France (1998); P.S.1 Contemporary Art Center, New York, USA (1998); Louisiana Museum of Modern Art, Humlebaek and Artspace 1%, Copenhagen, Denmark (1999); Hayward Gallery, London, UK (1999); About Studio/About Café, Bangkok, Thailand (1999); and Krisma, Helsinki, Finland (1999)

2nd Gwangju Biennale, Gwangju, Korea

Art in Southeast Asia 1997: Glimpse into the Future, Museum of Contemporary Art, Tokyo; Hiroshima City Museum of Contemporary Art, Hiroshima, Japan

Further Reading

Alex Farquharson, *Navin Rawanchaikul*, Paris: Editions de l'œil, 2002

Helen Michaelsen, *COMM. . .: Navin Rawanchaikul, Individual and Collaborative Projects 1993–1999*, Tokyo: S by S Co. Ltd.; Vancouver: Contemporary Art Gallery, 1998

Hans Ulrich Obrist, 'Navin Rawanchaikul: Temple, Streets, and Taxicabs', *Flash Art*, 33.120 (January–February 2000), pp. 98–100

Steven Pettifor, 'An Art World in a Taxi', *Asian Art News*, 11.6 (November–December 2001), pp. 48–51

Apinan Poshyananda, 'Navin Rawanchaikul', in *Fresh Cream*, London: Phaidon Press, 2000, pp. 496–501

Martha Rosler

Born Brooklyn, New York. Lives and works in New York, USA

Selected Solo Exhibitions, Projects, Performances and Screenings

2004 *Monumental Garage Sale*, Project Arts Centre, Dublin, Republic of Ireland

2003 *Short History of Performance*, Whitechapel Art Gallery, London, UK

2002 *3 Transient Tenants at the Central Terminal*, Moderna Museet, Stockholm, Sweden

Martha Rosler, Maison Européenne de la Photographie, Paris, France

Vin & Sprithistoriska Museet, Stockholm, Sweden (with Richard Billingham)

2000 *Hors Champ: Agenda Caravanes* (with Peter Boggers), Centre Pompidou, Paris, France

Romances of the Meal, performance in the *Indiscipline* project, Brussels 2000 exhibition hall, Brussels, Belgium

1998–2000 *Martha Rosler: Positions in the Life World. Retrospective Exhibition*, Ikon Gallery, Birmingham, UK; Institut d'Art Contemporain, Villeurbanne, France; Generali Foundation, Vienna, Austria; Museu d'Art Contemporani de Barcelona, Barcelona, Spain; Nederlands Foto Instituut, Rotterdam, and Rotterdam Foto Biennale, the Netherlands; New Museum, New York, and Institute of Contemporary Photography, New York, USA

1999 *OOPS! Or, Nobody Loves the Hegemon*, Galerie Christian Nagel, Cologne, Germany

1998 *In the Place of the Public*, Frankfurt Airport, sponsored by the airport and Museum für Moderne Kunst, Frankfurt, Germany

Martha Rosler, INIT Kunsthalle, Berlin, Germany

Selected Group Exhibitions

2004 *En Guerra (WAR)*, Centro de Cultura Contemporánia de Barcelona, Barcelona, Spain

2003 *Oleanna Space/Ship/Station*, at Utopia Station at the 50th Venice Biennale, Venice, Italy

M_ARS – Art and War, Neue Galerie, Graz, Austria

2002–2004 *Shopping: A Century of Art and Consumer Culture*, Schirn Kunsthalle, Frankfurt, Germany, and Tate Liverpool, Liverpool, UK

2002 *Sans Commune Mesure*, Musée d'Art Moderne Lille Metropole, Villeneuve d'Ascq, France

Visions from America: Photographs from the Whitney Museum of American Art, 1940–2001, Whitney Museum, New York, USA

2001 *Bruit de Fond*, Centre National de Photographie, Paris, France

2000 *The Wounded Diva: Hysteria, Body, Technology in 20th Century Art*, Kunstverein München, Städtische Galerie im Lenbachhaus und Kunstbau, Munich, Germany; Siemens Kulturprogramm, Munich, Germany; Galerie im Taxispalais, Innsbruck, Austria; Staatliche Kunsthalle, Baden-Baden, Germany

The Cool World: Film & Video in America 1950–2000. Part II: 1970–2000, Whitney Museum of American Art, New York, USA

Further Reading

Sabine Breitwieser and Catherine de Zegher (eds), *Martha Rosler: Positionen in der Lebenswelt*, Vienna: Generali Foundation; Cologne: Walther König, 1999

Jens Hoffmann, 'The Familiar Is Not Necessarily the Known', *NU: The Nordic Art Review* (Stockholm), 3.2 (2001)

Martha Rosler, *Decoys and Disruptions: Selected Writings, 1975–2001*, Cambridge, MA: MIT Press, 2004. An October Book/ ICP Book. Selected essays

Anthony Vidler, 'Martha Rosler', in *Warped Space: Art, Architecture and Anxiety in Modern Culture*, Cambridge, MA: MIT Press, 2000

Catherine de Zegher (ed.), *Martha Rosler: Positions in the Life World*, Birmingham: Ikon; Vienna: Generali Foundation; Cambridge, MA: MIT Press, 1998

Shen Yuan

Born in 1959, Xianyou, China. Has lived and worked in Paris since 1990

Selected Solo Exhibitions

2003 *Shen Yuan*, Kunstverein Nürtingen, Nürtingen, Germany

Beauty Room 5, Beauty Room, Paris, France

2001 Shen Yuan, Bluecoat, Liverpool, UK

Shen Yuan, Arnolfini, Bristol, UK

Un Matin du Monde, Chisenhale Gallery, London, UK

Shen Yuan, Institut français du Royaume-Uni, London, UK

2000 *Sous la terre, il y a de ciel*, Kunsthalle Bern, Berne, Switzerland

1999 *Diverged Tongue*, Project Gallery at CCA, Kitakyushu, Japan

Selected Group Exhibitions

2004 *Don't Touch White Woman: Contemporary Art between Diversity and Liberation*, Fondazione Sandretto Re Rebaudengo, Torino, Italy

Arte y naturaleza III, Montenmedio Arte Contemporáneo, Cadiz, Spain

A l'ouest du sud de l'est, Centre Régional d'Art Contemporain Languedoc-Roussillon, Sète, France

Le Moine et le démone, Musée d'Art Contemporain de Lyon, Lyons, France

A l'ouest du sud de l'est/A l'est du sud de l'ouest, Villa Arson, Nice, France

All Under Heaven, Ancient and Contemporary Chinese Art: The Collection of the Guy & Myriam Ullens Foundation, MuHKA (Museum of Contemporary Art Antwerp), Antwerp, Belgium

2003 *New Zone – Chinese Art*, The Zacheta Gallery of Contemporary Art, Warsaw, Poland

Su-mei tse/transports croisés/air de mode/Shen Yuan, Gallery Beaumontpublic, Luxembourg

2002 *Roud-point*, L'Académie des Beaux-Arts de Kinshasa, Kinshasa, Democratic Republic of Congo/L'Ecole des Beaux-Arts de Nantes, Nantes, France

Bienal de São Paulo, São Paulo, Brazil

Paris pour escale, Musée d'Art Moderne de la Ville de Paris, Paris, France

Fuori uso 2000, Pescara, Italy

1999 *Cities on the Move 5*, Hayward Gallery, London, UK

Art & Architecture, Asian Fine Art Factory, Berlin, Germany

Un Matin du Monde, Galerie Eric Dupont, Paris, France

Cities on the Move 4, Louisiana Museum of Modern Art, Denmark

1998 *Cities on the Move 3*, P.S.1, New York, USA

The Half of the Sky, Frauen Museum Bonn, Bonn, Germany

Cities on the Move 2, CAPC Museum, Bordeaux, France

Santiago Sierra

Born 1966, Spain. Lives and works in Mexico City

Selected Solo Exhibitions

2004 Galerie Peter Kilchmann, Zurich, Switzerland

Kunsthaus Bregenz, Bregenz, Austria (curated by Eckhard Schneider)

CAC Centre d'Art Contemporain de Brétigny, Paris, France (curated by Pierre Bal-Blanc)

Orizaba 160, Mexico City, Mexico

2003 *100 Hidden People*, Galería Helga de Alvear, Madrid, Spain

'El Degüello' (The Slaughter) Song, Battery Park, New York, USA

Illuminated Building, Arcos de Belén, Mexico City, Mexico

2002 *Hiring and Arrangement of 30 Workers in Relation to their Skin Colour*, Kunsthalle Wien, Vienna, Austria (curated by Gabriele Mackert)

3,000 Holes of 180 x 70 x 70 cm Each, Montenmedio Arte Contemporáneo, Vejer de la Frontera, Spain

Spraying of Polyurethane over 18 People, Claudio Poleschi Arte Contemporanea, Lucca, Italy

Santiago Sierra. Works: 2002–1990, Ikon Gallery, Birmingham, UK (curated by Katya García-Antón)

2001 *430 People Paid 30 Soles per Hour*, Galería Pancho Fierro, Lima, Peru (curated by Juan Peralta)

20 Workers in a Ship's Hold. 3 Urban Interventions, Barcelona Art Report 2001, Barcelona, Spain (curated by Rosa Martínez)

2000 *Workers Who Cannot Be Paid, Remunerated to Remain Inside Cardboard Boxes*, Kunstwerke, Berlin, Germany (curated by Klaus Biesenbach)

The Wall of a Gallery Pulled Out, Inclined 60 Degrees from the Ground and Sustained by 5 People, Acceso A, Mexico City, Mexico

12 Workers Paid to Remain Inside Cardboard Boxes, ACE Gallery New York, New York, USA

1999 *250 cm Line Tattooed on Six Paid People*, Espacio Aglutinador, Havana, Cuba (curated by Sandra Cevallos)

24 Blocks of Concrete Constantly Moved During a Day's Work by Paid Workers, ACE Gallery LA, Los Angeles, USA

Selected Group Exhibitions

2004 *Made in Mexico*, The Institute of Contemporary Art (ICA), Boston, USA (curated by Gilbert Vicario)

2003 *Hardcore*, Palais de Tokyo, Paris, France (curated by Jérome Sans)

Witness, Barbican Art, London, UK (curated by Mark Sladen)

Mexico Attacks!, Associazione Prometeo per l'Arte Contemporanea, Lucca, Italy (curated by Teresa Macri)

M_ARS: Art and War, Neue Galerie Graz, Graz, Austria (curated by Peter Weibel and Günther Holler-Schuster)

2002 *20 Million Mexicans Can't Be Wrong*, South London Gallery, London, UK (curated by Cuauhtémoc Medina); John Hansard Gallery, Southampton, UK, January 2003

Mexico City: An Exhibition about the Exchange Rates of Bodies and Values, P.S.1, New York, USA (curated by Klaus Biesenbach); Kunstwerke, Berlin, Germany

2001 *ARS 01 – Unfolding Perspectives*, Kiasma, Helsinki, Finland (curated by Maaretta Jaukkuri)

Comunicación entre las artes, Bienal de Valencia, Valencia, Spain (curated by Achille Bonito Oliva)

Plateau of Humankind, 49th Venice Biennale, Venice, Italy (curated by Harald Szeemann)

2000 *Novena Muestra Internacional de Performance*, Ex Teresa Arte Actual, Mexico City, Mexico (curated by Guillermo Santamaría)

Documentos, ACE Gallery LA, Los Angeles, USA

A Shot in a Head, Lisson Gallery, London, UK (curated by Patricia Martín)

Further Reading

20 Million Mexicans Can't Be Wrong, London: South London Gallery, 2002. Text by Cuauhtémoc Medina

ARS 01 – Unfolding Perspectives, Helsinki: Museum of Contemporary Art, 2001

Hardcore – Vers un nouvel activisme, Paris: Palais de Tokyo/Editions Cercle d'Art, 2003. Interview by Jérôme Sans

Loop, Munich: Hypo Kunsthalle, 2001. Text by Klaus Biesenbach

Valeska Soares

Born in Belo Horizonte, Minas Gerais, Brazil. Lives and works in Brooklyn, New York, USA

Selected Solo Exhibitions

2005 *Walk On By*, Art Gallery of Hamilton, Canada

2004 *Caprichos*, survey show at Marco, Monterrey, Mexico

2003 *Puro Teatro*, Museu Rufino Tamayo, Mexico City, Mexico

Follies, survey show at the Bronx Museum for the Arts, New York, USA

2002 *Mirroring*, Dwight Hackett Projects, Santa Fe, USA

Valeska Soares, Museu de Arte da Pampulha, Belo Horizonte, Brazil

Detour, Galeria Fortes Vilaça, São Paulo, Brazil

1999 *Pan American Series*, San Diego Museum of Contemporary Art, San Diego, USA

Galerie Papillon-Fiat, Paris

1998 *Vanishing Point*, Galeria Camargo Vilaça, São Paulo, Brazil

Untitled (from Vanishing Point), Christopher Grimes Gallery, Santa Monica, CA, USA

Vanity, Portland Institute of Contemporary Art, Portland, OR, USA

histórias, a project for The Public Art Fund, New York, USA

Selected Group Exhibitions

2004 *Anthology of Art*, Akademie der Künste, Berlin, Germany

Estratégias Barrocas, Centro Cultural Metropolitano, Quito, Ecuador

Non Toccare Donna Bianca – Contemporary Art between Diversity and Liberation, Fondazione Sandretto Re Rebaudengo, Torino, Italy

Flowers Observed, Flowers Transformed, The Andy Warhol Museum, Pittsburgh, PA, USA

2001 *Elusive Paradise: The Millennium Prize*, National Gallery of Canada, Ontario, Canada

F(r)iccoenes, Museu Reina Sofia, Madrid, Spain

Virgin Territory, National Museum of Women in the Arts, Washington, DC, USA

Brooklyn!, Palm Beach Museum of Contemporary Art, Palm Beach, FL, USA

2000 *InSite 2000*, San Diego, USA/Tijuana, Mexico

Ultra Baroque, Museum of Contemporary Art, San Diego, USA (cat.)

Good Business is the Best Art, The Bronx Museum, Bronx, New York, USA

Greater New York, P.S.1 Museum/Museum of Modern Art, New York, USA

Further Reading

Elizabeth Armstrong and Victor Zamudio-Taylor, trans. Fernando Feliu-Mogo, *Ultrabaroque: Aspects of Post Latin American Art*, exh. cat., San Diego: Museum of Contemporary Art, 2000

Collette Chattopadhyay, 'InSITE 2000', *Art Nexus*, 39 (February–April 2001), pp. 82–85

Regina Coppola, *Mirror Tenses: Conflating*

Time and Presence (brochure), Massachusetts: University Gallery, Fine Arts Center, University of Massachusetts, 2003

Paulo Herkenhoff, trans. Stephen Berg and Andrew Hahn, 'Valeska Soares', in *6 Artistas*, São Paulo: Galeria Camargo Vilaça, 1994, not paginated

Charles Merewether, 'A Sensorium of the Object', in *International Critics' Choice: An Exhibition Organized by The Mitchell Museum at Cedarhurst*, exh. cat., Mount Vernon, IL: The Mitchell Museum at Cedarhurst, 1993, pp. 11–12

Charles Merewether, 'Into the Void/Para dentro do vazio', in *Valeska Soares*, São Paulo: Galeria Camargo Vilaça, 1994, not paginated

Rodrigo Moura, 'Sculptures that Feel', *Art Nexus*, 50.2 (2003), pp. 52–56

Vik Muniz, 'Valeska Soares. Interview', *Bomb*, 74 (Winter 2001), pp. 48–55

Torolab

Raúl Cárdenas-Osuna

Born 1969, Mazatlán, Sinaloa México. Has lived in Tijuana since 1988. Director of Torolab, which he founded in 1995

Selected Projects/Torolab

2004–2005 *InSite 5*

2004 Architectural Biennial Beijing, Beijing, China

B2V Fashion Show, Vancouver Art Gallery, Vancouver, Canada

MovO, Moderna Museet, Stockholm, Sweden

Torolab, Vancouver Art Gallery, Vancouver, Canada

'City-Proyect' in *What We Want*, Collective Book Publication, Italy

Museum of Contemporary Art, San Diego, USA/Vancouver Art Gallery, Vancouver, Canada/CCAC Wattis Institute for Contemporary Arts, San Francisco, USA

2003 *Laboratorio de Arte Alameda*, collective exhibition, Mexico City, Mexico

Havana Biennial, collective exhibition at the Cuban Pavilion, Havana, Cuba

Instant City, collective exhibition, Cultural Centre of Mexico in Paris, France

El Toro Machado, installation at *Espectacular* exhibition, Cultural Centre of Spain in Mexico, Mexico City, Mexico

Transmediale 0.3: The House of World Cultures, Berlin, Germany

2001–2003 *Magic/Pool ToroVestimenta* collection, Las Vegas Convention Center, Las Vegas, USA

2002–2003 *Sensitive Negotiations*, collective exhibition, Art Basel, Miami, USA

Diagnósticos Urbanos, collective exhibition, Centro Cultural Tijuana, Tijuana, Mexico

VIII Salón de Arte Bancomer, collective exhibition, Museum of Modern Art, Mexico City, Mexico

2002 *Saun*, collective exhibition, Lux Gallery, San Francisco, USA

Montreal Biennial, collective exhibition, Montreal, Canada

No-one Over 21, collective exhibition with Jonathan Hernández, P.S.1, New York, USA

Pushale, Pasadena, USA

SOS, individual exhibition, Cedille, Paris, France

Artwalk, collective exhibition, San Diego, USA

2001 *Utopia Now*, collective exhibition, CCAC Institute, Oakland, CA, USA

Torolab, Laboratorio of the Future in the Present, individual exhibition, Museum of Contemporary Art, San Diego, USA

2000 *Laboratorio Experimental 0.2*, installation (with students of UIA University, Tijuana, Mexico)

El Toro Manchado, installation, Jai Alai, Tijuana BC, Mexico as part of the Nortec City Concert/March

No-one Over 21 project together with Jonathan Hernández and Fussible for InSite

1997

ToroVestimenta, a project of urban interventions, USA (San Diego, Los Angeles, Chicago, Texas, Boston, New York, Hawaii, Alaska), Vancouver, Tokyo, Osaka, Paris, Taiwan

Selected Conferences

'Urbanism' Roundtable at CECUT, Tijuana, Mexico, May 2004

'Territorios', International Architectural Conference, Mexico City, Mexico, 19–20 March 2004

'SOS Architecture', CCAC Institute, San Francisco, USA, 10 February 2004

'Torolab', Otis College of Art and Design, Los Angeles, USA, March 2003

'Arte y Ciudad', SITAC, Mexico City, Mexico, January 2003

'Torolab', Museum of Contemporary Art, September 2002

'Architecture Lecture Series', University of California at Berkeley, CA, USA, April 2002

'Mapping Global Culture Climates', Art Institute, Oakland, CA, USA, November 2001

'Architectural Review', University of Guadalajara, Guadalajara, Mexico, November 2001

'Nortec 2000' Music Conference, Centro Cultural, Tijuana, Mexico, November 2000

Wong Hoy Cheong

Born 1960, Penang, Malaysia. Lives in Malaysia

Selected Solo Exhibitions/Projects

2004 *Selected Works 1984–2004*, National Art Gallery, Kuala Lumpur, Malaysia

slight shifts, Pitt Rivers Museum, Oxford, UK

2003 *fact-fiction*, Kunsthalle, Vienna, Austria

Selected Works 1994–2002, Djanogaly Gallery, Nottingham, UK

2002 *Selected Works 1994–2002*, John Hansard Gallery, Southampton, UK

Selected Works 1994–2002, Bluecoat Gallery, Liverpool, UK

Whose Text?, Valentine Willie Fine Art, Kuala Lumpur, Malaysia

1999 *Seeds of Change*, Habitat, Tottenham Court Road, London, UK

Selected Group Exhibitions/Projects

2004 *Ethnic Marketing*, Centre for Contemporary Art, Geneva, Switzerland

Minority Report, Aarhus Art Building, Aarhus, Denmark

SHAKE, OK Centre for Contemporary Art, Linz, Austria and Villa Arson, Nice, France

2003 *Cam-taten*, Kunstraum, Linz, Austria

Dreams and Conflicts (Z.O.U. and Utopia Station), 50th Venice Biennale, Venice, Italy

Handlungsanweisungen – instructions for actions, Kunsthalle, Vienna, Austria

2002 *The Spice Route*, ifa gallery, Stuttgart, Germany

Refuge, Henie Onstad Kunstsenter, Høvikodden, Norway

2001 *ARS 01*, Kiasma Museum of Contemporary Art, Helsinki, Finland

2000 *Overtag*, BildMuseet, Umea, Sweden

Lines of Descent, Queensland Art Gallery, Brisbane, Australia

La Ville, Le Jardin, La Memoire, Villa Medici, Rome, Italy

Mutations/Urban Rumours, Fri-Art Contemporary Art Centre, Fribourg, Switzerland

Invisible Boundary, Utsonomiya Museum of Art, Utsonomiya, Japan

3rd Gwangju Biennale, Gwangju, South Korea

1999 *babel*, Ikon Gallery, Birmingham, UK

Sogni/Dreams, Fondazione Sandretto Re Rebaudengo per l'Arte/Venice Biennale

Further Reading

Blake Gopnik, 'Banal Biennale', *Washington Post*, 22 June 2003

Hou Hanru, 'Rereading History, from Discourse to Action', in *Wong Hoy Cheong*, UK/Kuala Lumpur: Organisation for Visual Arts/Valentine Willie Fine Art, 2002

Gavin Jantjes, 'Seeking Refuge', in *Refuge/Tilflukt*, exh. cat., Henie Onstad Kunstsenter, Norway, 2002

Ray Langenbach, 'Mapping the Cartographer', in *Wong Hoy Cheong*, UK/Kuala Lumpur: Organisation for Visual Arts/Valentine Willie Fine Art, 2002

Steven Henry Madoff, 'Venice Biennale', *Art News* (September 2003)

'Wong Hoy Cheong', in *ARS 01*, exh. cat., Kiasma Museum of Contemporary Art, Finland, 2001

Beverly Yong, 'Rhetorical Questions', in *Whose Text?*, Kuala Lumpur: Valentine Willie Fine Art, 2002

Yang Fudong

Born 1971, Beijing. Lives and works in Shanghai, China

Selected Exhibitions

2004 Dak'Art Biennial

Yang Fudong, Marian Goodman Gallery, Paris, France

Yang Fudong at TRANS>area, New York, USA (curated by Hans Ulrich Obrist)

An Evening with Yang Fudong, MediaScope, New York, USA

China Now, Gramercy Theater MoMA, New York, USA

2003 *Happiness: A Survival Guide for Art and Life*, Mori Art Museum, Tokyo, Japan

Yang Fudong at Büro Friedrich, Berlin, Germany

Out of the Red – La generatione emergente, Trevi Flash Art Museum, Trevi, Italy

The Paradise [12], The Douglas Hyde Gallery, Dublin, Ireland

50th Venice Biennale, Chinese Pavilion and Utopia Station, Venice, Italy

The Minority is Subordinate to the Majority, BizArt Art Center, Shanghai, China

Alors la Chine?, Centre Pompidou, Paris, France

Lifetime, Beijing Tokyo Art Projects

Camera, Musée d'Art Moderne de la Ville de Paris, Paris, France

2002 *Urban Creation*, 4th Shanghai Biennale, Shanghai Art Museum, Shanghai, China

Fan Mingzhen & Fan Mingzhu – Glad To Meet You (Twin Exhibition), Jin Sha Jiang Rd, Shanghai, China

The First Guangzhou Triennial, Guangdong Museum of Art, Guangzhou, China

There's No Accounting for Other People's Relationships, Ormeau Baths Gallery, Belfast, Northern Ireland

Documenta 11, Kassel, Germany

VideoROM 2.0, Giancarla Zanutti Gallery, Milan, Italy

2001 The First Valencia Biennial, Valencia, Spain

Psycho-Bobble, Galleria Raucci/Santamaria, Naples, Italy

Living in Time: Contemporary Artists from China, Hamburger Bahnhof, Berlin, Germany

Xu Xiaoxiao, video installation, Yokohama Triennale, Yokohama, Japan

Tonight Moon, video installation, Istanbul Biennale, Istanbul, Turkey

Mantic Ecstasy – Photography and Video, Hangzhou; Shanghai; Beijing, China

ARCO, Asian Party, Global Game, Madrid, Spain (curated by Hou Hanru)

2000 *Useful Life* (together with Yang Zhenzhong and Xu Zhen), Shanghai, China

Uncooperative Approach (Fuck Off), Shanghai, China

Multimedia Art Asia Pacific (MAAP) Festival, Australia

Home, Shanghai, China

Exit, Chisenhale Gallery, London, UK

1999 Love-Tokyo Art Festival, Tokyo, Japan

Hanover Film Festival, Hanover, Germany

Wu Shi Ren Fei (The Same But Also Changed), photography exhibition, 859 Tian Yao Qiao Rd, Shanghai, China

Post-Sense Sensibility Alien Bodies & Delusion, Beijing, China

Yuan Goang-Ming

Born 1965, Taipei, Taiwan. Lives and works in Taipei

Selected Solo Exhibitions

2002 *T2: Yuan Goang-Ming 'Human Disqualified'*, MOMA Contemporary Gallery, Fukuoka, Japan

2001 *Human Disqualified*, IT Park Gallery, Taipei, Taiwan

2000 *Contemporary Taiwanese Art Exhibition Vol. 7, Yuan Goang-Ming: Fish on Dish*, MOMA Contemporary Gallery, Fukuoka, Japan

1998 *The Reason for Insomnia*, IT Park Gallery, Taipei, Taiwan

Selected Group Exhibitions

2004 *The Era of Contention: Contemporary Taiwanese Visual Culture*, Herbert F. Johnson Museum of Art, Cornell University, New York, USA

The 2nd Auckland Triennial: *PUBLIC/PRIVATE*, Auckland Art Gallery, Auckland, New Zealand

The Story of Time: Selections from TFAM Collection, Taipei Fine Arts Museum, Taipei, Taiwan

2003 *Limbo Zone*, 50th Venice Biennale, Venice, Italy

25hrs Barcelona, international video art show, Barcelona, Spain

Assorted Asian Tigers, Proud Gallery, London, UK

Streams of Encounter – Electronic Media Based Artworks, Taipei Fine Arts Museum, Taipei, Taiwan

Cyber Asia – Media Art in the Near Future, Hiroshima City Museum of Contemporary Art, Hiroshima, Japan

Taiwan Art/Film/Video Festival, Lothringer13/Laden, Munich, Germany

Invisible City, The Vancouver International Center for Contemporary Asian Art (Centre A), Vancouver, Canada

Tirol Transfer, Gallery Krinzinger, Vienna, Austria

2002 Taipei Biennial 2002: *Great Theatre of the World*, Taipei Fine Arts Museum, Taipei, Taiwan

Translated Acts, Museo de Arte Carrillo Gil, Mexico

Luna's Flow: The 2nd Seoul International Media Art Biennale, Seoul Museum of Art, Seoul, Korea

Culture Meets Culture: Busan Biennale 2002, Busan Metropolitan Art Museum, Busan, Korea

Pause: Gwangju Biennale 2002, Gwangju, South Korea

2001 *01.01.01: Art in Technological Times*, San Francisco Museum of Modern Art, San Francisco, USA

Translated Acts, Haus der Kulturen der Welt, Berlin, Germany and Queens Museum of Art, New York, USA

Digital Orgy: The Third Bangkok Experimental Film Festival, Singapore, Bangkok, Hong Kong, Stockholm

2000 *Continental Shift/Voyage Between Cultures*, Liège Museum of Modern Art, Liège, Belgium

If I had a Dream. . ., Künstlerhaus Bethanien, Berlin, Germany

Fear of Water, Taipei Fine Arts Museum, Taipei, Taiwan

Close-Up: Contemporary Art from Taiwan, Emily Carr Institute of Art, Vancouver and Art Gallery of Greater Victoria, Victoria, Canada

The New Identity Part 4: Digital Edge, Mitsubishi Jisho Artium, Fukuoka, Japan

1999 *Time Migration: Techno-Art for the New Millennium*, Taipei Gallery, New York, USA

1998 Taipei Biennial: *Site of Desire*, Taipei Fine Arts Museum, Taipei, Taiwan

1997 ICC Biennial '97: *Communication/Discommunication*, NTT Inter-Communication Center (ICC), Tokyo, Japan

1996 Taipei Biennial: *The Quest for Identity*, Taipei Fine Arts Museum, Taipei, Taiwan

1995 Gwangju Biennale 1995: *InfoART*, Gwangju, South Korea

Selected Further Reading

Aron Betsky, 'Yuan Goang-Ming', in *01.01.01: Art in Technological Time* (exh. cat.), San Francisco: San Francisco Museum of Modern Art, 2001, pp. 138–39

Amy Huei-Hua Cheng, trans. Christine Chan, 'Interview with Yuan Goan-Ming', *YiShu: Journal of Contemporary Chinese Art*, Taipei (Spring 2003), pp. 86–89

Jane Farver, 'Yuan Goang-Ming', *Art AsiaPacific*, 37 (2003), p. 43

Eleanor Heartney, 'Report from Taiwan: The Costs of Desire (Review)', *Art in America*, 86.12 (December 1998), pp. 38–43

Notes on Contributors

Cecilia Andersson (Stockholm) is a curator and critic based in Liverpool where she runs Werk Ltd, a curatorial agency. She holds a diploma from the International Centre of Photography, a BA from Empire State College, New York City and an MA in Curatorial Studies from Goldsmiths College in London. Recent projects include *typO*, presenting works by Xu Bing, Olaf Nicolai and Claude Closky (FACT, Liverpool, and Moderna Museet, Stockholm); and *Learning to Watch* by Jennifer and Kevin McCoy (Sala Rekalde, Bilbao). Current activities involve a touring screening programme of Cuban video.

Bryan Biggs has been Director of Bluecoat Arts Centre, Liverpool since 1994. Previously he ran the exhibitions programme of Bluecoat Gallery. He was on the curatorial team of the Liverpool Biennial's *International 02* exhibition. A fine art graduate of Liverpool Polytechnic, he continues his art practice, with occasional exhibitions.

Lewis Biggs was Exhibitions Coordinator at Arnolfini, Bristol, 1979–1984, and Exhibitions Officer with the British Council Visual Arts Department until 1987. He was British Commissioner for the São Paulo Bienal in 1986. In 1987 he joined Tate, and was Director of Tate Liverpool from 1990 to 2000. In 1998 he became a founding Trustee, with James Moores and Jane Rankin Reid, of Liverpool Biennial, and has been Chief Executive of the Biennial since November 2000. He is general editor of the Modern Artists series, Tate Gallery Publishing.

Sabine Breitwieser is the Artistic and Managing Director of the Generali Foundation in Vienna (Founding Director, 1991) and has organised a number of exhibitions and projects in Austria as well as abroad. She has edited numerous publications and has contributed several essays on museum management as well as on contemporary art. She is a frequent lecturer in Austria and abroad, and is a member of the University Supervisory Board of the Academy of Fine Arts, Vienna. She has recently contributed to *Words of Wisdom: A Curator's Vade Mecum on Contemporary Art*, New York, 2001.

Laura Britton is Curator: Public Programmes at Tate Liverpool. She studied at the University of York, has a PGCE from the Institute of Education and an MA in the History of Art from the Courtauld Institute. At Tate Liverpool Laura organises artists' talks, conferences and symposiums, manages the University Network and coordinates the Critical Forum. Recently, she has organised events with Grayson Perry, Antony Gormley, Andy Goldsworthy and Channel Five. She also continues to work as an Associate Lecturer for the Open University.

As International Exhibition Assistant, **Sorcha Carey** has assisted in the research, development and production of *International 04*. Prior to joining Liverpool Biennial in July 2003, she was a British Academy Postdoctoral Fellow at the University of Cambridge, where she taught the history of Classical Art.

Mark Daniels is International Exhibition Coordinator at Liverpool Biennial. He studied architecture at Kingston University and has an MA in Art as Environment from Manchester Metropolitan University. As a curator his projects include *The Sitooteries* at Belsay Hall, Northumberland (2000), *A History of the Future* for Tyneside Cinema, Newcastle (2001), and *Commodity, Firmness & Delight* (2001–2002). He was guest curator of the final Visionfest visual art and design festival on Merseyside in 1997 before working on Photo '98 in Yorkshire and then moving to the North East to work as the inaugural Programme Director of Northern Architecture.

Rana Dasgupta is a writer based in Delhi, whose first novel, *Tokyo Cancelled*, will be published in the UK by Harper Collins in February 2005.

Paul Domela is Deputy Chief Executive of Liverpool Biennial where he is responsible for the International exhibition and the Learning and Inclusion programme. Together with International Foundation Manifesta he organises Coffee Break, discussions around visual art and contemporary cultural practice in a changing Europe. In 2004 he also co-curated the Liverpool/Manchester section of *Shrinking Cities*, Berlin. Between 1992 and 1999 he organised the public programme of the Jan van Eyck Akademie, Maastricht, the Netherlands.

Adrian George is Curator: Exhibitions and Collections, Tate Liverpool. A graduate of the Royal College of Art MA in Curatorial Practice, his first post was as curatorial assistant at the New Museum of Contemporary Art, New York. In 1999 he took up the post of Assistant Curator at Tate Modern, London. Since taking up his post at Tate Liverpool in July 2002 he has produced projects with the Liverpool Biennial; Thomas Ruff; Rut Blees Luxemburg; Janet Cardiff and George Bures Miller; Rebecca Horn; and an exhibition, *Art, Lies and Videotape*, focusing on performance art's representation within the museum context.

Catherine Gibson has been Exhibitions Curator at Bluecoat Arts Centre, Liverpool, since 1999. She was one of the curators of the Liverpool Biennial *International 02*.

Ceri Hand has a diverse range of experience in the arts, from practising artist to curating, publishing, arts management and consultancy. She is currently Head of Exhibitions at FACT; prior to this appointment she was Deputy Director at Grizedale Arts (where she curated a number of projects such as *Roadshow* and *Let's Get Married Today*), Director of *MAKE* (resource and magazine for women in the arts), independent curator (*Someone Must Have Been Telling Lies*, Forde Gallery, Geneva) and arts consultant/manager (*MUTE* and *TV Swansong*).

Patrick Henry has been Director of Open Eye Gallery since April 2004. He was formerly Curator of Exhibitions at the National Museum of Photography, Film & Television (Bradford, UK). His projects at NMPFT included *Luc Delahaye: Photographs* (2004), *Fabula* (2003) and *Symptomatic: Recent Works by Perry Hoberman* (2001). Published writings include catalogue essays for *Fabula*, *Symptomatic* and *In a Lonely Place* and articles for *Archive* and *Portfolio* magazines.

Paul Kelly has been working in the community development field for the past 15 years and is currently the Community Development Manager with Liverpool Housing Action Trust (HAT). Paul is interested in developing resources which help create sustainable communities and, in particular, enabling community organisations to manage their own community buildings. He is interested in how the arts can be used as a tool in the regeneration arena, and has extensive experience of developing innovative arts partnerships and projects to animate grass-roots communities.

Cressida Kocienski graduated with a BA (Hons) in Fine Art from Liverpool John Moores University in 2003, and now works as a freelance researcher.

Yu Yeon Kim is an independent curator based in New York. She was the Commissioner for Latin America for the 3rd Gwangju Biennale, South Korea, 2000 (*Exotica Incognita*) and the 2nd Johannesburg Biennale, South Africa, 1997–98. Recently she has curated *Translated Acts – Performance and Body Art from East Asia* at the Haus der Kulturen der Welt, Berlin, Queens Museum of Art, New York and Museo de Carrillo Gil in Mexico City (2001–2003). Other curatorial projects include *Fragmented Histories*, the Asia-Pacific section of the *Cinco Continentes y Una Ciudad* exposition at Mexico City Museum (1998); *DMZ_2000* (the Demilitarized Zone between North and South

Korea) and *OMNIZONE: Perspectives in Mapping Digital Culture*, an online project featured on both the Plexus.org and the Guggenheim Museum websites. Her current project is *DISAPPEARANCE*, a collaboration with the Haus der Kulturen der Welt and Tsinghua University in Beijing.

After graduating from art school, **Declan McGonagle** became Director of the Orchard Gallery in Derry in 1978. He went on to be Director of Exhibitions at the ICA, London, and then Visual Arts Organiser for Derry City Council. He was nominated for the Turner Prize in 1987 for making the Orchard Gallery an international centre for the artist. He was appointed as the first Director of the Irish Museum of Modern Art, Dublin, in 1990 and stayed for 11 years, with a string of other key roles including Irish Commissioner for the Venice Biennale in 1993 and the São Paulo Biennale in 1994. He recently directed Dublin's City Arts Centre Civil Arts Inquiry, which proposed a non-building-based model for the centre focused on research, programming, publishing and communication. In 2004 he was appointed as Director and Professor of Art and Design at the University of Ulster.

Marie-Anne McQuay is Programme Manager for FACT's Collaboration Programme. She studied Fine Art at Winchester before joining FACT in 2000 where she has coordinated collaborative commissions with international artists including Dias & Riedweg, Kristin Lucas, Stephen Willats and Nick Crowe. She plays an active role in Liverpool's art scene and contributed texts to Static's *Exit Review*. She is a member of Arena Art and Design Association's Gallery Committee: Arena provides artists with city-centre studio spaces and an exhibition venue.

Cuauhtémoc Medina (born Mexico City, 5 December 1965) is an art critic, curator and historian who lives and works in Mexico City. He has a PhD in Art History and Theory and is Researcher at the Instituto

de Investigaciones Estéticas, National University of Mexico; Associate Curator of Latin American Art Collections at Tate in London; and a member of *Teratoma*, a group of curators, critics and anthropologists based in Mexico City. In 2002 he organised Francis Alÿs's action *Where Faith Moves Mountains* (Lima) and curated the exhibition *20 Million Mexicans Can't Be Wrong* (London). Among his recent publications are 'Gerzso and the Indo-American Gothic' in Diana C. Dupont (ed.), *Risking the Abstract: Mexican Modernism and the Art of Gunther Gerzso* (2003), and 'Aduana/Customs', in Rosa Martínez *et al.* (eds), *Santiago Sierra: Pabellón de España* (2003).

Garry Morris works for National Museums Liverpool; he was responsible for the initial outreach work to develop the Transatlantic Slavery Gallery at the Merseyside Maritime Museum. He currently leads the Liverpool Slavery Remembrance Initiative, which is a partnership between National Museums Liverpool, Liverpool City Council, Novas Overture, and individuals drawn mainly from the black communities of Liverpool. Members of the partnership work as a steering group.

Ronaldo Munck is Director of the Globalisation and Social Exclusion Unit (www.gseu.org.uk) at the University of Liverpool, dedicated to bridging the local/global divide from an interdisciplinary perspective. While his own research focuses on the impact of globalisation on the workers of the world (*Globalisation and Labour*, Zed Books, 2002), he has also edited collections on regeneration in Liverpool (*Reinventing the City? Liverpool in Comparative Perspective*, Liverpool University Press, 2003) and on culture and politics in Latin America (*Cultural Politics in Latin America*, Macmillan Palgrave, 2000).

Sharon Paulger is the Programme Coordinator (Lifelong Learning and Inclusion) for Liverpool Biennial and is responsible for the development

and implementation of a programme of activities to positively engage specific target audiences with the International exhibition. The four target audiences to be addressed by the programme are specialists; secondary schools; communities defined by inclusion agendas; and exhibition visitors. Sharon also manages the volunteer programme for the 2004 Biennial. Sharon has been with the Biennial since May 2001 and prior to this she worked for PRESCAP (Preston Community Arts Project) and Preston Well Women Centre.

Prof. Dr **Apinan Poshyananda** has an MA in Fine Arts from Edinburgh University and a PhD in History of Art from Cornell University, New York. He is the Director-General of the Office of Contemporary Art and Culture in Thailand's Ministry of Culture. He has published work and curated exhibitions on Asian art in Asia, Europe, Australia, South and North America. He was named Outstanding National Researcher by the National Research Council of Thailand. For his contribution to international cultural exchange the rank of Knight, First Class, Royal Order of the Polar Star was bestowed on him by King Carl XVI Gustaf of Sweden.

Stella Wing Yan Fong graduated in 2004 from the MA in Curating Contemporary Art at the Royal College of Art before joining the Liverpool Biennial working group as a curatorial intern. She previously worked as an assistant curator at Hong Kong Heritage Museum, Hong Kong, from 1997 to 2002.

Project Credits

International 04 projects are supported by
afoundation
Arts Council England
The Foyle Foundation
Liverpool City Council
Liverpool Culture Company
Northwest Development Agency

Azra Aksamija

Bread and Games, Plant and Play

Commissioned by Liverpool Biennial *International 04*

Conceptual co-author: Andreas Mayer (Su.N)
Liverpool-based project manager: Rebecca Reid
Conceptual contributors: Ibrahim Aksamija, Nadja Aksamija, Marc Daniels, Adrian Devers, Paul Domela, Brian Melcher, Sharon Paulger, Rebecca Reid, David Rhöse, Cath Stevenson, Sue Wrigley

With thanks to Roger Appleton, Sabine Breitwieser, Maureen Doyle, Michael Egger (Su.N), Leslie Gibbons, David Moore, Stephen Munby, and all further project participants and volunteers

Supported by the Calouste Gulbenkian Foundation, Neighbourhood Renewal Community Chests, the Austrian Cultural Forum, London, and the Liverpool 1 Partnership Group

Lara Almarcegui

Enclosed Gardens

Commissioned by Liverpool Biennial *International 04*

With thanks to Richard Cass, Cass Associates, Jane Hughes

Supported by the Mondriaan Foundation and the Royal Netherlands Embassy

Gustavo Artigas

After Hours Museum

Logo design: Malcolm Llanas
Sketches: Alvaro Verduzco
Photos: Mara Alos

Yael Bartana

You Could Be Lucky

Commissioned by Liverpool Biennial *International 04*

Producer: Naama Pyritz
Camera: Yael Bartana, Itai Neeman
Sound: Daniel Meir
Editing: Yael Bartana
Stills photographer: Ilya Ravinovich

With thanks to Museum of Liverpool Life – Jennifer McCarthy

Supported by the Mondriaan Foundation, the Royal Netherlands Embassy and the Embassy of Israel

Ursula Biemann

Contained Mobility

Commissioned by Liverpool Biennial *International 04*

With thanks to:
Anatol Kuis-Zimmerman
Roland Fischer, soundtrack
Angela Sanders, editing assistant
Andrea Lansley, production co-ordinator
Aboubaker Abdullah
Asylum Link Merseyside
Robert Kronenburg, Transportable Environments, University of Liverpool
Kelvin Hughes, Ilford, Navigation Systems and Integrated Charts, London
Transas, Navigation Systems and Simulators, Portsmouth
Port of Rotterdam, vessel trafficking
The Digital Ship, London
Matthew Fuller and Leslie Robbins, Piet Zwart Institute, Rotterdam
Institute for Theory of Art and Design, HGK Zurich

Supported by Pro Helvetia

Luis Camnitzer

Christmas Trees, North South East Best and *The Squaring of the Circle*

Commissioned by Liverpool Biennial *International 04*

With thanks to the Palm House and Elizabeth-Anne Williams for their generous help

Supported by the Goethe Institut, Manchester

Paolo Canevari

Seed

Commissioned by Liverpool Biennial *International 04*

Courtesy Galleria Christian Stein, Milan

With thanks to:
Urban Splash
Forbidden Planet
Les Jones, Curtins
Chris Miller, project assistant
Sara Black, project manager

Supported by the Italian Cultural Institute

Choi Jeong Hwa

Happy Together

Commissioned by Liverpool Biennial *International 04*

With thanks to:
Roy Greenhalgh and Laura Challinor, Network Rail, Lime Street Station
Lime Street Station
Chris Miller, project assistant
Duncan Turner and Steve Seddon, Faber Maunsell
Brian Boardman, City Centre Development Control
Kerri Farnsworth, Liverpool Vision
Steve Warbis, Network Rail
Network Rail for the electrical supply

Supported by Visiting Arts

Amanda Coogan

Beethoven, the Headbangers

Commissioned by Liverpool Biennial
International 04

With thanks to Liverpool Philharmonic Hall
for generously allowing the film shoot

Royal Liverpool Philharmonic Orchestra for
permission to use extracts from their
recording of Beethoven's Symphony No. 9.
Courtesy of EMI and the headbangers

Supported by the Irish Cultural Relations
Committee

**Neil Cummings and
Marysia Lewandowska**

The Commons

Commissioned by Liverpool Biennial
International 04

With thanks to Cressida Kocienski, Jon
Murden, Rebecca Reid, Jean Stowells and
Ben White

Supported by The Henry Moore
Foundation

Aleks Danko

Rolling Home

Commissioned by Liverpool Biennial
International 04

With thanks to Jude Walton, Irene Sutton,
Phoebe Dougall, Bryan Biggs, Yu Yeon Kim,
Anna Waldmann and David Smith
(animation)

Aleks Danko is represented by: Sutton
Gallery, Melbourne, Australia; and Gitte
Weise Gallery, Sydney, Australia and Berlin,
Germany

Supported by Australia Council for the Arts

Dias & Riedweg

Sugar Seekers

In collaboration with Victor Twagira, Liliane
Ingabire, Moses R, Abdul-Aziz Liban, Amos
Mukumbwa, Nicolette Muzazi, Ariane
Muzazi, Sarah Katushbe

With thanks to:
FACT: Maria Brewster, Kathryn Dempsey,
Marie-Anne McQuay, Wibke Hott and
Alan Dunn
Refugee Action Liverpool: Julie
Kashirahamwe, Lee Omar
Technician: Jim Lakey
IART: Valentin Spiess and Christian Rohner
For their participation: Bolondo Boketsu,
David Medalla, Gustav Metzger and
Nikolas Pantazopoulos,
Peter Cross, Claudia Wegener and
Cuauhtémoc Medina, all at Quynny's
Quisine and Matta International Food
For permission to film: Liverpool Film
Office, Urban Splash: Tea Factory, Mersey
Film and Video, Liverpool John Lennon
Airport, Merseyside Maritime Museum:
Sam Prior, Radio City

Sugar Seekers has been commissioned by
FACT's Collaboration Programme in
partnership with Liverpool Biennial and
Tate Liverpool

Maria Eichhorn

A Stay in Belfast

Commissioned by Liverpool Biennial
International 04

With thanks to:
Marius Babias
Judith Barry
Stan Douglas
Galerie Barbara Weiss

Supported by the Institut für
Auslandsbeziehungen

Carl Michael von Hausswolff

Red Mersey

Commissioned by Liverpool Biennial
International 04

With thanks to Brian Gilgeous/Extreme
Oceaneering, Thomas Nordanstad, Apinan
Poshyananda, Navin Rawanchaikul, The
Castle Sound Studio, Brändström & Stene
(Stockholm) and Nicola Fornello
(Prato/Torino). The piece *Red Mersey* was
produced by and for the Liverpool Biennial
(2004) and is dedicated to all sailors
around the world.

Supported by the Embassy of Sweden and
IASPIS (International Artists' Studio
Programme in Sweden)

Satch Hoyt

The Triangle

Commissioned by Liverpool Biennial
International 04

Commputer programming: Qasim Nagui
Technical assistant: Tomasz Nazarko
Construction consultant: David Bober
Rigging: Steve Thomson at Gordon Alison
Ltd
Plexus Cotton
Maritime Museum – Garry Morris
Bill Broadbent, British Waterways
Albert Dock Company
Gower Street Estates
CB Richard Ellis
Albert Dock Residents' Association

Huang Yong Ping

The Pole of the East

Commissioned by Liverpool Biennial
International 04

With thanks to Doug Evans and John Sloan
of CB Richard Ellis
Gower Street Estates
Wayne Lavery and Ian McAuley of Sloyans

Supported by the Institut français du
Royaume-Uni

Sanja Iveković

Liverpoll

Commissioned by Liverpool Biennial
International 04

Thanks to Zeljka Prebeg Mutnjakovic and
Mario Beusan
Production and installation: Andrew Small

Supported by Visiting Arts and the
Liverpool Daily Post and Echo

Francesco Jodice

Natura: The Mersey Valley Case

Film (35min), photographs, drawings

Commissioned by Liverpool Biennial
International 04

Directors: Marco Gentile/Francesco Jodice
Editing: Boris
Project curator: Patrick Henry
Production manager: Leon Jakeman
Project consultant: Tony Eccles
Project supervisor: Meris Angioletti

Supported by the Italian Cultural Institute

Peter Johansson

Musique Royale

Music (ABBA, 'Dancing Queen'), music
equipment and loudspeakers, lacquer and
paint, prefab house made of wood, glass,
metal. Interiors: kitchen, wet-room
facilities etc.

Commissioned by Liverpool Biennial
International 04

Thanks to:
Treatment and concept: Barbro Westling
Architect: Nike Karlsson
Musician: Benny Andersson
Photographer: Tord Lund
Apinan Poshyananda
Project management: Sara Black

With generous support from:
Grötlingbo Möbelfabrik with Nicke, Torgny
and Tomas
IASPIS, International Artists' Studio
Program in Sweden
Stiftelsen Längmanska Kulturfonden
Andrehn-Schiptjenko Gallery, Stockholm
Leger Gallery, Malmö
Wayne Lavery and Ian McAuley, Sloyans
Peter Lewis, Team Leader, City Centre
Management
Joe Farley, Shanghai Palace
Chris Miller, project assistant

Supported by the Swedish Arts Council,
the Embassy of Sweden and IASPIS
(International Artists' Studio Programme in
Sweden)

Yeondoo Jung

BeWitched (2001–)
Ongoing project, 135mm multi-slide projection
Projection size: 2.5 x 2m

Commissioned by Liverpool Biennial *International 04*

Special thanks to:
Ilmin Art Museum
Gallery Koyanagi
Tomoko Kimata
Yukie Kamiya
Misytzu Daisuke
Sunjung Kim
Pil Lee
Art Omi
Ruth Adams
De Appel Centre for Contemporary Art
Istanbul Biennial
AK Bank
and thanks to all the people who shared their dreams with me

Supported by the Calouste Gulbenkian Foundation, Visiting Arts and The Henry Moore Foundation

Werner Kaligofsky

The Departed Returned, the Newly Arrived and the Guest

Commissioned by Liverpool Biennial *International 04*

With thanks to Laura Britton, Brian Hatton, Kwan May Ling, Paul Moran, Felicity Wren, Tom Ehringer and Didi Sommer for their support in this project

Supported by the Austrian Cultural Forum, London

Germaine Koh

Marks and *Relay*

Commissioned by Liverpool Biennial *International 04*

With thanks to:
Tate Liverpool Visitor Services Assistants and Information Assistants who submitted designs
Lord Mayor's Office

Supported by the Department of Foreign Affairs and International Trade of Canada,
the Canadian High Commission and The Henry Moore Foundation

Andreja Kulunčić

Teenage Pregnancy

Commissioned by Liverpool Biennial *International 04*

Project consultant: Ivo Martinovic
Special thanks to:
Arts in Regeneration
Dave Crawley, project assistant
Sue Sutton, South Liverpool Housing
Cressida Kocienski, project manager
The residents of Speke

Oswaldo Macià

Surrounded in Tears

Commissioned by Liverpool Biennial *International 04*

A project realised in collaboration with Jasper Morrison and Michael Nyman
Project manager: Nina Krieger

With thanks to:
Lord Mayor's Office
Lime Street Station
Network Rail
Liverpool Community College

Supported by Arts Council England

Jill Magid

Retrieval Room and *Evidence Locker*

Commissioned by Liverpool Biennial *International 04*

With thanks to:
Patrick Hall, Mersey Film and Video
Rolf Coppens, www.grrr.nl
Rene Brouwer, www.wrks.nl
City Watch CCTV operators (Merseyside Police and Liverpool City Council) and the Forensic Imaging Unit
Mersey Film & Video
Patrick Hall
Francis Ryan
Peter Woods

Supported by the Mondriaan Foundation and the Royal Netherlands Embassy

Iñigo Manglano-Ovalle

Iceberg, 2004
Stainless steel and aluminium with sound
9.14 m x 6.88 m x 5.03 m (30' x 22'7" x 16'6")
Courtesy of the artist and Max Protetch Gallery

Commissioned by Liverpool Biennial *International 04*

Iceberg (Prototype 2, No. 1), 2004
Titanium alloy and fibreglass
200 cm x 96 cm x 147 cm (79" x 38" x 58")
Courtesy of the artist and Max Protetch Gallery

Special thanks to:
The Canadian Hydraulic Center, Canadian National Research Council
Colin Franzen, architect
and
Port of Liverpool, Keppie Massie and Len Williams, property manager
Cecilia Andersson, project manager
Arup
Casper Jones
George Downing, Downing Developments

Supported by The Henry Moore Foundation and the Spanish Embassy

Esko Männikkö

Organised Freedom: Liverpool Edition

Commissioned by Liverpool Biennial *International 04*

With thanks to Dave Brougham (caretaker) and Maria Newall (housing officer) at the Altbridge Park office, the Altbridge Park Residents' Assocation for their support and advice, and all the residents of the three blocks at Altbridge Park for their welcome

Supported by FRAME (Finnish Fund for Art Exchange), the Finnish Institute in London and the Finnish Embassy

Dorit Margreiter

Grandeur et décadence d'un petit commerce de cinéma
2-channel projection
16mm transfer to DVD and video to DVD
Courtesy Galerie Krobath Wimmer, Vienna

Commissioned by Liverpool Biennial *International 04*

Camera (16mm): Hannes Boeck
Camera (video): Hannes Boeck, Dorit Margreiter
Text/voice-over: Kaucyila Brooke
Editing: Dorit Margreiter at Die Hoege, Germany
Film development and digital mastering: Synchrofilm, Vienna
Production designer/manager: Joanne Cook
Art department assistant/runner: Stewart Armstrong
Art department assistants: Sherry Adshead, Angela Byrne, Kevin Crooks, Christopher Coy, Eleanor Hawkridge, Sean Hawkridge, Damian Holliday, Joseph Jones, Julie Kinsella, Peter Kerrigan, Dale Leatherbarrow, Nadya Mezeli, John O'Hare, Conrad Olson, Melanie Peake, Kate Reed, Eleanor Rees, Marcus Twist, Martin Wilson

Merseyside Police
Jamie Swanson at North East Traffic Management
Liverpool City Council – Regeneration
Liverpool Stagecoach Company
FJC Supplies
Kevin Carroll
Absolute Services

Special thanks to:
Kevin Bell – Liverpool Film Office
Bill and Neil at Cooks Stores, Waterloo
Zigzag Discount Store, Crosby
Liverpool City Council
John Neary at Cleanaway
Tom Harnick
May
The residents of Canning Street
All at the German Church

Supported by the Austrian Cultural Forum, London

Cildo Meireles

LiverBeatlespool

Commissioned by Liverpool Biennial *International 04*

Sound engineering (Rio): Pedro Ariel Meireles
Production assistance (Liverpool): Sean Hawkridge

Takashi Murakami

Jellyfish Eyes – Max & Shimon, 2004
FRP, steel, acrylic, lacquer
Max: body: height 38.4"; platform (eye): 16.1 x 26.7"; pedestal: 55.1 x 53.5 x 7.5"
Shimon: body: height 18.7"; platform (eye): 11.6 x 17.7"; pedestal: 55.1 x 53.5 x 7.5"

Jellyfish Eyes – Saki, 2004
FRP, steel, acrylic, lacquer
Body: height 38.4 inches; platform (hill): 14.2 x 26 x 39"; pedestal: 43.3 x 48 x 7.5"

Jellyfish Eyes – Tatsuya, 2004
FRP, steel, acrylic, lacquer
Body: height 38.4"; platform: 15.4 x 18.5 x 19.8"; pedestal: 43.4 x 4.7 x 7.5"

Untitled billboard, 96 sheets

Commissioned by Liverpool Biennial *International 04*

Courtesy Kaikai Kiki New York, LLC and Marianne Boesky Gallery

Supported by The Japan Foundation

Yoko Ono

My Mummy Was Beautiful, 2004

Commissioned by Liverpool Biennial *International 04*

New York production:
Jon Hendricks
Robert Young
Karla Merrifield
Hephsie Loeb

Liverpool production:
Alan Ward
Sarah Jane Dooley
Rajwant Sandhu

Mathias Poledna

Academy, 2004

Commissioned by Liverpool Biennial *International 04*

Supported by the Austrian Cultural Forum, London

Marjetica Potrč

Balcony with Wind Turbine

Commissioned by Liverpool Biennial *International 04*

With thanks to:
Nova stran, Studio for Architecture, Ljubljana
Max Protetch Gallery, New York
Architect Andrew Brown from Owen Ellis Partnership
Dave Knowles, Curtins Consulting Engineers
Gray & Dick contractors
Graham Reed, Windsave Ltd
Paul Kelly, Liverpool Housing Action Trust for managing the project
And a special thank you to all residents of Bispham House

Supported by Visiting Arts and Windsave Ltd

Raqs Media Collective

With Respect to Residue (Table Maps for Liverpool)

Commissioned by Liverpool Biennial *International 04*

Designed with: Mrityunjay Chatterjee
Acknowledgement: Rana Dasgupta
Designed at the Sarai Media Lab

With thanks to all participating restaurants

Supported by Visiting Arts

Navin Rawanchaikul

SUPER(M)ART – How to be a Successful Curator: A Survival Game

Commissioned by Liverpool Biennial *International 04*

This project has been created in collaboration with Helen Michaelsen

Supported by Visiting Arts

Martha Rosler

Liverpool Delving and Driving

Commissioned by Liverpool Biennial *International 04*

In New York:
Caitlin E. Berrigan
Mary Billyou
Daniel Blochwitz
Linda J. Park
Eric Symons
Niko Vicario

In Liverpool:
David Dunster
Stella Wing Yan Fong
Tony Siebenthaler

Shen Yuan

Trampoline 12345

Commissioned by Liverpool Biennial *International 04*

With thanks to Shen Ye

Supported by the Institut français du Royaume-Uni

Santiago Sierra

El Degüello

Commissioned by Liverpool Biennial *International 04*

With thanks to Galerie Peter Kilchmann, Zürich and Lisson Gallery, London

Supported by the Spanish Embassy

Valeska Soares

Swirl, 2004

Crystal chandeliers, synthetic hair, velvet, synthetic panels and sound surround equipment
Dimensions variable
Courtesy of the artist and Galeria Fortes Vilaça, Brazil

Commissioned by Liverpool Biennial *International 04*

Produced by Tate Liverpool and Liverpool Biennial
Soundtrack by Grivo and Valeska Soares
Art production: Adrian George, Mark Daniels

Supported by Searchlight Electric Ltd

Torolab

In-Shop (Shop)

Commissioned by Liverpool Biennial *International 04*

Torolab:
Raúl Cárdenas-Osuna
Shijune Takeda
Bernardo Gutierrez
Jorge Blancarte

Merchandise selected by:
Prlamo Lozada
Taiyana Pimientel
Marcela Quiroz
Jonathan Hernandez
Julio Morales
Donna Conwell
Steve Fagins
Damon Bell
Cecilia Andersson
Michael Brown
Cuauhtémoc Medina
Toro Vestimenta

Thanks to:
Bonanza Projects
Cuauhtémoc Medina
Cecilia Andersson
EVC, Electric Vehicle Controls (UK) Ltd

Wong Hoy Cheong

Trigger

Commissioned by Liverpool Biennial *International 04*

Production and post-production:
Martin Wallace (producer)
Ilya Abulhanov (editor)
Andy Alias (sound design)
Sean Hawkridge and Vincent Leong (assistant directors)

and all the cameramen, production
assistants, volunteers/extras and staff of
the Adelphi Hotel
Also thanks to:
Marilyn Vaughn, Adelphi Hotel
Moon K. Chan, mfx, Kuala Lumpur
Catherine Gibson, Bluecoat Gallery
Wayne Docksey, Animal Acting,
Manchester
Velcro, Kaiser, Fotolynx

Yang Fudong

Close to the Sea, 2004
Video installation, 24–28 mins, 10-screen

Commissioned by Liverpool Biennial
International 04

Director: Yang Fudong
Music: Jing Wang

Supported by Liverpool Biennial, FACT (The
Foundation for Art and Creative
Technology), and Visiting Arts

Yuan Goang-Ming

City Disqualified – Liverpool

Commissioned by Liverpool Biennial
International 04

With thanks to Radio City Tower, especially
Lesley Marshall for giving free access to
photographer Kuomin Lee

Supported by Visiting Arts and The Henry
Moore Foundation

International +

Wild! The Liverpool Experience

Thanks to staff and participants from
Halewood Resource Centre, artist Andy
Weston, Rebecca Jones and Sarah
Haythornthwaite from Bluecoat *Connect*,
an innovative programme of
collaborations between artists and local
communities.
Supported by Arts Council England

Wild! The Journey

Thanks to staff and participants from the
L8 Resource Centre and Fazakerley

Croxteth Day Services, Anthony Gomez,
Peter Goodwin, artist Leo Fitzmaurice,
Rebecca Jones and Sarah Haythornthwaite
from Bluecoat *Connect*, an innovative
programme of collaborations between
artists and local communities.
Supported by Arts Council England

Wild!! Static

Thanks to:
Jo Lansley
Paul Sullivan
David Macintosh
Martin Vincent
Annabel Longbourne
Neil Cummings/Chance Projects
Lisette Smit (CASCO Projects)
Duncan Hamilton (White Diamond)

Steven Renshaw
Andy Poole
Laura Pullig
Barbara Jones
Mary Fitzpatrick
Tony Knox
Gaynor Evelyn Sweeney
Caroline Black
Steven Lloyd
John Borley

Supported by Arts Council England

Tracking

Thanks to participating pupils from Sutton
High Sports College, their head of art
Derek Boak, artists Patricia Mackinnon-Day
and Amanda Coogan, Ruth Bradbury of
Creative Partnerships and Judith Agnew of
Liverpool Philharmonic
Supported by Creative Partnerships

Cityscapes

Thanks to Andrea Lansley, Francesco
Jodice, Yael Bartana, Bronek Kram and
Toxteth TV
Supported by the Lottery through the UK
Film Council's First Light initiative

Buddies

Thanks to Geoff Molyneux, Jane Hughes,
Kate Reed, Leon Jakeman, Aboubaker
Abdullah, Des Shaw and Cath Stevenson

Viral Treats

Thanks to Ali Johnson, Carole Potter, Ian

Mitchell, Cecilia Garside, Nadja Kuenstner

Ways of Seeing Vol. 2

Thanks to Alan Dunn (FACT), Jean Niblock,
Michael Roberts, John Pettitt, Fee Plumley,
Mavis Thomas, Kath Healy and Bernadette
McGrath, John McGuirk (tenant), Hilary
Thorn (artist/SPLICE), Amanda Coogan
(artist), Mark Daniels (Liverpool Biennial),
Catherine Gibson (Bluecoat Arts Centre),
Cathy Butterworth (Bluecoat Arts Centre),
Mauricio Dias (artist), Walter Riedweg
(artist), Ariane Muzazi (project
participant), Laura Britton (Tate Liverpool),
Wibke Hott (FACT), Marilyn Vaughan
(Adelphi Hotel), Hoy Cheong Wong (artist),
Dorit Margreiter (artist), SPLICE (Liverpool-
based artists' network) and Valeska Soares
(artist)

Acknowledgements

Special thanks

Angelika Richter for helping to conceptualise the curatorial process

Aspects of Liverpool (seminar leaders)

Sara Cohen

David Dunster

Jennifer McCarthy

Derek Massey

Rogan Taylor

Permissions

Andrew Blackmore – Licensing, Liverpool City Council

Brian Boardman – Planning, Liverpool City Council

Steve Corbetts – Planning, Liverpool City Council

Tracey Fitzsimmons – City Centre Management, Liverpool City Council

Graham Holman – Licensing, Liverpool City Council

Peter Lewis – City Centre Management, Liverpool City Council

Anita McGowan – Special Projects, Licensing, Liverpool City Council

Anne-Marie McTique – Special Projects, Liverpool City Council

Brian Mason – Highways Department, Liverpool City Council

Anne-Marie Moran – Special Projects, Liverpool City Council

Paul Rice – City Centre Management, Liverpool City Council

Sing Yu – Highways Department, Liverpool City Council

Advisory support

Bill Gleeson, Liverpool Daily Post and Echo

Charles Hubbard, Edmund Kirby

Jane Luca, Granada Television

Roy Morris, Rathbones

Sara Williams, Liverpool Chamber of Commerce

Arts and Business:

Janet Dunnett

Paul Smith

Arts Council England:

Marjorie Allthorpe-Guyton

Kim Evans

Peter Hewitt

Arts Council England NW:

Michael Eakin

Aileen McEvoy

Howard Rifkin

The Cultural Consortium, England's Northwest:

Felicity Goodey

Lloyd Grossman

Libby Raper

Government Office Northwest:

Kevin Griffiths

Jennifer Latto

Janet Matthewman

Liverpool City Council:

Sir David Henshaw

Mike Storey

Liverpool Culture Company:

Maggie Barr

Kris Donaldson

Jason Harborow

Zena Harrison

Claire McColgan

Sir Bob Scott

Sue Woodward

Northwest Development Agency:

Nick Brookes-Sykes

Stephen Broomhead

Emma Degg

Helen France

Richard Hughes

Peter Mearns

Jonathan Pickthall

NWDAF (North West Disability Arts Forum):

Ruth Gould

Alison Jones

Danny Start

The Mersey Partnership:

Chris Brown

Laura Buckley

Barrie Kelly

Tom O'Brien

Visiting Arts:

Camilla Canellas

Ann Jones

Nelso Fernandez

Terry Sandell

Liverpool Biennial *International 04* venue partners

BLUECOAT ARTS CENTRE

Bryan Biggs – Director

Catherine Gibson – Curator

Jane Davies – Gallery Coordinator

Andrew Winder – Marketing Manager

FACT

Eddie Berg – Executive Director

Maria Brewster – Head of Collaboration Programme

Susanne Burns – Development and Communications Director

Kathryn Dempsey – Commissions Coordinator (Collaboration Programme)

Ceri Hand – Head of Exhibitions

Nick Lawrenson – Exhibitions Manager

Marie-Anne McQuay – Programme Manager (Collaboration Programme)

OPEN EYE GALLERY

Patrick Henry – Director

Dave Williams – Gallery Manager

TATE LIVERPOOL

Laura Britton – Curator: Public Programmes

Christoph Grunenberg – Director

Adrian George – Curator: Exhibitions and Collections

Simon Groom – Head of Exhibitions and Displays

Sophie Allen – Tate Biennial Project Coordinator

Jemima Pyne – Communications and Publishing Manager

Communications and Publishing Department

Ken Simons: Art Installation Manager

Art Handling Team

LIVERPOOL BIENNIAL

Founding Benefactor
James Moores

Liverpool Biennial Board
Eddie Berg
Bryan Biggs
Walter Brown
Bev Bytheway
Jane Casey
Kate Cowie (until June 2004)
Roger Goddard
Alison Jones
Jude Kelly
Francis McEntegart
Declan McGonagle (Chair)
Alistair Sunderland
Julian Treuherz (until February 2003)
James Warnock (Vice-Chair)
Jane Wentworth

Observers
Cllr Beatrice Fraenkel
Andrea Hawkins
Paul Kurthausen

Staff
Lewis Biggs – Chief Executive
Sorcha Carey – International Exhibition Assistant
Mark Daniels – International Exhibition Coordinator
Paul Domela – Deputy Chief Executive
Sarah Jane Dooley – Development Assistant
Judith Harry – Development and Marketing Manager
Nadja Kuenstner – Marketing Assistant
Sharon Paulger – Programme Coordinator: Learning and Inclusion
Raj Sandhu – Projects Assistant
Richard Wilson – Finance Officer
Lorna Woods Moses – Administration Manager

Consultants
Catherine Braithwaite – press consultant
Daniel Harris Associates – public relations
John Regan – corporate relations
TM3 – website developers
Love Creative – brand and campaign creative designers
Unit Communications – media buyers
Alan Ward – *International 04* catalogue, leaflet and graphics

Interns
Sue Algelsreiter, Lisa Baker, Amanda Barwise, Andrew Bullock, Louise Clennell, Martyn Coppell, Somali Datta, Wayne Dawber, Rachel Eade, Marie Noelle Farcy, Tamzin Forster, Linzi Harries, Sean Hawkridge, Annie Houston, Clare Hunter, Matthew James, Sally Lupton, Paul Luckcraft, John O'Hare, Clare Parker, Melanie Peck, Regina Peldszus, Renae Pickering, Anna Rowland, Sam Skinner, Elpiniki Vavritsa, Stella Wing Yan Fong

External Project Managers
Cecilia Andersson
Donna Berry
Sara Black
Joanne Cook
Paul Kelly
Cressida Kocienski
Andrea Lansley
Rebecca Reid
Catherine Sadler

Technical Management
Tom Cullen – Technical Supervisor
MITES – Moving Images Touring Exhibition Service

Learning and Inclusion Programme
Liverpool Community College:
Wally Brown, Tracy Brown
Knowsley Arts Services:
Charlotte Corrie, Sarah Craven, Jo Dry, Sarah Haythornthwaite
Gill Curry, Wirral LEA
Andrea St John, St Benedict's College
Carol Dockwray, Campion Catholic High School
Kay Wilkin, Liverpool LEA
Philip Wroe, Sefton Council
Karen Gallagher, Merseyside Dance Initiative
John McDonald
David Ward, Windows Project
Julia Midgeley, Liverpool School of Art and Design, LJMU
Roger Appleton, Broadside Films